BEAUTY OF ANOTHER ORDER
PHOTOGRAPHY IN SCIENCE

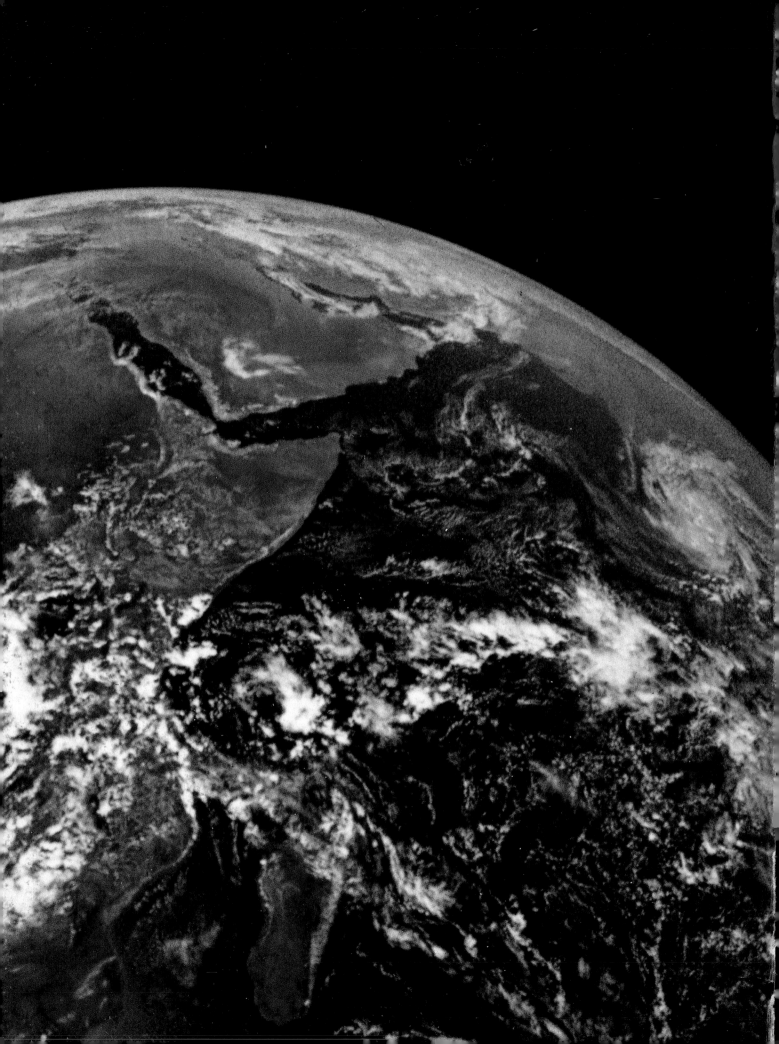

BEAUTY OF ANOTHER ORDER

PHOTOGRAPHY IN SCIENCE

Ann Thomas

with essays by
Marta Braun
Mimi Cazort
Martin Kemp
John P. McElhone
Larry J. Schaaf

Yale University Press
New Haven and London

In association with
National Gallery of Canada, Ottawa

Published in conjunction with the exhibition titled
PHOTOGRAPHY IN SCIENCE: BEAUTY OF ANOTHER ORDER
organized by the National Gallery of Canada and
presented in Ottawa from 17 October 1997 to
4 January 1998

Published by Yale University Press,
New Haven and London, in association with the
National Gallery of Canada, Ottawa

NATIONAL GALLERY OF CANADA
Chief, Publications Division: Serge Thériault

FOR YALE UNIVERSITY PRESS
Editing, design and production: Jane Havell

Typeset in Castellar MT and Trump Mediæval
Printed and bound in Singapore by C.S. Graphics

Title page: Detail of Earth taken from Mission
Apollo–Saturn 17, 7–19 December 1972. Dye transfer
print. Robert Mann Gallery. See Pl. 150.

ISBN 0-300-07340-2
Library of Congress Catalog Card No.: 97-61357
A catalogue record for this book is available from
The British Library and the Library of Congress

Canadian Cataloguing in Publication Data

Thomas, Ann.
Beauty of Another Order : photography in science.

Exhibition catalogue.
Issued also in French under title: Photographie et
science. Une beauté à découvrir.
Includes bibliographical references: p.

1. Photography—Scientific applications—Exhibitions.
I. National Gallery of Canada. II. Title.

TR692 T56 1997 621.36'7'074 C97-986006-7

PICTURE CREDITS

Photographs have been provided by the owners or
custodians of the works reproduced, except for the
following: National Gallery of Canada: 38, 46, 53,
67, 73, 130, 135, 144, 145, 150, 151; Photothèque des
Musées de la Ville de Paris: 39; Royal Observatory,
Edinburgh: 56; Science and Society Picture Library,
London: 21, 22, 24, 25 (right), 26, 29, 32, 49, 76, 121,
134, 140, 141, 142, 148; provided by the authors: 19,
63, 93, 102, 106, 118, 120, 132. We gratefully
acknowledge the granting of permission to use these
images. Every reasonable attempt has been made to
identify and contact copyright holders with regard to
illustrations. Any errors or omissions are inadvertent,
and will be corrected in subsequent editions.

This book is dedicated to two Canadians

Jon Darius, remembered for his pioneering work on photography in science
Roberta Bondar, who crossed the frontiers of space, camera in hand

Contents

Foreword

QUOTING the words of philosopher, mathematician, scientist, and historian Gottfried Wilhelm Leibniz— "the present is replete with the future and filled with the meaning of the past"— one writer, witnessing in 1858 the application of photography to science, correctly saw its importance in the continuum of ideas and actions that shape human civilization: its role in human history. François Arago, Director of the Paris Observatory, announcing the invention and discovery of the daguerreotype at a joint meeting of the Académie des sciences and Académie des beaux-arts on 19 August 1839, spoke about recording images of galaxies millions of light years distant and revealing one day the origins of life by bringing to our view infinitesimally small life forms.

By bringing together the works of photographers such as Louis Jacques Mandé Daguerre, William Henry Fox Talbot, Etienne-Jules Marey, Eadweard Muybridge, Anna Atkins, Charles Marville, Lewis Rutherfurd, Edward Emerson Barnard, Karl Blossfeldt and Berenice Abbott, among others, *Beauty of Another Order* looks at the scientific purposes and the aesthetic expression and influence of this genre of photography. It challenges the popular belief that poetry and science are antithetical. Called during the nineteenth century the "beautiful art-science", the "true retina of the scientist" and the "exact translation of nature", photography continues to play an important role in bridging the divide between C. P. Snow's "two cultures".

Photography was the offspring of a marriage of scientists, who researched its chemistry, optics and the action of light in the eighteenth and nineteenth centuries, and artist–entrepreneurs, who experimented with its visual effects and reproductive technologies in the hope of satisfying an insatiable public need for pictorial illusions. With the power to capture instantly aspects of the visible world—and later the forms of the unseen world—it embedded itself into the established visual culture with such force that we are still in the process of absorbing its effects.

The extraordinary aspects of the universe revealed by photographs of the sun's corona during an eclipse, the transit of Venus across the face of the sun, and those photographs that captured actions and organisms visible only to the assisted eye—from sequential movements of a galloping horse to "portraits" of bacteria, from the structure of distant galaxies to the mysterious secrets of the composition of matter—excited even those photographers who, like Peter Henry Emerson (1856–1936) a medical doctor and accomplished photographer, rejected the camera's capacity to record detail relentlessly. Emerson published a treatise in 1888 on photography as a medium of artistic expression, *Naturalistic Photography for Students of the Art*, in which he proposed that photographers follow the principles of the mid-nineteenth century plein air painters of the French Barbizon School by depicting nature with breadth and atmosphere.

Today his exquisite platinum and photogravure images of the marshes, rivers and fens of East Anglia, made in the late 1880s, are keenly collected by museums such as the National Gallery of Canada, along with scientific images by Anna Atkins, Duchenne de Boulogne, Etienne-Jules Marey, Eadweard Muybridge and others.

Beauty of Another Order situates within an historical context of art and science those images which were considered to be "faithful and unerring" but which were not, as well as those subjects thought to be too fast, too small, too vast or too distant to be captured on film. By including photographs by artist–photographers working in Germany and the United States in the 1920s and 1930s who were influenced by the techniques, appearance and concepts behind scientific photographs of the past, this exhibition and book propose that photographic works by contemporary artists—some of whom use scientific research and techniques from seismology, plant propagation and gene mapping—are not isolated phenomena, but rather part of a continuum.

This exhibition and book relied heavily on the generous support of many lenders. They are:

Anglo-Australian Observatory, Epping
Art Gallery of Ontario, Toronto
Bibliothèque Centrale du Muséum d'Histoire Naturelle, Paris
Canadian Institute for Scientific and Technical Information, National Research Council, Ottawa
Conservatoire des Arts et Métiers, Paris
George Eastman House, Rochester
Gilman Paper Company, New York
Hochschule der Künste, Berlin
Institut de France, Bibliothèque de l'Institut, Paris
International Center for Photography, New York
Metropolitan Museum of Art, New York
Münchner Stadtmuseum, Munich
Musée Carnavalet, Paris
Musée de l'Homme, Paris
Museum Folkwang, Essen
The Museum of Modern Art, New York
National Museum of Photography, Film and Television, Bradford
New York Public Library
Royal Society of Medicine, London
Société française de photographie, Paris
Thomas Fisher Rare Book Room, University of Toronto, and the Manuscripts Department, Science Library of the University College, London
Dr. William Alschuler, San Francisco
Gordon Bennett, Kentfield
Dr. Roberta Bondar, Toronto
Marta Braun, Toronto
John Erdman and Gary Schneider, New York
The Estate of Michel Doyon, Ancienne-Lorette
Hans P. Kraus Jr., New York
Robert Hershkowitz, Sussex
Howard Greenberg Gallery, New York
Ezra Mack, New York
Jay McDonald, Santa Monica
Robert Mann Gallery, New York
Robert Shapazian, Los Angeles
Marjorie and Leonard Vernon, Los Angeles
Stephen White, Los Angeles
Winter Works on Paper, Inc., New York.

I extend my gratitude to them all.

DR. SHIRLEY L. THOMSON
DIRECTOR, NATIONAL GALLERY OF CANADA

Acknowledgements

ALTHOUGH the absence of a history of scientific photographs suggests that *Beauty of Another Order* is a subject long overdue for scholarly attention, several exhibitions and publications have paved the way for more comprehensive treatment, among them *Once Invisible* at The Museum of Modern Art, New York in 1967; *Beyond Vision* at the Science Museum, London in 1984; *Images d'un autre monde* at the Centre national de photographie, Paris in 1991; *L'âme au corps: arts et sciences 1793–1993* at the Galeries nationales du Grand Palais, Paris in 1993; *A corps et à raison: photographies médicales 1840–1920* at the Hôtel de Sully, Paris in 1995; *Quest for the Moon* at the Museum of Fine Arts, Houston in 1994, and *In Visible Light* at the Museum of Modern Art, Oxford in 1997.

Beauty of Another Order was inspired by the compelling nature of a body of photographs cherished and preserved by a dedicated group of curators who had the foresight to collect a genre not always immediately recognized as worthy of attention in museums of fine arts. Their passion made this enterprise possible. Within my own institution I owe thanks to Dr. Shirley L. Thomson, Director, for steadfastly supporting and facilitating this exhibition and book. I thank Dr. Colin B. Bailey, Chief Curator; Daniel Amadei, Assistant Director of Exhibitions and Installations, and Helen Murphy, Assistant Director of Communications, who were instrumental in various ways in ensuring that the necessary support was acquired to bring both to fruition.

The writings of my distinguished co-authors —Dr. Mimi Cazort, former Curator of Prints and Drawings at the National Gallery of Canada; John McElhone, Conservator of Photographs at the National Gallery of Canada (both of whom are colleagues); Dr. Larry J. Schaaf, Professorial Research Fellow, University of Glasgow; Marta Braun, Professor of Film and Photography, Ryerson Polytechnical University, and Dr. Martin Kemp, British Academy Wolfson Research Professor, Department of the History of Art, Oxford University—have been an initial and constant inspiration. Their essays make a rich and indispensable contribution to this book. This publication marks a second fruitful collaboration between the National Gallery of Canada and Yale University Press. The considerable talents and expertise of Serge Thériault, Chief of Publications at the National Gallery, and John Nicoll of Yale University Press have been brought to bear upon every aspect of its production. Their unbridled enthusiasm for the images and ideas created a very constructive climate within which to work, while Jane Havell lent an astute and unflappable editorial presence and provided a dynamic layout and cover design for this book. Susan McMaster, English Editor, National Gallery, provided invaluable back-up. The challenge of copy photography was met with enthusiasm by Diane Watier, whose energy level surely constitutes one of the unrecognized scientific wonders of our time.

Johanna Mizgala, who provided curatorial support for this project, deserves special men-

10

tion. She helped with the index, organized the bibliography and captions for the book and assisted in numerous other ways, routinely performing the curatorial equivalent of rocky moon walks with great aplomb. Karen Colby-Stothart, Project Manager for the exhibition, kept all aspects of the project under control by implementing her superb organizational skills. Her unwavering support for the project and good humour were an inspiration to her colleagues. Hazel Mackenzie, Art Storage and Documentation Officer for Photographs; Lori Pauli, Assistant Curator of Photographs; Christine Lalonde, Curatorial Assistant, Inuit Collection; Susan McMaster, English Editor; Kate Laing, Head, Art Loans and Exhibitions; Denis Tessier, Special Events Officer; Judith Parker, Education Officer; Bonnie Bates, Library Loans; Anna Kindl, Library Acquisitions; Ursula Thiboutot, Chief, Communications Liaison; Alan Todd, Designer, and Cyndie Campbell, Archivist, made important contributions. James Borcoman, Curator Emeritus at the National Gallery of Canada, and Barbara Boutin, Secretary to the Collection of Photographs (both of whom retired during the preparation of this exhibition and book) are also to be thanked for their early support.

George Carmody and Irwin Reichstein, scientists and ardent collectors of photographs, are sincerely thanked for diligently reading and commenting on Chapters 4 and 7, as are Brydon Smith, my spouse and colleague, and my colleague John McElhone. At different times Claude Baillargeon, Andrea Kunard and Bruce Pert conducted research on aspects of the project, the results of which made important contributions to our knowledge of the subject. In addition to fulfilling research requests, Claude Baillargeon made thoughtful suggestions about the photographs he examined, many of which I have acted upon and which enrich the character of the exhibition.

Many people were most gracious in answering requests for information. Among them are Stanley B. Burns MD, Stanley Burns Collection; David Malin, Anglo-Australian Observatory;

Michael Rhode, Chief Archivist, National Museum of Health & Medicine, Washington; John M. Herr, Jr., Department of Biological Sciences, University of South Carolina; Randall C. Brooks, Curator, Physical Sciences and Space, National Museum of Science and Technology, Collection of Astronomy, Science and Technology; Lynn Delgaty, Archivist, Susan Cleveland, Corporate Communications Officer, and Harry Turner, Photographer, National Research Council, Canada; Marjorie Pearson, Thomas Fisher Rare Book Library, University of Toronto; Margot Montgomery, Director General of the Canadian Institute for Scientific and Technical Information (CISTI), Ottawa, and Dr. Ernie Small, Research Scientist, Agriculture Canada.

The following people went beyond the call of duty in answering questions concerning collections access, loans, copy photography and, of course, in making their collections available to us for viewing: Monique Ducreux, Directeur, Françoise Serre, Conservateur chargé du fonds patrimonial, Véronique van de Ponseele, Bibliothécaire responsable de la Photothèque, and Pascale Heurtel, responsable des manuscrits and the dedicated staff at the Bibliothèque Centrale du Muséum d'histoire naturelle; Jacqueline Dubois, Directeur, and Christine Barthe, Chargée de mission at the Photothèque Musée de l'Homme; Sylvie Aubenas at the Bibliothèque nationale; Michel Poivert, Président and Katia Busch at the Société française de photographie; Jean-Marc Léri, Conservateur Général, and Françoise Reynaud, Conservateur chargé des photographies, at the Musée Carnavalet; Marie-Sophie Corcy, Responsable des collections photographiques et cinématographiques, Conservatoire des arts et métiers; Mme N. Daliès, Conservateur général, and Annie Accary, Bibliothèque de l'Observatoire de Paris; Françoise Launay, Section d'Astrophysique, Observatoire de Meudon; Mireille Pastoreau, Directrice, and Annie Chassagne, Conservateur en chef, Institut de France; Danièle Roberge, Histoire de la médecine, Bibliothèque interuniversitaire de médecine, Paris; Dr. Uwe Meyer-Brunswick, Hochschule

der Kunst; Ute Eskildsen, Curator, and Robert Knodt, Associate Curator, at the Folkwang Museum; Anne and Jürgen Wilde; Ulrich Pohlmann at the Munich Stadtmuseum Photomuseum; Cornelia Kemp, Curator, Deutsches Museum; Hans Christian Adam, Göttingen; Bodo von Dewitz, Curator, Agfa Foto-Historama im Wallraf–Richartz Museum, Museum Ludwig, Cologne; Reinhold Mißelbeck, Curator, Museum Ludwig, Photo Sammlung, Cologne; Rolf Krauss, Stuttgart, Dr. Wenner Sobotka, Höhere Graphische Bundes-Lehr und Versuchsanstalt, Vienna; Ulrike Gauss, Chief Curator, Staatgalerie Stuttgart; Rolf Mayer, Irene Schmidt; Amanda Nevill, Head of Museum, Paul Goodman, Registrar, Brian Liddy, Will Stapp, Visiting Curator of Photography, National Museum of Film, Photography and Television, Bradford; Adam Perkins, Royal Greenwich Observatory Archivist, Department of Manuscripts and University Archives, Cambridge University Library; Sir Aaron Klug, President, Mary Nixon, Head of Fellowship and Information Services, and Sandra Cumming, Library Manager, Royal Society of London; David Stewart, Director of Information Services and Linda Griffiths, Librarian, Royal Society of Medicine; Tracey Dart, Publications Manager, Royal Society of Edinburgh; Shona McEachern, Deputy Librarian, Royal Observatory, Blackford Hill, Edinburgh; Ingrid Howard, Librarian, Royal Greenwich Observatory, Cambridge; Sara Stevenson, Scottish National Portrait Gallery, Edinburgh; Alison Morrison Lowe, Royal Scottish Museum, Edinburgh; Laura Gasparini, Biblioteca Panizzi, Reggio Emilia; Sandra Phillips, Curator of Photographs and Doug Nichols, Assistant Curator of Photographs, Lorna Campbell, Assistant Registrar, San Francisco Museum of Modern Art; Anthony Bannon, Director, James Conlin, Registrar, Rachel Stuhlman, Chief Librarian, Janice Madhu, Photo Collection, Reproductions, George Eastman House, Rochester; David Coleman, Head of the Department of Photography, Andrea Inselmann, Assistant Curator, Photography Collection, Kelly George, Photography and Film, Harry Ransom Research Center, University of Texas, Austin; Julia van Haaften, Curator of Photographs, Maryl Hosking, Loan Administrator and Sharon Frost, Photography Collection, Miriam and Ira D. Wallach Division of Art, Prints and Photographs, The New York Public Library; Maria Morris Hambourg, Curator of Photographs, Malcolm Daniel, Associate Curator, and Jeff Rosenheim, Assistant Curator, The Metropolitan Museum of Art, New York; Martha Hazen, Harvard Observatory; Deborah Martin Kao, Curator of Photographs, Fogg Museum, Cambridge; Peter Galassi, Chief Curator, Virginia Dodier, Study Center Supervisor, Department of Photography, The Museum of Modern Art, New York; Miles Barth, International Center of Photography; Jean Cargill, Botany Libraries, Harvard University, Cambridge; Olov Amelin, Assistant Director, Centre for the History of Science, Stockholm; Asa Thorbeck, Curator of Pictures, Nordiska Museet, Stockholm; Margareta Lindgren, Department of Maps and Prints, Uppsala University Library; Ingrid Fischer Tonge, Head Librarian, the Royal Library, Copenhagen; Anna-Elisabeth Brade, Professorial Assistant, and Rikke Glaesson, Photographer and Picture Archivist, Kobenhavens Universitets Medeicinsk-Historiske Museum, Copenhagen; Paul Mork, Curator, National Museet Etnografisk Samling, Copenhagen; Gunnar Lager, Library Director, and Margareta Bind-Fahlberg, History of Science Librarian, Kungl Teniska Hogskolans Bibliotek, Stockholm; Martha Labell, Photographic Archives, Peabody Museum of Archaeology and Ethnology, Harvard University, Cambridge; Joacquim Bonnemaison, Paris; Anita Agar, Toronto; Rebecca Willetts, Picture Researcher/Administrator, Science and Society Picture Library, Science Museum, London; Helena Wright and Shannon Thomas, National Museum of American History, Washington; Laurel Phoenix, University of California Observatories/Lick Observatory, Santa Cruz; independent scholars David Peat and Nancy Keeler.

The support and enthusiasm of colleagues

expressed in casual conversation or in the sharing of thoughts and information became a lifeline in a project of such overwhelming proportions. The expressed interest of colleagues not directly involved as lenders meant a great deal: Karen Sinsheimer, Santa Barbara; Tom Hinson, Cleveland; Joan Schwartz, National Archives of Canada, and Paolo Costantini, Canadian Centre for Architecture, Montreal. The work of contemporary photographers Lynne Cohen, Susan Derges, Juan Fontcuberta, Mark Ruwedel and Gary Schneider has been an inspiration. For making a home for me in New York and an abiding interest in the topic of art and science, I must again thank Gary Schneider, and also John Erdman.

There are often people who have been responsible in some way for offering constructive advice or sparking our interest in a subject, but whose names never make it to these pages. I thank them, and in particular the owner of an art gallery in Johannesburg who took the time many years ago to show a penniless but curious teenager a superb body of photographs of geological formations in the hope of convincing her of the worth of abstract painting. A personal note of thanks to my family and friends for their forbearance and especially to Rebekah, for whose generation there may be but "one culture".

ANN THOMAS
CURATOR, PHOTOGRAPHS COLLECTION
NATIONAL GALLERY OF CANADA

NOTE
Each author has chosen to illustrate the images in their respective chapters with a different intellectual emphasis, ranging from art history to technical and cultural history and from theory to connoisseurship. For this reason, caption information has not been standardized throughout the book, but has been customized to reflect the approach of each chapter.

1

Photography's Illustrative Ancestors: The Printed Image

MIMI CAZORT

THE PROGRESS of the natural sciences depends on the dissemination of new information, traditionally encoded in verbal texts and visual images. The relationship between text and imagery is complex, and in past centuries was inextricably intertwined.[1] This brief overview of scientific illustration in western Europe sets the stage for a consideration of photography and science—which, in this sense, constitutes one more step in a cultural continuum dating back four hundred years.

From classical times to the late middle ages, scientific knowledge was preserved in manuscripts, fresh copies of which were laboriously made by hand with inevitable mistakes and omissions. Where the manuscripts were illustrated, even more grievous distortions from the originals occurred. Images of human anatomy, for example, originating in the medical schools of Alexandria during the Hellenistic period, were preserved through increasingly stylized manuscript copies. Since none of their hypothetical Greek prototypes has survived, it is impossible to deduce from the degraded images what the originals looked like, or the precise nature of their informational focus (Pl. 1).

Around 1500, two developments strongly affected scientific illustration as it was to evolve,

in a fairly straight line, to the present time. First, the methodology of science turned away from its earlier modality, in which classical theory was accorded ultimate authority, towards observation. The analysis of natural phenomena then provided the basis for theory, rather than the other way around. This shift signified the birth of modern science.

Second, this new empiricism, characterized by a "quantitative mode featuring lists, diagrams, and tables that literally 'contain' knowledge",[2] favoured an emphasis on non-textual descriptive apparatus. Scientific illustration was soon recognized as integral to knowledge dissemination, and the pictured record came to be accorded parity with the text. Leonardo da Vinci, writing in the 1490s, was one of the first to articulate the importance of images in describing the complexities of natural phenomena. He noted, on a drawing of a human heart, "How in words can you describe this heart without filling a whole book?" It is a comment that applies equally to his drawings depicting foetal development (Pl. 2).[3]

This emphasis on picturing the observed phenomena resulted in a demand for precise rendering techniques, itself in accord with the nascent Renaissance explorations of naturalistic representation. However, a drawing of a sci-

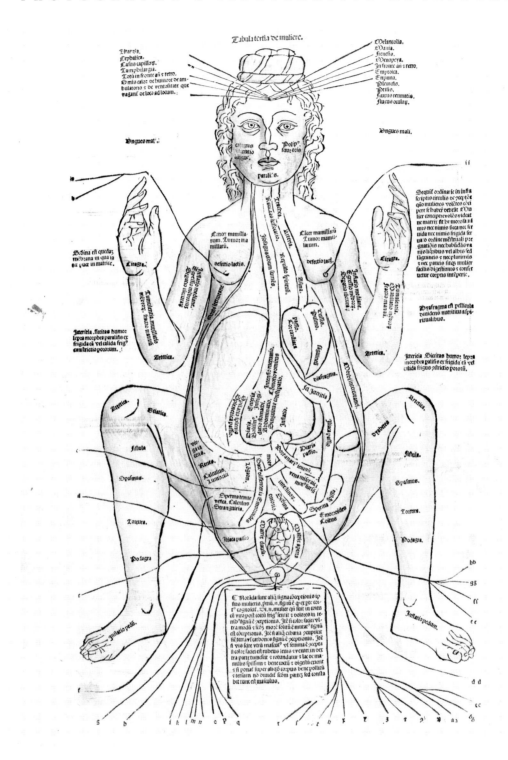

1 Anonymous, *Gravida, or Pregnancy Figure*, in Johannes de Ketham, *Fasciculus medicinae*, Venice, 1491. Woodcut with contemporary hand colouring. Yale University, Harvey Cushing/John Hay Whitney Medical Library, New Haven, Connecticut.

15

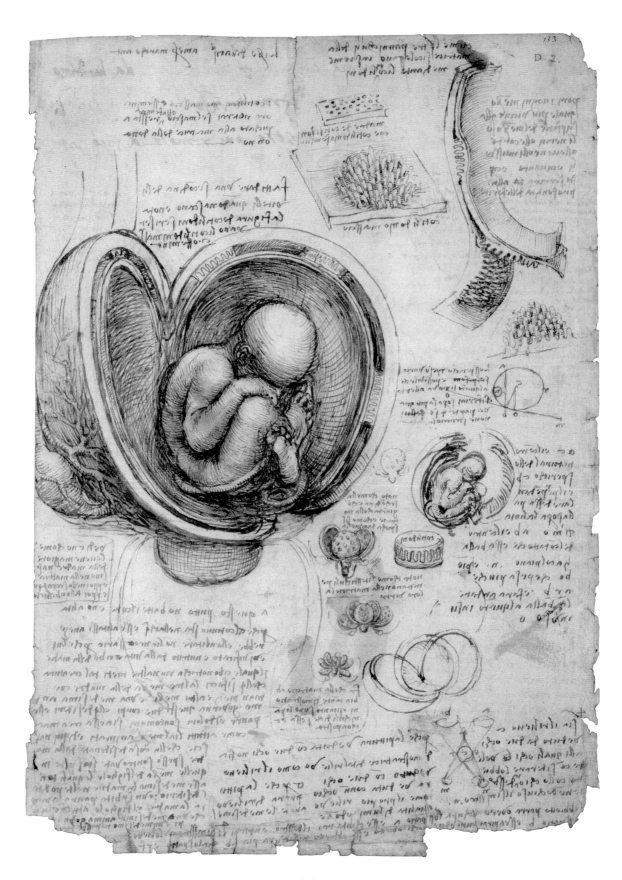

entific specimen, no matter how accurate, was a unique object, and therefore of limited use in the spread of scientific knowledge. Precise methods of image duplication were necessary to ensure their dissemination and to guard against degradation. Finally, wide distribution of the image–text product was essential. These needs, and the ingenious solutions devised to meet them, provided the impetus for the emerging art of scientific illustration.

The printing press, invented in Germany in c. 1450, solved the problem of exact duplication and was immediately and eagerly accepted. Images cut in relief on woodblocks could be set in with the typeface and printed simultaneously. The craft of making these blocks rapidly spread, and images developed from simple diagrams into realistic representations. Through the vast industrial network of printmaking, publishing, print and book marketing, scientific information spread rapidly throughout Europe, thriving even in the face of church censorship.[4] These enterprises were primarily located in the new university centres of northern Italy, Germany and France, though the artisan guilds operated separately from the universities.[5]

As printing and distribution systems became more efficient during the course of the sixteenth century, illustrated texts were eagerly sought by scientists associated with the new universities, who incorporated the information into their teaching. Now professors in Padua, Paris, Leiden and Marburg could test the information simultaneously. This is especially evident in the field of medicine, with its proliferation of books on anatomy, wound treatment and midwifery. New editions with improved illustrations quickly followed the old. The second (1612) edition of Conrad Gessner's famous *Historiae animalium* incorporated, with full credit, the woodcut illustrations from Guillaume Rondelet's book on marine life, published in Leiden in 1554.[6]

Given the centrality, then, of the pictured records, it is useful to consider in some detail the techniques that made them possible. The new graphic technology of printmaking was not invented specifically for scientific purposes. The earliest woodcuts were produced for religious reasons, often as souvenir items at pilgrimage sites.[7] They also illustrated works of literature, or existed as independent works of art.[8]

As the centuries passed, printmaking developed in tandem with the sciences, and as scientific knowledge increased, so did the demand for a more precise and detailed technology. The early medium of woodcut, though appropriate for depictions of generalized form, was inadequate for critical details and texture. It gave way about 1600 to an increasing dependence on engraving, and in the course of the seventeenth century subtle combinations of engraving and etching were exploited.

2 Leonardo da Vinci, *The Infant in the Womb*, c. 1490. Pen and brown ink. The Royal Collection, Her Majesty the Queen.

3 Anonymous German, *A True Portrait of the Weed called "Apios"*, from Leonhardt Fuchs, *Historiae plantarum: Premier livre des singula*, Basel, 1542. Woodcut. Thomas Fisher Rare Book Room, University of Toronto.

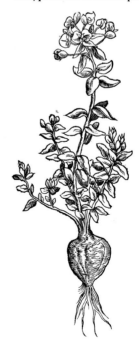

PREMIER LIVRE DES SINGVLA.
Le vray portraiƈt de l'herbe nommée Apios.

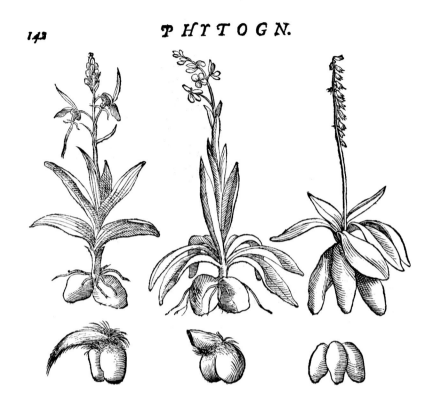

4 Anonymous, *Studies of Tuberous Rooted Plants*, from Giovanni Battista della Porta, *Phytognomonica . . . in quibus nova, facillimaque affertur methodus, qua plantarum, animalium, metallorum*, Naples, 1588. Woodcut, Biblioteca Universitaria, University of Leiden.

These latter complicated the printing process. Whereas the woodcut was a relief process and thus could be set together with the typeface, engraving and etching were intaglio processes— they were printed under heavy localized pressure from the incised, not the raised, surface. It is possible that the technical demands of scientific illustration actually prompted certain developments in printmaking technology, especially the combined etching–engraving methods of the seventeenth century, but this is so far not proved.

The technique of lithography, invented by Alois Senefelder in 1798, was put into wide use in the early nineteenth century. Lithography enabled a combination of both general and detailed presentation and, more importantly, an almost limitless edition run in either black-and-white or colour. Printed from the surface and thus doing away with the need for a special intaglio press run, it entailed a special press for the heavy lithographic stone; though cumbersome, it was cheap. Lithography became the chosen medium for scientific illustration, superseded only by photomechanically produced plates which could also be printed from their surface along with the typeface.

The search for modes of printing scientific images in colour has a less happy history, up until the invention of lithography. Inexplicably, the chiaroscuro woodcut (printed in register by successive blocks, usually in two colours plus black) was not exploited, perhaps because its virtue lies more in pictorial effects than scientific exactitude.[9] The various techniques of colour engraving, developed to a high degree in

France in the eighteenth century, were seldom adopted for scientific illustration, probably because they were labour-intensive and expensive, requiring a separate plate for each colour used.[10]

Apart from graphic technology, the ever-changing conventions of representation also determined the form of scientific illustrations, with artists and scientists contributing in varying degrees to their invention or their derivation from existing illustrative modes. The conventions that eventually won favour as conveying the maximum concentration of information were surprisingly uniform across the spectrum. The illustration of both the total organism and its details first appeared in texts on botany, medicine, zoology, and human and comparative anatomy (Pl. 3).[11] A delightful botanical illustration of 1588 showed the entire plant, and compared its bulb to human testicles, attempting to establish a new taxonomy on the basis of shape (Pl. 4).[12] Animals were represented in their natural environments even when they themselves were pure fantasy, as in the woodcut which portrays a porpoise as a sea serpent (Pl. 5).[13]

From the time of its invention in the early Renaissance, linear perspective rationalized the representation of mechanics and architecture. The convention of transparency (showing the exterior and the interior of the subject simultaneously, or the relationship of structure to surface) facilitated the illustration of man-made constructions and was also used to describe human anatomy, sometimes specifically linking ideal human and architectural proportions (Pl. 6). Depiction of the same subject from multiple points of view was common. The progressive development of living organisms over time was demonstrated by images in series (Pl. 7), as were comparative representations of the normative and the deviant. These conventions were to be later incorporated into photographic representation—in differing forms, at different stages in its development, and with varying degrees of success.

Despite the immense variety of their forms, these illustrations shared a single goal: objective verisimilitude. The degree of illustrative veracity depended, of course, on the contemporary state of scientific knowledge itself, based on first-hand acquaintance with the subject. The famous Dürer rhinoceros, based largely on a ver-

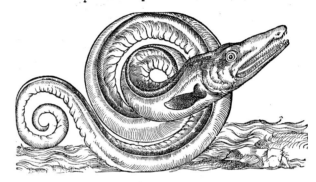

La peincture du Serpent de mer.

Que le nom de Marſouin ne ſignifie ſinon Porceau de mer, & que le Porc marin ne ſoit pas le poiſſon que nous appellôs Marſouin. Chap. XXXII.

5 Anonymous French, *A Depiction of a Sea Monster*, from Pierre Belon, *L'histoire naturelle des estranges poissons marins, avec la vraie peincture et description du Dauphin, et de plusieurs autres de son espece*, Paris, 1551, Book I, chapter XXXII. Woodcut. Thomas Fisher Rare Book Room, University of Toronto.

bal description of the exotic beast, was copied with all its errors for over a century.[14] Improbable specimens, known only through hearsay, were accorded credibility if the source of the information was deemed irreproachable. Thus Rondelet described and illustrated a fantastic "monk-fish", on the authority of Queen Margaret of Navarre.[15] Also, even when the details were correct, extreme size distortions could result if the artist had not seen the animal itself. Credible woodcuts of squid, sea urchins and lobsters are illustrated by Rondelet, but Gesner's copy of the lobster shows it attacking a man of the same size, and being attacked by a sea monster (Pls. 8, 9).[16]

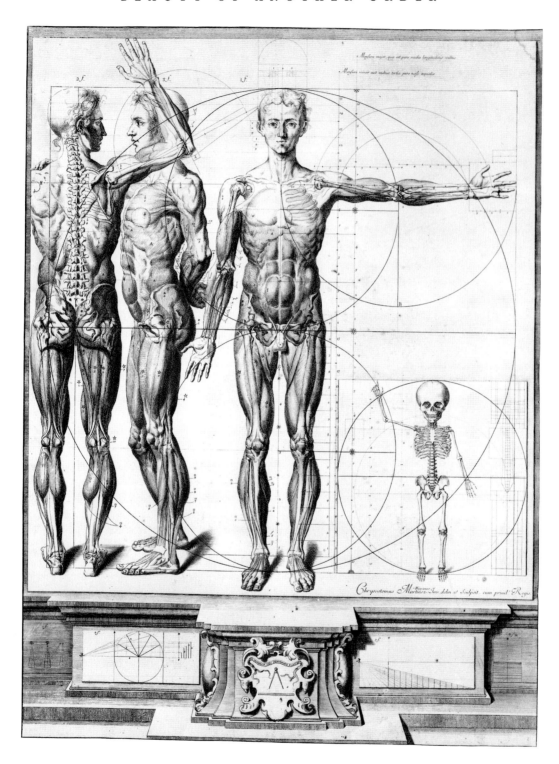

6 Crisostomo Martinez, *Myological and Proportional Studies*, for *Nouvelles figures de proportions et d'anatomie du corps humain*, 1686–89. Engraving and etching. Musée d'art et d'histoire, Cabinet des estampes, Geneva.

Different aspects of natural science developed at different speeds, depending on the accessibility of subjects. The illustration of human anatomy, based on the dissection of ubiquitously present cadavers, transcended the fantastic early on. Veracity in anatomical illustration was also stimulated by the vested interests of the artists who, from the Renaissance onwards, were concerned with the structure of the human body.

Some of the most interesting confluences between the conventions of scientific illustration and those of the fine arts are to be found in the full-figure anatomical illustration, which drew from figurative conventions in painting and sculpture. Contemporary modes of interpreting poses, gestures, proportion and ideals of beauty are reflected clearly in the anatomical representations. The expression of emotion and the depiction of character types by facial and head definition, often related to animals, was of periodic concern to both artists and anatomists from the early seventeenth through to the nineteenth centuries, making its first appearance in 1602 with Giovanni Battista della Porta's pioneering work on physiognomy.[17]

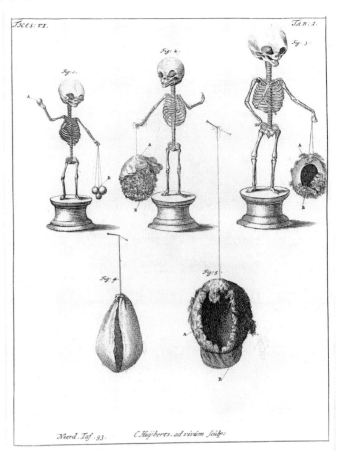

7 Cornelius Huyberts, *Three Foetal Skeletons*, from Frederick Ruysch, *Thesaurus anatomicus*, vol. VI, Amsterdam, 1709. Etching. Wellcome Institute Library, London.

8, 9 Anonymous German, *A Lobster: (De astaco, Rondeletius)*; *Lobster Attacking a Man (Astaci marini)* and *Lobster Attacked by a Sea Monster (In eadem tabula)*, from Conrad Gesner, *Historiae animalium, Liber IV: De aquatilibu*, Frankfurt, 1586. Woodcuts. Thomas Fisher Rare Book Room, University of Toronto.

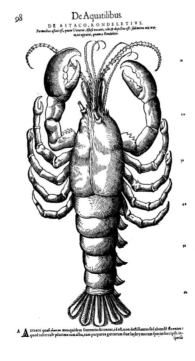

21

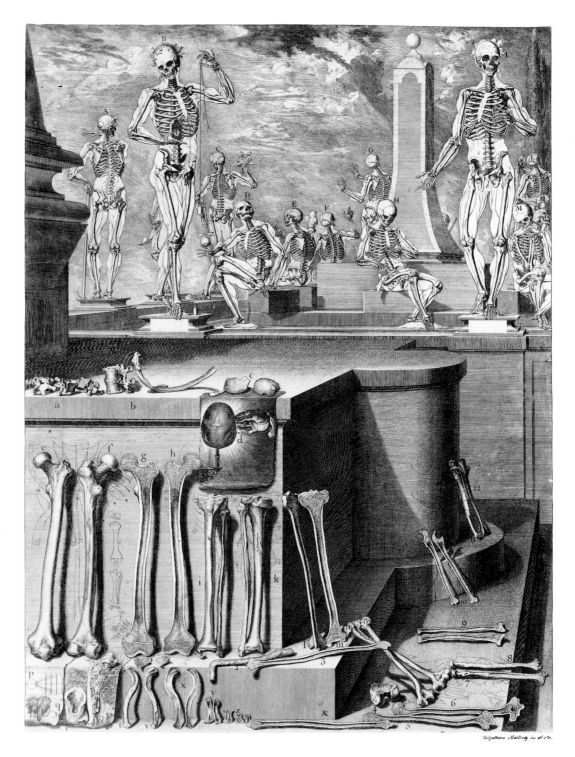

10 Crisostomo Martinez, *[Osteological Plate with Skeletons]*, for *Nouvelles figures de proportions et d'anatomie du corps humain*, c. 1686–89. Engraving and etching. Musée d'art et d'histoire, Cabinet des estampes, Geneva. (Note detail of bones.)

Scientific enquiry became more focused in the course of the seventeenth and eighteenth centuries, especially in the organic sciences but also in the earth sciences. The sixteenth-century concern with the way things were made gave way to investigations of the way things worked —i.e. attention shifted from structural to functional, and representational requirements adjusted accordingly.[18] Scientific advances also affected the way things were seen, and Newton's contributions to optical theory are indirectly reflected in the illustrations. Two anatomical treatises, which appeared simultaneously in Paris and Leiden between 1685 and 1690, indicate Anton van Leeuwenhoek's breakthrough in optical technology, the microscope. Now the illustrators were able to depict organic microstructures (Pl. 10).[19] The Leiden anatomist Bernhard Siegfried Albinus described in the Preface to his *Tabulae sceleti et musculorum* of 1747 his methods for ensuring precise skeletal measurements and also for counteracting parallax distortion. The title page to William Cheselden's *Osteografia, or the Anatomy of the Bones* of 1733 shows the anatomist–artist using a camera obscura to achieve precise representation of a skeletal torso (see Pl. 81).[20]

Methodical study necessitated the formation of repositories, or collections. These first took the form of private *cabinets des curiosités*, where wealthy amateurs assembled in their homes examples of natural science drawn from local sources or newly imported exotica from foreign parts.[21] The Medici court in Florence furnishes a conspicuous example of the patronage of aristocratic amateurs; the Grand Dukes Francesco I and Ferdinando both collected and commissioned natural science illustration.[22] The intellectual justification for the cabinets was the assumption, universally accepted, that every educated man needed to know the various shapes and forms of the natural world, and their contents were duly illustrated. Natural history museums, as we know them today, are the logical development of these cabinets.[23]

Around 1600, the first scientific museums began to appear. The anatomical theatre in Leiden, completed c. 1594, was—during the season when anatomies could not be conducted due to warm weather—converted into a natural science museum. The public paid admission fees to see anatomies in progress, preserved exhibits of human and animal skeletons, and dried and taxidermied examples. The Dutch anatomist Jacob Ruysch instituted a private museum in his home, with preserved anatomical specimens that he made himself with the help of his daughter, the noted painter Rachel Ruysch. Ruysch was instrumental in developing wax injection as a reliable technique for preserving anatomical specimens; as their preservation became more sophisticated, the line between a natural and a manipulated specimen became blurred, especially as a constructed specimen would be part natural and part wax, calling into question the very definition of verisimilitude itself. Prints made after these constructed or dried preparations constitute a special genre in scientific illustration.

The history of scientific illustration is fraught with non- or para-scientific representation; the taste for the grotesque, or non-natural, had ancient roots.[24] The definition of what constituted natural objects of interest was loose—it included freaks of nature, misbirths and monsters as well as normal specimens (Pl. 11).[25] The studio of the noted Bolognese natural scientist Ulisse Aldrovandi included, for example, both real and artificially constructed zoological and botanical specimens, many of which appear in his various illustrated books. He also possessed a collection of "monster" specimens which agreed with mythical accounts, such as an artificial salamander (they were theoretically born from fire), fabricated for him by obliging local artisans.[26] Aldrovandi's extensive correspondence with the Grand Duke Francesco de' Medici included a request for a specimen of the Golden Eagle, which was duly delivered.[27] He acquired examples of plants from the University of Bologna's *Hortus botanicus*, of which he was founder and director.

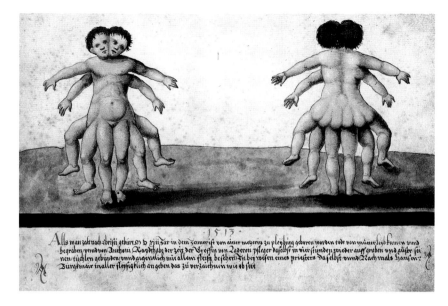

11 Anonymous German (copy after Hans Burgkmair), *Malformed Twins* ("Im Jahr 1513 in Bleiburg tofgeborene zusammlungewachsene Zwillinge"), c. 1513. Pen with grey ink, watercolour. Graphische Sammlung, Staatsgalerie Stuttgart.

In plotting the development of illustrations, it is necessary to bear in mind the agendas and also the limitations of the scientists who commissioned them. The scientists of the early Renaissance were caught between the medieval notion of creationism and the new empiricism. Sixteenth-century studies on geology and marine life revealed the inexplicable presence of fossilized sea shells and fish skeletons on mountain tops. Since continental movement and ancient seas had not yet been hypothesized, the choice was simply to posit some whimsical blip on the part of the Creator, or to seek other explanations. Natural phenomena could be explained rationally or otherwise; astrological influences on normally occurring events were given serious consideration until well into the seventeenth century.

During the same period, scientists in all fields were concerned with developing a new taxonomy for natural phemonema. Though classification and its terminology did not necessarily affect the mode of representation of individual specimens, it did affect the illustrations' organization, format and context. Belon followed the Aristotelian system of classifying birds according to their habitats and what they ate. He organized his book along these lines, and his illustrations consequently stress these aspects of the birds' appearances.

The goal of perfect versimilitude has been a constant in scientific illustration, but its definition is always in flux. Is it defined by the immediate or the norm? Can scientific accuracy be better served by illustrating a single specimen, or by generating an image based on a composite of several examples, in order to achieve a generalized or normative version? As the printed illustrations became more complex and subtle, these issues came to the fore. They continue to haunt the question of the validity of photographic images, as opposed to those manipulated by artists. The chief distinguishing feature of the scientific illustration that preceded photography was the intrusion of the artist's choice, itself dependent on current conventions of artistic representation.

Overriding superficial appearance, the artist in collusion with the scientist was free to choose significant features of the specimen to represent and, more significantly, distracting details to ignore. He could also adopt conventions that transcended objective realism (for example, in anatomical representations, red for arteries, blue for veins, white for nerves). Another virtue of the artist–scientist intervention was the free-

dom to correct deviations from the norm. Distortions could result, however, from the fact that the representation sometimes depended as much on current theories of how a specimen should look as how it actually did look (for example, the five-lobed liver, the horned uterus).

Related to this question was the matter of what constituted a reliable scientific specimen to be illustrated as exemplary. This was not an issue with non-varying objects of scientific interest, such as man-made structures (machines and mechanical devices like clocks), and seemingly unchanging structures (the outline of continents). It was very much an issue in the organic sciences such as human and comparative anatomy and medicine, where the available subjects ranged from normal to mildly deviant through to pathological.

We are here at the crux of the discussion as to whether artistic licence enhances or distracts from scientific verisimilitude. What constitutes truth in representation? Evaluation of the verisimilitude of any scientific image depends on the purpose for which the illustration was made. The camera does not lie, in that the photographic image minimizes the intrusion of the artist's vision. The specimens themselves, however, can "lie". A photographic image of, for example, a mycological specimen can reproduce any single mushroom with precise exactitude, reflecting its stage of development, its conformity to the norm of its species and, with equal validity, any deviation such as colour variation, insect infestation and the leaves of its host plant clinging to it. However, if the purpose of the illustration is to reveal to the reader the differences between a toxic and an edible fungus which closely resemble one another, it may be preferable to illustrate the example with a watercolour, which accentuates, say, both top and bottom of the cap, and the veil, bulb, surface viscosity and colour of a mature specimen. All these characteristics are rarely legible in one single example.

Finally, there is the issue of subjectivity *versus* objectivity on the part of the image-maker,

itself liable to cultural and technical as well as personal choices. The printmakers, with their access to pre-established visual codes, had enormous leeway in deciding where on the scale of conventional diagram or realistic representation to locate their interpretation—whether to integrate text or key letters or numbers into the image, whether to include cast shadows and ground lines, whether to place their subjects in the context of a laboratory or a lush forest.

The discussion continues as to whether photographic representation or artistic intervention provides a fuller compendium of information on any given botanical, anatomical or geological representation. A clear definition of the virtues and deficiencies of the hand-crafted *versus* the photographic image is in order. The Smithsonian Institution still employs artists, drawing with refined media such as carbon dust, to choose and delineate features of natural specimens. On the other hand, permutations and interrelations of organic forms, as well as their transformations over time, can be shown more accurately through the manipulative intervention of technological expertise in the photographic image. A recent example of this is the Visible Human Project which combines electronic scans of 30,000 slices of a single male human body in infinite variations, showing the venous, skeletal, muscle and visceral systems with a revelation of transparency that Leonardo could only dream of.

The questions raised throughout the history of scientific illustration can elucidate the problem as it exists today. Current technology has taken the potential for accurate delineation far beyond the expectations of the printmakers of previous centuries. Photography of a foetus moving *in utero*, for example, exceeds in accuracy the expectations of the illustrators of eighteenth-century gynaecological books, dependent as they were on dead specimens at various stages of foetal development. What may be lost, for better or for worse, is the imposition of the human value judgements of the artist–scientist.

2

Invention and Discovery: First Images

LARRY J. SCHAAF

No human hand has hitherto traced such lines as these drawings display; and what man may hereafter do, now that Dame Nature has become his drawing mistress, it is impossible to predict.[1] Michael Faraday, 1839

There are many cases in which it might be interesting to cause Nature herself to depict what she sees in her own phenomena, instead of trusting to the fidelity of Philosophers.[2] James D. Forbes, 1840

IN 1843, when Anna Atkins (1799–1871) started issuing her photographically illustrated *British Algae: Cyanotype Impressions*, she courageously breathed life into the promise held out to science by photography. Embodied in this pioneering book was photography's claimed ability to coax nature into leaving behind her own self-portrait (Pl. 12). The authenticity of photographic images, cheaply made and conveniently distributed on sheets of paper, could encourage the spread of scientific knowledge throughout a society increasingly eager for information. It had the potential to replace cumbersome methods of illustration such as the mounting of actual botanical specimens (Pl. 13). Atkins drew direct inspiration from the inventor of the art, William Henry Fox Talbot (1800–77), himself a botanist and soon to be a publisher, but even more so from her close friend, Sir John Herschel (1792–1871). Herschel,

however, took particular delight in a subtly different aspect of the art. For him, the real beauty of photography lay less in science facilitating the making of images, than in photography's capacity to reveal the truths behind science. In his study of the physical universe, photography became a tool for him to see beyond what man had ever been able to perceive.

Atkins sought the most literal translation of nature; Herschel yearned for the most poetic one. Art or science? Artifice or truth? Photography's intermediate relationship between the art of man and the science of nature—the inherent duality of its role—challenged the imagination from the very first public announcement in 1839. This conundrum echoes just as strongly today, often expressed as an aesthetic question about the eligibility of photography to be considered as a fine art. It is natural to think that science invented photography. To be sure, the

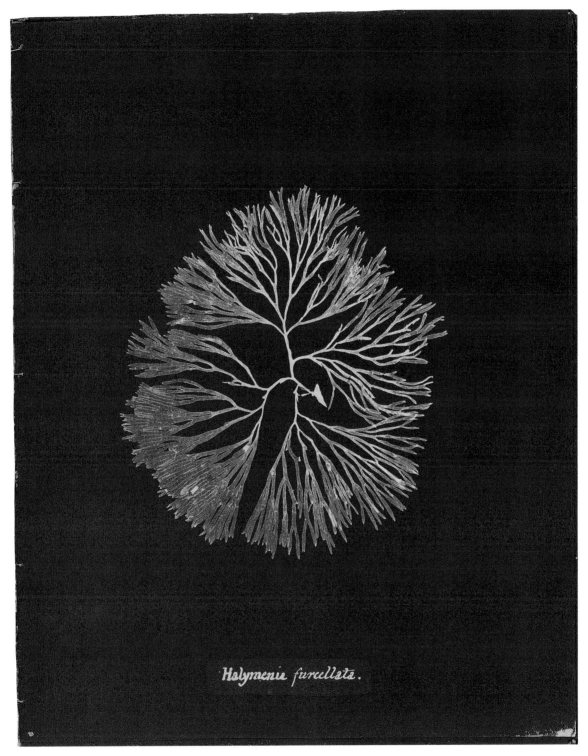

Halymenia furcellata.

12 Anna Atkins, *Halymenia furcellata*, from *British Algae, Cyanotype Impressions*, c. 1844. Cyanotype photogram, 25 × 19 cm. Titled within the print. From Sir John Herschel's copy, Spencer Collection, New York Public Library.

play was first staged within the halls of scientific institutions, and science provided the language for the script, but overwhelmingly it was man's craving for images that was the author. The immediate inventors of photography were various: in England, Thomas Wedgwood (1771–1805) and William Henry Fox Talbot, and in France, Joseph Nicéphore Niépce (1765–1833) and Louis Jacques Mandé Daguerre (1787–1851).[3] Each in his own way was a frustrated artist; their particular motivations varied, but each was launched on his quest by a need to create images, rather than by an investigation of science. But science was essential to the invention of photography. And photography was peculiarly well suited to return the favour to science by unlocking the secrets of nature.

In common parlance, the concept of the camera and that of photography are so often inter-

twined that it is perhaps surprising just how pedestrian a role the machine itself played in the invention of the art. The camera obscura had been a hidden partner of artists for centuries before the invention of photography.[4] Literally a "dark chamber", the lens of the camera obscura projected an image on to a screen opposite in a darkened room. Once reduced to the size of a bread box, cameras became working instruments that artists could take into the field, tracing the images projected on the ground glass, most often in silent preparation for the execution of a full sketch or a painting.

So peripheral a role did the camera obscura play that it was in fact the camera lucida, a drawing instrument totally useless to photography, that precipitated one major strand of the art's invention. Of the various claimants to the invention of photography, Talbot has left us the most complete record of his thoughts. Although each of the inventor's motivations was different, Talbot's extensive archives may provide a general model of the process of invention. As he later recalled, on

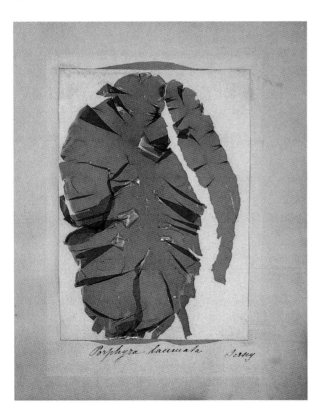

13 Anonymous, *Porphyra lacimata, Jersey*, mid nineteenth century. Excisita (mounted seaweed). 18 × 13.5 cm. Titled in ink on the mount. Private collection.

one of the first days of the month of October 1833, I was amusing myself on the lovely shores of the Lake of Como, in Italy, taking sketches with Wollaston's Camera Lucida, or rather I should say, attempting to take them: but with the smallest possible amount of success. For when the eye was removed from the prism—in which all looked beautiful—I found that the faithless pencil had only left traces on the paper melancholy to behold. After various fruitless attempts, I laid aside the instrument and came to the conclusion, that its use required a previous knowledge of drawing, which unfortunately I did not possess.[5]

The camera lucida was little more than a small prism that tricked the eye into seeing the image of nature on a sheet of drawing paper (much like the partial reflection on a window that allows one to see the outdoors and an interior simultaneously).[6] In the hands of a skilled

draughtsman such as Talbot's friend Sir John Herschel, the instrument could facilitate the recording of exacting scientific detail (Pl. 14). But there was no real image and, as Talbot lamented, the camera lucida could not teach him how to draw.[7] So his thoughts turned to the camera obscura, an instrument he had tried (with equal lack of success) in Italy a decade before, and

> this led me to reflect on the inimitable beauty of the pictures of nature's painting which the glass lens of the Camera throws upon the paper in its focus—fairy pictures, creations of a moment, and destined as rapidly to fade away. It was during these thoughts that the idea occurred to me how charming it would be if it were possible to cause these natural images to imprint themselves durably, and remain fixed upon the paper![8]

The random musings of an isolated creative mind? Hardly. Some years previously, the same question had been asked by a rival Talbot did not yet know. Daguerre, a Parisian artist and gifted showman, had a very different motivation from Talbot's lack of artistic prowess. A highly skilled draughtsman who regularly and happily sketched in the camera obscura, Daguerre sought a more economical way to record the richness of fine detail for which he was known. Deficient in formal education and untutored in the patterns of scientific research, Daguerre could bring tireless enthusiasm, but little else, to bear against solving his problem. So concerned did his wife become about his attempts to freeze the camera's images that she consulted the renowned chemist Jean Baptiste André Dumas (1800–84): "he is always at the thought; he cannot sleep at night for it. I am afraid he is out of his mind; do you, as a man of science, think it can ever be done, or is he mad?" With the open mind of a true scientist, Dumas replied that "in the present state of knowledge, it cannot be done; but I cannot say it will always remain impossible, nor set the man down as

mad who seeks to do it."[9]

No amount of science could teach Henry Talbot to see or to draw. But even though he confessed himself to be "not much of a chemist",[10] his extensive education and diverse reading naturally led him to re-cast any question involving light and optics into more familiar physical terms.[11] Pondering the problem of capturing the image presented by the camera obscura, he had the confidence, born of knowledge, to ask:

> why should it not be possible? . . . the picture, divested of the ideas which accompany it, and considered only in its ultimate nature, is but a succession or variety of stronger lights thrown upon one part of the paper, and of deeper shadows on another. Now Light, where it exists, can exert an action, and, in certain circumstances, does exert one sufficient to cause changes in material bodies. Suppose, then, such an action could be exerted on the paper; and suppose the paper could be visibly changed by it. In that case surely some effect must result having a general resemblance to the cause which produced it: so that the variegated scene of light and shade might leave its image or impression behind, stronger or weaker on different parts of the paper according to the strength or weakness of the light which had acted there.[12]

There is little reason to doubt Talbot's later assertion that he came to this breakthrough completely unaware of others' earlier attempts. With the advantage of hindsight, these can be seen to have been numerous. At the end of the eighteenth century, before his life was cut short at an early age, Thomas Wedgwood started on the path to the invention of photography. His father's pottery had a constant need for images; its technical demands also insured that Thomas Wedgwood received excellent scientific training. With extensive family connections in science, it can be assumed that Wedgwood assimilated a good deal of earlier knowledge in his work. Exploiting the well-known light sensitivity of silver compounds, Wedgwood was able to make

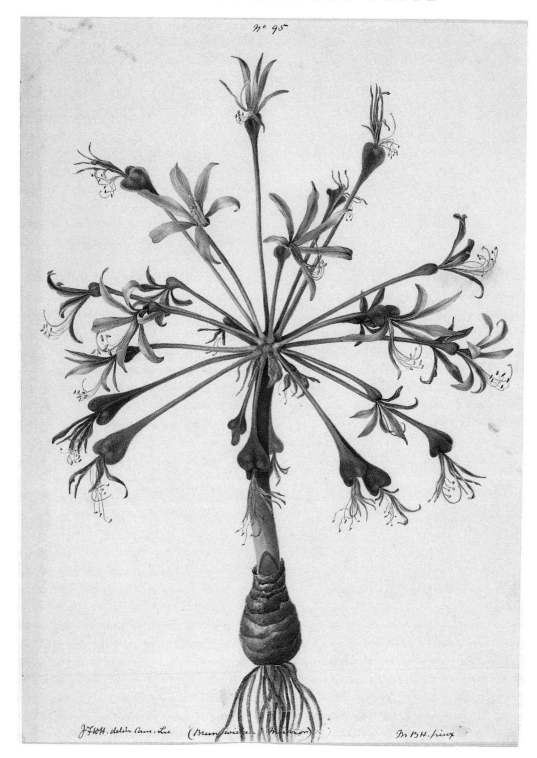

14 Sir John and Margaret Brodie Herschel, *Brunswickia Minor*, 1835. Watercolour over pencil
camera lucida drawing, 30 × 24 cm. Titled and signed in ink on recto, "J. F. W. H. delin Cam. Luc.
M.B.H. prinx." The Brenthurst Library, Johannesburg, South Africa.

shadowgrams of leaves and other objects, but failed to achieve enough sensitivity to make exposures in the camera. Produced on paper or white leather, his images were not true photographs in that they remained susceptible to the action of light. In 1802, the young chemist Humphry (later Sir Humphry) Davy (1778–1829), then lecturing on chemistry at the Royal Institution, published a brief account of his friend's work. Since Wedgwood's images could be viewed only under candlelight, Davy was forced to lament that "nothing but a method of preventing the unshaded parts of the delineation from being coloured by exposure to the day is wanting, to render the process as useful as it is elegant."[13] Why did Davy not complete his dying friend's work? A brilliant chemist, he should have been able to, and the only satisfactory explanation is that he did not possess Wedgwood's motivation actually to create images. Lord Brougham (1778–1868) observed that Davy "was fond of poetry, and an ardent admirer of beauty in natural scenery. But of beauty in the arts he was nearly insensible. They used to say in Paris that on seeing the Louvre, he exclaimed that one of its statues was 'a beautiful stalactite . . .'"[14]

There is some indication, however, that Wedgwood may have shared his process with other scientists. In 1799, James Watt (1736–1819) thanked Thomas's older brother Josiah (1730–95) "for your directions for the silver pictures, on which, when at home, I shall try some experiments."[15] Decades later, Sir Anthony Carlisle (1768–1840) claimed that he personally had experimented with Wedgwood.[16] After Wedgwood's death in 1805, his idea was widely republished. In 1816, the popular journal *Ackermann's Repository* suggested using Wedgwood's method as parlour entertainment: in addition to copying simple drawings and making profiles, *Ackermann's* suggested the use of partly transparent objects such as insects' wings.[17] Certainly Wedgwood's work must have been repeated, but apparently not by anybody with such a burning desire to achieve permanent

images that they left a record of their work. None of Wedgwood's own images is known to survive today, but they must have been very similar in appearance to Talbot's earliest photographs (Pl. 15).[18]

Henry Talbot could take no immediate practical steps towards photography whilst he was travelling. On returning to England, he faced both a heavy Parliamentary schedule and a commitment to completing other scientific research. It was not until sometime in the spring of 1834 that he could start his experiments. With Lacock Abbey's extensive library and kitchen facilities at his disposal, he rapidly came to the same point as Wedgwood's earlier work (although he had yet to become aware of the antecedent). By first coating ordinary writing paper with a solution of table salt, then brushing this over with a solution of silver nitrate, Talbot precipitated a light-sensitive silver chloride into the matrix of the paper fibres. Dried and sandwiched under glass with an object such as a leaf, the sensitive paper was exposed to the light of the sun. Within the space of perhaps a quarter of an hour, wherever light struck, its energy reduced the silver chloride to metallic silver. The result was a shadowgram of the leaf (see Pl. 15).[19] Thus far, Talbot had equalled Wedgwood but advanced no further, for the remaining light-sensitive silver chloride could not be washed out of the paper, thereby condemning the image to a life of darkness. Viewing under ordinary light would soon cause the paper to fog over.

Talbot's eye was keenly honed by practice in botanical classification, and his analytical mind quickly seized on a fortuitous anomaly. He observed that the periphery of his paper sometimes darkened at a different rate from the centre. Talbot deduced that this resulted from the vagaries of hand-coating, the edges sometimes receiving a more casual stroke of the brush than the middle area, thus changing the ratio between the salt and the silver. By using only a minimal amount of salt, Talbot found that he achieved the highest sensitivity. After exposure, immersing the exposed image in a saturated solution of

31

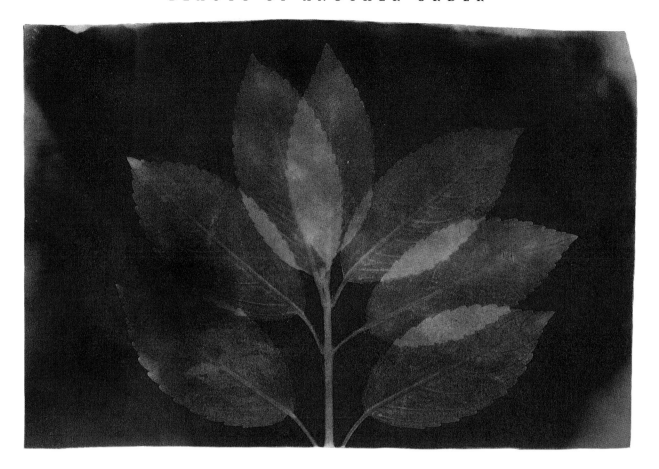

15 William Henry Fox Talbot, *Leaves*, 14 July 1839. Photogenic drawing negative, 11.6 × 17.2 cm. Inscribed in Talbot's hand on verso, "A. B. post. July 14. cleared N. Merc." Photographic History Collection/National Museum of American History, Smithsonian Institution, Washington, D.C.

salt altered the nature of the remaini ng silver compounds, rendering them relatively insensitive to the further action of light. In Geneva in the autumn of 1834, Talbot continued his photographic research, gaining mastery over his solutions, and identifying potassium iodide as another way to stabilize his images, but he was still not able to generate enough sensitivity to make use of the paper in the camera. No further advanced in his draughtsmanship by all this, Talbot turned to an unidentified artistic friend to scratch a design into a varnished sheet of glass. This could then be used as a "negative" to make multiple prints on his sensitive paper, a technique later familiar to French artists under the name *cliché verre*.[20] For Talbot, this ap-

proach served as an early demonstration of the applicability of photography to publishing, a role that was to have enormous future implications for science.

Talbot's inspiration the year before in Italy had come from the desire to sketch. While the solidified shadows of leaves and laces were intriguing, they were only a specialized point of view on nature. Talbot's sensitive coatings produced a "print-out" paper: all of the energy to reduce the silver came from the light of the sun, and the image became directly visible as the metallic silver was formed under the action of light. In trying to record the images of the camera obscura (his original quest), the light was channelled through a lens, and there was sim-

32

ply not enough solar energy left to reduce the silver. In the "brilliant summer of 1835", Talbot's research programme paid off in optimizing the sensitivity of his coatings. He also dropped back to much smaller cameras that could take advantage of proportionately larger lenses. Placed about the grounds of Lacock Abbey for periods of an hour or so, they accumulated sufficient light to make lilliputian negatives. Talbot's wife once called these crude little wooden boxes "mouse traps",[21] and traps they were, with their prey being nature's own effigy (Pl. 16). By the summer of 1835, Talbot had a working photographic system in hand. He called it "sci-

16 William Henry Fox Talbot, *Oriel Window, Lacock Abbey, from the inside*, c. 1835. Photogenic drawing negative, 3.4 × 5.8 cm. Bensusan Museum of Photography, Johannesburg, South Africa.

agraphy"—the depiction of objects through their shadows—and in this he revealed his true fascination with the nature of the negative images he had been creating. Others would be frustrated by the fact that light produced dark, and even Talbot himself would waver before fully accepting the virtues of this. He proposed a simple remedy in his 1835 notebook: "in the Photogenic or Sciagraphic process, if the paper is transparent, the first drawing may serve as an object, to produce a second drawing, in which the lights and shadows would be reversed."[22] Here Talbot clearly grasped the idea of using a negative to make a positive (two terms subsequently con-

tributed by Herschel). The name sciagraphy reflected Talbot's sense of wonder about an extension of vision beyond the ordinary—a depiction that served to replace a physical object. And he had replaced his own inadequate sketching with nature's surer hand, making her images permanent. Properly handled, Talbot's method of stabilization was so effective that some of his images from this period are still clearly visible today, more than 160 years after they were produced (see Pl. 16). He had succeeded in every point of Wedgwood's failure.

For the time being, knowledge of Henry Talbot's achievement was to remain within his family while his publications in other areas of science took full control of his schedule. In 1836, Talbot's investigations of crystals led to an invitation to give the prestigious Bakerian Lecture to the Royal Society. In 1838, he received the Society's Royal Medal for his work in mathematics. By the start of 1839, he had published nearly thirty scientific papers and two books, with two more to follow within the year. But keeping his sciagraphs for a later disclosure was a decision that Talbot was bitterly to regret. For some time, totally unknown to him, competition had been building across the English channel. His delay was to have the effect of plunging the new art of photography into the midst of a much larger struggle. Waterloo had not settled everything: by the time of the public introduction of photography, the field of conflict between France and England was not the one familiar to the soldier; it was rather the battlefield of commercial and cultural domination. A nation's science was as much a weapon as a tool.

Long before Talbot's personal triumph, and even before that of Daguerre, the first successful photographs had already been made in France, by Joseph Nicéphore Niépce. Had Niépce published his work prior to his death in 1833, it is likely that he would have received the recognition in public—as the inventor of the art—now accorded to him in specialist circles. Niépce was a gentleman and scientist who fol-

lowed a traceable path to his invention. Although his research notes are scattered and incomplete, recent scholarship has begun to structure the story.[23] Niépce's interest in photography seems to have been rooted in his work in lithography, a widely popular amateur art in the early years of the nineteenth century. Unaccomplished at drawing designs on the stone, he sought a way to get nature to execute the designs, and experimented first with the light sensitivity of silver compounds. By 1816, he had succeeded in getting rudimentary negative images in the camera, but could not overcome the problem that had frustrated Wedgwood: he could determine no way to make his images permanent (and none is known to have survived). Niépce continued to experiment, turning his attention to metal plates and stone. By 1822 he had succeeded, not with the salts of silver, but with a common tar. He dissolved bitumen— widely used as an etching resist for printing plates—in a solvent, flowed this on to a metal plate and, once it was dry, placed the plate under an oiled engraving and exposed the sandwich to light. After extended exposure, the light hardened the bitumen in the areas it could reach, making the bitumen more difficult to dissolve in a solvent. By flowing a solvent across the plate after the exposure, Niépce could dissolve those areas (under the lines of the original) which had not been hardened by light. The plate retained an image of its own, with the bitumen standing out in contrast to the polished pewter plate (Pl. 17).[24] The plate could also be further treated to act as a printing plate for ink. In a letter to his brother Claude (1763–1828) of 2 May 1816, Niépce observed that "this sort of gravure is already superior . . . because of the ease which it presents in multiplying the proofs and keeping them unchanged."[25] It was a conclusion that Henry Talbot would reach independently half a century later.

Under particular circumstances, Niépce's process of *héliographie* could even accumulate enough exposure in the camera to record an image of nature. In 1827, Niépce made a hastily arranged trip to Britain, a journey prompted by increasing concern for the health of his brother Claude, who had been attempting to find a market there for their internal combustion engine.[26] Niépce brought along some examples of his heliographs, presenting the scientific community with its first real challenge to accept photography. This attempt failed. Niépce stayed at Kew, then a lively village on the Thames at some remove from London. He first approached William Townsend Aiton (1766–1849), Director of the Botanic Gardens, establishing early photography's particularly close association with the field of botany. Aiton owned significant collections of paintings and drawings and had direct connections with King George III. He presented Niépce's idea to the King and it seems likely that Niépce's plates were exhibited at the Royal Court (although no evidence of this is recorded). Niépce, comfortable only with French, turned

17 Joseph Nicéphore Niépce, *Moonlight; copy of an engraving of a design by Daguerre for Melesville's play, Le Songe*, 1827. Heliograph, 10.5 × 13.5 cm (visible image area). Labelled on the recto of the frame, "Heliograph, from a Print by Niepce in 1827. Exhibited by H. P. Robinson, Tunbridge Wells." Labelled on the verso of the frame, "Heliography—les premiers résultants obtenus spontanément par l'action de la lumière par M. Niépse [sic] de Chalon sur Saone 1827" and "from a print about 2½ feet long. F. Bauer, Kew Green." The Royal Photographic Society, London.

to Franz Andreas Bauer (1758–1840) for translations. The Austrian-born Bauer was the finest botanical illustrator of his day, known for achieving high artistic standards while preserving exact scientific detail. A Fellow of the Royal Society, he was to become Niépce's greatest champion, and he attempted to introduce his new friend to the Society. Why did photography not take root in 1827 within Britain's premier scientific establishment? Two manuscripts in Niépce's hand, both dated 8 December 1827, have been interpreted as a formal presentation to the Royal Society.[27] The legend has grown that these were rejected, a surprising fate given that they should have been of immediate interest. The President of the Society, Sir Humphry Davy, had published Wedgwood's researches in 1802. The brilliant and eccentric Foreign Secretary, Dr. Thomas Young (1773–1829), had almost certainly been inspired by this; just a year later, in 1803, Young employed light-sensitive silver chloride to reproduce rings in the solar microscope (but with no desire to make them permanent).[28] A Vice-President of the Society, William Hyde Wollaston (1766–1828), invented both the camera lucida that pushed Talbot into photography, and the camera obscura lenses that most photographers would soon use. In 1804, his experiments were published on the light sensitivity of various compounds, notably gum guaiacum.[29]

Yet Niépce's efforts to establish his process in England failed so thoroughly that in 1839 he was virtually unknown. This failure was for reasons beyond his control. Embroiled in a nasty political crisis, the Royal Society was effectively paralysed by internal conflicts. Sir Humphry was critically ill and barely functioning. The divisions in the scientific community allowed a political appointee to take over from a scientist as president. The committee responsible for evaluating scientific papers did not meet even once between summer 1827 and spring 1828.[30] It is unlikely that Wollaston would have actually rejected the paper (as he was posthumously accused of doing), for he was dying and desperate

to get his own papers in order. It is far more likely that, rather than opposing Niépce, Wollaston never even saw his paper. An additional clue comes from the Saturday dating of Niépce's papers. The Royal Society did not meet on Saturday, but another Vice-President of the Society, Sir Evrard Home (1756–1832), held his own scientific soirées in Kew on that day. A contemporary recalled "the best days of Sir Evrard Home, who . . . used to meet here, almost every Saturday, at Mr. Bauer's, many of the eminent men of the day, for purposes connected with Botany and other branches of Natural Philosophy, and a friendly and social intercourse."[31] Is it not more likely that Niépce presented his work to this local group, which included Fellows? The story about the Society's rejection of Niépce's paper got its start with an 1840 recollection by Home's son: "Mr. Niépce wished the King to see his work, which he did as well as Dr. Wollaston, but the Royal Society could not enter into the merits of the thing as there was a secret in the case which Mr. N. would not divulge."[32] The Royal Society could not be in the position of endorsing to the King a process that remained a secret from them. In fact, as a group they could not endorse anything: in the preface to their *Philosophical Transactions* they emphasized that "it is an established rule of the Society, to which they will always adhere, never to give their opinion, as a Body, upon any subject, either of Nature or Art, that comes before them."

Even if Niépce was understandably reluctant to disclose his secrets to the fractious Royal Society, they still had well established mechanisms for reading and publishing the news of his discoveries. After all, the same group was to accept the reading of Talbot's first paper on photography in 1839, prior to his disclosure of the manipulatory secrets. Before leaving Britain, Niépce contacted a wide range of people and institutions. He approached the Society of Arts through Dr. Joseph Constantine Carpue (1764–1846), a scientist so interested in natural representation that he once obtained a corpse and nailed it to a cross in order to judge the accu-

racy of a Michelangelo.[33] No record of this approach survives. Niépce seemed to have been cursed with exceptionally unfortunate timing. Davy, Wollaston and Young all died soon after his trip. Sir Evrard Home survived longer, but his career was put in disgrace shortly after his death. Franz Bauer was the only one of this group to live to see the public announcement of photography. He put up a spirited defence of Niépce, but even he was to die within the year. Henry Talbot, not at this time a Fellow of the Royal Society, was away from London while Niépce was making his rounds. Herschel was similarly absent, and it is unlikely that either man had occasion to hear of the French inventor.

On his way to England in August 1827, Niépce stopped in Paris for his first meeting with someone with whom he had been corresponding for the past 18 months. Louis Jacques Mandé Daguerre was already famous as the inventor of the Diorama, an illusionistic public theatre that charmed and mystified audiences. Sometime during 1824, Daguerre started on his quest to freeze the images of the camera obscura, but made little progress. Daguerre first learned of Niépce's success through a lensmaker they knew in common, and opened a correspondence. Seeing Niépce's primal images must have been a tremendous encouragement to Daguerre, for they confirmed that his own goal was not a hopeless one. On 14 December 1829, the ageing Niépce, discouraged in all his attempts to interest others in his process, entered into a contract with Daguerre to develop and promote the process of heliography. Niépce died less than three years later, without ever having seen his process made public, and without having received a single original contribution from Daguerre's side of the partnership. Daguerre's records are as absent as Talbot's are complete.[34] He had no publication record, and no archives of his research have ever been proved to have existed. There is an attractive explanation for this. On 8 March 1839, Daguerre called on the American painter, Samuel F. B.

Morse (1791–1872), then in Paris to promote his invention of the telegraph. Morse wrote to his brother the next day, that while Daguerre was visiting him "the great building of the Diorama, with his own house, all his beautiful works, his valuable notes and papers, the labor of years of experiment, were, unknown to him, at the moment becoming the prey of the flames. His secret indeed is still safe with him, but the steps of his progress in the discovery and his valuable researches in science are lost to the scientific world."[35] Daguerre's "steps" to discovery and his "valuable researches in science" were never seen, and it is only through vaguely worded retrospective accounts after the public announcement of photography that the story is known at all.[36] But it is an intriguing story about a most fascinating process.

While we know nothing of how his researches progressed, we do know that Daguerre continued with unabated enthusiasm after Niépce's death. Removed from the support of collaboration, but in full possession of his partner's secrets, Daguerre still had his own ingenuity and drive. In 1835, he achieved a miraculous breakthrough on his own, so miraculous that it must have seemed magical even to him. By the time of his final experiments, Niépce had turned to silver-plated sheets of copper in order to gain extra brilliance. The contrast of the image was further increased by darkening (tarnishing) the background of the silver plate with the fumes of iodine, a substance Niépce had already exploited for its light sensitivity with silver. Additionally, he had begun to develop his heliographs with the fumes of a solvent, rather than a liquid wash. This brought out an invisible image—a latent image—created by a relatively short exposure in the camera. How explicitly did these steps influence Daguerre's invention after Niépce's death, either in direct empirical terms, or in creating a mental framework that encouraged the recognition of parallel phenomena? The Gernsheims neatly summarized one version of what has since become a classic legend in photography:

36

One spring day in 1835, so the story goes, Daguerre put away in his chemical cupboard an under-exposed plate, intending to repolish it and use it again. On opening the cupboard next morning he saw to his amazement that the plate bore a distinct picture! Not knowing which chemical had wrought the miracle, Daguerre repeated the conditions of the previous day and deliberately made an under-exposed plate, putting it in the cupboard and leaving it overnight. The next day, it also bore an image. For days on end Daguerre repeated this procedure, each day taking another chemical out of the cupboard. By a lengthy process of elimination of all the chemicals the cupboard contained, he eventually found that the vapour from a few drops of spilt mercury had made the positive images appear. Having gained from this knowledge, a satisfactory method of making pictures by light had been found; it was evident now that the plate required only a short exposure and that a completely invisible or latent image could be developed and converted into a positive picture by the condensation of mercury vapour.[37]

No one who has seen a well-executed daguerreotype can deny its magic. In the same way that Daguerre drew audiences into his illusionary world of the Diorama, the depth, tonality and detail of a daguerreotype image seduces the eye. To make a daguerreotype, a brightly polished silver plate was held over the fumes of iodine, producing a layer of light-sensitive silver iodide. Exposure in the camera produced an invisible latent image, one that could be made visible by holding the plate over fuming mercury. The mercury condensed on the plate wherever light had invisibly altered the silver iodide, disrupting the surface structure (one can readily imagine the effect, by recalling the experience of revealing a palmprint by breathing on a cold window). When the polished silver plate of a daguerreotype is tilted just so, reflecting a darker area of the viewing room, a positive image suddenly emerges to the eye as the mercury

appears whiter in tone than the background. By 1837, Daguerre had further perfected this by removing the excess silver iodide with a solution of common table salt. Although greatly improved on by subsequent experimenters, Daguerre's first process contained all the magic. His contract with Niépce, now taken over by the latter's son, was revised to promote the daguerreotype instead of heliography. In 1838, Daguerre tried to sell his secret by subscription, but he failed to find investors—no doubt, at least in part, because of his widely established theatre reputation as a creator of illusions.[38] In spite of his success at invention and his ability to promote himself, Daguerre had reached his limits.

In the end, it was not within the world of commercial speculation, but rather within the halls of science that photography was to make its public debut. Yet, in a manner disturbingly familiar to us at the end of the twentieth century, the formal scientific establishment was in turmoil at that time, with politics, money and power taking ascendancy over scientific research. By 1839, encouragement and investment in day-to-day basic science in France had been drastically cut, in favour of increased funding for the popularization of highly visible and attractive projects. The proud tradition of individual initiative so carefully cultured under Napoleon found itself without patronage in the Restoration. By the 1860s, the scandalous rot in French science would suddenly break through, with the realization that the country had fallen disastrously behind Germany. But at the time photography was made public in 1839, even with its terribly weak underpinning, French science had never had a higher public profile.[39] It was a situation peculiarly ripe for Daguerre's entrance.

In casting about for testimonials late in 1838, Daguerre approached a number of scientists and artists. In one of them, François Jean Dominique Arago (1786–1853), Director of the Paris Observatory and more importantly Secretary of the Académie des sciences, Daguerre found not only a ready ally, but someone for whom he could

provide a great solution. The traditional and closed scientific establishment, embodied by Arago's mentor, Jean-Baptiste Biot (1774–1862), was being forced to yield to younger scientists of a different type, men like Arago who were as conscious of the political arena as they were of pure research. Three decades before the introduction of photography, Biot, a generation older than Arago, had forcibly assumed publication rights over work that the men had done jointly. The public rift between the two mirrored the changes being introduced into the structure of the French scientific establishment. Biot felt that scientific work was an exclusive activity which should progress slowly and carefully, all the while maintaining high standards. Arago became the chief proponent of popularizing the work of the Académie des sciences, encouraging immediacy in the disclosure of new inventions, most visibly through the weekly publication of the *Comptes Rendus*.[40] He was strongly nationalistic. Sir John Herschel had worked closely with him in the past; however, by 1844, Herschel's wife Margaret wrote to his Aunt Caroline that "we can't tell what great stir in France of M. Arago's you allude to, for he is more *addicted* to politics than to Science . . ."[41] A modern assessment of Arago characterizes him as "at once volatile and warm-hearted in his personal relations . . . he either forged strong bonds with fellow scientists or engaged in sharp polemics . . . in both his writings and his public appearances, Arago conveyed a contagious sense of excitement . . . Arago never lost his . . . ability to stimulate his colleagues and excite the public about the progress of science."[42] The scientist Niépce had provided the artist Daguerre with the essential underpinning for the invention of the daguerreotype. Now, it was into the hands of the complex and persuasive scientist Arago that Daguerre delivered the fate of his new invention.

Arago, however, even went so far as to limit mention of Daguerre's deceased partner Niépce.[43] Efforts to establish an independent claim by another French inventor, Hippolyte

Bayard (1801–87), were derailed by Arago until after Daguerre's position was secure.[44] His reasons for this must have been strategic. To persuade the government of the immense importance of the daguerreotype, Arago felt that he had to establish Daguerre in a unique position, even if this involved suppressing historical niceties as to how it came about. This was made particularly difficult because there was a delay of more than eight months between Daguerre's first announcement and his final disclosure of the secrets of manipulating his process. Henry Talbot did as much as he could to take advantage of that delay, freely sharing his secrets and trying to encourage others to improve on his process. As soon as Talbot learned of Daguerre, he arranged for a public exhibition of his work. When Michael Faraday finished his regular Friday evening lecture at the Royal Institution on 25 January 1839, he called the audience's attention to a special exhibit in the library (see the quotation on page 26). Talbot had selected examples of his photogenic drawing process meant to demonstrate "the wide range of its applicability." He described what he was able to show:

> among them were pictures of flowers and leaves; a pattern of lace; figures taken from painted glass; a view of Venice copied from an engraving; some images formed by the Solar Microscope, viz. a slice of wood very highly magnified, exhibiting the pores of two kinds, one set much smaller than the other, and more numerous. Another Microscopic sketch, exhibiting the reticulations on the wing of an insect. Finally: various pictures, representing the architecture of my house in the country; all these made with the Camera Obscura in the summer of 1835.[45]

On 31 January 1839 Talbot made a more formal presentation, this time before the Royal Society, in which he broadly outlined the implications of his invention. Three weeks later, he freely disclosed the manipulatory details of photogenic drawing, throwing open the process for experimentation by anyone.

Talbot had personally experienced failure in sketching, and had observed how difficult (and expensive) it was to get artists to record some types of observations for him. He hoped that photogenic drawing would provide a new way to record scientific phenomena. On 8 September 1839 he wrote to Sir John Herschel that:

I believe you have not seen any of my photographic attempts with the Solar Microscope. I therefore enclose 4 specimens of magnified lace. I have great hopes of this branch of the Art proving very useful, as for instance in copying the forms of minute crystallization which are so complicated as almost to defy the pencil I expect to be able to compete with M. Daguerre in drawing with the Solar Microscope, when a few obvious improvements have been adopted.[46]

Talbot's *Slice of Horse Chesnut*, taken on 28 May 1840, demonstrated many of his hopes (Pl. 18). The microscopic structure was so complex as to defy any written description. To record it accurately would have been a challenge for an artist, especially when this point of view of the specimen could be accomplished only with the aid of the microscope.

Talbot took advantage not only of his own contacts in science, but also of the support of his well connected family, in order to spread the news of his art. On 30 April 1839 his mother, Lady Elisabeth Feilding (1773–1846), wrote from London to report that she had just given out some photogenic drawings:

This morning before I was visible arrived Dr. Hamel from Hamburgh, perhaps you know him (by name at least) as he is Membre de l'Académie Imperiale de Science de St. Petersbourg ... I gave him all mine & some you sent for Matilda, so you must send me some more for *her*. He wanted them extremely to send to Russia by *the Sirius* which sails tomorrow. They are for the Emperor's second son, a very scientific young Man. He wishes to lay some before the Czarowitch who arrives in London on Friday, &

18 William Henry Fox Talbot, *Slice Horse Chesnut* [sic], *Microscope*, 28 May 1840. Salted paper print, 16.9 × 20.6 cm (image), 18.6 × 22.3 cm (paper). Hans P. Kraus, Jr., New York.

I promised you would send me some more for him. He was particularly struck with those done from Nature. The Tower-at-Laycock Abbey, windows & *riband* which latter preferences rather surprized me, tho' it did *not* in the Queen. I gave him likewise many botanicals & the black lace. He is extremely eager ... & so enthusiastic about you he wants to go down to L. Abbey ...[47]

These early examples are still carefully preserved in the Archives of the Russian Academy of Sciences in St. Petersburg. Dr. Joseph Christianovich Hamel (or Gamell, 1788–1862) was a corresponding member of the Academy. While German-born, from 1829 he filled the position of a regular member of staff in the department of "chemistry and technology applied to art and craft". Highly respected and well liked, Hamel became a sort of roving scientific ambassador, gathering information on science and new technology. Shortly before departing for his regular foreign service in April 1839, he was asked by

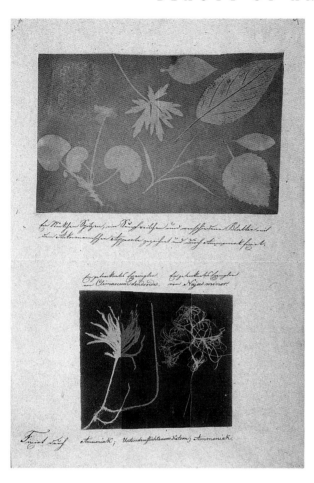

19 Julius Fritzsche, *Experimental examples to illustrate a scientific report*, May 1839. Photogenic drawing negatives, top 11 × 17.5 cm, bottom 9.7 × 10 cm. Russian Academy of Science, St. Petersburg.

tact printing. While it made a fair comment about this limited experience, his report must have been further discouragement for Talbot:

> Only one of these methods is of scientific interest, and this only is of very limited application . . . only flat, leaf-like objects may be reproduced as the apparatus is unworkable for any other objects. A negative drawing is produced in which the covered areas of the paper are protected from the blackening action of the sun's rays . . . with thin leaves, for example, the vascular network, which is more translucent than the parenchyma filled with chlorophyll, becomes relatively visible . . . from the foregoing tests it is self-evident that this method and apparatus can only be of very limited use to Science; it may be used by the Botanist for making a precise record of original specimens from the herbarium, but it is hardly of any value to the Zoologist. In fact, its practical use may be rather insignificant.[48]

two Russian botanists, Karl von Baer and Fyodor Brandt, to find out if Talbot's invention could be applied to the depiction of natural history objects. Hamel sent back not only examples of Talbot's photographs and writings, but also the necessary apparatus and chemicals. The chemist Dr. Julius Fritzsche, commissioned to conduct some experiments, successfully produced his own photogenic drawings (Pl. 19). When he issued his report on 21 May 1839, it was based on his experience with the specific materials supplied by the London printsellers Ackermann and Co. This outfit did not include a camera—only the frame and materials for con-

Once the manipulatory details of the daguerreotype had been announced on 19 August 1839, Daguerre himself actively encouraged others to take up the use of the process. François Arago had put his support behind a process that did, in fact, possess qualities in some ways superior to those of Talbot's paper. One of the chief advantages of the daguerreotype—particularly for some types of recording in science—was the extremely fine detail that could be preserved on the smooth silver plate. A scientist who benefited early and directly from Daguerre's personal tutelage was Andreas Ritter von Ettingshausen (1796–1878), a professor of physics and mathematics at the University of Vienna. He attended Daguerre's session in Paris in August and immediately began taking lessons. In a letter of 22 September, Count Apponyi reported to Price Metternich that "Daguerre is helping him with the greatest of kindness, sharing his skill and knowledge."[49] Ettingshausen was a clever and inventive person, exactly the type to take full advantage of

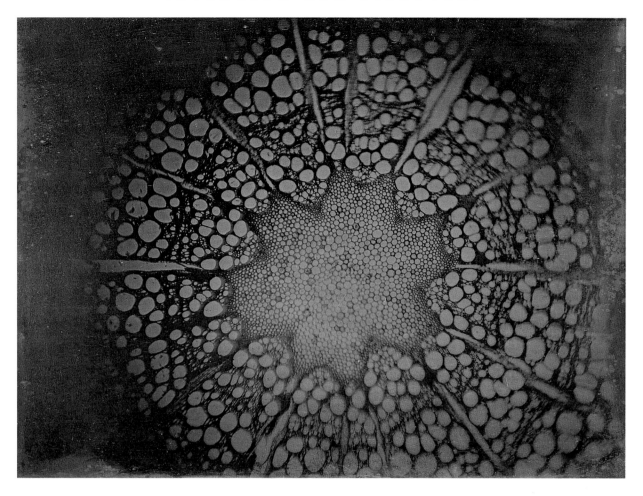

20 Andreas Ritter von Ettingshausen, *Section of Climatis*, 4 March 1840. Daguerreotype, 16.5 × 22 cm. Ezra Mack, New York.

Daguerre's new discovery. His *Section of Climatis* (Pl. 20), a whole plate daguerreotype taken in the solar microscope on 4 March 1840, eloquently demonstrates the potential of Daguerre's method. While it could not be replicated, as a solitary image its detail approached what could be perceived by the human eye looking into a microscope. As such, it conveyed a greater sense of reality than did the abstraction of Talbot's photogenic drawing made under similar circumstances.

Throughout 1839, Talbot continued the struggle to establish the viability of the negative–positive paper process. The British Association for the Advancement of Science, the rapidly

expanding alternative organization for the professionalization of science, held its annual meeting in Birmingham in 1839, precisely at the time that Daguerre was finally revealing his secrets in Paris. In what must have been an excruciating ordeal, it fell to Talbot to analyse his rival's invention:

Mr. Talbot then arose to offer a few remarks on M. Daguerre's photogenic process. M. Arago had stated to the Institute that the sciences of Optics and Chemistry united were insufficient in their present state to give any plausible explanation of this delicate and complicated process. If M. Arago, who had had the advantage of being for

21 William Henry Fox Talbot, *Stele—hieroglyphic tablet at Lacock Abbey*, c. 1840. Salted paper print. National Museum of Photography, Film and Television, Bradford.

mous amounts of solar energy to produce an image in a camera. The lengthy exposure times limited the subject matter and, of course, led to a loss of sharpness. Even if the camera did not move, the sun did, confusing the shadows that were the essence of Talbot's photographs.

Having finally come to accept the virtues of his negative–positive process, Talbot conducted hundreds of experiments in an effort to improve it.[53] In an exhilarating few days starting on 20 September 1840, Talbot discovered and rapidly perfected a method of taking advantage of a latent image. This was the key to Daguerre's

22 William Henry Fox Talbot, *Diogenes, in the great hall at Lacock Abbey*, 29 September 1840. Salted paper print, 12.3 × 8.8 cm (image), 18.5 × 11.3 cm (paper). National Museum of Photography, Film and Television, Bradford.

six months acquainted with the secret, and therefore of considering its nature in all points of view, was of this opinion, it seemed as if a call were made on all the cultivators of science to use their united endeavours, by the accumulation of new facts and arguments, to penetrate into the real nature of these mysterious phenomena.[50]

Talbot exhibited nearly 100 negatives and prints at this B.A.A.S. meeting, challenging others to find uses for the fledgling art.[51] After this, Talbot continued to distribute samples of his work to various scientific contacts, hoping to interest them in the process. His copy of a hieroglyphic tablet, one of the various stele at Lacock Abbey, demonstrated the possibility of distributing precise copies of objects of scientific interest (Pl. 21).[52] With the glorious weather of 1840, his own art began to teach him to see. In the spring and summer, he began to produce photographs of much higher artistic merit than his previous ones. His compositions became more complex and interesting, and his mastery of light and shade began. The main drawback of photogenic drawing, however, was emphasized by this success. Being a print-out process, it required enor-

23 William Henry Fox Talbot, *Sir David Brewster with Talbot's microscope at Lacock Abbey*, July 1842. Calo-type negative and salted paper print: negative 13.2 × 14.4 cm; print 13.6 × 14.8 cm (image), 18.6 × 22.6 cm (paper). Negative dated in pencil on verso in Talbot's hand. Hans P. Kraus, Jr., New York.

process—and to Niépce's before that. A short exposure to light produced an invisible change in the sensitive material. Subsequent development in a chemical bath acted on this change, amplifying it enormously to produce a visible image. Talbot's exposure times immediately plummeted from minutes to seconds. When he disclosed it to the public a few months later, he called this process the calotype. A very early, indeed a seminal, calotype negative was taken by Talbot within the first week of his work with the new process, and is a stunning example of its success. The view of Diogenes, a terra cotta figure still in the main hall of Lacock Abbey, was recorded with the relatively brief exposure of 1 minute 20 seconds (Pl. 22).

One of the first scientific colleagues (most likely *the* first) to whom Talbot revealed his newly discovered process was Sir David Brew-ster (1781–1868). This influential and always controversial Scottish physicist had been intro-duced to Talbot by Sir John Herschel, and he and the reclusive scientist of Lacock had become unusually close friends. In 1837, drawing up an

encyclopaedia article on the microscope, Brew-ster wrote to Talbot that:

I could have wished to have enriched it with some account of the very curious discoveries which you have made with the Polarising Microscope, and which I had the advantage of seeing when enjoying your hospitality at Lacock Abbey; but as these required to be illustrated with finely coloured drawings, I trust that you will speedily communicate them to the public in a separate form.[54]

Had Talbot already disclosed his unpublished process of sciagraphy to Brewster? They were confidants. Immediately after a subsequent trip, in July 1842, Talbot's wife Constance (1811–80) reported to his mother, Lady Elisabeth Feilding:

you are perfectly right in supposing Sir D. B. to pass his time pleasantly here. He wants nothing beyond the pleasure of conversing with Henry discussing their respective discoveries & vari-ous subjects connected with science. I am quite

amazed to find that scarcely a momentary pause occurs in their discourse. Henry seems to possess new life . . .[55]

It was during this visit that Talbot took Brewster's portrait, scientist to scientist, posing his colleague next to the microscope that was an important tie between them (Pl. 23). Although there is little evidence that Brewster ever did any substantial amount of photography himself, he was an avid collector of photographs.[56] In 1847, he wrote to Talbot:

I have just received the very valuable packet of Talbotypes which you have been so kind as to send me, and for which I thank you most heartily. I do not believe that a Child ever received a Toy with more pleasure than I do a Sun-Picture. It is a sort of monomania which my dealings with light have inflicted upon me.[57]

For all Brewster's enthusiastic support, no scientist proved more important to Henry Talbot's efforts than his long-time friend, Sir John Herschel. The two men had shared many interests prior to the invention of photography, some of which were directly applicable to the new art.[58] So accomplished was Herschel that he independently invented his own process of photography within days of simply hearing that it could be done—and from his sick bed! Herschel had been unable to travel to London to hear Talbot's first presentations on photography, so Talbot travelled on the newly opened railway line to Herschel's home in Slough. On 1 February 1839 Herschel showed him his own productions, similar in some ways to those Talbot had already accomplished, but significantly different in one important way. Talbot's early photographs were *stabilized* rather than permanently *fixed*.[59] The strong solution of table salt that he employed rendered the unused silver salts less sensitive to light, but they remained in the paper. To find a better solution, Herschel returned to his research of two decades before the introduction of photography. In 1818 and 1819, chance had

launched him on a series of experiments on hyposulphurous acids, a family of compounds related to the modern photographic "hypo".[60] In his very first photographic process, Herschel used the solvent power of sodium thiosulphate to "wash out" the unused silver salts. Properly handled, this was so effective at ensuring the longevity of the photograph that the same chemical is used by photographers to this day. Herschel did not invent "hypo" and never claimed to have done so.[61] However, he was the first to explore its properties, especially those which would later prove useful to photography.

"Hypo" was not the only practical contribution that Herschel made to the new art, nor were all his contributions chemical and optical. Early in his education, he had come to realize the importance of words as powerful symbols of ideas. Much of the basic vocabulary of photography is due to his efforts. The very name "photography" is due to his concern that Talbot's term, "photogenic drawing", was too limited. Among Herschel's most familiar terms are "negative" and "positive", taken by analogy from the field of electricity, and "snap-shot". In his youth, Herschel had been an avid shooter of birds. While he later abandoned that sport, in 1860 he was able to recycle one of its terms. He contemplated the possibility of "taking a photograph, as it were, by a snap-shot—of securing a picture in a tenth of a second of time . . ."[62]

Herschel's study of leaves (Pl. 24) is an exquisite example of his early work, likely to have been made in the spring of 1839. It is perhaps surprising to find that this beautifully preserved negative was not fixed with "hypo", but rather with pure water! Herschel recognized that "hypo" was then an expensive and unreliable compound. As effective as it could be when used properly, if contaminated or not fully washed out, "hypo" could leave behind destructive sulphur compounds that would eventually destroy the photograph. When he despatched instructions about photography to a friend at the Cape of Good Hope, he knew that the esoteric compound would not be available there at all, and

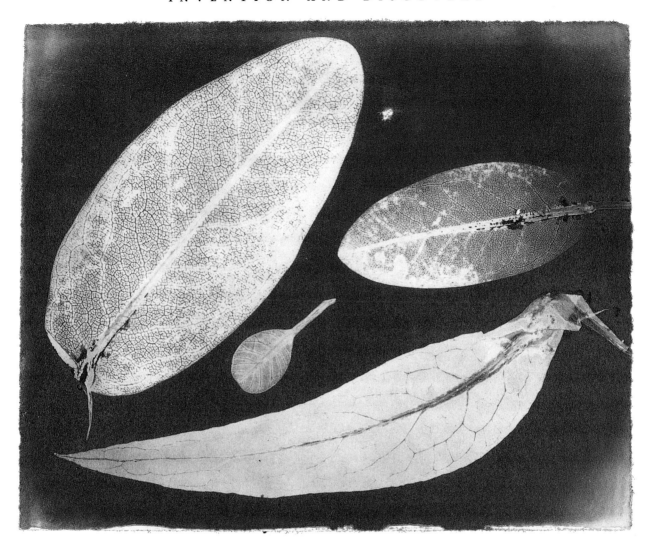

24 Sir John Herschel, *Experiment 512: four leaves—water fixed*, summer 1839. Photogenic drawing negative, 9.7 × 12.2 cm. Herschel Collection, National Museum of Photography, Film and Television, Bradford.

instead recommended Talbot's salt.[63] Herschel recorded in his research notebook on 19 April 1839 that "today also I succeeded in another *great* desideratum": fixing with pure water. Employing pure silver nitrate and avoiding the slightest contamination with chlorides, Herschel was able to produce a light-sensitive paper where the unused silver nitrate would remain fully soluble in water. His control of the conditions to accomplish this was much more strict than would have been possible commercially, but it was an elegant application of a full knowl-edge of chemistry. *Four Leaves* is probably as brilliant now as when the negative was first made, nearly two centuries ago.

Herschel's main interest in the new art of pho-tography centred neither on practical contribu-tions (he had no commercial interests) nor on its use as an image-recording medium. His approach to scientific recording, and hence his interest in image-making, differed from Talbot's. Herschel was a master-draughtsman and was highly accomplished in using the camera luci-da, the very instrument that had forced Talbot

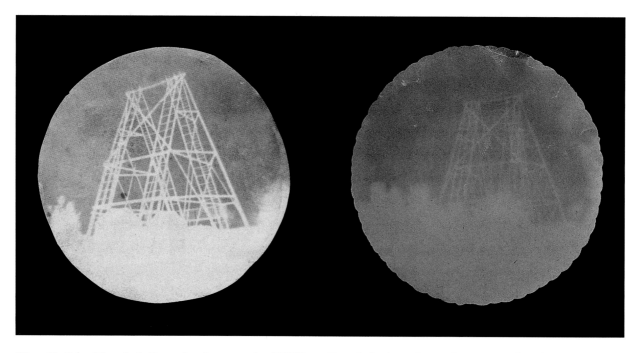

25 Sir John Herschel, *Decaying framework of William Herschel's forty-foot telescope at Slough*, 1839. Experimental negatives: left, silver on paper, summer 1839; right, silver on glass, 9 September 1839, each approximately 10 cm diameter. Left: Museum for the History of Science, Oxford. Right: Herschel Collection, National Museum of Photography, Film and Television, Bradford.

to invent photography in the first place. Herschel had usefully employed the camera lucida for decades before photography was invented. Unlike Talbot, who revelled in the fact that he could capture nature in a wink, Herschel preferred the contemplative activity of drawing, finding that it increased his powers of observation.[64] In the mid 1830s, at the very time Talbot was first inventing photography, Herschel produced some of his finest drawings during a sojourn at the Cape of Good Hope. These were usually collaborative efforts, with Sir John laying down the basic pencil drawing, and his wife Margaret sensitively colouring and finishing the final work. In his diary in 1835, he recorded that he had "outlined per Camera the great Candelabra bulb for M[argaret]. A most magnificent flower 2 feet in diameter (i.e., the head or hemisphere which it fills . . .)" (see Pl. 14).[65] Herschel remained loyal to the camera lucida throughout his life. He was not insensitive to the expressive power of photography, however; for example, he

took a great interest in the later artistic productions of Julia Margaret Cameron, and greatly encouraged her.

Because Sir John Herschel's personal interests centred on what the action of light upon substances could reveal about the universe, his few camera photographs have significance beyond the image itself. The Herschel family had come to prominence when Sir John's father, William (later Sir William) Herschel (1738–1822) discovered the planet Uranus. This, the first basic change to the Copernican universe, fired the public imagination. With support from the King, William constructed his giant 40-foot telescope at Slough, within sight of Windsor Castle. Once a powerful symbol of the emergence of science in the early nineteenth century, the telescope had fallen into disuse by 1839, the year of photography. Sir John Herschel used its wooden framework (which was larger than a house) as a convenient photographic subject, a poignant record of an instrument that would be disman-

46

tled before the end of the year. His paper negative of the telescope, part of a large series, was produced some time in the summer or early autumn of 1839 (Pl. 25). On 9 September he took a similar negative, but this time on glass rather than paper. A decade later, glass would begin to supplant rough-textured paper as a negative support, providing daguerreotype-like detail to negative–positive photography, but Herschel was way ahead of his time. His use of glass in this case was not in an attempt to secure finer detail. He recognized that paper was itself highly chemically active. In order to isolate the effects of different photochemical substances from their interaction with the paper base, he turned to the relatively neutral glass base.

Herschel conducted hundreds of experiments, meticulously recorded and sometimes illustrated in his research notebooks (Pl. 26). Most of

them were not practical for taking photographs. Indeed, Herschel had no desire that they be so, for he was interested in how the material universe reacted to light. These processes formed the basis for his major journal articles on photography, articles which provided the first scientific analysis of the tremendous implications that investigations in photography had for an understanding of the universe.[66] These articles began to provide a systemization of knowledge in this field. Herschel investigated an enormous range of materials. Sending some new examples to Henry Talbot on 24 March 1843, he proudly boasted that "in none of these specimens does either silver or gold occur—and our materia photographica is extending daily."[67] One of the examples enclosed with this letter was a particular variation of the cyanotype process, a photographic process that survived in common use

26 Sir John Herschel, *Experimental Notebook, 11–13 February 1839*. Photogenic drawing negatives and ink on paper. Herschel Collection, Science Museum Library, London.

27 Sir John Herschel, *Experiment 780: negative cyanotype*, summer 1842. Cyanotype, 10.2 × 8 cm. Inscribed in ink on verso in Herschel's hand, "780 To be retained by Mr Talbot." Inscribed in ink on verso in Talbot's hand, "see Phil. Mag. 1843 p. 249. Art. 223. Equal parts Amm. Citr. of Iron, and Red Pruss. Pot." Talbot Collection, National Museum of American History, Smithsonian Institution, Washington, D.C.

until quite recently in the form of the architect's blueprint (Pl. 27).[68] Described in a last-minute postscript to his final major paper on photography, the cyanotype was extraordinarily simple.[69] Two inexpensive, commonly available chemicals—ferric ammonium citrate and potassium ferricyanide—were mixed together and coated on to plain writing paper. Dried, and then placed under an object such as a leaf, the paper would, with a few minutes exposure to the sun, produce a rather unpromising-looking pale green image. When this feeble image was placed in water, the pigment prussian blue was formed, instantly converting it to a deep rich blue tone. Furthermore, this—one of the most permanent of all prints—was "fixed", as it were, by Herschel's desideratum, water. The cyanotype was limited

in use by its immutable blue tone, a drawback for renditions of many subjects, especially portraiture. However, it was used to splendid effect by Anna Atkins, in her photographs of the *Flowers of the Sea* (see Pl. 12).

Increasing pressures on Herschel removed him from the study of photography before he had the opportunity to explore fully his "materia photographica". By 1843, he was forced to lament to his wife:

Don't be enraged against my poor photography. You cannot grasp by what links *this* department of science holds me captive—I see it sliding out of my hands while I have been *dallying* with the stars. LIGHT was my first love! In an evil hour I quitted her for those brute & heavy bodies

48

which tumbling along thro' ether, startle her from her deep recesses and drive her trembling and sensitive into our view.[70]

Herschel's final contribution to the early days of photography was to explore the possibilities of photographs in full colour. Although the early photographers made brave statements about the Rembrandtish effects of their monochrome images, it was clear that full colour was what was hoped for. In perusing a path towards colour images, Sir John Herschel characteristically was not as interested in the prints that might result as he was in what photography might tell him about his "first love"—light. In order to analyse what effect different colours of light had on different substances, Herschel originally turned to bits of coloured glass and colourful solutions of chemicals. These filtered the light, producing a visual colour, but he soon detected that they affected the various wavelengths of light in complex ways. He then turned his attention to absolutely pure coloured light, produced not by subtraction from white light through a filter, but

29 Prof. John William Draper, *Experimental spectrum*, 27 July 1842. Daguerreotype, 9 × 7.5 cm. Herschel Collection, National Museum of Photography, Film and Television, Bradford.

rather by spreading the colours of light with a prism. The Royal Society eagerly offered funds to support his research with his invention of the "actinoscope" (Pl. 28). A clockwork mechanism would track the moving sun, keeping its rays focused on a prism. The prism projected a spectrum of pure coloured lights on to a sheet of sensitized paper, thus allowing Herschel to study the effects of each colour independently. Had it not been for the malfeasance of the optician charged with the building of the device—which caused a delay that made Herschel's schedule impossible—every indication was that he could have developed a primitive but functional colour photographic process by 1844.

Herschel's interest in the effects of coloured light was shared by others. Dr. John William Draper (1811–82), a New York physicist, was so

28 Sir John Herschel, *Description of a proposed Actinoscope*, 1842. Ink and pencil on paper, 44.6 × 28 cm. Herschel Collection, Harry Ransom Humanities Research Center, The University of Texas at Austin.

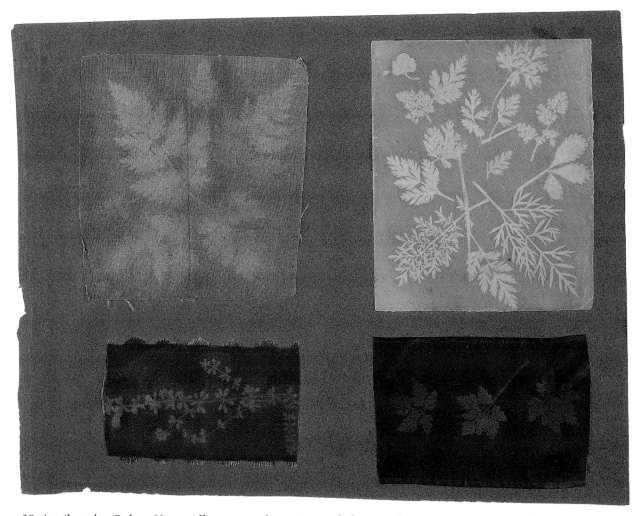

30. Attributed to Robert Hunt, *Album page of experimental photographic processes*, c. 1841. Photogenic drawing negatives on cloth and paper, 20 × 27 cm. Rubel Collection, courtesy of Hans P. Kraus, Jr., New York.

impressed with his early publications on photography that he sent the great scientist an example of his pioneering work (Pl. 29). Using the metal base of the daguerreotype plate, Draper had succeeded in providing a clear visual representation of the effects of light, a portrait of nature extraordinary in its elegance. Draper, like Herschel, understood that the use of colour filters only confused scientific investigations into the nature of light. Herschel immediately communicated his thoughts on this to a European audience:

Professor Draper of New York having . . . referred to a specimen of a Daguerreotyped impression of the solar spectrum obtained by him in the south of Virginia as having been forwarded by him to me . . ., I should hardly be doing justice, either to his urbanity or to the beauty of the specimen itself as a joint work of nature and art, were I to forbear acknowledging its arrival and offering a few remarks on it. And I do so the more readily, because, though forced to differ with him in some of the conclusions he has drawn from it, I recognize in him a zealous and effective contributor to this most interest-

ing branch of scientific inquiry, and the only one, so far as I am aware, besides myself who has attacked it in the only mode in which it can lead to distinct and definite results, that of prismatic analysis.[71]

Notwithstanding this close analysis of the work of another scientist, Sir John Herschel was primarily concerned with his own research programme. It fell to a young Cornish scientist, Robert Hunt (1807–87), to begin to record the history of the medium. Inspired by his personal contact with Herschel and his correspondence with Talbot, Hunt took a leading role in the organization of knowledge about photography.[72] Of humble origins, Hunt had been apprenticed to a London chemist; by the time of the introduction of photography, he had become a leading figure in the Cornwall Literary and Scientific Society. Early in 1839, he started manufacturing his own direct positive paper for sale. At the 1840 Glasgow meeting of the British Association for the Advancement of Science, Hunt established the importance of a scientific chronicle of the quickly emerging field. Correspondence with Herschel persuaded him to publish his 1841 *Popular Treatise on the Art of Photography*, the first true manual on photography in English, and the first organized history of the field. On various substrates and with various chemicals, he explored the full range of media sensitive to the action of the sun (Pl. 30), resolving to master each process himself before publishing it. Hunt also devised a number of processes on his own, including the chromatype: "the Process is so exceedingly simple, and the resulting pictures of so pleasing a character, that, although it is not sufficiently sensitive for use in the camera obscura, it will be found of the greatest value for copying botanical specimens, engravings, and the like."[73] Hunt described the result as "a beautiful very deep orange picture on a light dun colour, or sometimes perfectly white ground,"[74] a description so closely matching the present state of one of his examples (Pl. 31) that it proves the stability of the process.

It was through the efforts of scientists like Herschel and Hunt that the medium rapidly became practical for scientific work. In March 1841, Dr. George Butler (1774–1853), Talbot's childhood tutor, suggested:

what I should like to see, wd be a set of photogenic Calotype drawings of Forest Trees, the Oak, Elm, Beech &c. taken, of course, on a *perfectly calm* day, when there should not be one breath of wind to disturb and smear-over the outlines of the foliage. This would be the greatest stride towards effective drawing & painting that has been made for a Century. One Artist has one touch for foliage, another has another . . . but your photogenic drawing would be a portrait; it would exhibit the *touch* of the great artist, Nature . . .[75]

Butler was not thinking of photographs just as visual resources for artists. In allowing nature to take her own portrait, the prejudices of man would be bypassed (Pl. 32). As a scientist, Charles Piazzi Smyth (1819–1900), Astronomer Royal for Scotland and himself a photographer, recognized the advantage of the impartiality of photography for scientific recording. Smyth examined half a century's worth of successive published drawings of the grand Dragon Tree of Tenerife, supposedly the oldest living organism in the world, which had a physiognomy totally unfamiliar to Europeans:

With these three views before us, it is instructive, as connected with the language of drawing, to trace the gradual growth of error and conventionality, as man copies from man. Errors are always copied, and magnified as they go; seldom are excellences reproduced. After a few removes, the alleged portrait of nature, is only a caricature of the idiosyncracies of the first artist.

Smyth saw that the artist nature, through the medium of photography, had "an unflinching boldness in putting in the actual form of plants, be they as different as they may, from anything

previously seen at home, or from what in polite circles has alone been allowed to be called beautiful."[76]

Of the early processes, the daguerreotype—with its unflinching boldness and honesty—was to prove the most useful to science for field work. This peculiar process also seemed to attract more than its fair share of adventurous characters. One of the earliest was a scientist and artist of independent means, Joseph-Philibert Girault de Prangey (1804–92). His first interests were in the medieval architecture of France, even then being destroyed, and in 1834 he founded the Société Archéologique de Langres. Starting in the early 1830s, de Prangey made highly detailed drawings to record his archaeo-

31 Robert Hunt, *Experimental chromatype*, 1843. Direct positive photogenic drawing, 17.3 × 13.5 cm. Gernsheim Collection, Harry Ransom Humanities Research Center, The University of Texas at Austin.

32 William Henry Fox Talbot, *Oak Tree, Carclew Park, Cornwall, the home of Sir Charles Lemon*, c. 1841. Salted paper print, 16.8 × 20.9 cm (image), 18.9 × 22.9 cm (paper). National Museum of Photography, Film and Television, Bradford.

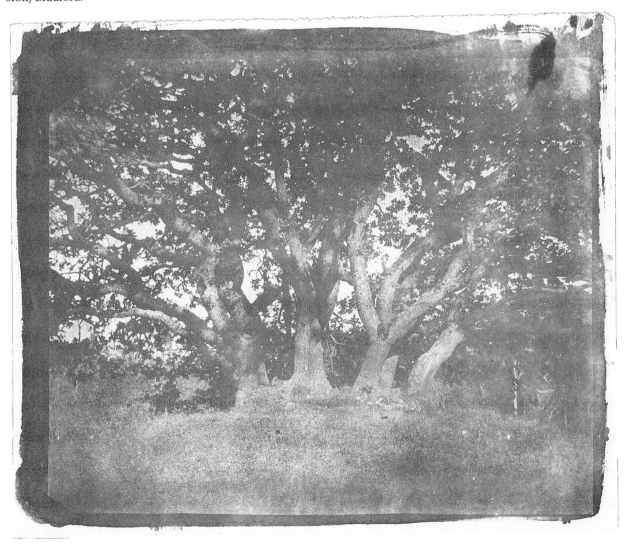

33 Joseph Philibert Girault de Prangey, *Etruscan Tombs at Castel d'Asso*, 1842. Daguerreotype, 19 × 24 cm. Gernsheim Collection, Harry Ransom Humanities Research Center, The University of Texas at Austin.

logical studies. The Arab and Moorish architecture of Spain was a special interest. Around 1841, he took up the practice of the daguerreotype to record areas of interest in France. In 1846 he published his *Monuments arabes d'Egypte, de Syrie et d'Asie Mineure*. Probably in preparation for this, in an extraordinary personal undertaking during the years 1842–44, he travelled throughout the Orient, carefully recording ancient architecture with the eye of an archaeologist. Carrying both a camera and a laboratory during this extended journey, de Prangey created a body of nearly 1,000 daguerreotypes.[77] One, his 1842 *Etruscan Tombs at Castel*

d'Asso (Pl. 33), shows the highly decorated tombs of what had once been a very wealthy and prosperous race. Like Henry Talbot's photograph of the stele (see Pl. 21), the daguerreotype recorded, with a minimum of artistic bias from the hand of man, and in precise detail, the unfamiliar architecture of a long-lost civilization.

If hand-drawn portrayals of the subjects of archaeology were suspect, even more so were the recordings of the then young field of anthropology. François Arago, in spite of his nearly boundless enthusiasm for daguerreotypy, was extremely pessimistic that Daguerre's invention could ever be applied to portraiture.[78] But por-

54

traiture in fact became the mainstay of daguerreotypy, particularly in America.[79] It was a French anthropologist and daguerreotypist, E. Thiésson, who turned to nature's art to secure truthful renditions of the daguerreotype to record the racial types of Portugal, South America and Africa. Work such as his 1845 daguerreotype taken in Mozambique, *Native woman of Sofala*— "thirty years of age; although still young, this woman has hair that is almost entirely white"—provided a scientific record for comparison (Pl. 34). The President of the Académie des sciences was so taken by the potential of daguerreotypes in anthropological studies that he proposed the establishment of a museum to record the human countenance.[80]

If for no other reason than their sheer variety, the innumerable photographic processes based on paper and glass provided the most opportunity for extending the vision of man into elements of nature. These processes provided test beds and visual "mouse traps" that could reveal the inner workings of nature. The daguerreotype, on the other hand, aside from wielding the visual magic of its image, was initially the most capable of producing a scientifically valuable image of the elements of the world that man could already see. Its tones were vibrant and its detail razor-sharp. Formed on a metal plate, extraneous influences could be more predictably controlled than they could be on an organic base such as paper. Later in the nineteenth century, long after the process had faded from commercial use, it was still employed in astronomical photography because of the dimensional stability of the metal plate. Unlike paper, which changes size with fluctuations in humidity (thus altering the spacing of the stars), the metal base of the daguerreotype could be kept at a precise size by merely controlling the temperature.

The daguerreotype, however, was trapped. A strong virtue of the paper processes was their ability to provide research data for individual scientists. The strongest virtue of the daguerreotype, on the other hand, was its ability to convey a detailed portrait of nature. But part of the

magic of viewing the daguerreotype is that it is an intensely personal experience. It is an inherently unique object, only awkwardly multiplied, and the data of science reaches its highest value when it is shared. It was possible to make daguerreotype copies of daguerreotypes, but the unit cost was high and the loss of quality unavoidable. Distribution was even more of a problem. While the practice of mounting dried bits of seaweed to illustrate a book was labour-intensive (see Pl. 13), at least a layer of desiccated plant cells adhering to paper was not too different from ink on paper. One can imagine the reaction of a publisher to the suggestion that a book be illustrated by numerous heavy and thick sheets of silver-plated copper (each mounted under glass). The only way to make the daguerreotype practical for publication, and thus

34 E. Thiésson, *Native woman of Sofala, Mozambique*, 1845. Daguerreotype, half plate. George Eastman House, Rochester, New York.

truly valuable to science, was to transform the mercury image into ink on paper. This approach harked back to the earliest days of Niépce's research, and possibly even to his original visual goal. However, it proved to be an impossible quest. Many attempts were made, some more successful than others. The early efforts of Capt. Levett Landon Boscawen Ibbetson were as good as any, but just as clearly demonstrated the insurmountable difficulties. In exhibiting a book of photographs, entitled *Le Premier livre Imprimé par le Soleil*, he explained:

> The history of it is this. In the year 1839, when residing in Switzerland, I saw one of the first specimens of the Daguereotype, and the idea immediately struck me, how much better it would be if the picture could be produced on paper instead of on silver. I was thus induced to experiment on this subject . . . Professor Agassiz, who took great interest in my labours, gave me letters to Mr. Robert Brown and M. Arago, suggesting the important use it might be to botanists.[81]

Ibbetson easily saw where the infant art might be useful. Later, he explained, "I was experimenting on some fish for Professor Agassiz, who was then engaged on his work on 'Fishes.'"[82]

Ibbetson decided against the direct use of Talbot's paper photography, hoping instead to transfer the daguerreotype image. In August 1840, Prof. James David Forbes (1809–68) wrote to Herschel that "Mr. Ibbetson has sent me a specimen of Photographic engraving (or rather I should guess Lithography) which no doubt you have seen."[83] Dr. William Buckland (1784–1856), addressing the Geological Society in 1841, singled out Ibbetson's "valuable application" of a

> process for rapidly producing perfect drawings from fossil shells on metallic plates, from which, when fixt by the engraver's tool, lithographic transfers may be rapidly multiplied to an almost indefinite extent. This process promises to be applicable to organic remains of

35 Levitt Landon Boscawen Ibbetson, *Fossils, Engraved on a Daguerreotype Plate*, 1840. Lithograph by A. Friedel, 14 × 21 cm. From *The Westminster Review*, vol. 34, no. 2, September 1840. Smithsonian Graphic Arts Collection, National Museum of American History, Washington, D.C.

every kind, and consequently of great utility in Palæontology.[84]

In spite of this enthusiastic response, however, the real basis for Ibbetson's work was the hand of man. He had developed a means of more securely fixing the daguerreotype image on the plate:

> the result . . . is that the Daguerreotype plates can be engraved upon by a common graver, or converted into etchings, the original picture being used as tracing lines. Faithful copies therefore of a picture originally delineated by Nature herself promise now to be multiplied to any extent . . . we have been favoured with the means of showing the practical use that may now be made of Daguerreotype pictures for the illustration of works on natural history, &c.

Ibbetson's depiction of fossils was

> an engraving from a Daguerreotype plate obtained in the usual manner by the light of the sun. When the impression was fixed upon the plate an outline of the image was traced upon it

by an engraver in the dotting style; a print was then taken from the plate and transferred to stone, when the shading required was filled in by a lithographic artist.[85]

It was the artist, A. Friedel at the Polytechnic Institution, who created the image more than nature did (Pl. 35).

It was the daguerreotype's alienation from the printed page that ultimately limited its role in science. The editor of *The Athenæum* saw the implications of Ibbetson's work:

for such is the minute accuracy of the Daguerréotype that every scale on a fish, and even the minutest part of an insect, can be therein beautifully displayed; and the picture once engraved, as Mr. Ibbetson has shown that it may be, it can be electrotyped, and the impressions multiple to any extent;—thus the works which, however desirable, no publisher could undertake with any chance of remuneration, from the elaborate detail of the drawings, and the consequent expense of the engravings, may be brought within the means of persons of very limited income.[86]

This echoed Henry Talbot's thoughts. In March 1839, in one of his first letters to Herschel about photography, he accompanied a print with the thought that "the enclosed scrap will illustrate what I call 'every man his own printer and publisher.'" Substituting photography for the printing press would "enable poor authors to make facsimiles of their works."[87] Talbot's interest in scientific publication was of long standing. In 1833, just before he conceived of photography, Talbot wrote to the botanist William (later Sir William) Jackson Hooker (1785–1865) that "the difficulty which you complain of, of getting any bookseller to publish a scientific work on Botany is not confined to that science." Talbot suggested that there was a societal benefit to be gleaned from support:

Abroad, not only is paper & printing cheaper, but assistance is rendered by the Governments.

In my opinion public libraries ought to be established in all our principal Towns at the national expense. A considerable sum should be voted annually for the encouragement of science, which should be in part expended in patronizing literary undertakings of merit. From 20 to 50 copies of such works should be purchased by government & distributed to these provincial libraries, which small at first, would soon become important.[88]

Six years later, after the introduction of photography, Talbot wrote again to Hooker, suggesting what would have been the first scientific publication to use the new art: "what do you think of undertaking a work in conjunction with me, on the plants of Britain, or any other plants, with photographic plates, 100 copies to be struck off, or whatever one may call it, taken off, the objects?"[89]

In the end, it was Anna Atkins, a scientist of unusual foresight and determination, who linked together science, photography and publication.[90] In 1843, she wrote to one of her friends:

I have lately taken in hand a rather lengthy performance, encouraged by my father's opinion that it will be useful—it is the taking Photographical impressions of all (that I can procure) of the British Algae and confervæ, many of which are so minute that accurate drawings of them are very difficult to make.[91]

Atkins's father was John George Children (1777–1852), recently retired from the British Museum, a close friend of Herschel and Talbot, and the person who had chaired the Royal Society meeting at which Talbot first revealed how to make photogenic drawings. In September 1841, Children wrote to Talbot:

on my return to Town, I found the Calotypes safe on my table . . . when we return into Kent, my Daughter & I shall set to work in good earnest 'till we completely succeed in practising your invaluable process . . . I have also ordered a Camera for Mrs. Atkins from Ross.[92]

In retrospect, it is not surprising that Anna Atkins took on the task that she did. A competent draughtswoman, she was well aware of the demands of scientific illustration, so much so that by 1823 she could very competently illustrate her father's translation of Lamarck's *Genera of Shells*.[93] Atkins also experimented with the popular art of lithography. In 1835, Children wrote to the botanist William Hooker saying that "my daughter, Mrs. Atkins, has a great fondness for Botany, and is making an Herbarium."[94] In 1839, just as photography was being introduced, Anna Atkins became a member of the Botanical Society of London, one of the first scientific organizations to admit women.[95] Anna Atkins knew both Talbot and Herschel and must have shared, at least at a distance, their passion for exploiting plants as convenient photographic subjects. More than any other category of scientist, botanists were quick to seize on the possibilities that photography offered. At a meeting of the Botanical Society in March 1839, John Thomas Cooper Jnr. showed "numerous figures of Mosses and Ferns produced by the Photogenic process of Mr. Talbot."[96]

In her effort to do something "useful", Atkins turned these tentative experiments into a reference work for science. In October 1843, she began issuing the first parts of her *British Algae: Cyanotype Impressions*.[97] The plates were made photographically, using Herschel's cyanotype process to contact print the plants (see Pl. 12). The text pages were photographic copies of Atkins's handwriting, titled with letters composed of strands of seaweed. She explained in her Preface:

> The difficulty of making accurate drawings of objects as minute as many of the Algæ and Confervæ, has induced me to avail myself of Sir John Herschel's beautiful process of Cyanotype, to obtain impressions of the plants themselves, which I have much pleasure in offering to my botanical friends.

Her father's position in the world of science

must have been a help in this pioneering project, and Atkins was fortunate enough to be in a position in society that enabled her to call on her friends (and probably also her servants) to help.[98] Algae specimens by the hundreds had to be selected, flattened and dried, in order to act as the "negatives". Thousands of sheets of cyanotype paper were coated by hand. Exposed to sunlight under the specimen for perhaps a quarter of an hour, they then had to be washed, dried and flattened for insertion into the books. It was a "lengthy performance", as she had clearly understood from the beginning. When finished ten years later, the final work encompassed around 400 photographic plates and 14 pages of text. Every page was an original cyanotype photograph. Perhaps 15 or more complete copies were produced. It was a prodigious undertaking. But was it useful?

In March 1839, when Talbot had proposed to William Hooker a photographically illustrated reference book, the botanist responded most to Talbot's enclosure of a *cliché verre*. Hooker found himself

> most pleased with . . . the imitation of an *etching*. Can that be made available for Botanical drawing? Plants should be represented on paper, either by *outline* or with the shadows of the flowers (which of course express shape) *distinctly* marked. Your beautiful Campanula hederacea was very pretty as to general effect:—but it did not express the swelling of the flower, nor the calyx, nor the veins of the leaves distinctly. When this can be accomplished as no doubt it will, it will surely become available for the publication of good figures of plants.[99]

Hooker saw the limitations of Talbot's primitive shadows—his sciagraphs—but also saw where the future of photography in science was to lie.

The science of art/the art of science: the art of photography, conceived within the world of science by man's desire for images, emerged as science's guide. As much as photography served as a medium of expression, it also served as a

way to extend the vision of man. In describing *A Scene in a Library* (Pl. 36) in his 1844 *The Pencil of Nature*, Henry Talbot did not dwell on the scientific journals and books from his library pictured in the image. What struck him most, in a perhaps fanciful but prophetic way, was the future potential of photography to see into the universe, providing a physical form to the secrets of nature:

> When a ray of solar light is refracted by a prism and thrown upon a screen, it forms there the very beautiful coloured band known by the name of the solar spectrum. Experimenters have found that if this spectrum is thrown upon a sheet of sensitive paper . . . a . . . truly remarkable . . . effect is produced by certain *invisible rays* which lie beyond the violet, and beyond the limits of the spectrum, and whose existence is only revealed to us by this action which they exert. Now . . . separate these invisible rays from the rest, by suffering them to pass into an adjoining apartment through an aperture in a wall or screen of partition. This apartment would thus become filled (we must not call it *illuminated*) with invisible rays . . . if there were a number of persons in the room, no one would see the other: and yet nevertheless if a *camera* were so placed as to point in the direction in which any one were standing, it would take his portrait, and reveal his actions. For, to use a metaphor . . . the eye of the camera would see plainly where the human eye would find nothing but darkness. Alas! that this speculation is somewhat too refined to be introduced with effect into a modern novel or romance; for what a *dénouement* we should have, if we could suppose the secrets of the darkened chamber to be revealed by the testimony of the imprinted paper.

The imaginative mind of the photo-historian, Robert Hunt, ran along similar lines when he mused in 1848 that:

> the phenomena of Reality are more startling than the phantoms of the Ideal. Truth is stranger than fiction. Surely many of the discoveries of science . . . exhibit to our senses subjects for contemplation truly poetic in their character.[100]

The pairing of science and photography enables us to contemplate the poetry of nature.

36 William Henry Fox Talbot, *A Scene in a Library*, c. 1844. Salted paper print, 13.3 × 18 cm (image), 18.9 × 23.3 cm (paper). National Gallery of Canada, Ottawa.

3

The Signature of Light: Photo-Sensitive Materials in the Nineteenth Century

JOHN P. MCELHONE

FROM its earliest appearance, photography has been a tool for scientific exploration of the natural world. At the same time, the processes and materials of photography have themselves been the subject of scientific enquiry. This enquiry begins in the eighteenth century, well before the advent of practical photographic processes, when "natural philosophers" such as Johann Schulze and Carl Scheele discovered the light sensitivity of some of the compounds of silver. This was a new phenomenon, the study of which would provide observations relevant to some of the great questions addressed by eighteenth- and nineteenth-century science. How do heat and light interact with matter? What is the nature of colour and human colour perception? And, most fundamentally, what is the nature of light?

Through the nineteenth century there is a rich interplay between the theory of science and the technology of photography. This relationship invoked fundamental questions about such things as chemical reactions, combustion, human vision and, most famously, about the particle and wave theories of light. During this time, photographic technology progressed from

simple shadow profiles of opaque and translucent objects, through the exquisitely detailed depictions found in daguerreotypes, to the complexity of translating the real colours of the world into a camera image. Of especial interest is the little known colour photographic process of Gabriel Lippmann in which physics and photography are melded. It is one of the few cases in which a line of pure scientific enquiry led directly to a completely new and fully formed photographic process.

THE BEGINNINGS OF THE SCIENCE OF LIGHT

Lippmann's invention came near the end of a long debate between physicists concerning the nature of light and its interaction with matter. In the eighteenth century, observations accumulated about how light behaved and how it could be manipulated by optical devices such as lenses. However, ideas about the fundamental nature of light had not progressed significantly since the time of Isaac Newton (1642–1727). In some ways things had regressed, since incomplete readings of Newton were used to defend the corpuscular (or emission) theory, which con-

ceived light to be streams of separate particles that travelled in straight lines, as a complete explanation.[1] The competing undulatory theory, given its most sophisticated expression by the Dutch astronomer Christiaan Huygens (1629–95), held that light rays were longitudinal waves, like the compression waves in a coiled spring, oscillating in the same direction as they move. It was thought that all waves needed some compressible substance in which to oscillate. This medium was clearly not air, since light could move easily through a vacuum, so a "luminiferous ether" was proposed, a kind of elastic fluid said to pervade the universe. While these fundamental questions remained in doubt, natural philosophers began to make detailed observations of the effects of light on matter. Johann Schulze was only one generation removed from the alchemical tradition when, in the 1720s, he studied the phosphorescence produced by a preparation of chalk and nitric acid.[2] He noted that a slurry of white chalk turned dark when left in the sun. Schulze attributed the darkening to the presence of silver nitrate, an impurity in the nitric acid, and went to some lengths to show that the effect was due to light rather than to heat. To show the effect, he made images of letters of the alphabet appear at the surface of a glass container; the letters disappeared when the slurry was stirred.

Light-sensitive silver compounds would be studied extensively before practical photographic systems emerged. For example, Jean Hellot (1685–1766) used paper soaked in silver nitrate in his attempts to develop new means of invisible writing.[3] Silver chloride was first isolated by Giambatista Beccaria (1716–81) who noted that it darkened when exposed to light.[4] Popular scientific manuals described entertaining ways of recording outlines and profiles using silver compounds.[5]

The question of whether it was light or heat that caused the changes in silver compounds was a critical issue for those who were examining the nature of heat and combustion. This was one of the many current questions in natural philosophy addressed by the pharmacist Carl Scheele (1742–86). It was light and not heat, Scheele found, that darkened naturally occurring silver chloride.[6] He accurately interpreted that the darkening was a transformation of silver chloride into metallic silver, the fundamental reaction of photographic systems.

The principles on which modern chemistry would be built were emerging at the end of the eighteenth century. The description of oxygen ("fire air"), first by Scheele and subsequently by Joseph Priestley and Antoine Lavoisier, led to the idea that combustion, or oxidation, was essentially a chemical reaction. A new definition of chemical elements was supplied by John Dalton's atomic theory of 1808: he proposed that an element was composed of tiny, homogeneous and indestructible particles.[7] With these basic insights, chemists went on to describe the characteristics of the atoms: Amedeo Avogadro defined their volume; Jöns Berzelius calculated their weight; Dmitry Mendeleyev classified them into a table that related their characteristic properties. Nineteenth-century science now had a theoretical framework in which to understand and manipulate the light-sensitive compounds.

EXPLORING THE LIGHT-SENSITIVE COMPOUNDS

By the end of the eighteenth century, there was a well established repertoire of substances observed to darken or fade when exposed to light; these included dyes and other natural products, and compounds of mercury, gold, iron and silver.[8] The behaviour of metals and metal compounds exposed to light was of great interest to the textile dyeing industry, since many of the dye mordants (fixatives) used were metallic compounds. Researchers such as Louis Berthollet[9] and Elizabeth Fulhame[10] examined chemical and light effects on metallic dye compounds in terms of oxidation and reduction, a thoroughly modern approach to the interpretation of chemical reactions. By the mid 1830s, the complete roster of compounds that were to be

used in photography in the coming years had been identified and characterized as undergoing changes when exposed to light: the silver halides (silver chloride, silver bromide and silver iodide), platinum chloride, ferric oxalate and potassium dichromate.

It was silver chloride that was examined most closely. The reaction of silver chloride to light exposure showed some complex aspects. The fact that blue light, for example, produced a deep violet colour on silver chloride-treated paper, whereas red light produced a much paler effect even after long exposure, was noted by Jean Senebier, the plant physiologist who first described photosynthesis.[11] Thomas Seebeck, the experimental physicist associated with Goethe's development of a theory of colour, found that paper treated with silver chloride would reproduce the multi-colour spectrum of sunlight refracted through a glass prism[12]—violet light produced red-brown or violet coloration; blue light produced clear blue, and red light produced a rose or lilac colour. A colour effect was also noted with the yellow resin, gum guaiacum, by the physician and experimentalist William Hyde Wollaston: exposed to blue light the gum turned green; further exposure to red light restored it to yellow.[13]

Silver chloride-treated paper was used as the detector in the first automatic recording photometer, created around 1818 by Marsilio Landriani.[14] It was used again by Mary Somerville, the author of a number of popular accounts of science in the early nineteenth century, to study the effect of filters on the "chemical rays" (the invisible radiation of the ultra-violet and infrared bands at either end of the visible light spectrum).[15]

The scientist most closely identified with the early inventions of photography is John Herschel (1792–1871), both through his association with Henry Fox Talbot and independently. Already in 1819 he had described the solvent action of the "hypo" compound that would eventually be used as photographic fixer.[16] Herschel was also well aware, by the time that Talbot began the experiments that led to photogenic drawing, of the variable sensitivity of silver chloride to the different-coloured bands of the solar spectrum.

Long after conventional photography had been established, Wilhelm Röntgen, professor of physics at Würzburg, noted another kind of invisible ray that acted on silver halide.[17] In 1895 Röntgen was experimenting with a Crookes tube apparatus, a partially evacuated glass vessel with electrodes at either end. It had been known for more than a century that an electric current applied to this device would cause the glass next to the negatively charged electrode to fluoresce. The fluorescence was attributed to cathode rays, thought to be "a stream of molecules in flight". Röntgen noted that another kind of ray, invisible to the eye, was detectable outside the tube by both phosphorescent materials and by photographic plates. These rays had the surprising ability to penetrate opaque matter, even the light-tight sealing paper around a photographic plate. Unsure of the nature of this penetrating energy, he provisionally called the phenomenon "X rays". In 1901 Röntgen was awarded the first Nobel Prize for physics for his discovery of this curious phenomenon (Pl. 37).

Henri Becquerel was intrigued by Röntgen's rays and suspected that the phosphorescent salts of uranium might also give off such penetrating energy. He found that a uranium compound placed on a light-tight package containing a photographic plate did indeed cause exposure of the plate. Quite unexpected was the fact that the uranium needed no light exposure, nor did it have to phosphoresce visibly in order to cause

37 Josef Maria Eder and Eduard Valenta, *Aesculapian Snake*, 1896. From the portfolio, *Versuche über photographie mittlest der Röntgenschen Strahlen*. Photogravure. Ezra Mack, New York. In the course of documenting the capabilities and technical characteristics of X-radiography, Eder and Valenta produced a portfolio of images of startling beauty.

the photographic effect. Becquerel's observation led Marie and Pierre Curie to study the uranium ore pitchblende; from this they described the phenomenon of radioactivity and isolated the new radioactive elements polonium and radium. Becquerel and the Curies were given the Nobel Prize for physics in 1903 for this work, which opened the way to nuclear physics (Pl. 38).[18]

So observations showed that this single substance, silver chloride, was affected similarly by a variety of radiant energies, including the visible colours as well as the invisible infra-red, ultra-violet, X-rays and the gamma rays of uranium. The mechanism by which this happened was the central problem of photographic science in the nineteenth century.

EXPLAINING THE ACTION OF RADIANT ENERGY ON SILVER SALTS

Eighteen thirty-nine was a banner year for photographic processes: Daguerre's photographs on a silvered metal plate were announced on 7 January; Henry Fox Talbot's photogenic drawing method was described at the Royal Institution later that same month; in July, Mungo Ponton published a method for making positive paper prints using potassium dichromate. The title of Ponton's article, "Notice of a cheap and simple method of preparing paper for photographic drawing in which the use of silver is dispensed with",[19] already indicated a dissatisfaction with silver-based photography—due mainly to its high cost and poor keeping qualities—which would stimulate the invention of dozens of alternative and modified photographic processes in the following years. In 1842 John Herschel described two new processes based on iron salts rather than silver salts: the cyanotype and the chrysotype.[20]

One issue that particularly drew the attention of scientists to the daguerreotype was this fundamental question of photographic chemistry: what happened to the silver iodide on the daguerreotype plate at the moment it was hit with the light that allowed its transformation into visible image particles? This was the problem of latent image formation.[21] Why did the compounds of silver darken at all when subjected to light? Scheele had already identified the darkened substance as being metallic silver.

38 Henri Becquerel, *Deviability of secondary rays produced by beta radiation*, 1901. Gelatin silver prints. Paula and Robert Hershkowitz, Sussex. In the years following his observation of the radiant energy coming from uranium, Becquerel used photographic techniques to study the physical behaviour of radioactivity. These autoradiographs record direct and secondary beta rays as they are bent in a magnetic field and diffracted through slits cut in a pair of opaque semicircular screens. The radioactive source is located at the bottom of each image.

This simple explanation comes closest, among the early interpretations, to our current understanding of the mechanism.

In the first detailed study of silver chloride photochemistry, published in 1828, Gustav Wetzlar theorized that silver chloride (AgCl) exposed to light would release chlorine and leave behind a basic salt (Ag_2Cl). He called this hypothetical product silver sub-chloride (Pl. 39). The physicist François Arago, who had announced the daguerreotype invention to the joint meeting of the Académies and to the Chamber of Deputies in 1839, provided the first theory of the daguerreotype image that same year, proposing that iodine was vaporized from the sensitized daguerreotype plate by the action of light, thereby revealing a "dormant image". The physicist and microscopist Alfred Donné challenged this theory of a chemical change, suggesting rather that the light produced a physical change in the silver iodide which left it more porous and absorptive during the subsequent mercury vapour development. Donné's suggestion was based on microscopic observation of the freshly developed daguerreotype image particle, which appeared to be fragile and spongy. In England, John Herschel was ready to accept Scheele's view that the process was a simple reduction of silver halide to silver metal, albeit in tiny quantities; this was referred to as the silver hypothesis. In the 1840s, Frederick Hardwich detailed the importance of organic substances—such as collodion, albumen and gelatin—in altering the sensitivity of photographic systems. This critical insight led to many of the improvements that were made in chemical sensitization of silver compounds during the rest of the century.

While the mechanism of latent image formation was subject to debate, the reducing agents (developers) that powered the transformation of latent image grains into silver image particles were being systematically explored and improved.[22] The earliest of these compounds were extracts from oak galls, already familiar as ink and dye components and also used in the lithographic process. Talbot's calotype process

39 Stanislas Ratel and Marie-Charles-Isidore Choiselat, *Portrait of the daguerreotypist Choiselat in his laboratory*, c. 1843–45. Daguerreotype. Musée Carnavalet, Paris. The chemists Choiselat and Ratel supported the sub-chloride theory for the mechanism of latent image formation in two papers published in 1843.

used a mixture of gallic acid and silver nitrate as a physical developer—that is, one that adds silver on to the developing grains from the developer solution. New, more powerful, reducing agents such as iron sulphate and pyrogallol were soon introduced which could do without the additional, and costly, silver in the developer mixture.

The study of organic chemistry as a separate subject had begun earlier in the century, when it was realized that carbon-containing molecules tended to have distinct three-dimensional structures and unique and complex reactions. The often explosive insights gained from this new

chemistry of complex molecules were used by the German dye industry to diversify into a new range of industrial products, including pharmaceuticals and photographic developers. The chemists employed by these commercial industries—a new venue for science at the time—not only created new reducing developers, but also elaborated an integrated theory of photographic development relating the chemistry of silver to the molecular structure of the developers (Pl. 40).

40 Bayer Farbenfabriken of Elberfeld Co., *Advertisement for photographic chemicals*, 1902. Letterpress. National Gallery of Canada, Ottawa. Like Bayer, the Berlin dye manufacturer Actien-Gesellschaft für Anilin-Fabrikation (AGFA) had moved into large-scale production of photographic products by the turn of the century.

The larger debate about the fundamental nature of photographic exposure, the latent image and development continued into the twentieth century, changing as the picture of what happens during chemical reactions invoked smaller and smaller levels of atomic structure. Ronald Gurney and Nevill Mott described latent image formation using quantum physics in 1938. Their explanation refers to events taking place at the level of single electrons, a physical scale that would have seemed unimaginably small to the first generation of photographic chemists.

COLOUR VISION AND THREE-COLOUR PHOTOGRAPHY

The convenient production of colour photographs, even by skilled professional photographers, was not possible until the first years of the twentieth century; only years after that did affordable and easy-to-use colour films become available. But the path to the understanding of colour reproduction, both in theory and in practice, began early in the nineteenth century.

Thomas Young (1773–1829) was a physician, a natural philosopher and an early interpreter of Egyptian hieroglyphs. Remembered chiefly for his new formulation of the wave theory of light (see below, page 69), he also turned his attention to the mechanisms by which the human eye perceives colour.[23] Knowledge of both physiology and physics no doubt helped him to differentiate the perception of colour from its physical basis. Scientists and artists since the time of Newton had been tied to the idea that there were seven primary colours from which all other intermediate hues could be derived, as painters did when they mixed tints on their palettes. In his new theory of colour vision of 1801,[24] Young considered the primary colours of light, not of paint, which cause colour sensation in the eye. In this system, any colour of the spectrum could be perceived by the human eye with the proper mixture of red, green and violet light stimuli.[25] Young postulated three types of colour receptor within the eye, each predominantly sensitive to light of one primary colour. This theory, largely forgotten in subsequent years, was revived and extended in the 1850s by the physiologist and physicist Hermann von Helmholtz.

Physiological optics was also the field where James Clerk Maxwell (1831–79) made his earliest contributions. Later he would formulate the electromagnetic theory of radiation and develop an important description of the behaviour of gases, but in the 1850s and 1860s he built on the Young–Helmholtz three-colour theory by precisely describing the colour sensitivity of the human eye across the visible light spectrum. In the course of this work, Maxwell demonstrated

the colour vision theory to the Royal Institution by means of photography.[26] He had a photographer make three black-and-white collodion negatives of a multi-coloured ribbon, placing a red-, green- or blue-coloured liquid in front of the lens for each exposure. Positive transparencies were then made from the collodion negatives. In the demonstration each image was projected in the colour that had been used to make it (liquid filters of the same colour were used), and the projected images were superimposed. The resulting view was a rather crude approximation of a natural colour rendering of the ribbon. Of course, the narrow colour sensitivity of the collodion plates limited the accuracy of the representation, but Maxwell had clearly outlined a way of photographically reproducing the colours of nature (Pl. 41).[27]

By 1868 Louis Ducos du Hauron had taken out a patent on a method for three-colour photography. His *héliochromie* system used glass filters of green, purplish-blue and reddish-orange to make three negatives; these were printed as carbon print matrices coloured with red, yellow and cyan pigments. The carbon matrices were assembled one on top of the other to produce a full-colour photographic print. Charles Cros independently described a theoretical three-colour system that same year.[28]

These methods were still limited by the fact that silver halide on the photographic plates was very sensitive to blue-violet light and hardly sensitive at all to light of any other wavelength. This meant that blue skies, for example, produced darkly mottled black areas on negatives and blank expanses on positive prints. An orange, however, might well appear as an unmodulated transparent oval hole on the negative and produce a strange dark void on the print.[29]

As was the case for photographic developers, help with this problem came from organic chemistry research in the emerging chemical industries. Starting in 1856, a series of manmade dyes was being created and studied in Germany and elsewhere. One of the organic chemists doing this dye work was Hermann

Wilhelm Vogel (1834–98), who was also well versed in the problems of photographic chemistry. Vogel tried incorporating a series of the new synthetic dyes in photographic emulsions, and tested the plates for sensitivity to light of various colours. He found that corallin, a yellowish-red dye, produced a large increase in a plate's sensitivity not only to yellow light but also, surprisingly, to green light. Similarly, green aniline dye increased photographic sensitivity to red light. He announced his findings in 1873, naming these additives "optical sensitizers".[30] These made possible the production of orthochromatic plates that were more equally sensitive to the various parts of the visible spectrum. The new dyes were also used to produce more selective coloured filters.

41 James Clerk Maxwell, *Ribbon*, 1861. Reconstructed by Ralph M. Evans from the original glass transparencies, 1961 (reconstruction courtesy of *Scientific American*, New York Public Library, New York).

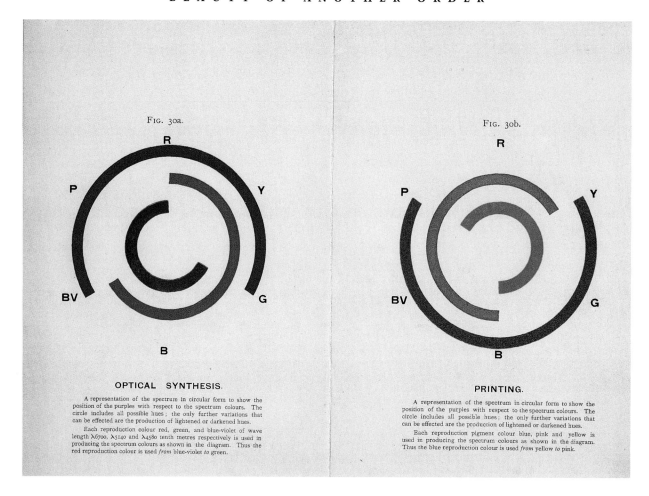

42 Alexander K. Tallent, Figure 30 from *A Handbook of Photography in Colours, section II, tri-colour photography*, Marion and Co., London, 1900. Coloured ink relief print. National Gallery of Canada Library, Ottawa. By 1900 the principles of additive and subtractive colour mixing were firmly established for photographers and printers.

In succeeding years, both du Hauron and Cros brought out newer versions of their subtractive three-colour print processes which took advantage of the new dye filters and orthochromatic emulsions. And a new generation of photographic inventors returned to Young's additive system of mixing coloured light to make colour images. One system, which appeared in the 1890s, involved photographic plates incorporating screens of fine coloured lines or tiny coloured granules acting as microscopic filters, both for making the image in the camera and for viewing it by transmitted light. This type of integrated system of three-colour transparency was most successfully developed and marketed by the Lumière brothers, Auguste and Louis, in their Autochrome process, commercially available by 1907. Three-colour screen plates were used for making colour photographs up to the 1930s, when modern three-colour chromogenic film and print materials started to appear (Pl. 42).[31]

All colour images are now made by three-colour analysis, recording and reproduction: photographic film and electronic detectors record three-colour information; colour photo-

graphic prints and video screens send three-colour stimuli to our eyes. But there is an alternative way of reproducing the colours of nature. To examine the methods that directly record all of the wavelengths of light that arrive at the photographic surface and then re-display them unaltered, such as the Lippmann process, we must first cover a few of the fundamentals of light, which were quite undetermined at the start of the nineteenth century.

THE NATURE OF LIGHT

The undulatory (wave) and corpuscular (particle) theories were alternate ways of understanding the fundamental nature of light. Throughout the nineteenth century, physicists worked to resolve the uncertainty over this question by comparing how well the theories could be used to explain the observed behaviour of light.

At the beginning of the century Thomas Young, mentioned earlier in connection with colour vision, revisited the corpuscular and undulatory theories in the light of experimental observation (Pl. 43). Reflection and refraction (light bending through a different transparent medium) were equally well explained by both theories. Diffraction, the light bending that occurs when a beam hits the edge of a body or a narrow slit, was not explained by either theory. Nor was the interference phenomenon that had recently been described by Young himself.[32] He found that when light coming from two closely spaced pinholes fell on to a reflecting surface, the area of reflected overlap showed alternating bands of dark and light, not the homogeneous light reflection one might expect. He used paper soaked in silver nitrate to record some of these patterns. Young explained these interference fringes by the interaction of two wave trains meeting in phase at some positions where they add together to produce a brighter light, and out of phase at other positions where they cancel one another out and the light is suppressed (Pl. 44).

Young's revival of the wave theory of light proposed that light was a regular series of spreading disturbances in a universally present medium called the ether; and that different colours of light had different wavelengths (or vibrational frequencies). This allowed for a clear explanation of interference phenomena, including Newton's observations of the colours generated in thin transparent films. Some British scientists and patriots resisted this new theory, considering it disrespectful to the memory of Newton (Newton himself did not consider the corpuscular theory entirely satisfactory). Nevertheless, Young's formulation stood and was considerably strengthened by 1818 with Augustin Fresnel's mathematical framework and his wave theory of diffraction. The Young–Fresnel theory differed from the undulatory theory, in that the waves were conceived of as transverse waves, which vibrate at right angles to their path of travel, like ocean waves. This aspect of the new theory allowed for an explanation of polarization, another recently discovered property of light. The transverse wave theory proved robust against its attackers for many years, strengthened by the work of experimentalists such as François Arago and Hippolyte Fizeau.[33]

The debate about light was widened considerably around 1865, when James Clerk Maxwell (whose coloured ribbon demonstration started off three-colour photography) suggested that the Young–Fresnel light waves were actually a kind of electromagnetic radiation. While mathematically investigating the propagation of electric and magnetic fields in space, Maxwell noted the speed of propagation to be the same as the known speed of light; and that the calculated properties of electricity and magnetism were identical to those observed for light—reflection, refraction, diffraction, interference and polarization. He also calculated that electromagnetic waves vibrate at right angles to their direction of travel—as do the Young–Fresnel light waves. All of this led to the inescapable conclusion that light was, in fact, a form of electromagnetic radiation. With Maxwell's equations, the unity of electricity and magnetism (described by Michael Faraday in the field theory of twenty years ear-

lier) now encompassed light as well. The drive to find unifying concepts to describe the observed phenomena of the universe is one that physicists have continued to pursue enthusiastically.

With this background, it is not surprising that when Wilhelm Röntgen recognized the existence of X-rays in the 1890s, debate arose concerning their physical nature. Evidence was put

forward to show that X-rays were particles (like the electrons of cathode rays) and that they were a form of electromagnetic wave (like light)—both equally convincing theories. The question was partly answered by Max von Laue in 1912 when he showed, first with photographs and then by mathematics, that a beam of X-rays hitting a natural crystal produced a diffraction pattern—precisely the kind of behaviour expected

43 Berenice Abbott, *Multiple beams of light*, 1958–60. Gelatin silver print. Photography Collection, Miriam and Ira D. Wallach Division of Art, Prints and Photographs, The New York Public Library, Astor, Lenox and Tilden Foundations. Abbott's image shows light reflecting, transmitting and refracting (bending) as it meets a glass prism; these were the fundamental properties of light known to the natural philosophers of the eighteenth century.

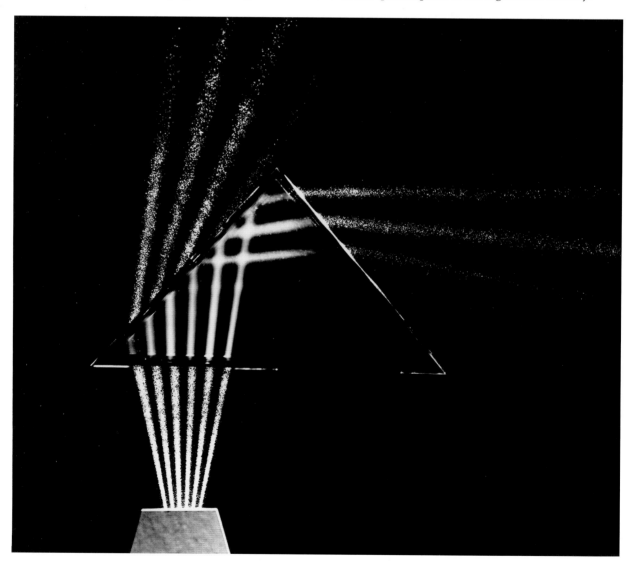

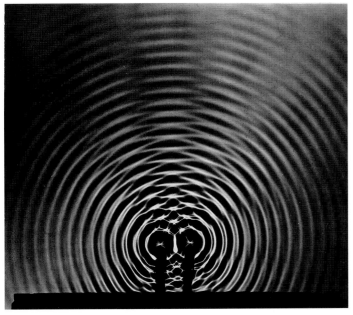

44 Berenice Abbott, *Wave interference pattern*, 1950s. Gelatin silver print. The Metropolitan Museum of Art, New York, gift of Ronald A. Kurtz, 1987. Some 150 years after Thomas Young described light wave interference, Abbott illustrated the phenomenon with a short exposure of two sets of water waves.

diffraction grating. Lawrence Bragg expresses the current view of the use of the words "wave" and "particle":

> To say that we must consider radiation and matter to be waves is too narrow a statement. What we are calculating is probabilities, and it so happens that the wave is a convenient way of treating probabilities mathematically. To ask, "Are they really waves?" is to raise a rather deeper philosophical question.
>
> So the dividing line between the wave or particle nature of matter and radiation is the moment "Now". As this moment steadily advances through time, it coagulates a wavy future into a particle past.[35]

But have these ways of conceptualizing light any more than poetic significance for photography? In at least one instance, the answer is yes. The exploration of light as an electromagnetic phenomenon led to the unique instance of a physicist creating a new kind of photography as a demonstration of theory.

of an electromagnetic wave.[34] Von Laue was awarded the Nobel Prize for physics in 1914 for this work, which led eventually to a method of analysing the shape of large molecules or crystals with repeating forms, such as DNA (see Pl. 75).

Early in the twentieth century, the pendulum seemed about to swing back to a particle-like understanding of radiation, with the idea that energy may be emitted only in strictly limited steps, or quanta. The wave/particle dichotomy was finally made redundant by quantum mechanics, which appreciates the dual wave and particle aspects of energy and matter, and which contents itself with describing the state of things only in probabilistic terms. In confirmation of this dualism, Charles Wilson would make cloud chamber photographs that showed "particles" scattering like a beam of light. In the same vein, electron and neutron particles would diffract from the surface of a crystal, like light from a

DIRECT COLOUR PHOTOGRAPHY

In the three-colour photographic systems described above, various wavelengths of light reaching the photographic plate are recorded as a combination of the three (physiological) primary bands; these combinations can be received independently by the colour receptors of the eye and synthesized into a full colour image by the brain. Another way to approach the problem of photography in natural colours is to ignore all the physiological aspects and to reproduce precisely each of the incoming wavelengths with a set of reconstructed outgoing wavelengths. Such systems can be called direct colour photography. The most successful system for directly recording all of the colour wavelengths of the spectrum is based on the interference of light waves.

Directly recorded colours of this kind are said to have appeared on the bitumen-covered pewter plates used by Nicéphore Niépce in his heliograph process of the 1820s. Niépce referred to

71

45 Edmond Becquerel, *Photograph of the solar spectrum, obtained by direct colour reproduction*, 1848. Becquerel colour process plate. Musée des arts et métiers–CNAM, Paris. Edmond Becquerel, father of Henri, was an important contributor to the theory and practice of direct colour photography. This plate, probably the oldest colour photograph in existence, has been carefully preserved away from light exposure, which would have obliterated its colours.

Newton's rings, the coloured rings resulting from light wave interference in thin films, to explain the colours on his plates.[36] As early as 1848, Edmond Becquerel (1820–91), father of Henri, actually produced direct colour photographs using a silvered metal plate treated with a complex series of halide sensitizing steps. The Becquerel *photochromie* process could not be fixed, and the images darkened and disappeared on further exposure to light (Pl. 45).[37] An American clergyman, Levi Hill, reported in 1850 that he had made—and fixed—daguerreotypes with natural colour images.[38] In 1868 Wilhelm Zenker advanced the theory that for photographs like Becquerel's, made on a mirror-like substrate, the source of the directly recorded colours are interference patterns produced by stationary light waves.[39] For an 1889 study regarding the behaviour of polarized light in the ether, Otto Wiener actually produced a photograph whose emulsion contained layers of alternately exposed and unexposed silver caused by stationary light waves.[40]

Stationary waves form as a result of interference. When two waves having the same amplitude and wavelength and travelling in opposite directions meet one another, a new resultant wave pattern is established that does not travel. At evenly spaced points (nodes) along the resultant wave there is no oscillation; here, the two component waves are constantly cancelling each other. Between nodes, the stationary wave oscillates from top to bottom through zero; the maxima here represent the added amplitudes of both component waves. Ocean waves and sound waves were known to be able to form these stationary (or standing) waves.

A completely workable means of making colour photographs was discovered in the course of examining the question of whether light could form stationary waves. Gabriel Lippmann (1845–1921), professor of experimental physics at the Sorbonne, announced this process, *photographie interférentielle*, in 1891.[41] The photographs are thin glass plates, often with a heavy low-angle glass prism mounted on the front surface. Like daguerreotypes, they are best examined by picking up the plate and turning it back and forth under a light source to find the best viewing angle. At first glance, the image is muddied and has a dull khaki monochrome tone; but under the right conditions a brilliant, high-resolution image with remarkable natural colour rendering appears. Some pure colours are rendered with a surprisingly high intensity; neutral colours may appear more restrained and underplayed, reminiscent of the whites on an Autochrome plate (Pl. 46).

The Lippmann plate holds a very fine-grained, transparent, silver halide emulsion which has been treated with sensitizing dyes to make its spectral sensitivity as uniform as possible.[42] To make an exposure, the plate is mounted in a special plate holder, emulsion facing away from the camera lens. The holder provides a reservoir into which mercury can be poured to form a reflective surface in direct contact with the emulsion. During exposure, the light rays are not only transmitted through the transparent emulsion,

but are reflected straight back by the mercury. This sets up a stationary light wave inside the emulsion, whose wavelength will be precisely related to that of the incident light.

Consider how this happens. In a normal photographic exposure, a travelling wave of green light, for example, will be absorbed by the silver halide particles throughout the thickness of the emulsion until its energy is completely gone. This will result in a conventional black-and-white negative where the density (blackness) is proportional to the amplitude (brightness) of the incoming light but has little relation to its wavelength (colour). In the Lippmann process, the

introduction of a mercury reflector behind the emulsion causes the incoming wave to be reflected back through the emulsion along the same pathway, its phase shifted by a distance equal to one half wavelength.[43] These two travelling waves meeting in the same path will set up a stationary light wave inside the emulsion; silver halide grains will be exposed only at regularly spaced intervals through the emulsion thickness. These exposed points correspond to the positions where there is constructive interference in the stationary wave. Between these are the nodes of the stationary wave, where the incoming and reflected waves have cancelled each other by destructive interference. At these positions, no light will be absorbed by the silver halide and the emulsion will remain clear after developing. The distance between the laminae of developed silver will be exactly half the wavelength of green light.

Now what happens when we look at this layered photographic image? The white light we use to look at photographs contains a mixture of all the wavelengths of visible light. Black-and-white photographs reflect or absorb this light without altering the relative proportions of the different wavelengths of light in the mixture. In the Lippmann plate, however, the evenly spaced grid of silver layers act as a diffraction grating, amplifying the wavelength of light that was recorded during exposure, and suppressing all other wavelengths. In the case of the green light exposure, the viewer will see only green light, the other wavelengths in the white light illumination having collided with, and been absorbed by, the layers of silver laid down through the thickness of the emulsion. In effect, the original light source has been reconstructed by the three-dimensional network of silver layers set up by the interference pattern. In the language of optics, the viewing part of the process is achieved by light diffraction from a volume grating.[44] The same thing will happen when any other pure spectral colour is used to expose the plate. The first colour photographs made by Lippmann and his colleagues were spectrograms,

46 Pierre Lambert, *Faverol, Normandy*, 1914. Light interference photograph, Lippmann process. Private collection. Lambert was a colleague of Lippmann in the physics department of the Faculté des sciences. He undoubtedly learned the techniques of interference photography directly from the inventor.

47 Hermann Krone, *Interference colour spectra*, 1892. Lippmann process. Deutsches Museum, Munich. These spectrograms record the analysis of sunlight and electric arc light.

the gradated sequences of monochromatic colours produced by instruments called spectrographs (Pl. 47).

The colours reflected from objects in the real world, however, are of course not pure spectral ones of monochromatic wavelength. Reproducing the compound colours of nature, those that are made up of infinitely variable mixtures of all of the colours of the spectrum, should be a much more complicated task. As it happened, making natural colour pictorial photographs with a conventional camera lens turned out to be almost as successful as making spectrograms with a slit spectrograph. Lippmann compared the rendering of complex natural colours by interference photography to the reproduction of complex natural sounds by Edison's new phonograph recordings.[45] He used the branch of mathematics called Fourier analysis to create a theoretical model explaining how the silver layers could allow

more than one wavelength of light to be recorded, or resolved, at the same time.[46] (Fourier analysis allows a complex periodic physical event—like the variation in air pressure caused by a musical instrument held on a single note—to be resolved into a series of simple wave forms.)

Word of Lippmann's invention was greeted in the photographic world with initial scepticism, if not outright scorn.[47] By the 1890s photographers and photographic journalists were inured to the almost monthly reports of new and worthy colour photographic inventions, which failed to live up to their hyperbolic advance publicity. As a matter of fact, interference colour photography, although it proved to be of great interest to physics, never became a commercial success. The reasons for this include its relatively slow speed, the requirement for special camera equipment, and the fact that it produced

unique images which could not be copied and had to be viewed under well controlled conditions—all complaints similar to those levelled at the daguerreotype process in the 1850s. In addition, faster and more convenient three-colour photographic systems began to appear in more workable versions at the same time as Lippmann's process emerged.

Physicists, on the other hand, remained enthusiastic about interference photography.[48] Here was a solution to the technical and commercial problem of colour photography, which was based on an elegant demonstration of purely physical principles bolstered by advanced mathematical interpretation—no untidy physiology or chemistry required! The 1908 Nobel Prize for physics was awarded to Lippmann for interference colour photography. His was the only name cited, despite persistent debate as to whether the work of the Germans Zenker and Wiener merited equal credit. To add to the controversy, this was the same year that Max Planck was first considered for the physics prize for his formulation of quantum theory. In writing about the awarding of the prize to Lippmann, Pierre Connes concludes, "that the Swedish Academy [was] overwhelmed by that potent brew of dazzling colours and double integrals", referring to the mathematical formulation that Lippmann used to explain his process.[49]

Interference photography is closely connected with the production of reflection holograms, familiar to most people as the small iridescent images set on to credit cards but also increasingly used by artists and by commercial photographers. Starting in the early 1960s, Yuri Denysiuk, the pioneer of reflection holography, used Lippmann's technique of recording interference fringes through the depth of a photographic emulsion to record three-dimensional images.[50] The term "Lippmann holography" is in current use to specify colour reflection holograms.[51]

Photography has made great contributions to science in the areas of biology, astronomy, medicine and the study of motion. But the inter-relations of photography in science are broader than the production of images. In the eighteenth and nineteenth centuries, the study of light-sensitive systems led to critical discoveries in physics, chemistry and physiology. As we move into a post-photographic world where all kinds of radiation are detected by charge-coupled devices rather than by light-sensitive silver salts, we can confidently expect many new illuminations.

CHAPTER

4

The Search for Pattern

ANN THOMAS

OBSERVING the world with rigour and curiosity is an act both of art and of science. Artists scrutinize the world around them for its beauty, its contradictions, and its signs of human experience. Their truths and perceptions are formulated quite differently from those of scientists. Often inspired by visual experience, artists create new phenomena and objects such as photography and film, along with other forms of visual expression that appeal strongly to our senses. While a universal understanding can be arrived at, the artist is not driven by the desire to present the universe in logical, measurable terms. Scientists, on the other hand, aim to alter our collective understanding of the world by describing it in terms of universal natural laws and physical principles. They attempt to do this by adding new insights and information to an existing body of knowledge. For scientists, careful and systematic observation of phenomena is the first step in a process of revealing and understanding the patterns through which the workings of nature may be understood. In this context, the photographic image becomes the permanent record of the act of observation, its explanatory power not automatically guaranteed but predicated to a greater or lesser degree upon the specific circumstances of its making.

THE ART–SCIENCE OF PHOTOGRAPHY: "A PERFECT AND UNERRING RECORD"

The element common to both art and science— careful observation of the visual facts of the world—is an important one, particularly for the medium of photography. A creation of both science and art, photography owes its physical existence to the research of the chemists, opticians and philosophers of light of the eighteenth and nineteenth centuries. The incentive for this research was provided partly by the artist–entrepeneurs who earned their living by offering visual images and spectacles to a public that delighted in seeing its world pictured, whether in splendour, with irony, or with understanding and explanation. Nineteenth-century photographs can thus be said to occupy a category of their own, and can best be evaluated in terms of criteria borrowed partly from science and partly from art. Mid nineteenth-century French critic Francis Wey (1812–82), while puzzling over whether photography was an art or a science, decided that "It was a kind of hyphen between the two."[1] In fact, "art–science" was the term used by the nineteenth-century astronomer Thomas W. Burr to describe the photographic recording of magnetic and meteorological data in 1865, when he wrote: "Among the numerous applications of the beautiful art–science of photography, there is probably not one that can compare in utility with the automatic registra-

tion of natural phenomena, by which a perfect and unerring record is obtained."[2] It was this element of the photographic image—the result of a relatively long history of scientific research into light-sensitive materials, the physics of light and the optics of camera lenses—that captured the imagination of artist and scientist alike. Photography offered a mirror-like representation of the world, which did not contradict but rather enhanced prevailing conventions of naturalism in Western art. The quest to know the precise position of a horse's hooves when at the gallop, for example, became part of a larger photographic project in the last quarter of the nineteenth century which was concerned with

the physiology and movement of humans and animals, but which was initially motivated by the desire to make a more realistic image of the horse in motion.

So, with a foot in both camps, photography seemed to be the ideal medium for making a permanent record of scientific observations and specimens. When coupled with the microscope, it went below the surface to answer the question, "What does it really look like, underneath?"

Unlike photographs made in the study of physiology or astronomy in the nineteenth century, or of physics in the twentieth century, which were of incontestable importance to the

48 Louis Jacques Mandé Daguerre, *Arrangement of Fossil Shells*, 1837–39. Daguerreotype. Musée des arts et métiers–CNAM, Paris.

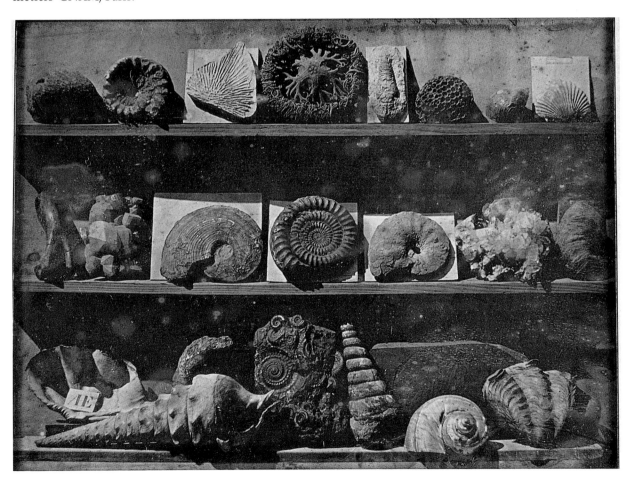

49 William Henry Fox Talbot, *Moth Wing (negative and positive)*, 1839–41. Calotype and salted paper print. National Museum of Photography, Film and Television, Bradford.

advancement of knowledge in these fields, nineteenth-century photographs and photomicrographs in the fields of biology, botany, zoology, paleontology, geology and meteorology, were for the most part important confirmations of knowledge that already existed. Made directly from nature or from specimens, using the camera, the microscope and simple contact with sensitized photographic paper, they satisfied an artistic and scientific need to have precise records of a particular species of plant, mammal, shell or organism. At the same time, they met the artistic need for beauty. They were also made in order to behold the exotic and the rare.

The choice of a fossil collection by Louis Jacques Mandé Daguerre (1787–1851) as subject matter for one of his first successful daguerreotypes was an indication that photography could in the future serve scientific needs in an exact and beautiful way (Pl. 48). William Henry Fox Talbot (1870–77) also used botany and fossil specimens as the subject of some of his earliest photogenic drawings (Pl. 49; see also Pl. 18). Before the medium could meet the exacting needs of the scientific community, however, it needed to mature technically, to reach a point where the image produced was not only a convincing representation of the object, but also a permanent, repeatable and easily legible record.

As mentioned earlier, the property most often identified with photography is its ability to render minute detail with precision. When examined in relation to specific scientific purposes, or seen relative to the properties of different photographic processes, this aspect of the photographic image has not always lived up to its reputation. While the daguerreotype produced a sharp and clear image, one that would have satisfied the needs of scientists, it could not be replicated, other than by copying (which provided a crude degree of resolution), by engraving the daguerreotype plate itself, or by making tracings and drawings from the daguerreotype image. The salted paper print made from a paper negative had the advantage of being reproducible, but lacked sufficiently high resolution of detail and did not produce a sufficiently wide range of tones. As glass plate negatives and collodion emulsions replaced earlier processes in the 1860s, and as photogravure, photolithography and half-tone printing became more sophisticated in the 1870s and 1880s, images began to

have the potential for a much broader dissemination. This changed the perception of photography's usefulness as a means of preserving rare or unique artefacts and specimens.

THE PHOTOGRAPH AS SPECIMEN: "BEAUTIFUL DETAILS"

In spite of technical limitations, by 1853—fourteen years after the announcement of the discovery of the daguerreotype process, and almost as long after the popularization of the photographic process on paper, the salted paper print—it was internationally recognized that photography had an important role to play in the context of natural history and ethnographic collections. Museums of art, natural history and ethnography had sprung up in Europe and North America in the nineteenth century with unprecedented rapidity. The importance of maintaining visual records of works of art and artefacts, including fossil specimens, vertebrate specimens and insects, was quickly understood by these institutions, as were the multiple purposes to which photographs of specimens and artefacts could be put. Not only could they provide an accurate and accessible visual catalogue of collections, but they could be publicly disseminated in the form of single prints, portfolios and albums.

Zoologie photographique, ou représentation des animaux rares des collections du Muséum d'histoire naturelle (published by Masson in Paris and Gambert in London) was the first attempt to publish by instalments a collection of photographs of zoological specimens. Beginning in 1853, its slow and uncertain realization also bears witness to the growing pains of the medium at that time. Those responsible for initiating the publication were Louis Pierre Rousseau (1811–74), a technician and assistant naturalist in the zoology department of the Paris museum, and Achille-Jacques-Jean-Marie Devéria (1800–57), an artist and curator attached to the department of prints and drawings at the Bibliothèque Nationale in Paris. They proposed to publish, with the help of the brothers Louis-Auguste (1814–76) and Auguste-Rosalie Bisson (1826–1900), who were in partnership from 1840 to 1864, ten fascicules of six plates each (Pl. 50).

In the spring of 1853 they presented to the Académie des sciences zoological photographs of parts of animal skeletons and of whole specimens representing all the principal categories of the animal kingdom.[3] Equal in impact to some of the photographs prepared for this publication was the sophisticated level of commentary on them from the members of the committee formed to appraise the work and its usefulness to the discipline of natural history. Composed of the naturalists and scientist–photographers Isidore Geoffroy, Henri Milne Edwards (1800–85), Henri-Victor Regnault (1810–78) and Achille Valenciennes (1794–1865),[4] the committee reported its findings on 6 June of that year.[5] They mentioned in the report that even though the photographic process used was nothing new, the results were sure to be of lively interest to zoologists. The "new art" of photography was seen to be capable of providing the natural sciences with a service much greater than that provided before by drawing and engraving—because, it was concluded, a zoologist must always pay attention to the multitude of details on a given specimen, and the artist's way of describing detail was to draw it in an exaggerated manner as if seen through a magnifying glass (which it probably was). It was generally understood by scientists that this resulted in a misrepresentation of the object. Consequently two kinds of drawing of a specimen were required: one of the whole specimen without enlargement of any particular feature, and one that enlarged certain characteristic parts. This, it was thought, was where the photograph could be efficient and provide both experiences in one image. A good-quality photographic image would give the overall view and, with a magnifying glass, the minute details could also be scrutinized. Two hand-drawn images could thus be replaced by one photograph. This was particularly useful for examining an object like a branch of coral with a very complex structure,

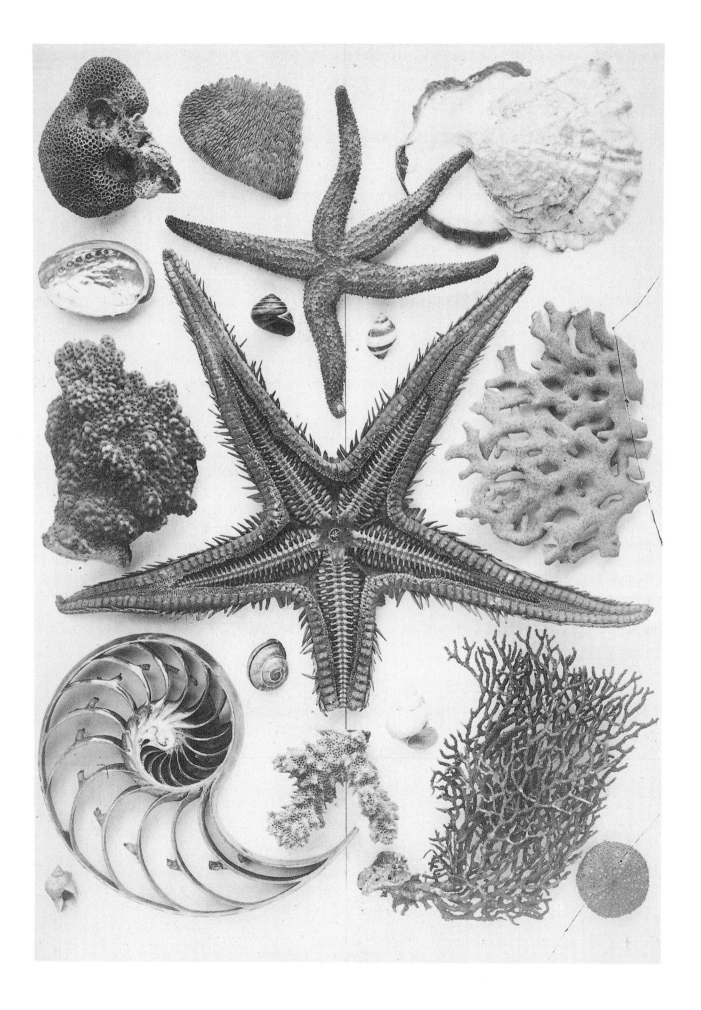

particularly one reproduced smaller than natural size. Examined with a magnifying glass, the details of the object would be made visible in the photograph, allowing all the tiny branches to be counted and the characteristic structures of each branch to be indentified. The most talented draughtsman, it was agreed, would have neither the patience nor the dexterity necessary to reproduce all these details faithfully. Not only could photography now provide this, but also at a low price.

A perhaps even more cogent point made by the committee was the way in which photography could present information in a fresh and unbiased manner, challenging the scientists' subjectivity and prior assumptions about a specimen. Acknowledging the unresolved technical problems still existed, such as the instability of the photographic print, the committee nevertheless put its full support behind the project. In addition, it recognized that, although photography was cheaper than hiring a draughtsman, there were nevertheless significant costs involved, and proposed that the Academy give financial help at some point. In December 1853, upon presentation of a sufficient number of successful prints, the Académie des sciences in Paris voted to grant Rousseau and Devéria 2,000 francs to defray the cost of the production of prints;[6] out of concern for the permanence of the image, these were eventually made by the photomechanical process of Niépce de Saint-Victor. Buoyed by the support he had received from the scientific community, in October 1853 Louis Rousseau requested that a skylight be put in the roof of the museum administration building so that a photography studio could be installed.[7]

Following the establishment of this photography studio, the Trustees of the British Museum in London approved the creation of a similar one. Roger Fenton (1819–69)—whose photographs of landscapes, the cathedrals of Great Britain and the Crimean War form a central part of the history of nineteenth-century British photography—was hired to photograph zoology specimens. He began in 1854, worked under contract for four months and then, after an absence of almost two years, returned to this work, including the photographic copying of prints, drawings, more natural history objects and also sculptures from the Department of Antiquities. Photographs showing the comparative skeletal structure of a human figure and that of a chimpanzee date from this period.[8]

In the mid nineteenth century, the single photograph of a specimen functioned as an extension of the specimen itself—the word derives from the Latin *specere*, meaning to look or look at. It was pored over, collected, identified, copied from, presented at scientific meetings and lauded for confirming a species or bringing a rare fruit to the attention of a group of *savants*. It is not surprising that in the first few years of photography, even the photographic image itself was used as a specimen of scientific research and presented as a rarity to be examined and speculated upon for its technical history.[9] Reliance on the magnifying glass to enhance the legibility of detail in the photographic print continued as late as the mid 1860s. The physiologist Lionel S. Beale (1828–1906) published a composite albumen silver print of photomicrographic images in 1865 as a tipped-in frontispiece to his book on the microscope. This print––displaying the magnification of various objects from the cross-section of a hydrangea stem to a parasite on a field mouse—was described as if it were an arrangement of actual specimens. "A lens of low magnifying power", he wrote, had been "appended to the volume, to enable the reader to see the beautiful microscopic details . . ."[10] American scientific illustrator Anna Comstock (1854–1930) made engravings of natural history subjects by copying from photographs—working, as it was noted, "directly from the specimen or from a photograph on the block . . ." She seemed

50 Bisson frères, *Mollusks and zoophytes*, 1853. Salted paper print. Bibliothèque Centrale du Muséum National d'Histoire Naturelle, Paris.

51 Ernest Benecke, *Autopsy of the first Crocodile on Board, Upper Egypt*, 1852. Salted paper print from paper negative. Gilman Paper Company Collection, New York.

to have considered "the specimen and its photograph as equivalent".[11]

When photographers were charged with the task of reproducing both commonplace and fantastic specimens, they attempted to bring the objects back to life with as much fidelity to detail and convincing modelling of form as possible. They wished the photograph to become a specimen on its own, whose exoticism would inspire wonder and, above all, be seductive to the eye. Where did truth to nature fit in to all of this? The act of photographing the specimen divorced from its natural context—in a studio, with a neutral setting and no indication of scale—led in itself to a startling transformation of the object. Thus was truth to nature somewhat compromised from the beginning. The decontextualization of the object was, however, handsomely compensated for by the powerful, almost tangible sense of presence with which it was endowed by photography's capture of precise detail and rich contrasts of light and shadow, particularly when made by the albumen silver and woodburytype processes.

ZOOLOGY AND PALEONTOLOGY: "CURIOUS IMPRESSIONS"

Mid nineteenth-century photographs showing animals within their habitat are rare. The rich salted paper print made by Ernst Benecke showing the autopsy of a crocodile (Pl. 51) is a candid view of an encounter between a traveller and what, for him, would have been an exotic species. It is possible that this is an early example of zoological fieldwork but since there is little evidence to show that the animal was to be treated either as a specimen or as a trophy, any suggestion of the level of interest would be purely speculative.

The photographers' dependence on specimens rather than fieldwork was influenced by two factors: the availability of the animal, and the inability of the camera to capture movement in anything but fugitive blurs. The latter was most significant, since the range of animal species available in zoos was too limited to reflect the interests of zoologists. Despite the introduction of the collodion plate and simple shutter mechanisms, animals in motion could not be photographed instantaneously until the late 1870s and early 1880s, when pioneers in animal motion made this feasible—Ottomar Anschütz (1846–1907; see Pl. 108), and also Etienne-Jules Marey (1830–1904) and Eadweard Muybridge (1830–1904).

Within the smaller associations of scientists and photographers—whose mandates embraced both theory and practice and thus shifted into each other's terrains with admirable adaptability—scientific papers were presented at meetings of the photographers' associations, and photographs were sometimes the *prima facie* evidence at the scientists' gatherings. Louis Rousseau and the zoologist for whom he worked, Achille Valenciennes, presented images and findings together to the Académie des sciences on more than one occasion. In July 1855 they addressed this prestigious group on the issue of the application of photography to science—as proof of this fertile match, they produced four photographs made from collodion

negatives which, since they were competently made, provided a wealth of detail. Two of the photographs showed specimen fossils of a polyp and a sponge, while the other two showed the teeth of young lions, one six months old and the other fifteen months. The characteristics considered most impressive about these images were their approximation to the actual size of the specimens and also their vivid presence, a "brilliancy and whiteness" that was "above all worthy of notice". Palaeontologist Richard Owen (1804–92), who assisted at the presentation, observed that he had never before witnessed such "perfect representation of anatomical subjects".[12] Along with these photographs of anatomical parts, Rousseau exhibited a salted paper print of a coral specimen, *Stylaster flabelliformis*, at the Exposition Universelle of 1855 (Pl. 52). While there is nothing in the photograph to indicate the scale of this specimen, which was propped up on a table for the taking of the photograph, its intricate textural details are shown to their greatest advantage against a plain background. This image, along with the others, was so strong that it inspired the critic Ernest Lacan to note that, on this occasion—unlike the 1851 Great International Exhibition in London, where the report of the jury criticized the absence of photographs of scientific subjects—photography had entered boldly into the domain of science and produced images of great richness.

Rousseau and Philippe Jacques Potteau (1807–76) were two of the most prolific and accomplished specialists in the photography of natural history and ethnographic subjects. Unlike many other photographers of this period, they dedicated their careers to scientific subject matter. When Rousseau was no longer able to continue with his ethnographic documentation around 1860 because of failing stamina, he was succeeded by Potteau, a helper in the zoology laboratory at the Muséum d'histoire naturelle and from 1847 a technician there.

Shells possess a varied geometry of spirals, radiating lines and surface patterns which

52 Louis Rousseau, *Coral Stylaster Flabelliformis*, 1855. Salted paper print. Institut d'Ethnologie du Musée de l'Homme, Paris.

has attracted the attention of both naturalists, interested in the development of growth and its relationship to form, and mathematicians, fascinated by the mathematical progressions reflected in the growth patterns and in the geometrical ordering of their structures. *Fossilized Shells*, Plate IV from *Carte géologique détaillée de la France*, a woodburytype, is a rare example of the work of Charles Marville (1816–79?) in the domain of natural history subjects; he was far better known for his architectural views of pre-Hausmann Paris. The woodburytype process has been used to full advantage in the reproduction of these shells, giving them a richness of tone and volume of form that certainly made for a satisfying account of detail, even if the representative coloration is lacking (Pl. 53). The layout of the shells that we see here is typical of conchology illustrations prior to photography.

Scientific curiosity was not stimulated only

53 Charles Marville, *Fossilized Shells (Bassin parisien, terrains tertiares [Eocène], Etage des sables de Beauchamp)*, 1873, Plate IV from *Carte Géologique Détaillée de la France, séries Paléontologiques*. Woodburytype. Jay McDonald, Santa Monica.

54 James Deane, *Tracks of Insects or Small Crustaceans*, Plate 40 from *Ichnographs from the Sandstone of Connecticut River*, Little, Brown, Boston, 1861. Salted paper print. The Metropolitan Museum of Art, New York, Horace W. Goldsmith Foundation Gift, 1990.

55 Aimé Civiale, *Circular panorama taken from Bella Tolla (3030 metres)*, 1866. Collotypes, printed by Jean Dominique Gustave Aroca, 1882 or earlier. Bibliothèque centrale du Muséum National d'Histoire Naturelle, Paris.

by the exotic, however; the most ardent scientific pursuits have proceeded from finds that were local and, in one case, literally underfoot. Dr. James Deane (1801–58) of the village of Greenfield, Massachusetts, had his natural interest in geology especially piqued in the winter of 1835 by the "curious impressions" to be seen upon the slabs of stratified sandstone brought from the nearby stone quarry at Turner's Falls to be used for building sidewalks. Apparently many of the townsfolk also saw the impressions as bird tracks, but Deane recognized them as important fossils, and followed through by making drawings and photographs of them, as well as researching and disseminating information about them. In the publication of his work, *Ichnographs from the Sandstone of Connecticut River* (1861), put together posthumously by his friends, original albumen silver prints were tipped in and accompanied by drawings (Pl. 54).[13] His photographs were considered "such exquisite specimens of art, such contributions to science . . . they should be saved from oblivion":

> We believe . . . that these copies, rivalling as they do the actual specimens, will be really useful to those pursuing similar scientific investigations; they will also at least furnish a

beautiful table-book, to excite an interest in the community in the marvels of nature.[14]

The significance of fossil footprints on new sandstone in Massachusetts was one of the earliest subjects discussed by American geologists. In 1845, Edward Hitchcock (1793–1864) related them to 39 different animal species, including 32 of birds. John Collins Warren (1778–1856), a medical doctor immortalized in two daguerreotype portraits, used a salted paper print as a frontispiece to his 1854 book, *Remarks on Some Fossil Impressions in the Sandstone Rocks of Connecticut River*.

GEOLOGY AND METEOROLOGY:
"NATURE CAUGHT SHARP"

Single specimen photographs, which mirrored examples of the exotic, mundane, newly discovered, morbid and grotesque, usually did so using every descriptive property within the power of the medium—high resolution, neutral backgrounds and regulated studio lighting which would flatter and enhance the forms as fully as possible. But there were exceptions to the conventional exploitation of the medium's ability to capture detail: photographers attempting to demonstrate the structure and pattern of an object or form did so with whatever means the

86

process offered, experimenting unabashedly with its boundaries. The problems encountered by Aimé Civiale (1821–93) and Charles Piazzi Smyth (1819–1900)—respectively, how to represent the geographical and geological features of the Alps, and how to capture cloud formations for meteorological purposes—required visual solutions for which the photographic process was well suited, but for which the single representative photograph was inadequate.

Theories about the age of the earth, beginning in the 1820s, had raised questions about the Alps, a site of vast geological crumpling that gave rise to various speculations by Catastrophists. Aimé Civiale's panoramic and detailed photographs of the Alps, extremely unusual for the time from both technical and aesthetic standpoints, were thus highly topical.[15] They take their essential form from an established tradition in painting and drawing in which the representation of a 360° region is described by the juxtaposition of horizontal sections. Sometimes composed of as many as 14 sections, Civiale's panoramas pushed this pictorial extension of space to an even more complex geometry (Pl. 55).

Civiale produced two bodies of work on the Western Alps: individual views of selected details and the panoramas. The details were taken from the environs of different stations, which indicated the direction and the angle of incline of the layers of terrain, the structure of rocks, and the forms and slopes of glaciers. They were, in his opinion, "the indispensable complement of the panorama from the geological point of view". He summed up his production from 1859 to 1866 as being composed of 55 views of details and 28 huge panoramas taken in the Tyrol, Switzerland and part of the Savoy.

In 1866 he showed three panoramas to an assembled group of photographers and scientists at the Société française de photographie; all were from the area in the Western Alps known as the Pennines, and they represented ranges between Mont Blanc and Mont Rose, two of the highest peaks in the Alps. They were made, he stated, for the purposes of geology and geography. His working method was to show a considerable area of the mountainous terrain in a way that would give not only a view of part of the mountain chain, but also show how each mountain mass compared with the others around it. In order to do this, he chose a number of summit stations at points with an average altitude of 3,000 metres, considerably lower than the summits of Mont Blanc and Mont Rose. The stations were located at distances determined by the point at which arcs drawn from the summits of the mountains intersected or juxtaposed one another. Civiale did not, as one might have expected, conceive of these panoramas as two-dimensional documents that mapped the terrain and could be laid out and examined for patterns, but three-dimensionally.

Civiale's visualization scheme shares its geometric ordering with the theories of Elie de Beaumont (1798–1874) concerning the geomorphology of the Alps. Because the Alps showed evidence of considerable plate upheaval and were thought to have been the site of earlier widespread glaciation, de Beaumont, over a period of some twenty years from 1829 to 1852, evolved a theory that included from four to 22 upheavals in which he detected geometric ordering.[16]

He proposed that the mountains of Europe could be represented as tangents of 22 circles, of which the 15 largest formed a complicated "pentagonal network". In his 1860 address to the Académie des sciences, Civiale cited Elie de Beaumont and Regnault (presumably Victor Regnault) as having drawn his attention to these theories and instructed him in the geomorphology of the Alps.[17] In 1882 he made mention of having submitted plans for his third trip to de Beaumont, who "guided and encouraged" him.

Civiale's plan to make each full panorama a polygon with at least 14 planes was based on a realistic assessment of what he could accomplish in a full day's work, with the delimiting factor being available sunlight. Ideally, he felt that the more planes one could describe the better, since the greater the number of sides, the closer the approximation would be to the actual circumference of the area, and a more accurate representation of nature.

Civiale's panoramas and detailed views were appreciated at the time both for their systematic attempt to reproduce naturalistically the structures of physical geography and geology, and for their sheer visual grandeur. Large groups of the detailed views and circular panoramas (on one occasion there were 15) were included in exhibitions held by the Société française de photographie in Paris over a ten-year period from 1859 to1869.

For eyes that were already sensitized by the richly detailed and uniform surfaces of the daguerreotype and the albumen print made from collodion glass plate negatives, these prints by

Civiale must have appeared rough and generalized. And if we are to take Civiale's word for it, they were made so by design. The identification of structure and patterns required conditions of simplification, and Civiale judged the waxed paper negative process superior for this purpose. According to him, it would "render with precision the various planes and fine detail without hardness, and with a moderate exposure time."[18] In order not to be severely slowed down by the relative slowness of the paper negative as opposed to the collodion glass plate, Civiale experimented with the process, attempting to improve its sensitivity; glass plates, with their weight and fragility, were ruled out in the circumstances of long and arduous climbs to and from the summit stations.

Although Civiale's gigantic images may have played a role in making manifest the appearance of the geological folding of this region, what revolutionized the dating of geological strata in the nineteenth century was, ironically, a process that produced far smaller images from minute samples. Although initially it was considered "absurd to study the structure of a mountain through a microscope", the technique of examining thin sections of rock under the petrological microscope was considered one of the major developments in advancing the science of geology in the nineteenth century.[19]

As solid and immutable, relative to human time, as was Civiale's mammoth subject of the Alps, Charles Piazzi Smyth's equally large-scale subject was ephemeral. The title of his three volumes of albums of enlarged photographic prints (housed in the Royal Society, London) hints, with a touch of melancholia, at its fugitiveness: "Clouds that have been at Clova, Ripon". In his handwritten introduction to the first volume, dated 1892–93, he expresses the challenge of his elusive subject in practical terms:

No graphical representation of the clouds, always more or less in wind-motion, and organic change of shape, can be trusted to have caught Nature sharply in the act of marshalling her

hosts of atomic agents, unless the whole picture can be begun, perfected, and finished, with remarkable definition . . . over every part of its surface, in something less than the tenth part of a second.[20]

Piazzi Smyth's interest in recording meteorological data and clouds predates the albums by over twenty years. It is part of a longer history and larger context of study of atmospheric and meteorological phenomena, in which he employed and produced spectrographs and rainbands. In the mid 1870s he made $2\frac{1}{4} \times 4\frac{1}{4}$-inch plates upon which he recorded stereo views of clouds; he also made lantern slides for projection with oxy-hydrogen light. His wife Jessie (née Duncan, 1815–96) shared his scientific interests; as well as being a knowledgeable geologist, from 1876 to 1886 she kept daily records of temperature, pressure, humidity, wind, clouds, the strength of rainfalls and the spectrum of the sky. Convinced that meteorology was a science and should be considered as such, Piazzi Smyth suggested that those who doubted its scientific veracity should read Sir John Herschel (1792–1871), "that most transcendental and classic scientist" on meteorology in the *Encyclopaedia Brittanica*. Piazzi Smyth had known Herschel from his youth and clearly regarded him as a mentor. When he was in South Africa, and Herschel had returned to England, he received information from him regarding the invention of photography and also some of the supplies he needed in order to practise this new art.[21] From that time on, the camera was an essential tool for Piazzi Smyth, who used it on his travels and at home.[22]

It would be easy to categorize Piazzi Smyth's cloud photographs as meteorological in intent and leave it at that; it was, after all, his stated purpose and he was trained in science. He was, however, something of a free spirit who, on occasion, proposed outlandish theories that earned him the disapproval of his fellow scientists. He had started his career in 1834, at the young age of 16, as an apprentice astronomer at

the Observatory of the Cape of Good Hope, recommended by Sir John Herschel. He became Astronomer Royal in Edinburgh, where he was in charge of telling the time and observing the skies from 1846 to 1888. His interests ranged from seismology and astronomy to spectroscopy, and from meteorology to metrology. An indefatigable traveller, he and his wife Jessie were in Tenerife in 1856 and in Russia in 1859. From the time of his return to England from South Africa in 1846, he travelled regularly in Europe.

In 1891, after retirement to Ripon in North Yorkshire, he picked up his "cloud camera" once again; it was elevated slightly by being positioned in a garret window in his "dear wife's" little geological museum. Happy to be out of the smog-filled atmosphere of Edinburgh, he introduced improvements such as a new lens and once again turned his sight to the heavens. Using a specially designed viewfinder, he could gaze upwards, select his subject, gaze immediately downwards into the viewfinder and trigger the shutter, which was designed for maximum speed.[23] In his words, this plan

> allowed of every view being very closely scrutinized, even during the never ceasing and often very rapid movements and changes of . . . clouds, whether from wind or molecular variations—up to the final ecstatic instant for a squeezing touch being applied to the said trigger, and securing thereby that one view out of almost an infinite number of possible ones.[24]

The photographs in the album, approximately 8 inches square, are enlargements from much smaller negatives and hence without much detail. Dark and grainy, they are sequenced chronologically (with occasional absences of weeks because of the weather), and accompanied by extensive technical data: records of the taking of the photograph, as well as temperature, pressure, humidity, wind directions, cloud formations, precipitation and the sky spectrum. Narrative descriptions of meteorological events even more ill-disposed to being photographed

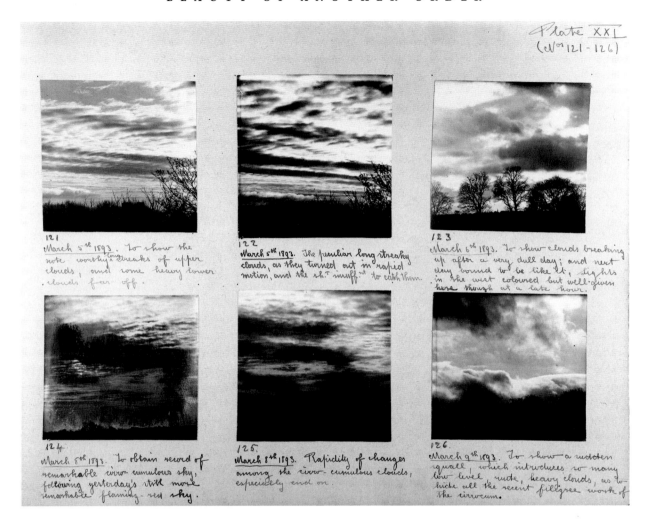

56 Charles Piazzi Smyth, *Cloud Forms, Clova, Ripon, Plate XXI (Nos. 121–26; March 5th–9th)*, 1893. Gelatin silver print collage. Royal Society of Edinburgh.

than clouds, such as "thin, hazy cloud-veils", "strong winds", "foggy mists . . . dulling the vigour of light and shade of the clouds. . ." were often interspersed with the photographs.

These photographs of clouds above Ripon were made at a time when meteorology was receiving considerable attention. Because of the infinite variety of cloud formations, it was difficult for scientists to determine any governing principles, thus the classification system remained strictly one of appearances and positions in the atmosphere's strata. In 1891, at an international meteorological conference held in

Berlin, the revised cloud classifications of R. Abercromby and Hildebrand Hildebrandsson were accepted; the principal meteorogical stations throughout the world were asked to join in an international project to document, over a period of a year, their observations and measurements of clouds. In 1905, A. W. Clayden would publish an atlas of photographs entitled *Cloud Studies*, organized after the recommendations of the international committee; Piazzi Smyth's cloud photographs could have made a similar contribution, but his interests were not of the institutional sort, as his biographers have

THE SEARCH FOR PATTERN

corroborated. He had financed many of his own projects, including an infamous trip to Egypt to measure the Great Pyramid of Gizeh[25] and, in spite of his rigorous recording of data and his obsession with measurement, these later albums in particular have above all a personal, diaristic significance (Pl. 56). Earlier in his life, in South Africa and Scotland, he also sketched and painted—landscapes, clouds and the effects of light and atmosphere on the earth.

Piazzi Smyth's passion for the subject perhaps overruled his need to be more analytical about the results of the data he so painstakingly accumulated. One may also wonder whether he had hoped his compulsive daily recording would lead to a publication, or if the end result simply did not matter to him. We do know that he hoped his photographs might be used for weather forecasting: "he believed that photographs of different cloud formations were greatly superior to verbal descriptions, and that the study of systematic records of them could not fail to provide a scientific basis for forecasting."[26]

We also know that he found the album format, a personal and very intimate manner of safeguarding and viewing photographs, to be appropriate for the display and communication of "meteorological documents". In his Introductory Note he advised on presentation and documentation "for the due scientific furtherance of each picture in and by itself alone".[27] His biographers, H. A. and M. T. Brück, summed up this final body of work by Piazzi Smyth by drawing attention to his integrated vision of art and science: "The cloud photographs were Piazzi Smyth's last work," they wrote. "It is fitting that they should have combined the scientist with the artist in him."[28]

Given the scope of their intentions and the sheer magnitude of their subjects, both Civiale and Smyth's projects were, in a sense, impossible. The process of making photographs was far from a simple mechanical procedure even during the latter part of the nineteenth century; it required the photographer to have a knowledge of optics and chemistry beyond a level of sim-

ple, passive understanding. Their projects were awkward to realize with the current technology and photochemistry, and they both experimented with improving their equipment. In the light of later technical and technological developments their images may appear crude and unfinished from a technical point of view, but they tested the limits of the medium in relation to how photography could treat subjects that had previously seemed either too vast to encompass or too ephemeral to visualize; in so doing they pioneered new ways of presenting photographic information.

The last decade of Smyth's life and of the nineteenth century witnessed major discoveries and inventions in astronomy, physics, chemistry and technology, events that did not touch his own work. Something of the exuberance that he had experienced as a privileged, educated individual whose life had spanned a considerable part of the nineteenth century was expressed in the autobiographical description that appeared on the title page of his albums, accompanying his more formal honours of "LL.D.ED and late Astronomer for Scotland": "C. Piazzi Smyth . . . Now in retirement at Clova through 40 years of scientific experiences by land and sea, abroad as well as at home; at 12,000 feet up in the atmosphere, on the wind-swept peak of Teneriffe, as well as underneath the Great Pyramid of Egypt and upon it . . ."

BOTANY: "EVERY ACCIDENT OF LIGHT AND SHADE"

The study of plant organization—plant anatomy, growth patterns and the environmental factors influencing growth and form—experienced significant advances in the nineteenth century. Around the time of the announcement of the daguerreotype process, two important studies were published, in 1837 and 1839, outlining the mathematical laws of phyllotaxis, the study of plant structure, by L. Bravais (active 1840s) and A. Bravais (1811–63). Knowledge of plant anatomy was also furthered by the investigations of Wilhelm Hofmeister (1824–77) and Simon

Schwendener (1826–1919) into the mechanical principles governing the structure of plants.

The search for botanical structure through photography took a variety of forms from the straightforward documenting of individual specimens in single and multiple images to the formation of taxonomies. In 1843 Adolphe Brongniart (1804–49) divided the vegetable kingdom into cryptogams (unicellular, comprising those plants which have no stamen, pistils or proper flowers, including ferns, mosses, algae, lichens and fungi) and phanerogams (flowering plants, which have stamens and pistils).[29] In the same year Anna Atkins (1799–1871), an accomplished draughtswoman, turned to photography in order to reproduce her specimen collection of algae.[30] Her skill at drawing, already demonstrated, suggests that she saw photography as a means to capture the multitude of details of the complex interlacings that made up each individual specimen, and as a way of achieving a comprehensive taxonomy in a form that would allow for limited distribution. Composing her specimens directly on the sensitized paper, Atkins generally showed her objects in their entirety but at the same time placed them in a lively relationship to the edges of the paper. In so doing she created an effect that was both pleasing to the senses in its simplicity and elegance, and revealing of the specific form and complexity of the object (Pl. 57).

As a picture-making process and as a way of organizing, preserving and disseminating specimens, the photogram technique, in combination with the cyanotype process, was attractive to individuals interested in assembling a collection of botanical specimens in image form. Anna Atkins's album set a high standard. In spite of some of the limitations of the photogram technique already discussed, and the lack of colour reproduction possible in either the cyanotype or silver processes, enthusiam for photography as a medium to delineate plants, leaves and vege-

tation was very much in evidence in the mid nineteenth century. In 1868 *Leaf prints: or Glimpses at Photography*, by Charles F. Himes (1838–1918), Professor of Natural Science, Dickinson College, Pennsylvania, still recommended the photogram technique.[31] A number of skilled practitioners followed in Atkins's footsteps: Lady Hatton (active 1850s), who mounted both specimen and its cyanotype image together—to allow, perhaps, a comparison of the faithfulness and flaws of this new kind of reproduction (Pl. 58); Celia Glaisher (active c. 1859),[32] and Bertha Evelyn Jacques (1863–1941) among them.

The explanatory power of the photogram process, however, was limited; botanists whose interests lay in plant sexuality, a key aspect of cryptogamic classification, would have searched the works of these photographers in vain for the hidden reproductive organs. Sydney Courtfield was possibly responding to this limitation when in 1877 he wrote in the preface to his book on ferns that the albumen prints (there were also woodcuts) would "bear examination with a low power magnifying glass".[33] Another limitation of the photogram process was that it demanded the use of completely dry specimens, and marine algae are at their most representative in three-dimensional form when immersed in water.

As for the describing powers of the artist compared to those of the photographer, Gavin Bridson, historian of botanical illustration, cites Franz Bauer's illustrations in *Delineations of exotick plants cultivated in the Royal Garden at Kew* (1796) as proof that "competent botanical artists were never defeated by intricacy alone".[34] Furthermore, the selectivity that is sometimes required in emphasizing one feature over another (as in archaeological artefact delineation and in some anatomical and botanical illustration) is a property in photography arrived at with some difficulty.

One instance where this limitation worked in

57 Anna Atkins and Anne Dixon, *Papaver rhoeas*, c. 1856. Cyanotype photogram, from the album *Cyanotypes*. Hans P. Kraus, Jr., New York.

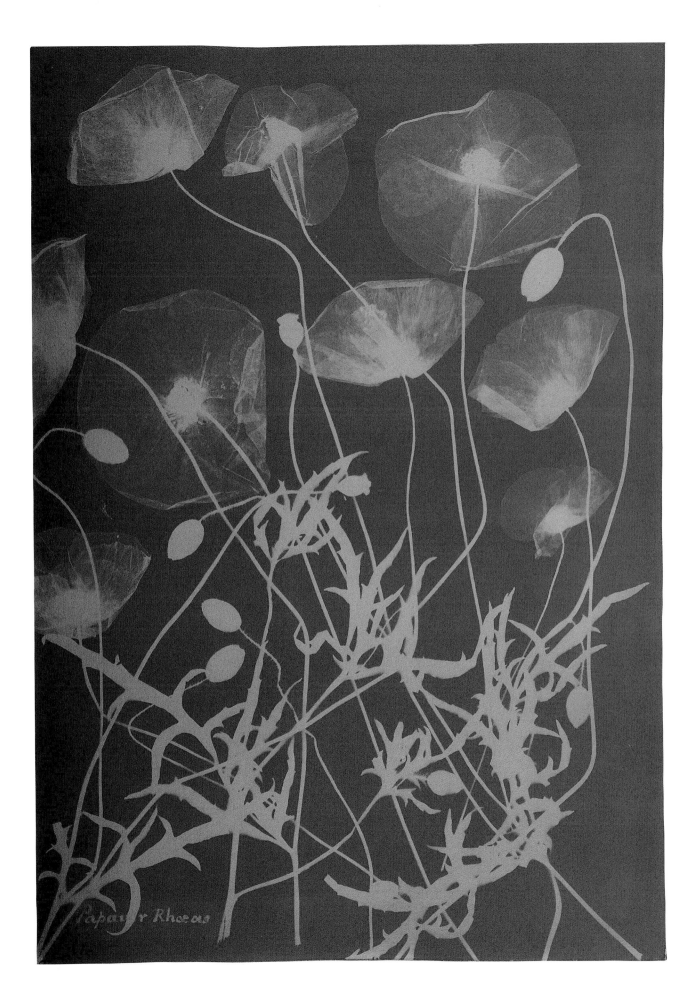

Papaver Rhoeas

58 Lady Hatton, *Hypolepis Eepeny and Specimen*, c. 1855. Cyanotype. Ezra Mack, New York.

59 W. L. H. Skeen and Co.'s studio, *[Durian fruit]*, between 1862 and 1903. Albumen silver print. National Gallery of Canada, Ottawa.

the photograph's favour, however, and where it is difficult to imagine that an artist drawing by hand could have achieved a greater degree of precision is in the photograph of a durian made at W. L. H. Skeen and Co.'s studio, active between 1862 and 1903 (Pl. 59). The durian is a fruit with a reputation for being rare, smelly and delicious; in the nineteenth century it would have been considered highly exotic for the photograph's intended European audience. The external structure of its outer layer is made up of a wonderful geometric complexity of hundreds of small prickly pyramid shapes projecting from its surface. The photograph was described by James Borcoman as providing evidence of the medium's "ability . . . to copy every accident of light

and shade, every line and indentation, as witnessed in the carefully delineated triangular facets".[35]

Exaggeration for the purpose of emphasis also proved to be as alien as selectivity to the syntax of the photograph. *The Great Dragon Tree* by Piazzi Smyth is an example of how photography earned its reputation in the nineteenth century as a more faithful rendition of nature than drawing (Pl. 60). A member of the species *Dracoena draco*, the tree was celebrated in the nineteenth century for its reputation as the oldest living plant; it was found on the island of Tenerife, the largest of the Canary Islands, located off the northwest coast of Africa. It was the subject of a number of highly exaggerated renderings by

SKEEN & Co 537

60 Charles Piazzi Smyth, *The Great Dragon Tree (dracoena draco) at the Villa Orotava*, 1856, No. 19 from *Tenerife, An Astronomer's Experiment, or Specialities of a Residence above the Clouds*, 1858. Albumen silver print. National Gallery of Canada, Ottawa.

artists, each distorting features in different ways and representing the tree according to already familiar and accepted forms (see page 51 for further discussion). Piazzi Smyth's photographs, by representing the tree directly, in context and without manipulation, allowed a more realistic representation to supplant the fanciful.[36] An account of his talk to the Botanical Society of Edinburgh in 1858 , noted that:

> the author treated at length the Dracoena Draco, as being, par excellence, the characteristic plant of the lowest zone of Teneriffe, and having in one of its specimens, the "Great Dragon Tree of Orotava" acquired more fame than any other individual specimen of the vegetable kingdom;

and he concluded [his talk] with an exhibition of the forms of the Dragon Tree at different ages, and other Teneriffe plants optically projected on a screen eight feet square, from photographs of which the original negatives had been prepared by himself.[37]

PHOTOMICROSCOPY: "EYE-PLEASURE"
We have always hungered to see what exists in the world beyond the range of human vision. The imagery revealed by the microscope excited both scientific interest and pure visual delectation right from the beginning. Popular entertainment was possibly the last thing Robert Hooke (1635–1703) and Antony van Leeuwenhoek (1632–1723) had in mind when they

designed the microscope in 1664–75, but by 1726 a form of entertainment existed in Germany known as *Augenergötzungen*, or eye-pleasure. Martin Frobenius Ledermüller (1719–69) invited people to view the astonishingly beautiful images of his solar microscope, projected large in a dark room.[38] Before the microscope, spherical glass containers holding water were used to make structures of organization in living things and in inanimate objects perceptible to the human eye.

Once microscopes had been invented, however, the degree to which details and those underlying structures not visible to the naked eye could be observed depended on the state of development in microscope technology. Developments in optical technology of the nineteenth century, in the form of achromatic and apochromatic objectives, made viewing more precise, but did not eliminate all the ambiguities associated with peering through the microscope. It was not easy to draw what was magnified, let alone arrive at any degree of accuracy. Before photography, writers of microscopy treatises and manuals cautioned observers against too hasty an interpretation of the magnified structures. What sometimes appeared as, and was perceived to be, a diagonal line on a butterfly or a housemoth wing was merely a cast shadow or some other result of the process.

The arrival of photography proposed an attractive alternative to the drawing of microscopic detail which, for all its selectivity, relied predominantly on memory. The camera obscura and the camera lucida had been used in conjunction with the microscope before 1839, but with the coupling of photography and microscopy there was a sense of optimism that the image would advance from an impressionistic rendering to an unfalteringly precise account of every spine or minute follicle of a recorded specimen. Its impact was most strongly felt in the life sciences: botany, zoology and anatomy.

As early as 1835 William Henry Fox Talbot was experimenting with his solar microscope, producing magnifications of a cut of wood and the wing of an insect upon sheets of salted paper.[39] In his notebook entry for 23 September–3 October 1839, some three to four weeks after his letter to Herschel detailing his attempts with the microscope, he noted the "Photogenic Microscope" as a challenge to the practitioners of the daguerreotype.[40] Talbot's own photomicrographs included objects like butterfly wings that were considered excellent test-objects for microscopists wishing to perfect their observing techniques, the properties in the lines on the feathers and scales making them more difficult to find than other microscopic forms. Two of the first known daguerreotypes made with a microscope used zoological and botanical subject matter: a spider and the cross-section of a clematis stem.

When François Jean Dominique Arago (1786–1853) announced Daguerre's discovery of the first stable, easily repeatable photographic process, he linked photography to microscopy. He also speculated, as had Sir David Brewster before him, as to how this branch of observation coupled with photographic recording might one day lead to a rational explanation of life. Arago inventoried the life forms made visible through the microscope: zoomicrobes, ciliata and other microorganisms living in air and in all liquids. Daguerre may have been inspired by this allusion to the microscope in Arago's speech; or perhaps he had already anticipated this marriage of instruments and process, as he did with the telescope, for he is reported to have made a daguerreotype of a spider under the solar microscope.[41]

Dr. Andreas Ritter von Ettingshausen (1796–1878), Austrian scientist, mathematician and professor at the University of Vienna, was present at Arago's announcement and extended his stay in Paris to take lessons directly from Daguerre. He communicated Talbot's and Daguerre's findings to his friend Prince Metternich (1773–1859), Chancellor of Austria, who had a passionate interest in natural history and had participated in Ettingshausen's popular

61 Léon Foucault and Alfred Donné, *Ferment globules [brewer's yeast] (enlargement 400 per cent)*, Plate XI from *Atlas de cours de microscopie complémentaire des études médicales*, 1845. Engraving copied from a daguerreotype. George Eastman House, Rochester, New York.

62 Jean-Bernard-Léon Foucault, *Ferment globules [brewer's yeast] (enlargement 400 per cent)*, July 1844. Daguerreotype. Société française de photographie, Paris.

demonstrations on electricity and magnetism at the university in the early 1830s.[42] The Vienna *Theaterzeitung* reported on 19 September 1839 that "Ettingshausen was strongly of the opinion that this discovery of Science and in particular of Optics, will address needs that lie beyond art."

Upon his return to Austria in the beginning of October, Ettingshausen moved into Metternich's castle of Johannisberg am Rhein in order to teach the Chancellor the daguerreotype process. In Vienna he displayed the daguerreotypes they had made together in his classroom at the university, to much public enthusiasm.[43] In early 1840 Ettingshausen decided to photograph the cross-section of a plant in its magnified form, an opportunity to experience the substructure of the plant world in an even more profound way.[44] He appears to have made this in the studio of Austrian artist Carl Schuh (died 1863), using Schuh's artificially lit microscope

(see Pl. 20). The prospect of a magnified and detailed image of the cellular structure of a plant stem must have created far-reaching expectations, but in fact the details were strongly distorted by aberrations of the lens that could not be corrected. A drawing was made of the image, and later etched by Josef Berres (1796–1844), Professor of Anatomy at the University of Vienna and one of the pioneer photographers in Austria.

Both the zoological and the botanical applications of photography and microscopy reached a dead end very fast as far as the use of the daguerreotype was concerned. It was not until the 1850s that photography was again applied seriously to microscopy in these fields.

PHOTOMICROGRAPHS: "A PRECIOUS CONQUEST"

Due to the persistence of the physicist Jean-Bernard Léon Foucault (1819–68) and of Alfred

Donné (1801–71), physician, scientist and early experimenter with photogravure, efforts to use the microscope for anatomical investigations steadily continued. Their decision to translate their daguerreotypes into engravings assisted in gaining credibility for photomicroscopy in their field. They were responsible for two of the earliest daguerreotypes made in 1840 with the solar microscope. On 24 February 1840 Donné had the honour of presenting "microscope–daguerréotypes" to the Académie des sciences of specimens of bone tissue and objects of natural history. Donné stated that he wanted to profit from this marvellous invention, which would allow the objects to be "produced with a rigorous truth, unknown until now with the introduction of the medium of photography." Donné had dedicated himself to the study of what he called the "intimate structure of substances" through the microscope—human secretions such as mucus, urine, sperm, blood and milk. He believed that it was in revealing the organization of these fluids that one would come to a fundamental understanding of their functions, and eventually to a knowledge of their content.[45]

Donné was one of those who saw photography as a "precious conquest" of science, one that would allow for the reproduction of the details and all the related circumstance of an object "in a way that could never be as strikingly portrayed by an artist's hand" (Pls. 61, 62).[46] Dr. David Gruby (1810–98), who studied with Berres in 1931 at the University of Vienna before going to Paris in 1840, was also very active in recording with photomicroscopy the results of his findings in bodily fluids and parasitology. He also taught microscopy privately, and amassed a vast collection of photomicrographs which were discovered upon his death but were little known beforehand.[47] The decades between 1850 and 1870 witnessed a steady growth of publications relating to photomicrography. By this time the negative/positive paper process had gained ascendancy, and several photographers became known exclusively for their work with photography and the microscope.[48]

Like other physicians studying human anatomy, Dr. Gruby used photomicroscopy in his study of the human brain. All the principal means of studying the central nervous sytem and in particular the brain in the latter part of the nineteenth century employed photography at some point: physiological, clinico-pathological, histological and zoological. The histological aspect, the examination of microscopic structure, involved the use of photomicroscopy, and can be seen in the published works of U.S. neurologist John Dean (1831–88) and French neuroanatomist Dr. Jules Bernard Luys (1828–95), who worked at the Salpêtrière in Paris.

John Dean's study, "The Grey Substance of the Medulla Oblangata and Trapezium", pub-

63 John Dean, Plate 5 from *The Grey Substance of the Medulla Oblangata and Trapezium, Smithsonian Contributions to Knowledge*, no. 16, 1864. Photolithograph by Lodowick H. Bradford.

64 Dr Jules Luys, *Four diameter cross-section of segments of cerebellum*, 1873 or earlier, Plate LXVIII (reads LXVI) from *l'Iconographie photographique des centres nerveux*. Albumen silver print. Bibliothèque de l'Institut de France, Paris.

lished in the *Smithsonian Contribution to Knowledge* in 1864, was a portfolio of photolithographs from albumen photomicrographs; it also appeared in book form the same year (also published by the Smithsonian Institution), illustrated by photolithographs produced by Bradford.[49] It is reputed to be the first photographic book of anatomical cross-sections. On 9 May 1864 the President of The American Photographical Society presented *The Anatomy of the Medulla Oblangata* to a group of members, who were favourably impressed (Pl. 63).[50]

Oliver Wendell Holmes (1809–94) made this comment:

Of all the microphotographs [sic] we have seen, those made by Dr. John Dean of Boston, are the most remarkable for the light they throw on the minute structure of the body. The sections made by Dr. Dean are in themselves very beautiful specimens . . . when the enlarged image is suffered to delineate itself, as in Mr. Dean's views of the Medulla Oblangata, there is no room to question the exactness of the portraiture, and the distant student is able to form his own opinion as well as the original observer. These later achievements of Dr. Dean have excited much attention here and in Europe, and point to a new epoch of anatomical and physiological delineation.[51]

In Paris Luys turned to photography in a deliberate effort to consolidate his reputation in the field of medical research. With the intention of illustrating his research findings in a publication on the nervous system, he wished to avoid the criticism levelled at his previous book on the same subject, published in 1865, that the lithographic plates were more a product of the author's imagination than fact. Consequently, the Preface to his 1873 publication, *L'Iconographie photographique des centres nerveux*, consisting of a text volume and an Atlas of 70 photographs and 65 lithographs, makes it clear that the use of photographs eliminated entirely any possibility of faulty subjectivity. He goes so far as to state that in choosing photography he was "substituting the action of light for [my] own personality, in order to obtain an image both impersonal and accurate".[52] Small, impeccable albumen prints of no more than 11 × 16 cm, they are marvellous tracings not only of the network of neural communication in the human body but also of abstract form (Pl. 64).

Luys also showed an appealing sensitivity to the aesthetic presentation of his specimens, observing that when he cut sections from the brain, which had hardened in a solution of chrome, the specimen was of a greenish coloration that gave it a generally neutral tint and rendered it less photogenic and completely lacking in aesthetic quality. What probably concerned him most was the legibility of the specimen in the final photographic rendering, which would have been only moderately sensitive to the collodion emulsion.[53]

A SENSE OF FORM:
"ELEMENTAL AMAZEMENT"

Microscopy in the late nineteenth century and early twentieth century introduced a new view of reality to scientist and artist alike. The hand-drawn illustrations by German protozoologist Ernst Haeckel (1834–1919) of the symmetries and abstract intricacies of the diatom kindled the fires of popular imagination (Pl. 65). Like the study of cryptogams, protozoology looked at simple life forms; it was an area of study that attracted a great deal of attention in the nineteenth century, particularly after the publication in 1859 of Darwin's *On the Origin of Species by Means of Natural Selection* because of the role that these unicellular beings might possibly play in determining a stage in the evolutionary path between the plant and animal worlds. The topicality of the subject explained in part the fascination it held for photomicrographers who were not practising scientists. Haeckel's own system of Phylogenetic classification, which he published in 1868, was considered to be too inclusive and not sufficiently representative of the enormous differences from structure to reproduction that existed in the world of protozoa.

Haeckel's influence on German photographer Karl Blossfeldt was profound, both in terms of the inspiration of his Natural Philosophy and in the visual impact of his drawings of diatoms.[54] His name and work were repeatedly invoked in articles appearing in German magazines addressing photomicrography in the 1920s and 1930s. It was as if in the face of increasingly abstract ideas and images of reality issuing from the physical sciences, the alien underworld of unicellular beings had taken on a friendly, familiar and entertaining form.

Scientists D'Arcy Wentworth Thompson (1860–1948) and Theodore Andrea Cooke (1867–1928)[55] illustrated their arguments about morphology in the early part of the twentieth century with the use of photographs that were especially revealing of the underlying structures of natural forms. Unlike Goethe, who advocated an appreciation of nature through the perception of the senses, Thompson believed that mathematics had everything to do with understanding morphology: the problems of form were mathematical, and the metamorphosis and growth of these forms were clarified by studying the physical principles of mechanical and molecular dynamics. Despite his emphasis on the mathematical nature of structure, the 1963 edition of his book *On Growth and Form* reproduces a number of photographs that illustrate underlying principles governing the form of symmetry and the surface tensions of liquids. Harold Edgerton's photographs of two of the phases of liquid splashes appear, as do A. M. Worthington's phases of a splash, accompanied by simplified diagrams. Worthington's photographs inspired Thompson to make comparisons between the forms expressed by surface tension in liquids and those found in nature, such as the thin-skinned aqueous life forms, known as hydroid polyps.

> The cup or "crater" tends to be fluted in alternate ridges and grooves, its edges get scalloped into corresponding lobes and notches, and the projecting lobes or prominences tend to break off or break up into drops and beads The naturalist may be reminded also of the beautifully symmetrical notching of the calycles of many hydroid zoophytes, which little cups had begun their existence as liquid or semi-liquid films before they became stiff and rigid. The next phase of the splash (with which we are less directly concerned) is that the crater subsides, and where it stood a tall column rises up, which also tends, if it be tall enough, to break up into drops. Lastly the column sinks down in its turn, and a ripple runs out from where it stood.[56]

In Thompson's view, photography was the only means by which actions of forces occurring with such rapidity could be studied.[57] The photographs of both Worthington and Edgerton are examined more closely in relation to motion in Chapter Six of this book (see Pls. 121, 122).

Diagrams of two photomicrographs of

snowflakes by Wilson Alwyn Bentley (1865–1931) were also reproduced in Thompson's book. Thompson referred to the structure of the snowflake as "a beautiful illustration of Plato's One among the Many".[58] Most kinds of crystal, because of their complexity of construction, presented a challenge to the artist but snow crystals had the additional drawback of being ephemeral and proved to be supremely difficult; the resulting drawings from the microscope were often crude. Bentley was not the first to capture the infinite variety of snow crystals, or "snowflowers" as he called them, through photography (James Glaisher was making photomicrographs of them as early as 1855[59]), but he is the photographer most commonly associated with this subject. By 1890 the complete mathematical theory of crystal structure was published; it has been shown by pure geometry that all 32 crystal classes can be accounted for by a total of 230 space groups, and that all of these have been found in natural crystals. Fascinated by water in all its forms, Bentley first began drawing his observations of snowflakes, by hand, as a young boy.[60] His *modus operandi* for making a photomicrograph of a snowflake was to select a specimen out of a cluster (attempting to keep the glass slide as cold as possible and the snowflake frozen), gingerly lift the chosen snowflake with a bird's feather on to a glass placed in the microscope end of the camera, point the camera towards the shed's only window, and focus the image with the aid of pulleys and other devices (including mittened hands) at the viewing end of the camera where he could see it on the sensitized glass plate.[61]

Although Bentley gained a reputation for being able to select the best snowflakes for recording purposes and to determine as well the most favourable regions, the optimum temperatures and the most opportune moment during a snowstorm for finding these specimens, his field of operations remained close to home.[62] He

was a practitioner who relied on others, such as W. J. Humphreys (1862–1909) and Prof. George Henry Perkins (1844–1933) of the University of Vermont, to articulate the scientific value of his work.[63] His photographs comprise a rich visual catalogue of the structural pattern of the snowflake, introducing the variety of six-fold symmetry of which snow crystals are most commonly composed. Like many who used photography to record the beauty of natural form, Bentley, through intuition rather than learning, surpassed the level of merely recording specimens by demanding that the images be more than legible and true; he desired that the intricate and individual beauty of each specimen be fully translated in the photograph (Pl. 66).

Conventional uses of photomicroscopy continued into the twentieth century, only to become increasingly sophisticated with the introduction of the electron microscope, which first became commercially available in 1935. Over the next five years, the instrument was subjected to a rapid series of refinements, to the point that it could enlarge to fifty times the magnification of the best light microscope. This heralded the new technologies of today, such as the scanning electron microscope which not only has an extremely high resolving power but also reproduces the nooks and crannies in the microworld with an astounding sense of three-dimensionality.

Roman Vishniac (1897–1990) was a photographer and scientist whose photographs and photomicrographs of marine life, insects and insect optics represent a continuation into the twentieth century of the practices established in the nineteenth. His roots were in Europe but he came to maturity as a science photographer in the United States—after internment in a concentration camp he fled from Europe, arriving in New York at the end of 1940. He had already produced a moving record of the Jewish life of eastern Europe in the years that preceded the

65 Ernst Haeckel, *Thalamophora (Foraminifera)*, Plate 2 from *Kunstformen der Natur*, Leipzig and Wien, Verlag des Bibliographischen Instituts, 1904. Engraving. McGill University Blacker-Wood Library of Biology, Montreal.

66 Wilson Alwyn Bentley, *Snowflake crystals, nos. 307, 427, 201, and 383*, 1911–24. Albumen silver prints. National Gallery of Canada, Ottawa.

Second World War, and it is this body of work for which he is best known. Lacking the necessary language skills to work as a medical doctor, he set about earning a living as a photographer. In 1950 he gave up his commercial portrait work to devote himself to scientific photomicrography. One of his projects involved an investigation on insect optics undertaken with Prof. Talbot Waterman of the Zoology Department at Yale.[64]

His professional training in the sciences, first as a zoologist and then as a doctor, placed Vishniac in a similar position to some of the nineteenth-century photographers of science with similar training, who came to photograph their subjects with an especially well-informed eye.

For Vishniac, the secrets revealed by the microscope about the natural world were of great importance to scientific knowledge, but he could not help but be moved by their beauty (Pl. 67). "Everything made by human hands", he said, "looks terrible under magnification—crude, rough and unsymmetrical. But in nature, every bit of life is lovely. And the more magnification we use, the more details are brought out, perfectly formed, like endless sets of boxes within boxes."[65]

Thus photomicroscopy was not only in general scientific use by the end of the nineteenth century but its images were increasingly attracting attention as objects of aesthetic interest. As early as 1858 diatoms were appreciated as satis-

67 Roman Vishniac, *Skin from my left hand*, c. 1965. Dye coupler print. Howard Greenberg Gallery/Mara Vishniac Kohn, New York.

68 Laure Albin Guillot, *Bud of an Ash Tree (section)*, 1931, Plate VIII from *Micrographie décorative*. Photogravure. National Gallery of Canada, Ottawa.

fying purely aesthetic needs: "Any one who will look at a set of illustrations of the Diatomaceae or Desmidiaceae [diatoms] will at once perceive the suitableness of many of their forms for decorative purposes".[66]

Mention has already been made of the dramatic impact of the lantern slide projecting glowing images in a darkened room, in the projection of photomicrographs of microorganisms by Maddox and his colleagues to The Photographic Society, and by Piazzi Smyth's Dragon Tree magnified to eight feet for an audience at the Botanical Society of Edinburgh. In all likelihood, the first exposure to the startling beauties of the photomicrograph for many photograph-

er–artists of this generation would have been through the viewing of very large, projected images using lantern slides, an instructional aid pervasive in universities in the late nineteenth century and the early decades of the twentieth. It is easy to imagine the impression this would have made upon a society unaccustomed to the spectacles of film, television and computer-simulated imagery. By the 1920s and 1930s a form of art photography known as "decorative micrography" was flourishing. The highly unlikely subject of the diatom would be transformed into a motif of visual fantasy, as seen most particularly in the works of Laure Albin Guillot (c. 1880–1962).[67]

In 1931 Albin Guillot published in France a portfolio of photogravures, *Micrographie décorative*. Printed with metallic inks, it was everything that the nineteenth-century writer could have wished who wanted to see a series of photographs of diatoms used as an element in a tiling pattern. It was resplendently decorative, the epitome of decorative micrography. Each page is a shimmering, richly patterned array of complex, interlocking, repeating forms reminiscent of "fairytale science", or the "jewel bedecked fabric samples from the treasure chests of an eastern potentate" as one writer referred to it (Pl. 68).[68] It was the intention of many of these photographers both to explore the objects under the microscope "as conscious pictorial forms" and to respect scientific fact.[69]

There was also a measure of rebellion in the adoption of scientific subject matter and presentation by German artist–photographers of the early twentieth century. Art historian and photographer Franz Roh expressed this attraction as an assault upon the instruments and rationality of science. "We capture the world of the microscope", he declared, "not just for scientific reasons, but also with elemental amazement at the wondrous forms of the microcosm."[70]

By the 1950s, the decorative and abstract values of photomicrographs had taken such hold that for some photographers like Peter Keetman (born 1916) content was no longer of concern.

69 Karl Blossfeldt, *Cosmos bipinnatus*, c. 1929. Gelatin silver print. Anne and Jürgen Wilde, Cologne.

The influence of abstract art was such that the magnifications of ice crystals, oil drops and cells that comprised his photographs could be recognized purely as expressions of form and structure, divorced from the original subject matter.

FAUX SPECIMENS : "THE CHARM OF EARTHLY THINGS"

"Structure, not mood, is the governing element in a picture. Crystalline severity, logic, balance, transparency—these are the qualities we expect in a work of art." [71] When László Moholy-Nagy (1895–1946) wrote in his highly influential book of 1925, *Malerei, Fotografie, Film*, that "we have—through a hundred years of photography and two decades of film—been enormously enriched in this respect. We may say that we see the world with entirely different eyes,"[72] his comment was not only about the tools of photography and film making new forms of expression possible, it was also about an expanded field of subject matter that made photographic images themselves a source of inspiration. Photographic images of science, abundantly reproduced in his book, were considered to be essential to the New Vision. In this way, the boundaries between the specimens of science and the subjects of art started to blur on the visual level as art photographers pursued subject matter that would reflect the changing influences of technology and science upon their lives.

Photographs of scientific specimens that revealed visible surface structures of plant and animal forms exerted influence over a number of photographers, whose images have been singled out for their contribution to the history of twentieth-century photography. Characterized by neutrality of presentation, clarity of expression and emphasis on the revelation of structure, these images share some of the attributes associated with the photographs of natural history subjects by Marville, Skeen and Rousseau from the mid to the latter period of the nineteenth century.

Underlying the work of Karl Blossfeldt (1865–1932) is a mission which is scientific in its quest to prove the existence of archetypal forms in nature, and artistic in its search for the unifying aesthetic elements of symmetry and harmony in these archetypal forms. With their appearance of scientific enquiry, his photographs look like specimens or ersatz specimens. The object photographed is centrally positioned before the lens on a plain background, with even lighting. Everything in the preparation—from the posing and exposure to the printing and choice of paper—was done with an eye to maximum clarity: the print quality favoured a crisp, clear delineation of form and a uniformity of appearance (Pl. 69).

Like Blossfeldt's, the photographs of Albert Renger-Patzsch (1897–1966) were sharp-focused and specimen-like. His engagement with the world was driven by a desire to mirror its materiality with precision and objectivity, qualities associated with scientific investigation. He believed that photography could render "the structure of wood, stone and metal with a perfection beyond the means of painting".[73] In his photographs of plants, attention is paid equally to the overall intricate geometry of the structure and to the precise detailing of complex surface textures (Pl. 70). It was this insistence on clarity and completeness of description over interpretation that led contemporary critics to wonder what made his photographs art and not science:

> Why the outcome is not an expression of scientific exactitude but of an unquestionably artistic order remains inexplicable What makes him an artist is his pursuit of the charm of earthly things, his ability to force even the most accidental and transient phenomena into pictures that are superbly organized, balanced, and structured . . .[74]

Although committed to the exact representation of natural objects such as plants and crystals, Ernst Fuhrmann (1886–1956), of the three German photographers mentioned in this context, was the one most deeply committed to the

70 Albert Renger-Patzsch, *Crystal*, c. 1930. Gelatin silver print. Marjorie and Leonard Vernon.

biophilosophical view of the natural world, seeking interconnections and "the true essence" of nature. This was a viewpoint which, in spite of its origins in evolutionary theory, opposed the rational and analytical methodology of science because of its lack of spiritual quest. For Fuhrmann, the structure of the material world was a Hegelian cycle of interconnecting stages governed by alternating states of decomposition and regeneration—a view that precluded the specificity and inductive aspects of scientific reasoning. For all the appearance of objectivity and neutrality that the photographs of Blossfeldt, Renger-Patzsch and Fuhrmann demonstrate, their photographs are about the ineffable and intangible, embracing the Talmudic dictum "if you look closely upon the visible, you will understand the invisible" as a metaphoric rather than scientific inspiration.

The American Berenice Abbott (1898–1991) was less metaphorical in her approach.[75] She came to this subject in 1939 inspired by its "gutsiness". Rejecting science-inspired photography as, like decorative photomicrography, "mere by-play" and also disdaining a category of straight scientific visual documentation for being inexcusably dull, her first body of photographs showed natural and mechanical objects. They reflect her fascination with the forms and structures of animate and inanimate objects and her desire to observe and record them more closely. A firm believer in photography as a medium with its own syntax that did not borrow from painting, she identified verisimilitude (the ability to record the objects before the camera as faithfully as possible) as a singularly important property. As an inventor, experimenter and innovator in the techniques and

technology of photography, she was able to satisfy her drive to obtain ever-more faithful representations of tonality by devising her own technique. In the early 1940s she created a system, Projection Photography or Supersight, to allow her to project and enlarge the subject directly on to a 16 × 20-inch paper or film; her photographs of birds' wings, fish, moths and insects date from this period. Slightly later are her photographs of penicillin mould, soap bubbles, leaves, the inner workings of a fob-watch and magnetism. Made using a macroscopic lens and a flash from 1946 onwards, they are also excellent examples of the balance she managed to achieve between sheer beauty and factual clarity. While we are drawn into the geometry of the polygonal areas described by the soap bubbles, a classic example in surface tension theory, the image is also compellingly attractive as a formal, aesthetic construction. She experimented as early as 1940 with making photograms of wave motion, with liquid in a glass-bottomed container through which she projected a light source. In the late 1950s she expanded her photography of wave motion to include patterns of both light and water waves. On a larger scale and governed by strong aesthetic decisions, these images of Abbott's recall von Laue's experiments with light diffraction of some 44 years earlier.

Although her work showed an attraction to the mechanical and material nature of the natural world, rather than to natural history, she shared with German artists and photographers of the 1930s an excitement about science and its relationship to photography. Two appointments provided her with the opportunity to produce serious bodies of scientific photographs. The first was in 1944 when she became photography editor of *Science Illustrated*. Her responsibility went to the heart of what concerned her deeply at that time: the appropriate illustration of scientific texts so that the more abstract concepts would come across to the lay reader in a vivid way, and the generation of standards of visual presentation that would make these images more aesthetically attractive without sacrific-

ing accuracy. The second came about in 1958 when she was hired to work with a team of scientists and science high-school teachers within a group known as the Physical Sciences Study Committee (PSSC). This initiative to investigate ways of improving science education in the U.S. closely followed the announcement on 4 October 1957 of the Soviet success in the launching of Sputnik. Funded by the National Science Foundation with assistance from the Ford and Sloan foundations, the project was based at the Massachusetts Institute of Technology in Cambridge, Massachusetts.[76] Two high-school text books were the result, illustrated with a selection of Abbott's photographs demonstrating wave motion, principles of gravitation and the dynamics of moving objects in space.[77]

Several of these photographs showed aspects of motion imperceptible to human vision. For example, a small light mounted on to the rim of a wheel enabled the curved trajectory, or cycloid, that the wheel makes as it moves along a straight line to be traced and recorded—Abbott's narrow, horizontal print captures the motion with clarity and jewel-like beauty (Pl. 71). A selection of her photographs for this project was exhibited at the New School for Visual Research, New York, in May 1959. Various tableaux involving pendulums (Pl. 72), toy trains, metal balls, spanners, glass prisms and glass water tanks were assembled to simulate the principles of the transformation of energy, of gravitation governing an object ejected from a moving vehicle, and interference patterns in water. The most eloquent testimony to Abbott's contribution in this field came from physicist and historian of science, I. Bernard Cohen (born 1914), in a memorial speech delivered in 1992:

One of the photographs . . . displays in a single complex image a complete lesson in the physics of motion. . . . In this display, Berenice was able to show in a series of strobe images the phenomena of a ball being shot upwards from a toy train moving straight forward at constant speed.

71 Berenice Abbott, *Cycloid: A Light Trace by Time Exposure*, 1958–60. Gelatin silver print. Lisette Model Archive, National Gallery of Canada, Ottawa.

72 Berenice Abbott, *Transformation of Energy*, 1958–60. Gelatin silver print. National Gallery of Canada, Ottawa.

111

In her photograph the viewer can observe that while the ball rises up and falls, it will also continue to move forward with the motion of the train, always remaining in the air just above the point from which it had been fired upwards. It can be seen that eventually the ball will land at the exact same point on the moving train from which it had been earlier shot upward. Furthermore, Berenice's photograph demonstrates that the upward motion and subsequent descent of the ball is exactly the same, moment by moment, as would have been the case if the train had not been moving at all. In a single image Berenice has captured one of the revolutionary discoveries at the beginning of modern science, Galileo's breakthrough in conceiving the resolution and composition of independent motions, which led him through falling bodies and a glimmering of the principle of inertia to the founding of modern physics.[78]

The work that Abbott made for the PSSC is very different from her earlier scientific photographs; they are very graphic, with the objects photographed against dark backgrounds and the use of high-speed flash intensifying the forms so that the contrast of light and dark is strong and the forms precisely delineated. The magic of these images, all rendered with impeccable technical mastery and pristine, rich tonal contrast was captured in a two-page display in the *New York Times Magazine*, 17 May 1959, under the heading "Portraits of Natural Laws".[79]

BEYOND THE VISIBLE: "ALL OUR PRECONCEPTIONS MUST BE RECAST"
Berenice Abbott, Karl Blossfeldt, Albert Renger-Patzsch and Ernst Fuhrman celebrated in their photographs a world of material and natural forms shaped by visible light, and brought into being photographically by its action. The vision of the world to which they subscribed was essentially that of the nineteenth century; it was focused on the outward appearances of form. Meanwhile, scientists at the forefront of research into the nature of matter were grap-

pling with some of the most fundamental questions regarding its reality, and whether its essential components could be visualized at all.

D'Arcy Thompson's statement in 1917 that "we have come to the edge of a world of which we have no experience, and where all our preconceptions must be recast"[80] was perhaps inspired by discoveries such as X-rays, radium, X-ray diffraction crystallography and Einstein's theory of special relativity. These discoveries introduced entirely new ways of considering the nature of matter, space and time. With the important discoveries of X-rays by Röntgen in 1895, radioactivity by Henri Becquerel in 1896, and diffraction of X-rays by Max von Laue in 1912, the visualization of hidden structures or subvisible worlds in science took an unexpected and irreversible turn. The traditional view of images formed by light was about to be overthrown by the discovery that visible light was but a small part of the electromagnetic spectrum, which also contained other forms of radiation, capable of producing images including those made by the action of X-rays.

The discovery of X-rays by Wilhelm Conrad Röntgen (1845–1923) was instrumental in formulating the study of the composition of matter, as a diagnostic process and as an imaging system. The discovery resulted from research into cathode rays. One day in his darkened laboratory he undertook an experiment that would allow him to observe two essential differences between cathode rays and X-rays: the latter travel greater distances and penetrate certain kinds of matter. The cathode tubes had been covered in black paper and yet, when the discharge tube was activated, a large letter "A" painted with a solution of platinocyanide, lying a considerable distance from the tube, would illuminate with a flickering light. Röntgen knew that the rays from the cathode tube could not travel that far. He determined that these penetrating rays originated from a source inside the tube where the cathode rays struck the glass; he then tested their penetrating power by "blocking" them with various materials, including his own hand.

Not only was a shadow outline of his hand obtained, but also the bones of the hand. His next step was to find out whether these rays would act upon a photographic plate. In his first photographic experiments he predicted some of the future uses to which his discovery would be put:

> In taking three key photographs, he pioneered three key areas of X-ray imaging. First, a photograph of his closed wooden box of weights clearly revealed its contents, thus presaging the security application found at every airport check-in. Second, an X-ray of his hunting rifle revealed a flaw inside the metal of the gun: it was the first time a hidden structural flaw had been exposed without destroying the object. Finally, and most startling of all, he took a permanent X-ray of his wife's left hand, revealing the bones and the rings that she was wearing. To produce this image, Bertha held her hand still against the plate for about 15 minutes, which gave her a dose of X-rays that dangerously exceeded the limits set in modern health and safety standards . . .[81]

Röntgen received the first Nobel Prize in physics for his discovery, in 1901. Thus began a feverish experimentation throughout the world with radiography and the search for subjects with matter composed of different densities. Banal and unusual objects were brought into service in order to test the transmission powers of X-rays. A range of different densities and transparencies was obtained by placing lilies, begonias (Pl. 73), blocks of wood, metal dividers, chains, reading spectacles and other assorted objects in front of the X-ray machine. Alongside the more conventional diagnostic X-ray images of fractured bones were those of human gastrointestinal cavities replete with apparent obstructions—such as toy bicycles and forks—that seemed to herald the chance meetings between objects celebrated by the Surrealists twenty years later. In August 1896 Ludwig Zehnder, an assistant of Röntgen, made "The first X-ray

image of a human body". The "body" was something of a fiction, however, as it was composed of the body parts of several people. Along with the human hand, which became the leitmotif for experiments in X-ray imaging, a menagerie of rats, frogs, snakes and other hapless creatures formed the subject of visual experiments. Exposures ranged from five to 15 minutes.

Two Viennese chemists, Josef Maria Eder (1855–1944) and Eduard Valenta (1857–1937), both known for their work in photographic chemistry and Eder also for his work in the history of photographic technology, showed how stunningly beautiful the negative rendering of the internal structures of both animate and inanimate forms could be. In 1896 they published a portfolio of 15 elegantly composed images made by X-rays but reproduced as photogravures. Their subjects included the hands of individuals of varying ages, a human foot, a variety of fish, frogs, a rabbit and a snake. Composed with simple factuality and a brilliant luminosity, they show just how exquisitely the stark graphic contrast of black, grey and white typical of X-ray photographs could be translated in the delicate linear and tonal range of the photogravure process (Pl. 74). Since the text of their publication is devoted to the technical aspects of producing X-ray photographs, these two scientists clearly took advantage of the opportunity to make the images as beautiful as possible.[82]

The images of radioactive decay made by Henri Becquerel (1852–1908) are photographic, but not in the conventional sense (see Pl. 38). Neither camera nor light source was used to produce the images that appeared on photographic film. First made in 1896, a year after Röntgen's discovery of X-rays, they were created by placing a uranium compound in contact with a photographic plate in a bag:

> Among these phosphorescent substances, uranium salt is particularly suitable for investigation because of its unusual composition that seems to reveal the harmonic series of bands that make up their absorption and phosphores-

73 Francis Davis, *Begonia X-rayed*, c. 1925. Gelatin silver print. Stephen White, Los Angeles.

74 Josef Maria Eder and Eduard Valenta, *Radiographs of Frogs in anterior and posterior positions*, 1896, from *Versuche über Photographie mittlest der Röntgenschen Strahlen*. Photogravure. Ezra Mack, New York.

cence spectrums. Lamellae of uranium potassium sulphate were placed on photographic plates covered in black paper, or protected by an aluminium sheet, and exposed to the light for several hours. In developing them, I saw that the uranium salt had emitted rays that reproduced the silhouettes of the crystalline lamellae through the black paper and the screens of metal or thin glass on the plates.[83]

Like Alfred Donné, who in 1844 complained to his students that he could not rely on Parisian weather for the requisite sunshine and cloudless skies "to paint upon the screen" various magnifications of objects seen through the solar microscope,[84] Becquerel's intention of exposing the package to sunlight was frustrated by the weather. When he attempted to repeat this experiment late in February to confirm that it was the action of sunlight upon the phosphorescent crystals that made them emit radiation, the skies continued to be overcast. On 1 March he decided to go ahead and develop the plates he had prepared in late February without exposing them to sunlight. He anticipated only very faint images, but to his surprise the depictions of the non-phosphorescing crystals was intense, indicating that the radiation originated from within the substance, and did not require the stimulation of sunlight. He then produced other exposures in total darkness. This enabled him to identify uranium salts as a "radioactive" substance, a word first coined by Marie Curie (1867–1934) and Pierre Curie (1859–1906). The resulting images were an integral part of Henri Becquerel's presentation when, along with the Curies in 1903, he was awarded a Nobel Prize.

Moholy-Nagy would have had no difficulty accepting the strange abstract realities of Becquerel's images, given the resemblance they bear to several photograms he made in the early 1920s with Lucia Moholy. Likewise, von Laue's X-ray crystal diffraction images would certainly have been known to him through Döhmann's book on X-ray photography.

In 1912 Max von Laue (1879–1960), with his assistants W. Friedrich and P. Knipping, experimented with X-rays and crystals in order to determine the wave nature of X-rays. The patterns that formed on the photographic plate not only proved that X-rays could be diffracted, but also that the individual lattice structure of the crystal could be pictured. Integral to the paper that he submitted upon receiving the Nobel Prize for Physics in 1914 were the X-ray diffraction photographs of crystal lattices that provided tangible proof of what he had already quantified and predicted through mathematical formulations.

With new knowledge about the properties of light, and developments in microscope technology and the optics and chemistry of photography in the first half of the twentieth century, it became increasingly possible to explore what existed beneath the visible surface of organic and inorganic matter. In 1952 von Laue's X-ray crystallography diffusion technique was used by Rosalind Franklin (1920–58) and R. G. Gosling to capture on film a photographic tracing of what would later be interpreted as the double helix structure of the DNA (deoxyribose nucleic acid) crystal, the chemical responsible for genetic encodement (Pl. 75).

ATOMIC PHOTOGRAPHY:
"STRONGER LIGHTS, DEEPER SHADOWS"
The discovery of X-rays in 1895 and of X-ray diffraction crystallography in 1912–15 had a profound impact on particle physics research and on our knowledge of the structure of matter. They resulted in the making of scientific photographs which looked, and functioned, more like diagrams than the pictorial representations of nature of the nineteenth century.

Stark in their simplicity and abstract as the images of Becquerel and von Laue were, they were nevertheless, in every respect, as much about reality as were photographs of plants, mountains, butterfly wings and all manner of specimens of the natural and material world. They were more startling and more difficult to absorb, however, because the reality they des-

75 Rosalind Franklin and R. C. Gosling, *X-ray diffraction patterns of A and B forms of sodium salt of DNA*, 1952. Gelatin silver prints. Medical Research Council Centre, Cambridge.

cribed was so much further removed from the world of surfaces and appearances than anything previously captured in photographs. If two such opposite pictorial representations of the natural world can be linked at all, Talbot does it in his observation about the structure of the picture itself, quoted fully on page 29: "the picture, divested of the ideas which accompany it, and considered only in its ultimate nature, is but a succession or variety of stronger lights thrown upon one part of the paper, and of deeper shadows on another."[85]

These and later photographs that arose from particle physics research were named "Discovery Photographs" by Jon Darius (1946–93), the Canadian-born astronomer and physicist, because of their impact on knowledge.[86] Appearing to the uninitiated eye like machine-processed photographs made from grossly over-exposed and randomly abraded negatives—with thin lines, streaks, squiggles, bursts and dots of light, interrupting in unpredictable patterns an impenetrable black field—they contain information which has greatly advanced scientific knowledge. Photographed either as they left

their tracks on a lead sheet or producing their own images directly on nuclear emulsion film, these stronger lights and darks "thrown upon . . . the paper" are the atomic signatures of particles, anti-particles and radiation tracks from the outermost reaches of the cosmos, which became crucial to our understanding of the building blocks of matter (Pl. 76).

Although the concept that matter was composed of atoms existed from the period of classical Greece, a microscope did not exist until the 1950s that could picture them. A greater understanding of the atomic structure of matter was arrived at through important discoveries made in the nineteenth century, such as the observation of Robert Brown (1773–1858) in 1827 that the movement of solid particles in liquid is continuous and random. Knowledge about the structure of atoms was advanced in 1895 with the identification of electrons, the negatively charged particles that move around the nucleus of the atom.

In 1894, around the same time that Charles Piazzi Smyth was photographing clouds in his beloved skies over Ripon, the scientist C. T. R.

Wilson (1869–1959) was also observing clouds forming around the peak of Ben Nevis. Wanting to investigate the interaction of clouds and sunlight, he designed a "cloud chamber"—an apparatus which, in its earliest form, consisted of a small cylinder measuring 7.5 cm in diameter and under 1 cm in height, filled with supersaturated air. By introducing X-rays into his cloud chamber, Wilson was able to capture photographically the tracks of sub-atomic particles. Later versions of the cloud chamber varied in size and construction, contained different substances, and were bombarded with different forms of radiation according to the purpose of the experiment. It was supplanted in the 1950s by the bubble chamber. Although a camera was sometimes used to record events taking place in the cloud chamber through the glass lid, the chamber itself often incorporated the function of the camera, becoming what Darius calls a "photographic detector".

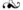

Although the history of photography's role in revealing the forms of nature and the underlying structure of matter is not very long, it has been richly varied. The search for patterns in science and art through over 160 years of the photographic medium has manifested itself in different processes and formats. In 1837, at the dawn of photography, before the cloud chamber was dreamed of, Sir David Brewster (1781–1868) saw the microscope as the key to unlocking the secrets of the nature of matter: "It has become quite a new instrument in modern times," he wrote, "and it promises to be the means of disclosing the structure and laws of matter, and of

making as important discoveries in the infinitely small world, as the telescope has done in that which is infinitely distant."[87] A mere two years later, François Arago envisaged that the application of photography to the microscope might one day lead to a rational explanation of life itself:

> Initially used for the observation of some insects whose forms naturalists simply wanted to amplify so as to reproduce them better in engravings, the microscope subsequently and surprisingly proved to reveal a whole world of zoomicrobes and ciliata in the air, in water, in every liquid—curious reproductions that may one day provide the clues for a rational explanation of the phenomena of life.[88]

Of all its properties, the photograph's capacities to render detail and to represent objects faithfully were highlighted most often in the nineteenth century, and continued in the twentieth to be most strongly associated with its purpose and appreciation. Berenice Abbott described photography in 1953 as the link between art and science:

> Photography is a new way of making pictures and a new way of seeing. Indeed, the vision of the twentieth century may be said to have been created by photography. Our familiar awareness of the visual world has been evolved for us not alone by the eye but by the camera, used for a myriad purposes. The very character of the medium, its dualistic science–art aspects, is the index of its contemporaneity. It took the modern period, based on science, to develop an art from scientific sources.[89]

76 CERN Laboratory (European Laboratory for Particle Physics), *Particle Traces in a Bubble Chamber*, 1970.
Gelatin silver print. CERN Laboratory, Geneva/Patrice Loiez/Science Photo Library.

5

"A Perfect and Faithful Record": Mind and Body in Medical Photography before 1900

MARTIN KEMP

WHEN the pioneer of psychiatric photography, Hugh Welch Diamond, tried to persuade his audience at the Royal Society in 1865 that photography of mental patients "makes them observable not only now but for ever, and it presents also a perfect and faithful record, free altogether of the painful caricaturing which so disfigures almost all the published portraits of the Insane", he was making what had become standard claims for the instrumental objectivity of photographic representation.[1] Since the goal of visual objectivity had provided the fundamental justification for the realistic depiction of seen forms in medical books from the time of Vesalius's *Fabrica* in 1543, it would seem obvious that the advent of photography in 1839 should signal a new era in medical representation. The mechanical eye of the camera, set up unwaveringly in front of a subject in such a way that the reality of the subject's existence is inscribed by light on the photographic emulsion, promised to overcome all the problems of subjective errors which had traditionally arisen from medical artists' fallible perceptions and personal styles. The essence of the act of photographic representation—its process of optical and chemical transcription—did indeed alter the parameters of representation in medicine, but in ways that were less immediate and far more complicated in technical, representational, intellectual and social terms than was apparent at, literally, first sight.

Photography did not enter the service of medical science and practice in a theoretical vacuum. In the wake of the Renaissance revolution in illustrative techniques, it had become increasingly apparent to perceptive practitioners that complicated issues of representation were involved—both with respect to the represented subject and to the acts of depiction, reproduction and understanding. The sophistication of the debates in medicine—and, indeed, in the full range of natural and human sciences which had employed elements of veridical depiction—has not always been adequately recognized by historians and theorists of photography. In this chapter I will begin by defining the issues, aiming to tease out the ways in which the special characteristics of photography affected the parameters of contemporary and subsequent debates, before looking at a series of topics which seem to

provide the most vivid manifestations of the impact of photography on a range of medical sciences, particularly as a tool of analysis (the term "medical sciences" will include aspects of early anthropology and the "pseudo-sciences" of physiognomy and phrenology). I will pay particular attention to the aspects of medical photography that intersect in the public domain most fruitfully with "normal" portraiture, and this will take us into the heart of some of the major eugenic and psychological debates of the age.

WHO IS RECORDING WHAT, AND FOR WHOM?

Diamond's assertion that photography provides "a perfect and faithful record" begs a series of important questions about the advertent and inadvertent intentions of the person or persons doing the recording, and the relationships between these intentions and the viewers of the imagery, envisaged and actual. Some of the key questions had been the subject of longstanding debates in the theory of medical representation, and none of them was to be as readily circumvented as the early advocates of photography claimed, although the grounds for some of the central arguments do shift markedly. The issues range from the general matter of the determination of content in relation to what the author and illustrator saw, or thought they were seeing, to technical issues of the nature of the media used.

The fundamental practical problem, recognized from the very earliest attempts of anatomists to utilize the new modes of Renaissance depiction, was how the author could ensure that the "artist" depicted what was there, or what the author believed to be there. From the first, surgeons and physicians found that it was not possible simply to place artists skilled in naturalistic representation in front of a dissected body and expect them to show what the authors wanted. This problem was particularly severe when the illustrator was confronted with deeper internal structures for which he did not possess established criteria for viewing and effec-

tive schemata for portraying. In such circumstances, the author would need to establish ways of ensuring that the illustrators became the "tools" for the eyes and hands of the doctor, to use the term adopted by Albinus in the eighteenth century to describe his attempts to subordinate his artists' vision to his own.[2] This difficulty seemed to be avoided in those rare circumstances where the medical expert possessed sufficient skills as a draughtsman to generate his own illustrations, but even in such instances the doctor–artist needed to fight the limitations of his own established schemata and graphic tricks, to say nothing of the even greater tendency for the representation to conform to what was known rather than what was seen (to use this old but still useful formula).

It seemed to some observers that photography, at a stroke, should remove this problem once and for all. It was not so much that any doctor could simply become a photographer—from the first, special skills and knowledge were involved in the production of photographs of the desired technical quality—but rather that a layer of artistic mediation was eliminated. In reality, the mediation shifted to different aspects of the processes of representation, in relation to the particular sets of choices that the photographer must make in determining the staging, exposure and printing of the images. Medical photography did, and still does, involve a continual struggle to extract visual legibility from the confusing and largely unfamiliar interior landscape of the body, particularly in view of the limitations of the static, "one-eyed" and, in the earlier phases, monochromatic image. The drawn representation has the interpretative advantage for the viewer that it can indulge in obvious "visual pointing" through techniques of emphasis and selection, whereas the act of photography will tend to present its own inherent selections, translations and suppressions, depending upon the technical parameters of the apparatus, medium and ambient conditions. At worst, the camera and the chemicals could produce effects which looked as if they were in the specimen

but were in reality artefacts of the processes themselves. Not infrequently, photographic images in medical texts were supported by explanatory line diagrams or reinforced by retouching to help the viewer look selectively to extract the desired information. In addition, we need to remember that, in the earlier phases of photographically generated illustrations in books, photographic images were necessarily transposed into engravings, woodcuts or lithographs, because there was no means of reproducing them directly on the printed page. The need for selective visual pointing through diagrammatic reinforcement or photographic manipulation became particularly urgent with the rising requirement to record, correlate and classify specific pathological signs of defined maladies, in the context of the nineteenth century's new demands of diagnostic medicine.

A closely related problem, debated with particular urgency in the eighteenth century, was whether the illustrator should faithfully depict an individual specimen, with all its potentially atypical features, or aim at the normative morphology, synthesizing the accumulated knowledge of many acts of observation. The poles are represented by Bernhard Siegfried Albinus's *Tables of the Skeleton and Muscles* of 1747 and subsequent editions (Pl. 77), in which the elegantly poised figures make polished display of their dissected anatomies against picturesque backgrounds in a suave and bloodless synthesis of the anatomist's wisdom, and William Hunter's *Anatomy of the Human Gravid Uterus* of 1774 (Pl. 78), in which his artists were ostensibly required to depict all the visual idiosyncrasies of what was apparent in an individual dissection in what may be called a "warts and all" style.[3] Hunter, as a dogmatic British empiricist, was insistent that the direct portrayal of particular specimens represented the highest form of visual integrity for the author of an illustrated text. Again, it would seem that this requirement had been fulfilled by the advent of photography, since surely a photograph could never show anything other than the specific items in front of

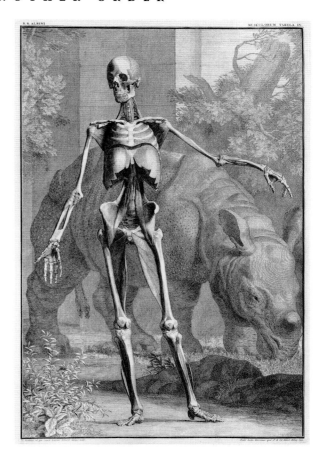

77 Jan Wandelaar, *The Fourth Order of Muscles, Front View, Musculorum*, Plate IV from Bernard Siegfried Albinus, *Tables of the Skeleton and Muscles*, 1747. Etching with engraving. Private collection.

the lens. However, matters are not that simple. The specimen needs to be prepared for photography, the forms dissected and clarified, left in the body or removed, supported in desired positions, perhaps sectioned, possibly stained and labelled, kept moist or dry, and lit to bring out desired features. The photographer then needs to undertake all the technical choices involving the camera, film, depth of field, contrast and printing. With the exception of special illustrations of pathology, in which a report on a particular case will place an emphasis upon what is specific in this individual instance, there has been a general tendency to nudge the photo-

graphic image used for pedagogy in the direction of the normative, through a careful rigging of the various medical, visual and technical choices.

Not the least significant of these choices is the contextual and accessory material which is to be visible in the photograph. If, say, the photographer is required to represent a goitre on a patient's neck, more than the goitre is likely to be revealed. Does the photographer or print-maker include details of the patient's face and body; and if so, should the body be clothed or unclothed? Are those parts of the scene caught by the lens whose aspects are medically redundant to be excised or masked out, or may they be included with impunity, on the assumption that they have no effect on our understanding of the intended content of the image? Is the issue of their elimination simply one of preserving the patient's right to anonymity in the age of photographic portraiture? The irrelevance of accessories and contexts (such as Albinus's landscape backgrounds) was a commonplace of earlier histories of medical illustration, but increasingly it has been realized—and was apparent to those who chose the staging in the first place—that visual supports performed important if often unrecognized roles, particularly with respect to what may be called the intellectual and social rhetoric of the imagery. The depiction of dissected forms in company with the tools of dissection, laid out on wooden blocks with pins, attracting flies, and adorned with reflections of windows on moist membranes (all of which can be found in illustrations from the sixteenth to the eighteenth centuries) casts the anatomist's enterprise in a very different light from the display of the whole or parts of the body gracefully or heroically posed, perhaps elegantly draped, and set within fine interior or exterior settings.[4] The first style is geared to what I have called the "rhetoric of reality", in which the depiction includes a series of visual pointers to the author's claims to be portraying the forms directly "from life". The second sets the understanding of the architecture of the human body within the humanist pursuit of gentlemanly learning, suitable for a civilized society which aspires to explore the glories of God's creation. Many books, particularly the great picture-books of anatomy aimed at wealthy patrons, used both modes of rhetoric, speaking both of the civility of the anatomist's profession and its claims to reveal the observed truth.

By the time of the advent of photography, both rhetorics in their more overt forms were becoming discredited in the face of a rising fashion for simple, unadorned, visually reticent and stylistically sober portrayals, aimed not least at the growing numbers who were learning and

78 William Hunter, *Fetus in utero*, Plate XII from *Anatomy of the Gravid Uterus*, 1774. Engraving. Private collection.

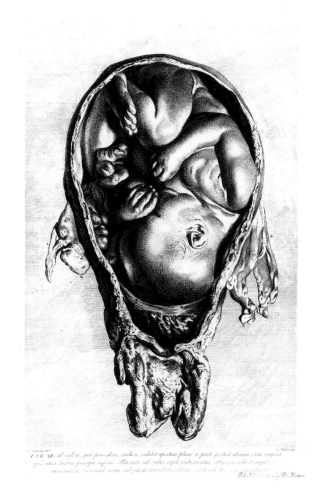

123

practising medicine within the professional colleges, societies and institutions that were beginning to dominate nineteenth-century medicine in the urban societies of Europe and north America. This "non-style", which found its perfect expression in 1858 in the first edition of Henry Gray's famous *Anatomy* (Pl. 79), is of course a rhetorical device in its own right, designed to preach the objective values of a professional class dedicated to a high scientific understanding of the mechanisms of the human body.[5] Photography, it seemed, provided the archetypal non-style, given its apparent elimination of the artist's hand. However, the very inclusiveness of the photographic image, which can rarely avoid the seepage of "border information" unless the image is trimmed or otherwise doctored, meant that the problem of accessory messages remained insistent. In the case of the portrayal of a whole body in, say, a case of gross damage or deformity, the posing of the figure, its costume and its setting require conscious and unconscious choices, and any choice carries with it some kind of meaning. Even when portraying parts of the body within a more limited pictorial frame, it was difficult to avoid signs that gave some clue about the attitude of the originators of the image, and perhaps about the status of the patient in a variety of social and racial terms. If these clues could be eliminated, the elimination in itself may comprise a statement about the Olympian objectivity of the doctor and the position of the patient as an anonymous case. Repeatedly in the earlier phases of medical photography, we find the apparently gratuitous posing of the "sitter" and the staging of the photograph to be in keeping with a series of accepted stylistic modes both in medical illustration and, more broadly, in terms of conventions of artistic portrayal in photography and more traditional media. This tendency to fit photographic images within existing genres of portrayal was, as we will see, particularly marked when depicting the insane.

Underlying all these questions is the fundamental issue of the role of visual representation in medical science.[6] It may seem obvious to us that a variety of kinds of illustration are integral to the communication of medical knowledge. This was not always the case. There had been a longstanding resistance to illustration, particularly within the tradition deriving from the great Alexandrian philosopher, Galen. The key argument, which continued to be aired in the eighteenth century, was that the body itself was the only reliable illustration, and that pictures provided a misleading substitute for the real thing. Even Vesalius, whose *Fabrica* in 1543 set entirely new and enduring standards for the depiction of anatomy, sternly reminded his readers that his magnificent woodcuts did not remove the necessity of first-hand experience of dissection (Pl. 80).[7] However, there were compelling reasons for illustration. Direct experience of the

79 H. V. Carter, *Lymphatics of the Upper Extremity*, Figure 229 from Henry Gray, *Anatomy*, Parker, London, first edition, 1858. Wood engraving. Osler Library of the History of Medicine, McGill University, Montreal.

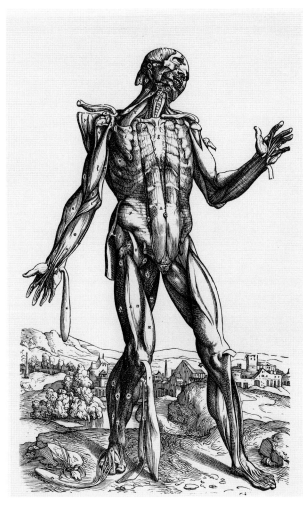

80 Venetian, sixteenth century, *The Fifth Plate of the Muscles*, 1539–41, from the portfolio *Andreæ Vesalii Bruxellensis Icones Anatomicæ*, Bremer Press, Munich, for the New York Academy of Medicine and the University of Munich, 1934. Woodcut. Private collection.

reshaping medical illustration. Even for those who had direct access to anatomies, the role of illustration as differential pointing meant that graphic representation could perform a valuable function, either as a form of preparation for recognizing what should emerge during dissection, or as a visual commentary to the act of dissection itself.

We should also not forget that an illustrated text often has an advantage in a competitive market for books, whether in terms of traditional patronage or sales of modern textbooks. As cheaper means of photographic reproduction became available, so illustrated texts could be mass produced at reasonable cost with no deterioration in the quality of the illustrations. However, the onset of the "Craze for Photography in Medical Illustration" (to use the title of an editorial in the *New York Medical Journal* for 1894) does not seem to have been primarily motivated by the economics of production.[8] Just as we now see high-tech computer graphics used to demonstrate that the author and publisher are masters of the latest techniques, so the exploitation of photographic reproduction became an assertion of the up-to-dateness of the scientist's enterprise. Indeed, some authors' motives for the liberal use of photographic illustration beyond what was strictly necessary for the medical content of the text were challenged in the period itself. During the course of the 1894 debate, the intelligibility of photographs was compared unfavourably with drawn illustrations. An article in the 1886 edition of the *British Medical Journal* compared photographs of morbid specimens to "Ovid's Chaos".[9] Critics of photography pointed out that the anonymity of patients could be compromised, often without their consent, and that images of naked figures could all too easily pander to voyeurism.[10] The portrayal of naked women evoked obvious taboos, and the display of the genitals of either sex possessed an obvious potential to scandalize more sensitive or censorious spectators. As early as 1865, a photograph of a man with two sets of genitalia in *The Lancet* was condemned as a "mere mask for

real thing was not always readily available even to students of medicine, and a large proportion of the audience for many early anatomical texts—the aristocratic and the learned—would never witness an anatomized body. Lack of accessibility to first-hand experience became exacerbated with the development of the new technological means of seeing minute features by microscopy. It is no coincidence that, from the first, photomicrography was a major focus of those who saw photography as the means of

81 G. Vandergucht, *Frontispiece showing the camera obscura in use*, from William Cheselden, *Osteographia, or the Anatomy of the Bones*, London, 1733. Etching with engraving. Wellcome Institute Library, London.

obscenity".[11] The public issue of photographs of congenital freaks and pathological monstrosities, some intended to be looked at through the popular stereoscopic viewing devices, suggests that fears of an unhealthy market for such images were well founded.

It can be seen therefore that photography arose in a context in which many of the questions raised by verisimilitude in scientific representation were already under active debate and had been resolved in a variety of ways. As a means of representation, photography had radical consequences for the relationship between the object and the resulting image. For all the traditional elements of subjective choice, the photograph was nevertheless directly and systematically dependent upon what stood in front of the lens. Even the most helpful of the available optical devices, most notably the camera obscura used by Cheselden in his *Osteographia* of 1733, did not deliver such a direct trace of the seen thing (Pl. 81).[12] The level of trust inspired

by a photograph was certainly exaggerated by its keenest advocates, but photography did legitimately command a kind of respect as an act of documentation distinctively different from that accorded to a traditionally drawn image. This obvious point has been unnecessarily obscured in much recent writing on photographic representation.

Whether or not the photographic image (like the perspective picture) relates in some special and non-arbitrary way to our mechanisms of seeing—as I believe it does—it stands in a measurable optical relationship to its subject. The size, say, of a gland distended by infection can be compared systematically in photographs with the relative proportions of the undiseased organ. A graded measuring rod can be included within the frame, as became a favoured device in anthropological photography, in which the differentiation of head shapes and bodily proportions was a major goal. Series of images of the same kinds of things, which could be made more

126

prodigally than was possible when specialist draughtsmen had to be employed, also allowed systematic arrangements of images in sets according to classificatory categories. Banks of photographs could be built up for reference and analysis, perhaps even suggesting new classifications of objects which might stand in a special relationship to each other. Galton's methods of eugenic analysis used series photographs as a major tool in the foundation of a new science of evolving human types and in the recognition of new categories. And, like all systems of categorization, these new methods could be used for good or for ill.

The camera also possessed the important potential to extend the act of vision beyond the limits of the human eye. The first major photographic adjunct to the act of seeing was the "freezing" of very rapid motions by instantaneous photographs, which became possible as the sensitivity of photographic emulsions was spectacularly increased during the first half-century of photography's existence. Both the pioneers of chronophotography, Etienne-Jules Marey in France and Eadweard Muybridge in America, regarded the human figure as central to their investigations of motion through sequential photographs (see pages 151–58).[13] The revelations of the unseen, intermediate positions of the limbs of human beings and animals in rapid motion suggested that photography could provide a truer way of seeing than our limited human apparatus. The mechanical eye was also used to probe visual corners of the human body which were previously inaccessible other than through the destructive dissection of dead organs. At surprisingly early dates, devices were invented for photographing the interior of the digestive tract by endoscopy; the inside of the bladder; the architecture of the larynx, and the "photographic" receptor of the eye itself, the retina.

Perhaps even more dramatic, not least in the public imagination, were the results achieved by photographic techniques that involved emissions of a frequency or type invisible to the unaided eye. The first and unsurpassed sensation was the revelation of X-rays by Röntgen in 1895, which seemed magically to transcend the normal definitions of sight with respect to opaque bodies. The fact that the whole process, from the generation of the emission to its reception and recording, was in the hands of non-human agencies lent the X-ray a special status as a scientific record. Yet it also left the image open to the accusation that it was an artefact of the system used rather than a record of visible reality. When Baraduc published photographs in 1897 that claimed to record the invisible "aura" of energy surrounding people in particular states, there was no obvious reason for the viewer to distrust the results any more than those produced by X-rays, although we now know that they have as much claim to truthful representations as Elsie Wright's and Francis Griffith's photographs of fairies.[14]

More recently, other forms of technological perception and representation lay similar claims to authority—such as ultrasound imaging (of, say, the foetus in the womb); electron microscopy (which has given us wonderful images of the picturesque landscapes embedded in tiny features of human tissue), and positron emission tomology (which provides computer-analysed scans of brain activity). Yet we should not lose sight of the way that the conception of the "seeing" devices is modelled on the human mode of vision, in order to produce the kind of visual image which we can accommodate through our normal experience and expectations. The whole process of making such images is "rigged"—not in an arbitrary way, but to work within the limits of our accustomed means of viewing and making images.

Such, then, are some of the complexities of the issues raised by medical photography in the contexts of traditional practice and the advent of new potentials. These, and perhaps as yet unrecognized matters, are only incompletely researched, particularly with respect to the huge numbers of images generated in different aspects of medical practice and pedagogy across the

world.[15] We are certainly not in a position to offer an authoritative survey or overview. At this stage, the best we can do is to select what seem to be exemplary episodes and themes as a way of stimulating further reflection and research.

FACES AND RACES

Given the central role of portraiture in early photography, it is hardly surprising that it was taken up avidly in those branches of the human sciences concerned with facial features and the external appearance of the head. The science of physiognomy—reading the "signs" of the face to detect fundamental traits and temperaments—is of great antiquity, having been credited at one time to Aristotle. After falling into relative obscurity, it was given a huge international boost which persisted well into the nineteenth century by the theories of Lavater, whose extensively illustrated writings appeared first in Germany in 1775–78, and then across Europe in various editions and popular abridgements.[16] The sciences that dealt specifically with insanity had effectively been founded in the later part of the eighteenth century, and gave additional impetus to the studies of facial indicators: temporary or enduring abnormalities of feature and expression were seen as providing reliable diagnostic signs of the types of madness that were inflicting the patients. A further boost to the systematic study of the configuration of the head in the early nineteenth century was provided by the phrenological techniques of Gall and Spurzheim, who claimed to diagnose mental proclivities from the "bumps" of the cranium.[17] The growing interest in the scientific definition of normal and deviant physiognomies and head types became entangled with the new notions of inheritance and evolution, particularly the sensational ideas of Darwin, and with the increasingly methodical study of racial types during an era of major world colonization by European powers.

The camera rapidly became a favoured tool for the explorer who wished to record the appearance, customs and dwelling places of the native inhabitants of newly discovered territories. Sets of photographs, taken and compiled according to methodical programmes, were regarded as providing a rich source of data for the study of racial types for the new science of the "natural history of man". Particularly striking early examples are J. T. Zealy's 1850 daguerreotypes of plantation workers of African origin in the southern states of America. By the 1860s more general photography of ethnic types, often on the basis of their picturesque novelty as "savages" within the expanding imperial domains, was in part redirected into more systematic endeavours.[18] The Société d'Ethnographie in Paris began a major project to document human types across the globe, not least because it was felt that the discrete nature of ethnic groups was increasingly threatened by mixing. One of the grandest individual projects was undertaken by the Hamburg photographer, Carl Dammann, who published an album of more than 600 photographs in 1873–74, issued in English as the *Ethnological Gallery of the Races of Men* in 1875.[19] The newer styles of depiction were increasingly based on systematic recording and classification, characterized by a growing obsession with anthropological measurement; faces and heads received the most attention.

The most systematic of the anthropological measurers of crania was Paul Broca, professor of clinical surgery at the Faculty of Medicine in Paris, who was the first to provide clear clinical evidence of the localization of brain functions. He was a founder of the Anthropological Society in 1859 and of the *Revue d'anthropologie* in 1872.[20] As an anthropologist, he worked on the premises that various human races could be ranked on a scale of human ability, and that those races exhibiting what he called "lesser degrees of humanness" stood closer to evolutionary descent from ape-like ancestors. Accordingly, he classified and minutely measured key features of the body and most particularly of the head, to determine what criteria would best serve to place the races on the scale. The subtlety of measured differences between key

dimensions, particularly that of the capacity of the cranium, ruled out photography as a source of data; key visual characteristics, however— such as the facial angle resulting from prominent jaws, thick lips and flat nose—could be indicated by photographs, providing a graphic means of comparison between "advanced" white races and others whose appearances and behaviours "recapitulated" more primitive stages in the evolutionary process.

A particularly effective illustration of how photography could serve the needs of phrenology and physiognomy as applied to racial types was provided in 1873 by Lieut.-Col. William Marshall. His study of a group of inhabitants of south India, *A Phrenologist amongst the Todas*, was illustrated with autotypes of photographs by Bourne and Shephard of Simla and Nicholas and Curths of Madras (Pl. 82).[21] Marshall declared that he was undertaking a "phrenological enquiry into the nature the barbarous races".[22] He was concerned not least to provide some insights into the "mysterious process by which, as appears inevitable, savage tribes melt away when forced into contact with a superior civilisation".[23] He regarded small, relatively enclosed communities as particularly revealing, since endogamy produces a greater uniformity of type than is apparent in communities of more mixed composition. Since isolated races "present scarcely more differences in appearance and character than any one dog does from any other in the same kennels of hounds", no more than ten representative photographs of each sex would be adequate to provide a record of the characteristic head type.[24] His examples of "real life" were each photographed in profile and front face, in keeping with the systematic form of representation promulgated by Pieter Camper in the eighteenth century (Pl. 83).[25] On the basis of photographic and physical surveys of the

82 Bourne and Shepherd, Plates 3 and 4 from William E. Marshall, *A Phrenologist amongst the Todas*, Longmans, Green and Co., London, 1873. Collotypes. National Gallery of Canada Library, Ottawa.

83 Pieter Camper, Plate III, figs. 1–5, etching, *The Works of Professor Camper on the Connection between the Science of Anatomy and the Arts . . .*, printed for C. Dilly, 1794. Osler History of Medicine Library, McGill University, Montreal.

heads—allowing for difficulties caused by the natives' hairstyles—such traits as the "Concentrative" and "Amativeness" could be reliably deduced. Marshall was confidently able to identify, for example, that the women of the Todas manifest "love of children and adhesive feelings", yet are demonstrably inferior in "perceptive faculties".[26]

It is easy now to be dismissive of such pseudo-science, and to exclude it from even the fringes of medical science, but the promise of quantifiable criteria for the definition of race and character possessed an obvious appeal in an age obsessed with the promotion of all branches of study of humanity into domains of measured certainty. It is no coincidence that this was the age in which Giovanni Morelli, trained as a doctor, promised to identify the styles of great artists of the past on the basis of a systematic study of the physiognomy of the tell-tale features, such as ears, eyes and noses, which they characteristically accorded to their figures.[27] And it was in this spirit that in 1866 John Down characterized as "Mongolian idiocy" the congenital syndrome that now bears his name—on the basis that the physical and mental characteristics of those afflicted made them resemble members of the "great Mongolian family".[28]

Specific presentational methods were developed to serve the needs of the measurers. A system of photographing naked figures against a squared backdrop was devised by John Lamprey and published by the Ethnological Society of London in 1869 (Pl. 84).[29] Thomas Huxley, public advocate of Darwinism, established a method of systematic surveying of the body in full face, profile and with one arm extended, in images that included a prominent vertical measuring rod beside the subject, a method occasioned by a request from the Colonial Office for a programme for the "formation of a systematic series of photographs of the various races of men comprehended within the British Empire".[30] Not surprisingly, Huxley's rigorous method was often not sustainable in the field, for a variety of practical reasons and taking into account the varied social, religious and sexual niceties which affected the behaviour of both the photographers and their victims.

The most impressively systematic of all the projects to use photography in the service of new sciences of humankind was that undertaken by Francis Galton, a cousin of Darwin, in the 1870s and 1880s. In his *Inquiries into the Human Faculty* of 1883, which established the term "eugenics", he aimed to define an all-encompassing science of human heritable attributes—intellectual, moral and physical—with respect to individuals, families, groups, classes and racial types.[31] The purpose of such understanding would be to "co-operate with the workings of nature by seeing that humanity shall be represented by the fittest races".[32] Faced with the reality of "natural selection" as the Darwinian dynamic of evolutionary change, Galton believed that eugenic understanding could potentially ensure that "what nature does blindly, slowly and ruthlessly, man may do providently, quickly and kindly". Armed with the right data, man could:

learn how far history may have shown the practicability of supplanting the human stock by

130

84 John Lamprey, *Front and profile views of a Malayan male*, c. 1868–69. Carbon prints. Royal Anthropological Institute of Great Britain and Ireland.

better strains, and to consider whether it might not be our duty to do so by such efforts as may be reasonable; thus exerting ourselves to further the ends of evolution more rapidly and with less distress than if events were left to their own course.[33]

Since Galton was convinced that mental attributes could be measured by studying physical signs in the body, and that the face provided a singularly eloquent witness to heritable qualities, ways were required to establish visual typologies in order to define chains of descent and nexuses of affinities in individuals and groupings. Having observed a portrait painter in

action, he estimated that that a detailed likeness was the result of recording as many as "24,000 separate traits", and realized that handmade images in series could never be produced on the necessary scale.[34] Convinced that photography provided a special "assurance of truth" and that it was "subject to no errors beyond those incidental to all photographic production", Galton looked towards the new method in the accomplishment of the massive task of documentation required by his programme of research.[35] In 1877 he obtained from the Home Office photographs of inmates at Pentonville and Millbank jails, analysing them within three categories: killers, thieves and sex offenders. In 1884 he launched

131

85 Francis Galton, *Phthisical and non-phthisical cases*, 1877–90. Albumen silver prints. The Library, University College, London.

his *Record of Family Affinities*, as a kind of questionnaire for doctors, and in the same year established his project for *Life History Album*, promoted by the British Medical Association, which solicited the help of parents in compiling written and photographic records of their children's progress. As he worked through his accumulating visual material, he found that by "continually sorting the photographs in tentative ways, certain natural classes began to appear".[36] As a way of defining the "central physiognomical type of any race or group", he devised his technique of "composite portraiture" as the analytical arm of "pictorial statistics".[37] He claimed that his composites had finally realized the exalted synthesis of "typical forms" for which artists had been erratically striving over the ages.[38] By re-photographing portraits of members of his groups on a single photographic plate (sometimes combining as many as 200 examples), he aimed to extract the essential features of the common type underlying the individual variations in physiognomy. In addition to defining criminal physiognomies, he

sought composite "family likeness", and the common features of other groups—such as Jews, lunatics and patients prone to illness (Pl. 85).

Galton's theories and programmes were hugely influential. A particularly close follower was Artur Batut in France, who used composite portraiture as the central tool in his publication of 1887.[39] The general line of descent of this programme of eugenic manipulation into its hideous manifestations during this century are all too obvious. In retrospect, the science of Galton himself, with its aim of reducing the "residuum" of undesirable types of humanity, may seem to carry a whiff of genocide (Pl. 86). Morel's definition of "degenerate variants" in 1857 or an essay on "The Degenerates and the Modes of their Elimination" dating from 1900, could lead all too clearly to measures far from the benign kind that Galton envisaged.[40] It is difficult to look at Galton's programme now without the benefit of appalled hindsight, but if we take into account the tremors caused by Darwin's theories and their implications for the slow and brutal processes of the "survival of the fittest" in future generations of humans, Galton's aspiration to avoid the pain of bringing "beings into existence whose race is predoomed to destruction by the laws of nature" becomes more understandable and appears less sinister than misguided.[41]

Alongside the study of fixed features, a branch of physiognomics had been developed to provide criteria for the interpretation and portrayal of transitory expressions in terms of emotional states. A particularly influential impetus came from the visual arts, in the form of Charles Le Brun's widely translated *Conférence* of 1667, which annexed Cartesian notions of the way the bodily machine expressed the passions of the soul in the quest to define the specific facial configurations which could be taken as manifestations of such emotions as love, anger and fear.[42] Advocates of "pathognomics" could claim a testable basis for their ideas, not least in terms of the study of facial musculature, in a way that eluded those who advocated the divination of

character from fixed features. From Dr. James Parsons in 1747 to Dr. Charles Bell in 1806 and 1844, emphasis shifted towards a detailed study of the complex muscular interplays that result in such eloquent expressions.[43] Again, photography seemed particularly well placed to act as a tool of record and analysis. However, no one who has photographed faces in action can fail to discover how slippery are the readings of fleeting expressions. What was needed was some form of experimental control.

86 Batut, Plate II from *La photographie appliquée à la production du type d'une famille, d'une tribu, une race*, 1887. Collotype. National Gallery of Canada, Ottawa. The top two rows show coalminers of the Montagne-Noire region; the bottom two rows show native women of the Pyrenees. The centre three images are identified as archetypes, obtained from the male subjects (left); the female subjects (right), and all the subjects (centre).

Such a control was devised by Guillaume-Benjamin Duchenne de Boulogne in his 1862 treatise *Mécanisme de la physionomie humaine*, the most remarkable of all the photographically illustrated books in medical science before 1900.[44] Arguing, unremarkably, that photography is as "truthful as a mirror" as a form of "orthography of the physiognomy in motion", and given the traditional view that facial features are the "mirror" of the soul, he began in 1856 to photograph inmates of the Salpêtrière mental hospital in Paris, where he worked.[45] He began with the assistance of an actor, Jules Jalrich, but found that the results failed to clarify the actions of individual muscles. He then devised an experimental method for the activation of individual muscles in the face, convinced that each muscle separately manifested a "movement of the soul".[46] The "grand zygomatique", for example, he identified as the "muscle of joy", and at one point he listed no fewer than 53 emotions that could be codified in terms of muscular action.[47] His technique involved the application of electrodes to male and female volunteers in order to precipitate the expressions which arose from the contraction of a particular muscle or muscle formation. An elderly man proved to be the ideal subject, on account of his lined face, leanness, emphatically coarse look and limited cutaneous sensitivity (Pl. 87). The resulting photographs, taken with the assistance of Adrien Tournachon, Nadar's brother, were as visually striking in their way as the often exaggerated portrayals in the drawn manuals of expression. They were consciously set by Duchenne in the context of the great tradition of Leonardo and Michelangelo as artist–anatomists, compared to the paintings of such masters of expression as Caravaggio, Rembrandt and Rivera, and praised as exemplars for those practising the "plastic arts".[48] The "Partie Esthétique" towards the end of the book included photographs of women expressing a variety of emotions, and analysed famous sculptures from antiquity. While his favoured male subject was assigned the basic function of demonstrating the

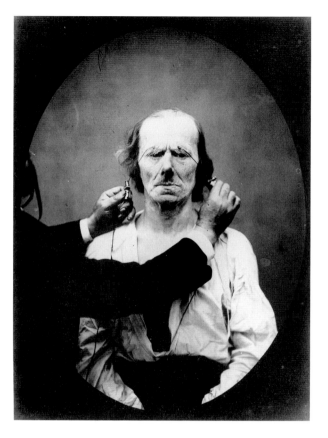

87 Guillaume-Benjamin Duchenne de Boulogne, Figure 13 (1854) from *Mécanisme de la physionomie humaine*, 1862. Woodburytype. By permission of the Syndics of Cambridge University Library, Department of Manuscripts and Archives.

muscular mechanisms, his women subjects were staged in little emotional and erotic dramas that demonstrated the way that the face could be read as a complex seat of narrative expression, even to the extent of documenting simultaneously competing instincts and convictions, such as "terrestrial love" and "celestial love".[49] His instrumental analysis of the expression of emotions achieves compelling visual results, yet the definition of each particular emotional state remains that of the observer, because the subjects were not actually experiencing that particular emotion at the time of the making of the image.

Duchenne's methods and even some of his

illustrations were influentially adopted by Darwin in *The Expression of Emotion in Man and Animals* (1872), which was highly critical of the unscientific arbitrariness of traditional handbooks.[50] He quotes a section on fright from Le Brun to illustrate the "surprising nonsense that has been written on the subject", and argues that very few works of art shed any worthwhile light on the question.[51] Like so many of his contemporaries, he saw photography as a tool for arriving at the truth, since it extended the limitations of the subjective eye: "I have found photographs made by the most instantaneous process the best means for observation, as allowing more deliberation".[52] He supplemented the use of Duchenne's photographs (for which he obtained permission) with other examples—above all, those taken both independently and at his behest by Oscar Rejlander, some of which exhibit the photographer's special penchant for theatricality (Pl. 88).

Where Darwin extends Duchenne's work is by setting human characteristics in the broader context of the natural world and its evolution— not in terms of traditional parallels between human facial types and animal physiognomies, but through an understanding of the origins of the expressive mechanisms:

> No doubt as long as man and all other animals are viewed as independent creations, an effectual stop is put to our natural desire to investigate as far as possible the causes of expression With mankind some expressions, such as the bristling of the hair under the influence of extreme terror, or the uncovering of the teeth under that of furious rage, can hardly be understood except on the belief that man once existed in a much lower and animal-like condition.[53]

Indeed, the expression of emotion in the human sense was not the reason why the muscles evolved:

> every true or inherited movement of expression seems to have had some natural and indepen-

dent origin. But, when once acquired, such movements may be voluntarily and consciously employed as a means of communication.[54]

The result is that some actions of the muscles result from the direct and spontaneous reaction of the nervous system, while others are the result of acquired habits and their consciously expressed antitheses.[55]

Characteristically concerned with the global scope of the study of man, Darwin circulated questionnaires to correspondents around the world, and his book analyses the results of the 36 that were returned. He concluded that "the same state of mind is expressed throughout the world with remarkable uniformity", in spite of

88 Oscar G. Rejlander, *Illustrations of Helplessness and Indignation*, 1872, Plate 6 from *The Expression of the Emotions in Man and Animals*, 1872. Collotype on paper. National Gallery of Canada, Ottawa.

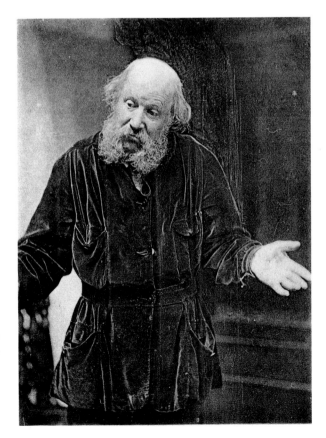

all the obvious cultural differences in languages of gesture.[56] Darwin's methods were intended to place the subject on a broader and firmer scientific basis than that so far achieved, even by Duchenne.

SIGNS OF MADNESS AND BADNESS

The portrayal of grotesque and "deviant" versions of humanity (or "sub-humanity") had been a feature of Western art from antiquity. The devilish physiognomies of medieval gargoyles, the monstrous parodies of Bosch and the risible foibles of Bruegel's cloddish peasants exploited the grotesque in contexts of the highest theological and social moment. The "fool" had long been a feature of the graphic and literary arts, not least through the image of the Ship of Fools. During the eighteenth century, the portrayal of the clinically insane arose as a conspicuous genre in its own right, with depictions of the inmates of asylums occurring in increasing numbers, either as freaks evoking horrified fascination or in the context of wider allegorical, social and moral meanings. Hogarth's series of paintings and prints devoted to *The Rake's Progress* (1753) culminates in a scene where the intemperate rake ends his days in Bedlam in the company of deranged beings who are characterized in terms of contemporary categories of insanity.[57] Attempts to describe external signs of insanity in relation to the classification of mental states were becoming increasingly sustained; they were accompanied by depictions of the insane as front-line tools of medical analysis and pedagogy. The most notable painted examples were the series of portraits produced by Théodore Géricault in 1822–23 for Dr. Etienne-Jean Georget, medical officer at the Salpêtrière, where Duchenne and Charcot were later to work.[58] Géricault's subtle and moving characterizations serve to alert us to a major problem in the portrayal of the insane, whether in painting or photography. The more subtle the

image, the more slippery it becomes as an analytical tool and the harder it is to use as a definitive exemplar of a category (Pl. 89).

The first developed programme to use photography as a major tool in the sciences of the insane was established by Hugh Welch Diamond in 1852 within the women's section of the Surrey County Asylum in Twickenham.[59] A founder-member of the Royal Photographic Society, Diamond was exceptionally placed both to recognize the potential of photography in defining the visual signs of the "types of insanity" and to control the technical parameters of the new medium in delivering the desired results. Speaking to the Royal Society in 1865 (see page 118, above), he made an eloquent plea for the status of photography as a kind of universal language, much as Leonardo had claimed in the Renaissance for painting. The photographer, he informed his distinguished audience of scientists, has

in many cases, no need for any language but his own, preferring rather to listen with the picture before him, to the silent but telling language of nature—it is unnecessary for him to use the vague terms which denote a difference in the degree of mental suffering, as for instance, distress, sorrow, deep sorrow, grief and melancholy, anguish and despair; the picture speaks for itself with the most marked impression and indicates the exact point which had been reached in the scale of unhappiness.[60]

Photography presents a means of avoiding those "peculiar views, definitions and classifications" that had arisen when no adequate bank of visual images was available. The images provided by the photographer "arrest the attention of the thoughtful observer more powerfully than any laboured description". In addition to its analytical and communicative potential, Diamond also investigated the possibility that photogra-

89 Théodore Géricault, *Portrait of a Woman Suffering from Obsessive Envy*, c. 1822. Oil on canvas, 72 × 58 cm. Musée des beaux-arts, Lyon.

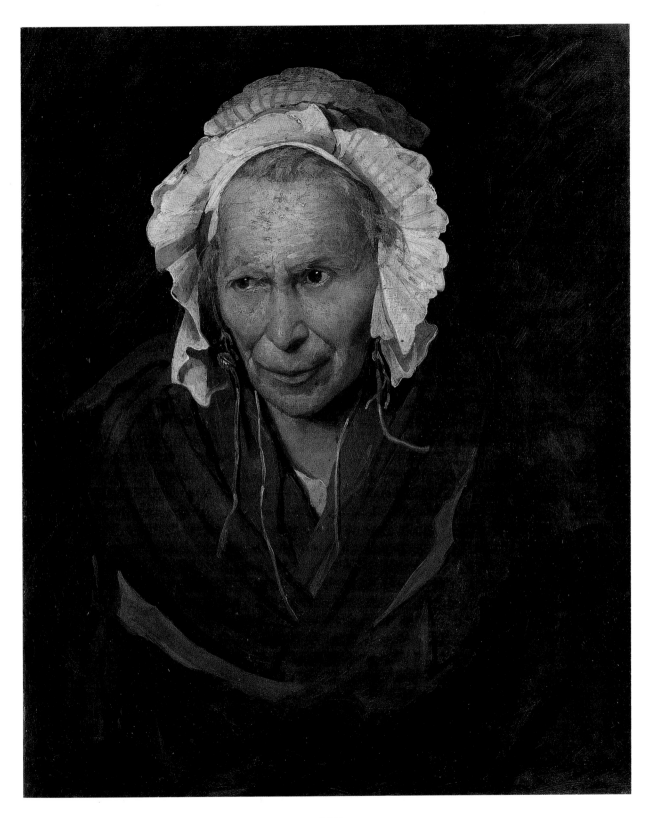

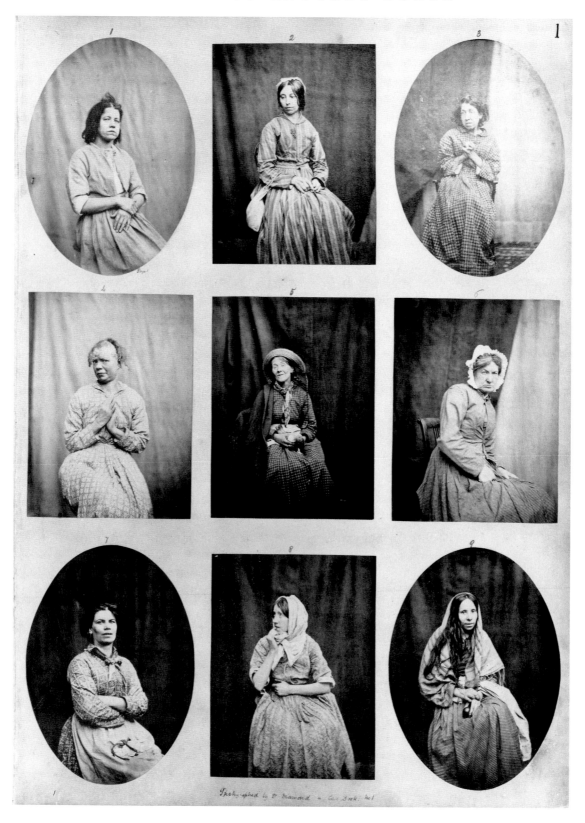

phy might actually play a role in treatment. He claimed that patients who were shown photographs of themselves *in extremis* were better able to develop an objectively therapeutic view of their condition. Looking at Diamond's actual portraits, we can see how their staging works entirely within the framework of portrait photography of the time, including the costumes and backdrops. It was the accepted nature of the conventions that permitted the attentive viewer to determine where postures and expressions departed from the decorous norm (Pl. 90).

The ambitions set for photography by Dr. Jean-Martin Charcot at the Salpêtrière after 1862 were no less extensive than those of Diamond, and existed in the context of an unrivalled attempt to create what may be called "visual psychology"—in which imagery and environments played a central role in diagnosis, recording, clinical suggestion, treatment and the design of the patients' surroundings.[61] Collaborating with Paul Richer, a trained artist, he published a richly illustrated series of annual publications devoted to the *New Iconography of the Salpêtrière*, which promoted a "method of analysis that completes written observations with images".[62] Richer also illustrated Charcot's *Les Démoniaques dans l'Art* (1887), which used artists' representations of possession and insanity to underscore the historical pedigree of his visual ambitions (Pl. 91).[63] Not surprisingly for someone who had trained under Duchenne, Charcot had already identified photography as a major resource.

Désiré-Magloire Bourneville, and Paul Regnard who arrived at the hospital as an intern in 1875, worked with Charcot on the *New Iconography*. It appeared in Paris as a series of volumes between 1876 and 1880, each visually prefaced by a comforting image of the hospital, particularly a view portraying it as a gracious establishment at the end of an avenue of trees.[64] Each photograph or series of photographs is used to document a case study, which includes a detailed diary of the patient's behaviour. The selection and presentation of the images set the

photographs consciously within the grand tradition of historic art, above all by reference to the rhetorical and theatrical resources developed by history painters over the centuries. The new objective tool was, for Charcot, providing non-subjective data for the reading of emotional states in an analogous way to the works of the great masters, who had taught us the language of bodily signs as best they could in the days before photography.

The appearance of the first of Bourneville and Regnard's volumes coincided with the *Nouveau traité élémentaire et pratique des maladies mentales* by Henri Dagonet, the Strasbourg physician, which used photographs by various doctors to illustrate the "principal types of

90 Dr Hugh W. Diamond, *Depictions of the Insane*, Plate I (group of nine images on sheet), 1856. Salted paper print. Royal Society of Medicine, London.

91 Paul Richer, *Saint Benoit Healing a Possessed Man*, from Dr Jean-Martin Charcot, *Les Démoniaques dans l'Art*, 1887. Osler Library of the History of Medicine, McGill University, Montreal.

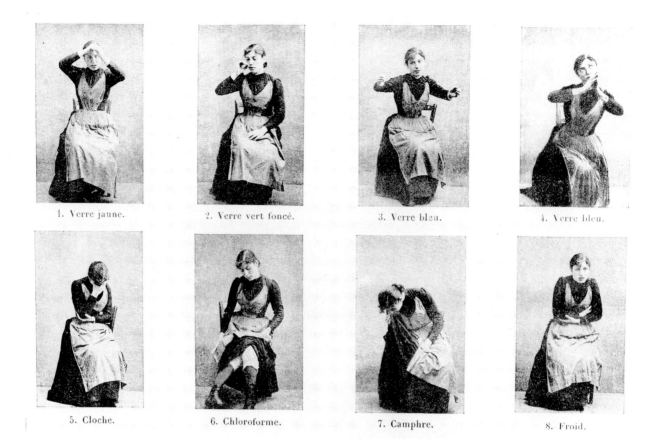

1. Verre jaune. 2. Verre vert foncé. 3. Verre bleu. 4. Verre bleu.

5. Cloche. 6. Chloroforme. 7. Camphre. 8. Froid.

92 Albert Londe, *Stages in catalepsy under the influence of several stimulations*, Plate VII from *La photographie médicale. Application aux sciences*, 1893. Engraving from a photograph. New York Public Library.

insane".[65] His eight sheets of plates illustrating 33 types, reproduced in the new medium of woodburytype, were intended as visual guides to the physiognomic characteristics of those suffering from specifically definable illnesses. Dagonet saw the parade of "real" photographic evidence as lending his book a special documentary authority, designed to lay to rest any doubts about the accuracy of his descriptions and classifications.

In the light of such activities by the pioneer photographers of the insane, it is not surprising to find that Charcot decided to established an official, in-house photographic unit at the Salpêtrière in 1878. Four years later, Albert Londe, who was to become a historian and major

theorist of medical photography, and who in 1891 was to make a significant contribution to photomicrography in pathological anatomy, arrived to work under Charcot's direction, not only taking photographs of the kind now expected but also devising new technologies for the recording of symptoms that had remained elusive for both the draughtsman and the standard photographic camera.[66] Londe was responsible for at least three inventions: a double camera, whereby one lens could be used to focus on mobile patients while the other linked system could be activated without delay to capture the instant of any significant motion; a portable reflex camera carried on a neck strap, devised in collaboration with Charles Dessoudeix, which

140

could be used informally and without the need to intimidate patients with the normal rituals in the staging of a portrait; and an elaborate apparatus with twelve lenses and an electric shutter set for five speeds, which could expose twelve sequentially "frozen" images on one plate in emulation of Marey's chronophotography.[67] Londe also recognized that somewhat longer individual exposures, which blurred moving limbs, could also effectively convey the nature of repetitive motions (Pl. 92).

In addition to his practical work, Londe produced a major reference work in 1893 dedicated to Charcot, his *La Photographie médicale*, which provided a historical overview of the photograph in medical practice, as an introduction to his definitions of the means and ends available to the specialist photographer.[68] In his preface, he justly noted that the practitioners of his own day were "only at the infancy of this new science". When photographing the exterior of the body—his particular concern at the Salpêtrière—he set out a systematic agenda in five parts: the depiction of the whole patient in views from front, sides and behind, against a neutral grey background; the portrayal of the head alone, defining three vertical planes as reference levels for depth of field (those of the eyes, nose and ears) and warning that photography of heads from close range produces unwanted distortions of relative scale through extreme effects of perspective; studies of hands, placed over a diagonally disposed board; pictures of the feet and lower limbs; and detailed images of the skin.

Given that photography of faces in medical and pseudo-medical contexts had centred on the contrast between characteristic forms of so-called normal and deviant physiognomies, it was natural that it was taken up in the context of the growing study of "criminal types", both for the obvious purpose of recording individuals for police records and as an analytical tool in the more general investigation of criminality. Galton's investigation of the facial types of criminals in London jails in 1878 set the tone for the analytical studies. The second major point of ref-

erence for the definition of kinds of criminality in relation to physical characteristics was provided by the Italian psychologist and physician, Cesare Lombroso, whose *L'uomo dilinquente* of 1876 went through many editions and translations in Europe and America.[69] Lombroso set out to determine those physical signs or "stigmata" that marked out the innately criminal person from the normal one. Studying the skull of Vihella, a notorious villain, he came to a sudden and wondrous realization that the born crimi-

93 Cesare Lombroso, Plate I from *L'uomo dilinquente: in rapporto all'antropologia, giurisprudenza e alle discipline carcerairie*, Fratelli Bocca, Rome, 1878. Lithograph. The University of Minnesota Library.

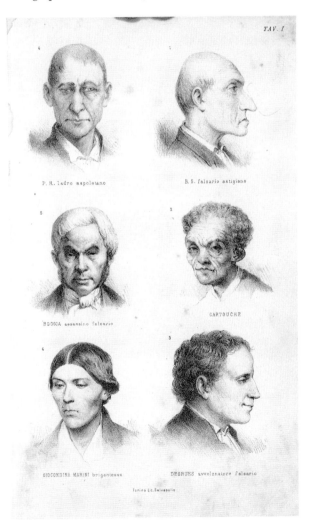

Sets of plates, each of which included as many as 56 individual photographs of criminals from Italy and elsewhere, were subjected to a tabular analysis according to 17 key physiognomic signs, with the idea that typical criminal traits would in this way become vividly apparent.

Although the conservatism of the judiciary meant that such evidence gained only limited credence in courts of law, large programmes of judicial measurement were set in train by police forces, both for reasons of precise identification and to provide data for systems though which the criminal type could be detected. The systematic recording of criminal types became a minor industry, with photography playing a central role. In France, Alphonse Bertillon (1853–1914) described and codified the procedures that were increasingly adopted throughout the world by those countries with advanced systems of policing and record-keeping (Pl. 94).[71] One particularly notorious individual—Giuseppe Musolino, a Calabrian bandit and multi-murderer—warranted two competing monographs in 1903 and 1904, in which photographs played an important role in interpretations of his "insanity" or "criminality".[72] The documentation of his physical characteristics extended to a photograph of his naked torso adorned with a decorous fig-leaf. In Britain one of the most influential promoters of such methods was Havelock Ellis; he openly acknowledged the influence of Gall and Lombroso in The Criminal (1890).[73] Amongst the photographic evidence put forward by Ellis were four-part images made with mirrors, as Galton had suggested, supplied by Dr. Hamilton Wey at Elmira, the New York State Reformatory. Such surveys were seen as providing incontrovertible instruction in how to recognize deviant departures from the healthy norm.

At one level, craniometry and criminal anthropology remained specialist territories, disputed by partisans of various theories and by argumentative number-crunchers. Yet the ideas irresistibly entered common currency, often in schematic form—much like the story of our

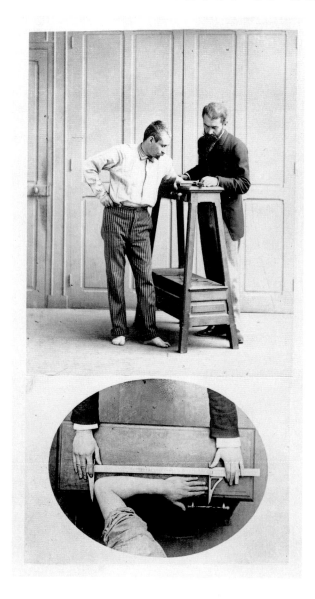

94 Alphonse Bertillon, *Measuring the Elbow*, from *Service d'identification de la Préfecture de police pour l'Exposition universelle de Chicago*, Paris, 1893. Albumen silver print on paper. National Gallery of Canada, Ottawa.

nal was "an atavistic being who reproduces in his person the ferocious instincts of primitive humanity and the inferior animals".[70] All those features of the head that could assume "primitive" forms, resembling those of apes and animals, were read as denoting savage traits (Pl. 93).

descent from apes, to which the notions of primitive criminality were so closely linked. Photography played a significant role in this popular transmission of visual notions. Sir Arthur Conan Doyle, trained as a doctor in Edinburgh, regularly allowed his detective Sherlock Holmes to exercise his physiognomist's eye for criminal and non-criminal traits:

> A man entered who could hardly have been less than six feet six inches in height, with the chest and limbs of Hercules From the lower part of his face he appeared to be a man of strong character, with a thick, hanging lip, and a long straight chin, suggestive of resolution pushed to the length of obstinacy.[74]

BODILY INTERIORS

On the face of it, the use of photography in anatomy could hardly be more obvious, playing up to its role as a tool of visual description and not venturing into analytical areas of the kind we have been studying. However, photography struggled from the first with the description of the interior topography of the dissected body. It was soon found that a black-and-white photograph of the often messy forms revealed in dissection was very difficult to read, since there could be little tonal and textural differentiation between different organs at different levels, and the visual quality deteriorated even further during the process of reproduction. When visual experiences are presented which are unfamiliar—as is the case in the interior landscapes of the human body—the viewer is less able to produce coherence by filling in the gaps on the basis of prior knowledge. Even as late as 1896, when Cleland and Mackay used osteological photographs in one of the publications designed to rival *Gray's Anatomy*, they admitted that "distinctness has been secured with the aid of retouching, often of an elaborate kind".[75] Even so, the results are hardly very impressive.

Retouching, particularly in the early days of photographic processes, was widely used to bring coherence into anatomical images. Reveal-

ing examples are provided by Nicolaus Rüdinger's pioneering attempts during the 1860s and 1870s to exploit "non-subjective" techniques of representation in the illustration of anatomy books. Impressed by the potential of photography to provide a true record of a dissection, the Munich anatomist availed himself of newly available methods of photographic reproduction to illustrate frozen sections and other aspects of his anatomical demonstrations. His *Atlas* of 1861 was illustrated with photographs by Joseph Albert, but they were so heavily reworked as to be virtually handmade prints.[76] Albert's photographs were also used in two later anatomy books by Rüdinger, but only as a basis for plates in steel engraving by Meermann and Bruch.[77] In 1873, the first and second volumes of a more comprehensive anatomical

95 Joseph Albert, *The trigemenal nerve and structure of the tympanic membrane*, Figure XII from Nicolaus Rüdinger, *Atlas des peripherischen Nervensystems*, 2nd edition, Stuttgart, 1872. Collotype. Thomas Fisher Rare Book Room, University of Toronto.

96 David Waterston, *Abdomen, Abdominal Cavity*, No. 4 from *The Edinburgh Stereoscopic Atlas of Anatomy*, T. C. and E. C. Jack, Edinburgh, 1905. Gelatin silver stereograph. Thomas Fisher Rare Book Room, University of Toronto.

series proudly advertised "thirty six figures in collotype [*Lichtdruck*] by Max Gemoser".[78] The collotype process—direct printing from a gelatine-coated plate after exposure to light under a photographic negative—had been developed to a usable point by Joseph Albert, and was first exploited in the printing of larger editions from lithographic stones by Max Gemoser in Munich in 1873.[79] It was, however, hard to deliver the degree of definition achieved in the hand-drawn lithographs of earlier atlases, and Gemoser's collotypes show extensive retouching. Even with such manipulation and the added enhancement of colour, the clarity of detail fails to rival representations by specialist artists. However, for Rüdinger, the virtue was that he could claim to be showing the real thing (Pl. 95).

Perhaps the most effective attempt to overcome the shortcomings of photography was made through stereoscopic imagery, which could give some real sense of the plastic shape and spatial positions of the various organs. An early example is a set of stereoscopic photographs of surgical matters undertaken in the 1860s by Thomas Billroth of Zürich, published in 1867.[80] A particularly grand stereoscopic atlas of clinical photography was published between 1894 and 1900 by Albert Neisser in Leipzig, documenting case studies and organized in sections devoted to surgical procedures, gynaecology and obstetrics, pathological anatomy, forensic evidence and diseases of the skin.[81] In the field of anatomy, one of the most pedagogically useful of the stereoscopic publications was devised by David Waterston and published in Edinburgh in 1905.[82] It comprised a series of cards, on the lower part of which were pasted stereoscopic photographs. The upper section of each card contained the descriptive texts, with keys to the labels that had been inserted into and on the

144

actual dissection (Pl. 96). The photographic images were to be viewed through a lenticular stereoscope of the kind that Sir David Brewster had earlier perfected at St. Andrews (where Waterston was to become Bute Professor).[83] Each box of cards was issued with a specially designed folding metal stereoscope.[84] The additional level of illusion helps hugely in separating out the spaces between superficial and deeper structures, and the scale-less quality of the images can produce a striking impact, with the progressively excavated interiors of the thorax and abdomen assuming cavernous qualities. The greatest limitation of such stereo-anatomies is the need for a special viewer. A photograph of the *Atlas* set up in the anatomy museum at St. Andrews shows that it was specially installed in a stereoscopic viewing box for use by students.

There is a sense in which straightforward anatomical photography was doing no more than providing a substitute for traditional forms of representation. Although its advocates could trumpet the standard claims about superior objectivity, it struggled perpetually to provide a visual cogency that would rival the best hand-drawn illustrations. More significant for the consideration of photography as a tool with a new potential within medicine were those techniques devised to serve special medical purposes.

Photomicrography (see Chapter 4) had already been envisaged by Talbot as a valuable scientific application of his new invention, and was specifically applied to histological preparations of slides and teeth as early as 1840 by Alfred Donné, who worked at the Charité Clinic in Paris. In 1845, Donné published engravings after some 86 photomicrographs by Léon Foucault (see Pls. 61, 62).[85] No less remarkable, and carrying a greater visual *frisson*, were the specialized techniques invented from the 1860s onwards which permitted photography to enter zones into which the eye or the standard camera could not venture. Devices and set-ups were designed to reveal the inner secrets of organs *in situ* and in the living patient in a way that intrusive surgery or destructive dissection could not

achieve. Pioneer attempts to photograph the larynx were made by Mandl in Vienna and Czermak in Budapest,[86] and in 1883 Lennox Browne, in collaboration with a teacher of singing, Emil Behnke, used a powerful carbon arc lamp, lenses and reflectors to provide superbly detailed images of the delicate engineering of the human voice box, at exposures of ¼ second.[87] The retina also presented both a particular challenge and a source of fascination for medical photographers. Rosebrugh's studies of cats and rabbits in Toronto in 1864 were followed by Jackman's and Webster's twenty-minute exposures of a living human retina in 1885.[88] Even more remarkable were the probing devices that relied upon the miniaturization of photographic apparatuses and that laid the foundations of modern endoscopy. The ingenious Walter Woodbury, inventor of the woodburytype for printing photographic images in half-tone (as used by Duchenne and Darwin), published a "photogastroscope" in 1890, which depicted the rough terrain of the interior of the stomach. Four years later Max Nitze accomplished the first successful photographs of the bladder using a cytoscope, providing striking pictures of the rugged stones that occasioned their owners so much agony.[89]

Such images—effectively allowing us as miniature beings to traverse the intimate cavities of the human body, rendering them as awesome caverns and mysterious tunnels—went beyond medical utility in their impact. They foreshadowed the television programmes and illustrated books of scale-less anatomical landscapes that have been designed for popular consumption in this century.

MALFUNCTIONS AND MALADIES

In the wake of the revolution in diagnostic medicine in the late eighteenth and early nineteenth centuries—which established the need for systematic recording of symptoms and detailed documentation of the histories of patients' conditions, particularly on a comparative basis—it is easy to see why photography, as the acclaimed medium of objective record, should be seen as

such a boon to the medical documentation of diseases. The photographic aesthetic also fell nicely into line with the greater standardization of surgical procedures within the increasingly institutionalized systems for the teaching and practice of medicine. With the convenience and speed of the second-generation processes, particularly after the invention of the dry-plate process in 1871 by Richard Maddox, himself a physician, a range of individuals and organizations in virtually all countries with developed medical institutions promoted schemes of photographic documentation. Scattered initiatives to document pathological and surgical matters had appeared in the 1850s, and the next decade saw significant progress in a number of centres, among them London, Washington and Paris.[90] In 1863, Dr. Henry Wright appealed to readers of the *Journal of Photography* to contribute to the collection he was assembling at the Medical and Chirurgical Society of London.[91] The practice of photographing patients in the hospitals of Paris had developed so far by 1869 that it could usefully be subjected to a comprehensive review.[92] A year later, in Philadelphia, Maury and Duhring established a pioneering periodical of medical photography, *The Photographic Review of Medicine and Surgery*; its range of photographs gives a good indication of the main genres in the early 1870s, including some effective examples taken before and after surgery.[93]

97 Unknown, frontispiece from Lewis Sayre, *Spinal Diseases and Spinal Curvature: Their Treatment by Suspension and the use of the Plaster of Paris Bandage*, Smith, Elder and Co., New York and London, 1877. Woodburytype. Thomas Fisher Rare Book Room, University of Toronto.

The most obvious early subjects of pathological and surgical photography involved conditions or deformities that manifested themselves externally in a gross manner, not only because they were easiest to document photographically but also because they attracted the kind of public fascination traditionally evoked by freaks and monsters. Images of such prodigies of nature as Siamese twins reached markets beyond that of the medical profession. Within the medical arena, images taken before and after treatment not only served to document successful surgical interventions, but also acted to promote a surgeon's personal achievements. Conspicuous congenital or pathological malformations, both before and after surgery, constituted a genre in their own right from the 1860s onwards. Johannes Wildberger in Germany and Adolf Lorenz in Austria were significant proponents of orthopaedic photography.[94] Lewis Sayre, formerly of the Bellevue Hospital Medical College in New York, illustrated four photographs in 1877 by the well-known London photographer John Edwin Mayall, which exercised a visual impact beyond their apparently minor role in his book as a whole, which was illustrated primarily with engravings (Pl. 97).[95] Photographs by

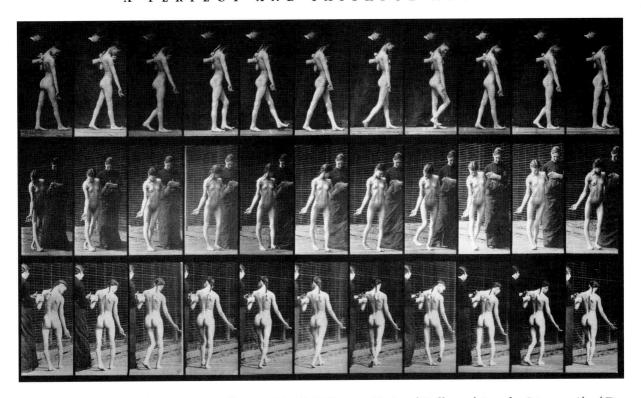

98 Eadweard Muybridge, *Spastic Walking*, 1885–87. Collotype. National Gallery of Canada, Ottawa, gift of Dr. Robert W. Crook, Ottawa, 1982.

Mayall had much earlier provided the basis for woodcuts in the third edition of Jonathan Pereira's *The Elements of Materia Medica* in 1849–54.[96]

The most ambitious and visually spectacular of the projects to document malformations of the body went beyond the recording of static postures. We have already noted the use of chronophotography by Londe to record the motions of patients afflicted with mental conditions. The originator of "time lapse" photography, Eadweard Muybridge, had exploited his technique to create living inscriptions of the irregular gaits of those afflicted by anatomical and motor disorders. In addition to his compelling revelations of human and animal motion in unhampered individuals, Muybridge worked directly with Francis Dercum in 1885 under the aegis of the University of Pennsylvania, using a specially constructed studio to document such conditions as infantile paralysis, spastic walking (Pl. 98) and lateral curvature of the spine, as well as artificially induced convulsions in a healthy subject. Selected images were published in 20 plates at the end of his huge, complex and sometimes disturbing compilation *Animal Locomotion* in 1887.[97] Dercum, who was an instructor in nervous diseases, regarded Muybridge's revelations as potentially important evidence in understanding the neurology of patients with various kinds of motor deficiencies and irregularities.

One of the most effective early uses of pathological photography was that concerning the skin, which did not present the obvious problems posed by internal organs. A series of publications—among them those by Alexander Squire, Hardy and Montméja, and George Fox—used the cartographic potential of a camera mounted directly in front of or above a suitably

147

illuminated surface to map the lesions characteristic of specific maladies.[98] Squire, a pupil of Sir William Jenner, used his photographs—"coloured from the life by one of the best artists"—in the service of the new comparative methods of diagnostic documentation, "securing accurate representations of remarkable cases, to compare them with other similar cases that subsequently came under my care."[99] The ambitions of Montméja, who took up photography specifically for the purposes of medical iconography, are nicely encapsulated in his photographic byline, "A. de Montméja. Ad naturam phot. et pinx"—an emulation of the great tradition of draughtsmen and printmakers who boasted that they portrayed things "from life". Montméja's naturalism is strongly purposeful; his selective and often vivid hand-colouring emphatically picks out only the lesions, and serves as a direct form of visual pointing. Hardy's introduction, in which he praises his pupil's "undeniable talent as a photographer and colourist", claims that photography rectifies the inexactitude of even the most scupulously naturalistic of earlier illustrative methods, and is cheaper to originate. The alarming external manifestations of the advanced stages of syphilis feature prominently in their compilation; such details became a major focus of dermatological photography, for example in Neisser's stereoscopic atlas where gummata and carcinomas are paraded in their full three-dimensional horror.

In such fields as pathology, orthopaedics and surgery, the reforming role of photography in showing when something abnormal or exceptional was happening to the human body might in retrospect seem clear, and less fraught with problems than depictions of the insane and criminal—and so it seemed to many at the time. However, as in other areas of medical photography, the problems were legion. The difficulties posed by visual confusion and lack of selective emphasis have already been noted and were apparent to some contemporary critics, although such shortcomings were less conspicuous when the subjects manifested external symptoms of a visually dramatic kind. The social issues are less obvious, but of no less moment. By the end of the century questions of anonymity and consent were being prominently debated. Identification of patients was a particularly sore point when the subject was a disease that carried a social stigma, such as syphilis. Some of the issues—such as the photographic recording of those in no condition, physical or mental, to give their consent—remained intractable to absolute answers. There were also niceties of social status to be taken into account. Generally speaking, it seems more likely that those of low social status and little influence in society would find themselves illustrating medical texts than members of the professional classes or the aristocracy.[100] Here, as always, the medical record produced by the camera was deeply, if covertly, expressive of the subjective proclivities of the originators of the images and of their subsequent viewers.

CONCLUSION: REPRESENTATION, RHETORIC AND INFORMATION

In as much as any medical text bears the mark of the culture from which it has arisen, it is inevitable that any photograph illustrative of that text will carry a series of corresponding cultural signs. The rise of photography coincided with increasing demands in many areas of science and technology for a style of illustration that was neutral and with the need to disseminate instructional texts to large readerships at affordable prices. Photography seemed well placed to meet both these requirements, at least after the invention of techniques for printing images in large numbers. The apparent neutrality of the "non-style" was itself a very special mode of rhetoric, the rhetoric of disinterested objectivity. The texts that were illustrated photographically frequently aspired to present sober accounts of empirical observations and procedures, in which the personalities of the scientists as emotional and social entities were increasingly excluded—at least from the most direct scrutiny.

148

Although texts and illustrations may serve as comparable monitors of the cultures of medical science, we should not lose sight of the fact that it is in the nature of visual artefacts that they function in ways that are not precisely text-like and stand in their own traditions, even when they are annexed to serve an end dictated from outside those traditions. Many of the photographers used by doctors were schooled and continued to practise in the standard genres of professional photography; inevitably, they brought with them the practical techniques and visual habits they had acquired. Even doctors who trained in photography were drawn into a set of assumptions as to what sort of thing a photograph was considered to be. It is not surprising, therefore, that the social texture of these images can be felt beyond their scientific content, a texture that can be related to the individual and institutional motivations of the participants on both sides of the camera. However, while determining the social and technical ways in which "the faithful and perfect record" remained elusive even for the most scrupulous practitioner, we should not fail to recognize that photography did provide a new tool with radical potential for the assembly of evidence and the conveying of information within defined modes of communication. The sheer ease with which huge numbers of depictions could be assembled was not the least important of the benefits, since in any wide-ranging comparative or classificatory study large numbers of images made in similar circumstances with similar technical means provided invaluable banks of data. The ability of the photographic eye to peer into obscure recesses and to magnify the minute served real functions in the transmission of knowledge. And, in the final analysis, even the limitations of the photographic process—with all its technical shortcomings in relation to our own flexible acts of perception—can be turned to advantage. Photography operates within established parameters; by the knowing operative, these can be kept constant or varied systematically to show something within defined technical and optical co-ordinates. The act of photography is predicated on a distinctly different relationship between the object and its representation than exists in other acts of depiction, although it is dangerous to generalize about the consequences of that difference in the varied territories across which it has been deployed. Even in the field of medicine, its consequences have been various and sometimes unexpected.

Even now, photography has not eliminated other modes of visual representation in medicine, including the traditionally drawn image, both naturalistic and diagrammatic. It is a tool, like the computer. Used with a full awareness of its strengths and limitations, it can deliver types of result that other kinds of images cannot manage. By 1900, successive generations of proponents of photography in medicine had realized not only that it did not deliver the easy benefits that at first had seemed obvious, but also that it had its own special role within the complex business of conveying medical information through the eyes and ears of the profession and public alike.

CHAPTER

6

The Expanded Present: Photographing Movement

MARTA BRAUN

THE PHOTOGRAPHY of movement challenged the generally held belief that the camera can only reproduce what is visible to us (if only we knew how to look). Instantaneous photography of moving objects established a world that is unavailable to our vision—a world beyond the reach of our senses. High-speed photographs of objects in motion show us what we can see only by looking at pictures, never by means of direct observation, and the accuracy of these pictures can be established only by comparing them to other photographs of the same movements. But if photographs of movement—and the technology that produced them—challenged the primacy of vision, this was only one of a number of their far-reaching effetcs. They led to the invention of motion pictures, and to significant advances in aviation and medicine. They furnished the basis for the study of ballistics; the training of athletes and soldiers; the beginnings of modern physical education; and the development of scientific labour management. Finally, they provided an iconography of dynamism for the art of the twentieth century, and helped change forever our experience of time and space.

The desire to capture movement, like the wish to see photographs in colour, stemmed from the medium's perceived role as guarantor

of the visible. Lack of movement and lack of colour were seen as attenuating photography's identification with real life; they were addressed almost immediately after the medium's birth in the 1830s, and continually thereafter. The limitations of the earliest photographic optics and chemistry prohibited the recording of moving subjects until the 1850s, when the advent of smaller cameras, faster lenses and simple shutter systems heralded the first widespread attempts at the photographic conquest of motion. The "snapshots" of this period (the word was coined by the astronomer Sir John Herschel in 1860) showed pedestrians and horse-drawn carriages photographed from a distance and frozen into awkward postures. The attitudes fixed by the camera—the machine that could not lie—were quite different from anything seen by the naked eye or depicted by the artist, and they aroused what would become longstanding arguments over competing claims to truth.

The concern of artists with what the world looked like—how it appeared to the eye, and to the camera as a mechanical and therefore objective extension of the eye—was shared with scientists. Both were interested in understanding what could be seen in terms of what could not, and both began with observation. Science had already exploited the new technique of photog-

150

raphy with successful results, particularly in recording what could be observed through the telescope and microscope (see Chapters 4 and 7). The first scientific experiments in recording objects in rapid movement, however, depended not on any existing instrument of observation, but on electricity or, more specifically, on the creation of electric sparks to produce the optical effect created by a flash of lightning as it illuminates the earth for a split second, freezing all motion.

The creation of sparks in the laboratory evolved from experiments in electricity undertaken long before the birth of photography. By the eighteenth century, these experiments had produced methods to create electricity (such as the Wimshurst machine, which built up an electrostatic charge by induction), and a means of storing and then discharging the resulting charge in a capacitor, a device made of layers of conducting plates and insulation. The Leyden jar, a mid eighteenth-century discovery, was one of the earliest of these. It was a glass jar wrapped and lined in tin foil. A spark was produced by linking the inner and outer foil layers with a conducting material attached to an electrostatic charge.

The optical effects of Leyden jar sparks were well known. Charles Wheatstone, for example, trying to determine the speed at which electricity travelled through a wire in 1834, noted how

A rapidly moving wheel, or a revolving disk on which any object is painted, seems perfectly stationary when illuminated by the explosion of a charged jar. Insects on the wing appear, by the same means, fixed in the air. Vibrating strings are seen at rest in their deflected positions. A rapid succession of drops of water, appearing to the eye a continuous stream, is seen to be what it really is, not what it ordinarily appears to be.[1]

It was not long before experimenters in England, France and Germany substituted the photographic plate for the eye. In 1850, John Tyndall in England used the electric spark illumination

of the Leyden jar to register the shape of a jet of water. A year later, William Henry Fox Talbot photographed a printed sheet rotating rapidly on a wheel. Talbot reported that the portion of the words printed on the paper "were perfectly well-defined and wholly unaffected by the motion of the disc",[2] and claimed that "it is in our power to obtain the pictures of all moving objects, no matter in how rapid motion they may be, provided we have the means of sufficiently illuminating them with a sudden electric flash."[3] In 1858, the German Dr. Bernhard Feddersen even had the photographic plate register the sparks themselves, to calculate their duration, the amount of energy they produced, and to show the direction of the electrical current. Feddersen used a rapidly rotating concave mirror to reflect the spark produced by his Leyden jar on to a moving wet plate. Knowing the mirror's speed of rotation, the length of the exposed band on the plate, and the angle between the beginning and end of the image and the mirror, he was able to determine mathematically the length of exposure on the plate and therefore the temporal duration of the electric spark. About the same time, the French physicist Eugène Ducretet illustrated the precise shape of the spark and its electrical decomposition in the atmosphere.[4]

While the advent of sophisticated electrical circuits and better capacitors would see the electric spark dominating high-speed photography for fifty years, at this early stage it could arrest only a single instant in any rapid movement. To record a movement in its duration, and to represent the relation of time and space that is the true form of any movement, scientists needed a method of photography that would furnish a succession of images, and at rapid intervals. The first requirement was fulfilled in 1874 with the astronomer Jules Janssen's "photographic revolver", an instrument that made a sequence of 48 images in 72 seconds, by means of a clockwork mechanism that rotated a circular daguerreotype plate mounted behind two slotted discs. Janssen invented his revolver to follow the transit of Venus across the sun and also,

crucially, to enable the study of the precise moment at the beginning and the end of the transit, when the activity at the surface of the sun, visible just for an instant, would yield information valuable to astronomical research (see Pl. 127). Although the transit itself is an event slow enough to be visible to the eye, the pictures on Janssen's daguerreotype were permanent, and could be studied at will.[5] This prompted Janssen to dub the photographic plate "the true retina of the scientist":

> it faithfully preserves the images which deposit themselves upon it and reproduces and multiplies them indefinitely whereas our retina erases all impressions more than a tenth of a second old, the photographic retina preserves them and accumulates them over a practically limitless time.

Although Janssen recognized that "the principal difficulty at the present time comes from the inertia of the sensitive plates, as images of this kind necessitate an extremely short time of impression," he nevertheless foresaw a brilliant future for series photography:

> The properties of the revolver, to be able to automatically give a series of numerous images as close together as one desires will allow one to approach the interesting question of physiological mechanics related to the walk, flight and various animal movements. A series of photographs that would embrace an entire cycle of movements relating to a determined function would furnish precious information on the mechanism of the movement . . . In regard to the still obscure question of the mechanism of flight, for example, one realizes how interesting it would be to obtain a series of photographs reproducing the various aspects of the wing during that action.[6]

I think it is important to note that the subjects of Janssen's statement are physiological movements, not astronomical. For while is true that

99 Baldus and Ozanam, *Pulse of an eleven-year old boy/94 beats per minute (no. 2 in a series of photographic representations of the pulse)*, 1869. Albumen silver print. Société française de photographie, Paris.

any rapid events remained beyond the reach of the slow daguerreotype or wet collodion plates then in use, it is also true that the world of such events inside and outside the bodies of men and animals—the beat of the heart or the rapid movements of the bird's wing—seemed, after mid century, to be of particular importance. The discovery around 1847 of the laws of thermodynamics, demonstrably applicable to both the organic and inorganic world, had produced a new conception of the body as a field of dynamic economies, manifesting different forms (light, heat, magnetism and electricity) of a single force or energy. But just how the body's energies were conserved and transformed—how it produced heat, transmitted impulses from nerve to muscle, deployed its energies in locomotion or became fatigued (the corporeal analogy to entropy)—remained still to be mapped out. This investigation had come to the forefront of physiology, a new science recently emerged from the shadow of anatomy as clinical laboratories became the norm in Europe. And by the time Janssen was writing in the late 1870s, the investigation had also begun to appeal to the imaginations of social scientists, philosophers and liberal reformers. For if the body could indeed

be treated as a thermodynamic machine, then science could subject the work it produced to the same quantification and measurement as the work of other machines, outside of the moral sphere of idleness and the exercise of the will.

Among the most recondite areas of the study of the human motor was the beat of the heart. The moments of contraction and distension of each heart chamber and the order in which they occurred, the shape of the pulse in normal and pathological cases, and the production of the double percussive sound the heart makes were all uncharted. The heartbeat was relatively slow, however, and this made possible some early experiments to inscribe its movements on a wet collodion plate. In 1865, Dr. Ernest Onimus, a student of Duchenne de Boulogne, captured the form of the contraction and dilation of the exposed heart of a tortoise simply by leaving the lens on his camera open long enough for the two phases to register their two different positions on the plate. Then, on 2 July 1869, Dr. Charles Ozanam presented a method of employing wet collodion plates to record the movement of the pulse to the Société française de photographie in Paris. Ozanam first artificially reproduced the artery and its movements by filling a 1 mm-diameter glass tube with mercury, sealing it at one end with a thin rubber membrane, and pressing the membrane against any part of the body where the pulse was strong enough to bob the mercury up and down in the tube. He then constructed a 35 × 12 cm black box, in which he enclosed the tube against a slot the same size which he cut into one side of the box. On the opposite side, he rigged a mechanism to move a wet collodion plate horizontally at a centimetre per second. As the mercury in the tube was raised and lowered by the rhythmic beat of the heart, light coming through the slot conveyed the mercury's motion to the plate as a jagged curve (Pl. 99). Ozanam was so successful with this method that he proceeded to carry out an encyclopaedic study of the pulse of subjects from 5 to 65 years old.[7] His experiments were repeated in 1877 in Vienna by a Dr. W. Winter-

nitz who used red liquid instead of mercury in his rubber-capped thermometer tube, and a heliostat (a slightly convex focusing mirror) to direct strong sunlight at the tube through a narrow slit in a cardboard shutter. Moving up and down in response to the pulse, the red liquid intermittently blocked the sunlight from a glass plate that moved behind the tube, and the result was again a stepped curve representing the movement of the heart.[8]

That same year, Etienne-Jules Marey (1830–1904), a French physiologist who would fulfil Janssen's predictions and hone the camera into a scientific instrument of the utmost precision, used the wet collodion plate to inscribe the variations in an interface of mercury and sulphuric acid as it responded to changes in the bioelectrical phenomena produced by the heart muscle. In other words, he made an electrocardiogram. But Marey noted that the photographic plate was, in this case, only translating the phenomena into phases of rectilinear movement as a function of time. He had already constructed graphing instruments to do this; they gave the same results as the curves on the photographic plate, and they did it more quickly.

MAREY AND MUYBRIDGE
Trained as a doctor, Marey's real interests lay in engineering and mechanics. He was what today we would call a biophysicist, convinced that the motion of the animate machine was subject to the laws of theoretical mechanics—laws that govern any assemblage of matter in motion—and determined to formulate what these laws were. Consequently, he borrowed graphing instruments used to measure changes in physics—like James Watt's "indicator" which graphed the steam pressure produced in a cylinder throughout the piston stroke—and fabricated instruments which could graph the changes that occurred in the body. Marey's graphing inscriptors allowed him to monitor movements hidden within the body, and have them trace themselves in a form of writing—he called it "the language of life itself"—which made them

intelligible for the first time. These ancestors of the electrocardiographs, encephalographs and oscilloscopes—still among the standard diagnostic apparatus today—were deceptively simple. A rubber membrane stretched across a slightly convex metal wafer intercepted the movement, such as the pulse, relayed it by hollow rubber tubes to a second rubber-covered wafer, surmounted by a stylus that traced the movement on to the surface of a smoke-blackened cylinder. With these instruments, Marey made the first accurate recordings of the pulse, respiration and muscular contraction (where he was able to show the earliest expression of fatigue); through their mediation, he transformed the present moment from a singular and ephemeral instant into a continuous and permanently recorded event.

To verify the results he had recorded, Marey fabricated mechanical models to replicate the phenomena he had analysed: a mechanical circulatory system, an artificial heart and lung, and a mechanical insect and bird that flew. For the study of the locomotion of men and horses, which he began around 1870, he had drawings prepared from his graphic notations and recombined the movement in slow motion by putting these into a zoetrope. Marey seems to have been among the first scientists to see the importance of this popular optical toy, a descendant of the phenakistoscope, invented in 1833 by the Belgian physicist J. A. Plateau. Both the zoetrope and phenakistoscope (as well as an almost identical device produced at the same time by Simon Ritter von Stampfer, called a stroboscope) took advantage of our inability to perceive the instants separating the phases of an object's rapid movement if those phases pass the eye faster than about 16 per second. When looked at in a mirror through evenly spaced slits on the circumference of a rapidly whirling phenakistoscope disc, a series of figures, each one representing a successive phase of a movement drawn on the disc, will give the illusion of continuous movement. In the zoetrope, the disc became a cylinder open at the top with slits in its circumference. Marey's zoetrope confirmed for him one of the most important findings given by his graphing instruments: in both the trot and the gallop, there was a phase when all four of the horse's legs were off the ground.

It was during this period of his study of human and animal locomotion proper that Marey confronted the limitations of his graphic method: it could not provide all the information he needed to make a proper analysis of the highly complex and numerous relations among the parts of the animate machine. His metal wafers required some form of physical contact with the movement they recorded, and not all moving subjects could be attached to them. Even to trace the up-and-down and back-and-forth trajectory of the bird's wing in flight, for example, he had to construct an elaborate harness and double lever system which could be used only with large birds and which prevented free flight. Nor could his inscriptors give a picture of the exterior characteristics of the form of the body in its changing dimensions as it moved, or of all the relationships that occurred both between one body part and each of the others simultaneously. Marey needed a pictorial solution—and in 1878, while he was still struggling with his birds, he saw one: a sequence of photographs of trotting and galloping horses published in the Parisian science journal *La Nature*.

The photographs in *La Nature* had been taken by Eadweard Muybridge (1830–1904), born Edward Muggeridge in Kingston-upon-Thames, England. Muybridge emigrated to America in 1851 and in the early 1860s took up photography in San Francisco, rapidly establishing himself as one of the outstanding landscape photographers in the West. In 1872 his reputation brought an invitation from Leland Stanford, builder of the Central Pacific Railroad and former governor of California, to photograph his horses. Intent on developing the greatest racing stable in the country, Stanford wanted Muybridge to produce a single representative image that would decide that perennial question of equine mechanics: whether or not there were

moments in the trot or gallop when the horse was entirely free of the ground. In 1874, however, the experiments were suspended when Muybridge left the country after being acquitted of the murder of his wife's lover on the grounds of justifiable homicide; they were redoubled two years later. During the intervening time Stanford had become aware of Marey's results, so when Muybridge returned to Stanford's new 9,000-acre farm at Palo Alto, Stanford instructed him to verify Marey's data by taking a series of photographs which would depict the complete phases of motion of each gait.

Stanford imported a set of Scovill cameras from New York and Dallmeyer lenses from England for this new set of experiments. Muybridge aligned twelve of these cameras along an outdoor track opposite 15-foot-high sheeting marked off with numbered lines 21 inches apart. The camera shutters, devised by Stanford's rail-

way engineer John D. Isaacs, were attached by an electrical contact to threads of galvanized cotton stretched across the horse's path; they were tripped in rapid succession by the animal as it raced down the track (Pl. 100). By the summer of 1878, Muybridge had succeeded in producing the first successful serial photographs of the horse in motion. Confined by the slowness of the wet-plate process, his pictures showed the horse as hardly more than a black silhouette against a white background. But because they were made by a camera, they established—with the authority a drawing could never have done—that the horse was suspended in the air in the trot and the gallop. They also established for the first time a picture of the phases of each gait (Pl. 101). Their publication was greeted with universal excitement, even while the awkward postures came as a shock to eyes used to seeing motion represented by the artistic conventions

100 E. J. Muybridge, *Arrangement of the Camera for Taking the Illustrations of the Paces*, Plate 1 (frontispiece) from J. D. B. Stillman, *The Horse in Motion*, Osgood, Boston, 1882. Collotype. National Gallery of Canada Library, Ottawa.

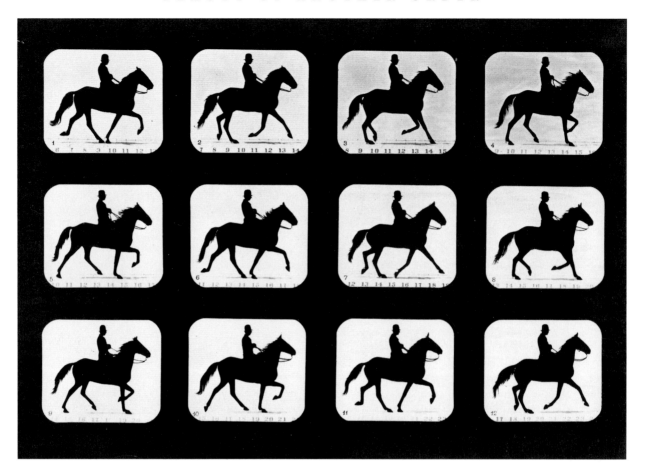

101 Eadward Muybridge, *Man astride horse*, 1878. Albumen silver print. Marjorie and Leonard Vernon.

of the age. Muybridge increased his cameras to 20 and then 24 and, in the summer of 1879, photographed other animals as well as gymnasts from the San Francisco Athletic Club who travelled to the Palo Alto studio. He made and sold zoetrope strips from the results and in late 1879 had perfected his "zoopraxiscope"—a projecting phenakistoscope. Called by the *London Illustrated News* "a magic lantern run mad", Muybridge's zoopraxiscope combined a magic lantern projector with two counter-rotating discs. One of these held images of the phases of movement drawn or painted from his photographs, and the other was slotted and timed so that it acted as a primitive shutter giving the intermittency needed for the illusion of motion. In 1880, armed with his zoopraxiscope, Muy-

bridge set out to give illustrated lectures—a vastly popular form of entertainment and edification that preceded and presaged the cinema—on that ever-fascinating subject, the horse.

However impressed one might be at the startling quality of Muybridge's photographs, there were serious questions about their scientific validity. He claimed to have taken pictures with exposure times as fast as $\frac{1}{2000}$ of a second, but neither these times nor the intervals between exposures were regular: the latter depended on the horse tripping the shutter threads, and these might stretch or contract before they broke. Because he used a battery of cameras, Muybridge could not photograph his horses from a constant perspective or a single point of view, and the distance between the phases of their movement

156

was so great that reconstituting the trajectory of the movement was burdensome.

When Marey saw Muybridge's sequential images he immediately realized that photography could be used to expand his graphic method. He also knew that to give as exact a rendering of motion as his graphic method did, a photograph had to show "the relationship existing at any moment between the distance covered and the time elapsed",[9] something that Muybridge's battery-of-cameras system did not allow. Muybridge's zoopraxiscope lecture tour in Paris in September 1881 confirmed the scientist's view. Muybridge, Marey wrote, "could not avoid errors that inverted the phases of the movement and brought to the eyes and spirit of those who consulted these beautiful plates a deplorable confusion."[10] So Marey set out to construct a camera that would render a visible expression for the passage of time simultaneously with a picture of the moving object in space. Within five months he presented his *fusil photographique* to the Académie des sciences in Paris (Pl. 102). It was a photographic gun modelled on Janssen's but significantly faster and more compact: Marey's gun took twelve pictures on a glass disc at intervals of ¹⁄₇₂₀ of a second, a speed that allowed him to photograph free flight for the first time. Apart from the gun's ingenious mechanism, the speed of exposure was achieved by the sensitivity of the new gelatine bromide plates that Marey was able to buy. These dry plates were first introduced commercially in 1880, and they opened a floodgate of experimentation in instantaneous photography and the scientific photography of movement.

But as the dry plate inaugurated a new epoch in movement photography, there was still much to be done in the way of making the camera into a precision instrument. Marey, for one, was not satisfied with the images produced by his gun: they were too few and too small, they lacked detail, and they were still, for his needs, placed too far apart on the plate for him to be able to analyse the intermediary phases of movement. Indeed, there were profound differences between the camera's way of capturing motion and that of the graphing instruments which he hoped it would supplant. The graphing inscriptors did not make pictures of the movements they were tracing; rather, they furnished Marey with a continuous expression of movement against precisely determined units of time. The camera depicted movement in quite a different way: it actually made a picture of the changes that occurred in instants in time, reproducing the outward form of the movement attended by a profusion of pictorial detail. Its reproduction was intermittent, and it represented sequential moments in time without the moments in between. For all that the camera could seize both the movement and its outward form simultaneously and required no transmitting force on the part of the subject, the rendering of movement in time as a continuous fluid passage was lost. The graphic method had given movement as a continuity, moving with the movement, echoing its every displacement, but it did so at the cost of concrete detail. The camera provided pictures with as much concrete detail as one would wish, but it did so at the cost of continuity and clear expression. Thus, to Marey's way

102 Etienne-Jules Marey, *Fusil photographique: view of the interior, exterior, and plate holder*, from *La Nature*, April 1882. Engraving. New York Public Library, New York.

103 Etienne-Jules Marey, *Man walking with cane*, 1890–91. Photographic transparency on glass. Robert Shapazian, Los Angeles.

104 Etienne-Jules Marey, *Man dressed in black costume with white stripes running*, 1886. Modern gelatin silver print from original negative. Musée Marey, Beaune.

105 Etienne-Jules Marey, *Demeny dressed in black with white stripes in preparation for geometric chronophotography, costume of 1884.* Modern gelatin silver print from original negative. Musée Marey, Beaune.

of thinking, although the photographic gun was an important breakthrough, it was still far from an ideal instrument.

Marey's next phase of research would solve these impediments, and it was undertaken in almost ideal circumstances. The city of Paris had ceded him a large space in the Bois de Boulogne where he constructed a sophisticated outdoor laboratory (his Station Physiologique); he had hired a new and able assistant, Georges Demeny, who was eager to apply Marey's physiological findings to the re-education of the body; and his mechanic, Otto Lund, turned out to be a genius at making Marey's plans into reliable instruments. By the summer of 1882, Marey had created a new method of making a sequence of rapid exposures. Working with human beings again, because their motions were easier to follow than birds, Marey dressed a man (he worked on the male, never on the female, because he saw the male as the archetypal human body) all in white and had him move in bright sunlight in front of a black background set up at the Station. Marey operated on this body with an ordinary camera but left the lens open in front of a rotating metal disc with from one to ten slots cut into it at even intervals. As the man moved in front of the black background, he was in a different location each time a slot in the rotating shutter exposed the glass plate, and his image was recorded on a different location on the plate to create a sequence of overlapping images.

This was a revolutionary method of photography, but it was totally in keeping with the principles Marey had established for the graphic method. Yet it still had a major defect: time and space, the two characteristics of movement, could not be rendered with equal emphasis. If he wanted the muscular forms clearly rendered, he had to record the phases of the movement more slowly, creating gaps between them. If he wanted to increase the number of images to render the temporal element more vividly, then the speed increase resulted in confusing superimposition. His next move was to operate against

the camera's inherent capacity to replicate all detail visible to the eye. For it was precisely the surfeit of detail frozen by Marey's camera that was obscuring what he wanted to see—the clear expression of movement. It was the camera's duplication of the seeming normalcy of vision that Marey had to supersede, in order to find the vision beyond sight. Operating on the subject this time, rather than the camera, he eliminated the confusing superimposition, first by covering the offending limbs in black velvet, and then by covering the whole body in black and marking its joints in white. Removing the imprint of flesh and skin finally revealed the moving parts of the animal machinery. Now he had pure movement detached from the performer, conveyed in a graphic form, and a photographic image totally without precedent (Pls. 104, 105).

Marey called this method "chronophotography", a name that soon came to be applied to all sequential photography. Chronophotography allowed Marey to give the first descriptions of the mechanics of how we actually walk, run and jump and how the animals with whom we share this planet propel themselves. In 1886, a new

106 Unknown, *Runner wearing experimental shoes and holding the recording apparatus*, 1872. From *Animal Mechanism*, 1874.

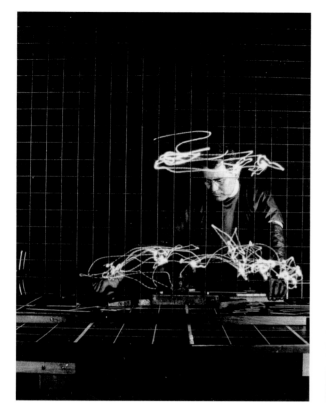 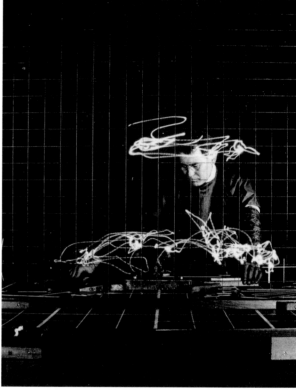

107 Frank Gilbreth, *Photograph of efficient work operation* and *Photograph of inefficient work operation*, c. 1935. Gelatin silver prints (stereograph). George Eastman House, Rochester, New York.

and blacker background and a faster plate resolved the problem of the clear delineation of musculature (Pl. 103) and allowed him to take up his study of flight again. He photographed birds obliquely and overhead to prove, finally, that if human beings wanted to fly it was not the bird that had to be imitated, but its flight. By substituting small electric light bulbs for the metal buttons and stripes on the human body, Marey could study pathological locomotion. By combining chronophotography and dynamometry—graphs produced by a pressure-measuring machine attached to the subject's shoes—he could measure the energy expended in each different locomotive act, opening the doors to the study of fatigue as a physiological phenomenon and, ultimately, to a scientific study of work (Pl. 106).

Frank Bunker Gilbreth's photograph of effi-

cient and inefficient work operation (Pl. 107) comes from one of the final phases of this study. In Europe at the end of the nineteenth century, Marey's chronophotographic and graphic methods were used to represent and analyse the motions of workers on shop floors and in offices in the bid to determine the ideal speed or posture needed to provide maximum economy of effort and minimum fatigue. This attempt to lay down an objective scientific basis for work separate from the age-old conflict between labour and capital rested on the unquestioned belief that the physical and mental wellbeing of workers was the foundation for the wealth and productivity of the nation—a belief that was ultimately naive, as events in America would show. There, the practitioners of scientific management, "efficiency engineers" or "industrial engineers", sought to increase productivity by

160

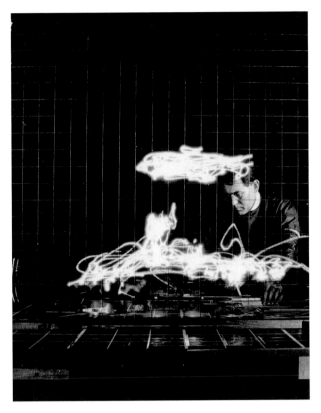 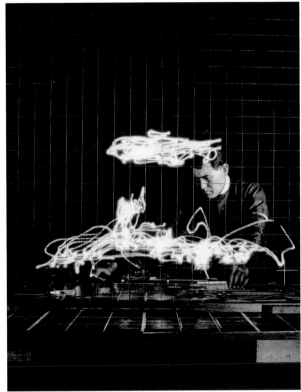

streamlining the work process and shifting its control from the worker to the manager. Frederick Winslow Taylor, usually thought of as the father of scientific management, claimed that to re-engineer the industrial workforce, management had to determine not only each step of the work process, but also the way each step was performed. Taylor used a stopwatch to analyse the motions of each repetitive task performed in the factory, timed the fastest worker, and forced the others to do their work at the same rate by tying speed of production to wages. Gilbreth was one of the colleagues who moderated Taylor's excesses by using chronophotography. His "chronocyclegraphic method" put the worker in a darkened room and tracked the movements of a light bulb attached to his wrist with a stereoscopic camera. He could interrupt the circuit to the bulb so that the

worker's movements would show up on the plate as dots or dashes, and movements of different workers performing the same task could be compared. These images, and wire models made from them, focused on standardizing the movement, not the time. They were instructional tools—the less adept worker could be taught to make his gestures more efficient by imitating the most streamlined and limited motions revealed by the chronophotographs.

ANSCHÜTZ AND LONDE
The immediate dissemination of Marey's results in popular science journals like *La Nature*, along with Janssen's continued—and equally well known—crusade on behalf of scientific photography, created a subtle shift in the status of the medium. The association of photography with scientific discovery in an age that identified sci-

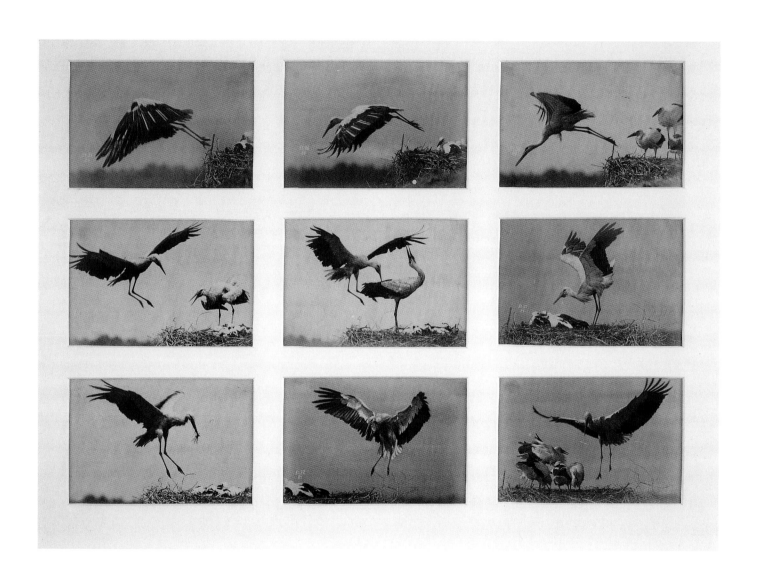

108 Ottomar Anschütz, *Storks*, 1884. Nine albumen silver prints from glass negatives. Museum Ludwig/Agfa Foto-Historama, Cologne.

entific knowledge with truth meant that its practitioners might be considered more than just "photographers". And the high status of science and scientists in the nineteenth century, when science was the prerogative of gentlemen and amateurs, accounts for the attraction of photographers to scientific photography. Eadweard Muybridge, Ottomar Anschütz (1846–1907) and Albert Londe (1858–1917) were not scientists who came to photography to solve problems they were already working on, but photographers who came to scientific photography as to a higher calling.

When Ottomar Anschütz of Lissa in East Prussia (now Posen, Poland) began to specialize in chronophotography in 1884, he was already a well-known professional photographer whose work was widely exhibited and published in Germany. He was also a gifted mechanic who had devised a number of improvements to his camera shutters to take advantage of the speed of the new dry plates when they came on the market. His single instantaneous images of troops on the march, street scenes and running horses, taken in 1882, were noted by the photographic press for their sharpness and large dimensions; by 1884, his photographs of horses captured in mid-stride were being compared favourably in German newspapers to those of Muybridge and Marey. In March of that year Anschütz published his striking images of storks taking off, flying with their enormous wings fully spread, and landing (Pl. 108). These dramatic images and Marey's earlier investigations of flight now became curiously intertwined in the birth of modern aviation. First, Anschütz's stork images inspired the early glider designs of German aeronautics explorer Otto Lilienthal, whose trial flights Anschütz subsequently recorded. Then, in 1896, when Lilienthal was killed in a glider accident, the news of his untimely death prompted Wilbur Wright to re-examine Marey's experiments on flight described in his *Animal Mechanism*. Next, as Wright recorded: "I was led to read more modern works, and as my brother soon became

equally interested with myself, we soon passed from the reading to the thinking, and finally to the working stage."[11] The result of the Wright brothers' work, the Kitty Hawk, was the world's first successful aeroplane.

When Anschütz turned to chronophotography, he used a battery of twelve cameras equipped with cloth focal-plane shutters of his own invention. The shutters made it possible to take twelve photographs in about ½ second at an exposure time of up to $\frac{1}{1000}$ second. The results were pictures of significantly higher quality than Muybridge's in their sharpness, detail, depth and composition.[12] Their exhibition, and increased coverage of Anschütz's activities by the popular press, soon attracted the interest and money of the German government. The Ministry of Culture granted him 25,000 marks for apparatus, and the Ministry of War assigned him to photograph the cavalry officers of the Hannover Militär Reitinstitut in order to develop a scientific basis for instructional techniques. In the summer of 1886, Anschütz left for Hannover, taking with him a new and improved chronophotographic apparatus, constructed with the money from the government grant. He had doubled his cameras to 24 and had constructed electrically linked shutters, each equipped with a small electromagnet operated by an electrical metronome. With this apparatus Anschütz could make 24 exposures in from 3 seconds to $\frac{72}{100}$ of a second. The individual cameras were quite small—they produced a 20 × 20 mm negative—and the entire array was only three metres long. So for subjects that were relatively close to the camera, he could move the battery itself past a central optical axis and lessen the parallax of the images.[13] At the riding school he photographed the cavalry and horses in every exercise, to show not only each pace of each animal, but also its relationship with the rider and the rider's posture, balance and position. Then he took pictures of athletes running, jumping, throwing javelins and discus, and other moving subjects for a proposed atlas on human and animal locomotion. In September 1888, Anschütz

even set out for the Krupp artillery range at Buckau-Magdeburg with his new high-speed cameras to record a sequence of the flight of a cannon shell. He had the shell itself set off his battery of four cameras by breaking tensioned wires strung across its flight path in the manner of Muybridge's experiments. But Anschütz's cameras were supplied with focal plane pneumatic shutters so no vibration would be introduced, and the intervals between the wires were carefully calibrated with a spark chronometer capable of measuring minute fractions of a second.[14] His results were partially successful. His timing was off—an image of the shell in flight appeared only on the first camera plate. And although he did get one clear picture at an exposure calculated at 0.000076 of a second, he did not achieve the sequence he set out to make. The experiment was conducted over a very short period—one or two days—so that the usual work of the factory and firing range were not too disturbed. This was his only attempt at the subject.

The eclectic and inventive Albert Londe—an amateur photographer and inventor who published more than a dozen important books on photographic processes and technology, founded the Société d'Excursions des Amateurs de Photographie in 1887, and created the first laboratory of radiology in 1897[15]—came to chronophotography by way of medical photography. Hired in 1882 as the chemistry assistant in the photography laboratory at the Salpêtrière hospital in Paris by Jean-Martin Charcot, who held the chair of nervous diseases, Londe moved quickly from that job to become the photographer and then, in 1884, the head of the hospital's photographic services. His subject was the symptoms of nervous diseases, primarily hysteria, manifested by Charcot's patients who were mostly women. The scope of Londe's photography was descriptive rather than analytical: Charcot wanted visual evidence to support his conviction that hysteria was a real organic disease with particular symptoms, and he wanted images that could be used to illustrate his lessons or his books. Londe's first camera, which

he constructed in 1883, combined aspects of both Marey's *fusil photographique* and Muybridge's battery of cameras, and was intended for use with commercially available 13 × 18 cm dry plates. It contained nine lenses arranged in a circle that Londe could consecutively unmask by a rotating slotted disc shutter operated by a clockwork mechanism and an electrical release.[16] He could vary the time between the demasking of each lens at will and, unlike Marey, he had the potential to photograph any subject moving in any direction and against any background. He intended the camera to be used as a portable machine by doctors, yet it never seems to have been adopted for such a purpose. He himself took few medical subjects: his preferred subject was the astonishing effect of instantaneity itself.

In 1891, Londe constructed a prototype of a larger multi-lens camera that could make images on 24 × 30 cm dry plates. This machine was not portable: it had twelve lenses arranged in four rows, each with its own electrically operated shutter that allowed for any combination of order, frequency and speed. By this time, on the example of Marey's Physiological Station, Londe had successfully appealed for state funding to build an outdoor studio in the gardens of the Salpêtrière hospital (Pl. 109). He had also begun what would be a long and fruitful collaboration with Dr. Paul Richer (1849–1933), a physician and gifted medical illustrator who was the director of Charcot's clinical laboratory and, from 1903, professor of anatomy at the Ecole des Beaux-Arts. The outdoor studio and Richer's interest in art and physiology effectively enlarged the scope of Londe's work from photographing patients in their hospital rooms in a clinical setting to photographing the wide world of movement in all its forms. Charcot died in August 1893, a few months before the definitive model of Londe's twelve-lens camera was finished. Contaminated by the polemic over hypnosis, one of the foundations of his diagnosis of hysteria, Charcot's reputation was already in decline. With his death, hysteria moved into the

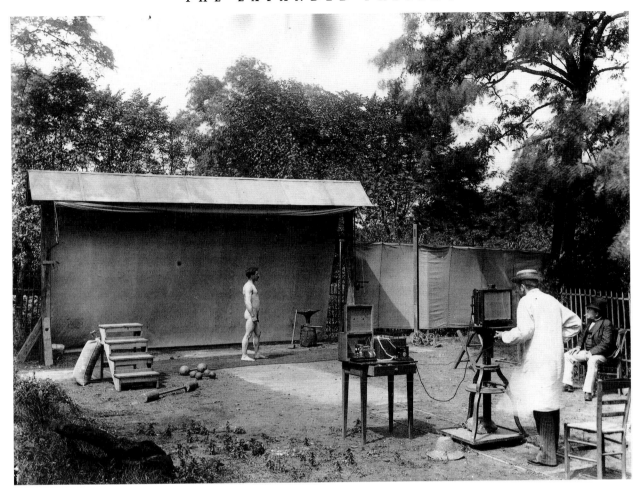

109 Unknown, *Albert Londe operating his twelve-lens camera, Marey seated on his right*, 1894. Société française de photographie, Paris.

shadows of clinical research at the Salpêtrière, and Richer moved new subjects into the sunlight for Londe to photograph.

One of these, a male athlete, participates in a play of doubling (Pl. 110). He submits to the double gaze of the doctor and the photographer, and leaves a double imprint—on the photographic plate and on the box. The image in the upper left corner doubles for the beginning or end of the series, which otherwise reads logically from right to left and from top to bottom. This chronophotograph is one of more than 300 Londe produced for Richer. Richer used a selection of these, as well as composite drawings he made from them, to illustrate a series of books

aimed at helping artists accurately depict the human body in motion.

The by now longstanding polemic over the non-conventional postures revealed by instantaneous photography was met in Richer's books—including the well-known *Physiologie artistique de l'homme en mouvement*, and *Atlas d'anatomie artistique*, both published in 1895—by the author's positivist-based view that the artist's search for truth must rightfully begin with the accurate observation of empirical phenomena. Chronophotography would extend the artist's realm of observation to include those poses not held long enough to be seen by the naked eye, and would act as a corrective to the

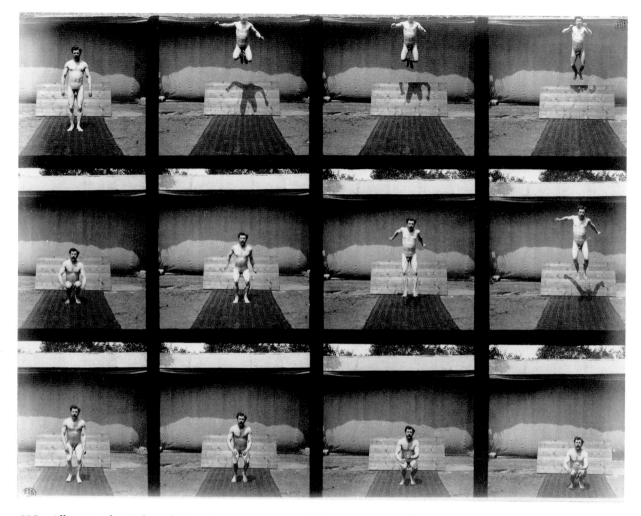

110 Albert Londe, *Male nude jumping*, c. 1890. Bromide (contact sheets). École nationale supérieure des beaux-arts, Paris.

data given by the unaided senses. The idea that correctness in art now had to be determined not by what can be seen by the eye but by photographic means had also informed Marey's and Demeny's 1893 book for artists, *Etudes de physiologie artistique faites au moyen de la chronophotographie: Du Mouvement de l'homme.*[17] As Marey wrote:

> These positions, as revealed by Muybridge, at first appeared unnatural, and the painters who first dared to imitate them astonished rather than charmed the public. But by degrees, as they became more familiar, the world became rec-

onciled to them, and they have taught us to discover attitudes in Nature which we are unable to see for ourselves, and we begin almost to resent a slight mistake in the delineation of a horse in motion. How will this education of sight end, and what will be the effect on Art? The future alone can show.[18]

The same athletes modelled for all the pictures in this book; they were elite specimens, athletes of grace and vigour, whose bodies conformed to the masculine ideal of the late nineteenth century. For Londe and Richer, in particular, their bodies were also intended to provide a canon of

166

proportions, "to establish a scientific *typos* of human proportions, at least insofar as the white race is concerned."[19] It was not so much the movement of the bodies in which Londe and Richer were interested, but the bodies that were in movement during those invisible changes in the direction of their actions, and the way that light and shadow played over rippling muscles and delineated the expressive images of male force.

DEMENY AND KOHLRAUSCH

In the work of Georges Demeny and Ernst Kohlrausch, chronophotography was used not only to educate the sight but also to intervene in people's habitual relationship with their bodies: the images became the means of educating the body by new movements, whose repetition and segmentation instilled a sense of responsibility and discipline, a respect for authority and class difference.

Demeny had first come to work with Marey in 1880 because he wanted to establish a scientific rationale for gymnastics and a scientific status for his ideas. He believed, as did many young French patriots after the débâcle of the Franco–Prussian War, that the way to combat the degeneration of the citizen and the soldier was through physical education, and he thought Marey's physiological investigations could be used to determine just how to get the individual into shape. In 1882, Marey and Demeny were given as subjects the cadets and officers from the Ecole Joinville-le-Pont, a military academy outside Paris that trained gymnasts and athletes for military and educational service. The army intended to revise their training manuals according to the results of the chronophotographic experiments, while Demeny hoped that the camera's fragmentation of the movements of these crack athletes would allow him to elicit the secrets of their physiological superiority. Marey described the thinking that led to this work:

One must make chronophotographs of the most

strong and expert subjects, of gymnastic champions for example. These elite subjects will thus betray the secret of their success, perhaps unconsciously acquired, and which they would doubtless be incapable of defining themselves. The same method could equally well be applied to the teaching of movements necessary for the execution of [the correct movements needed in] all manual performances, and in all kinds of sports.[20]

Success followed: on his own and with Marey, Demeny published the results of these experiments, and his methods of training gained the central currency he sought (Pl. 111). The manual for military and civil physical education was entrusted to him in 1887; in 1891 he was nominated to a commission sent to Sweden to investigate physical education instruction there, and he began a series of instructional and inspirational books on the physiological basis of his training methods. From 1890 to 1893 he continued this study of athletes, dissecting the movements used in different sports, the movements of children being trained in physical exercise and of soldiers being trained to march and handle arms. This work had a specifically didactic purpose. Broken down by the camera, and recombined in slow motion on the zoetrope or on the prototype projector Marey had by this time constructed, these movements were intended to be watched, absorbed and imitated by different, less physically fortunate bodies, and then the results measured against the original example by being re-photographed.

Demeny's chronophotographic work in gymnastics was replicated by Ernst Kohlrausch (1850–1923), one of the least known of the nineteenth-century chronophotographers.[21] Kohlrausch was a gymnastics teacher at the Kaiser Wilhelm Gymnasium in Hanover and from that base forged a distinguished career within local, regional and national gymnastics associations. In 1887 he wrote *The Physics of Gymnastics*—a classic textbook that went through eleven editions—on the proper body positions for various

exercises, heavily illustrated by drawings show-
ing how the muscles worked together in partic-
ular gymnastic movements. Kohlrausch must
have been aware of Anschütz's chronophoto-
graphic experiments at the nearby Militär
Reitinstitut in Hannover, but it was only after
he read Ferdinand August Schmidt's lengthy
article on chronophotography and its application
to the study of gymnastics (published in the
Deutsche Turn-Zeitung on 22 December 1887)
that he began to imagine chronophotography as
an instructional tool in gymnastics. Schmidt
had called chronophotography "a new and
important tool for the scientific, artistic, and
also gymnastic understanding of the teaching of
the movements of the body . . . [It] shows unmis-
takably in true-to-nature images all of the indi-
vidual moments from which a movement is

constructed, and which gives us a previously
unobtainable opportunity for a correct view and
an exact measurement of this subject." As far as
he was concerned, "We can be certain that many
still dark points of the teaching of movement
will be illuminated by such pictures. Through
this experience our possibilities of seeing will
undoubtedly become wider and deeper."[22]

When Kohlrausch set about making a
chronophotographic camera his aim was strict-
ly practical. He wanted some way of making
chronophotographs that could be used by gym-
nastic teachers in schools and clubs, so he had
to construct a machine that was cheaper than
anything produced by Muybridge, supported by
his millionaire patron Stanford; Anschütz, with
his grants from the Prussian Ministry of Cul-
ture; or Marey, with his government financing.

111 Georges Demeny, *Movement of a fencer*, 1890. Modern gelatin silver print from original negative.

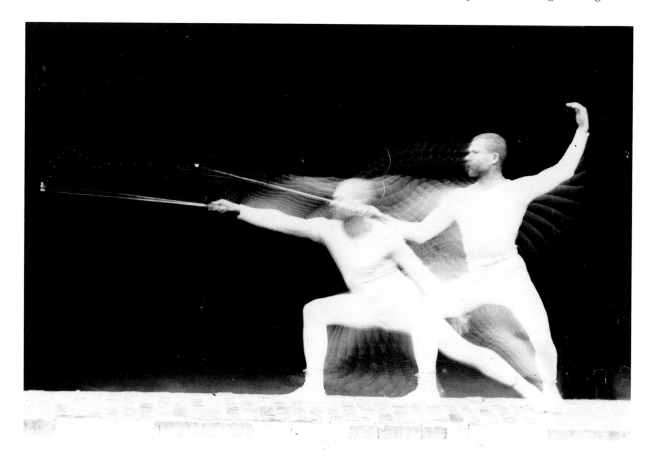

168

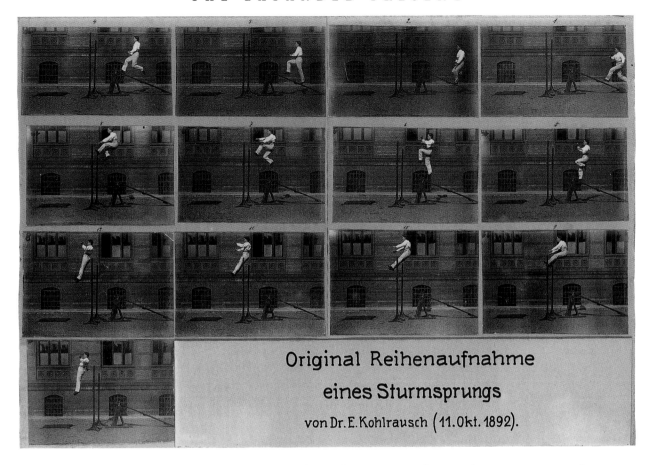

Original Reihenaufnahme

eines Sturmsprungs

von Dr. E. Kohlrausch (11. Okt. 1892).

112 Ernst Kohlrausch, *Springboard Jump*, 1892. Gelatin silver print, toned. Deutsches Museum, Munich.

Kohlrausch's first apparatus (for which he applied for a patent in October 1887) was, in fact, made out of the cheapest materials he could find. A large wooden ring held 24 cameras—their bodies made of a combination of wood and cardboard—and their glass plates. When turned by a handle, the cameras passed a spring-loaded shutter mounted behind an aperture at the top of the machine, and an image was made. This system, the first chronophotographic device to take a series of pictures on multiple plates from a single optical axis, eliminated the parallax inherent in the pictures of Muybridge and Anschütz. A second version of 1894 used only one camera body. Four lenses were mounted on a revolving ring in front of the camera and 25 photographic plates were mounted on a revolving ring behind it. These were connected by a gearing system that positioned a lens in front of the camera's aperture just at the moment when one of the plates was in position to record the image, tripped a cardboard shutter and then blocked the light from the camera until another lens came into position.

Perhaps in search of further funding, Kohlrausch started to work on Londe's original subject, the movements of patients suffering from nervous diseases. But we know nothing about the outcome of this venture, and there were no further developments. Although he had succeeded in building a series camera that was affordable, Kohlrausch lacked the resources to market it. He seems to have mounted his pictures of athletes on a zoetrope to show each exercise in slow motion to his students, and there is some possibility that he constructed a

way of mechanically combining the images to project them. Today, no athlete could do without the assistance of what the camera reveals; although the modern video camera has replaced Kohlrausch's apparatus, his pictures—the earliest ever taken of athletes outside the constraints of a studio or laboratory—remind us of our fascination with the body in expressive motion (Pl. 112).

MUYBRIDGE AND EAKINS
The most dramatic fulfilment of that fascination has been provided by Muybridge, whose locomotion study carried out at the University of Pennsylvania is one of the most curious challenges to our faith in the camera as the guarantor of the visible. After his meeting with Marey and his success with audiences in Paris, Muybridge left for London in February 1882 where he lectured with his zoopraxiscope and continued to look for the person or institution that would support a new project in locomotion photography. At first he met with the same success he had found in Paris; but the acclaim was abruptly ended one day in April by the news that Stanford had published Muybridge's Palo Alto

113 Thomas Eakins, *"Marey-Wheel" Chronophotograph of George Reynolds*, 1884 or 1885. Modern gelatin silver print. Philadelphia Museum of Art, gift of Charles Bregler.

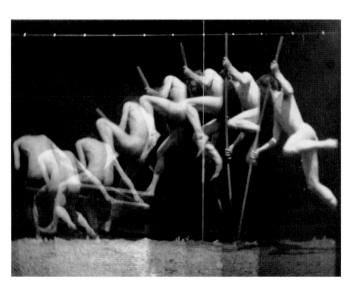

photographs to illustrate a treatise on the horse, but without Muybridge's name on the title page. Funding from the Royal Society, which Muybridge had hoped would be his as an independent investigator of locomotion, was now out of the question. The scale of the blow to his pride can only be imagined. Hastily, he booked passage on a ship home to initiate a suit against Stanford for copyright infringement.[23] Muybridge also wrote to Marey with an appeal to collaborate on a new project with himself and the French realist painter Ernst Meissonier, but it was never realized.

Back in America, no one seemed bothered by the omission of Muybridge's name from the Stanford publication and Muybridge continued to enthral audiences with his zoopraxiscope lectures. A demonstration in Philadelphia on 13 February 1883 brought him into contact with the realist painter Thomas Eakins (1844–1916). An accomplished photographer in his own right, Eakins photographed his family and friends, models to be used as *aide-mémoires* for his paintings, and he also used the camera in his teaching at the Pennsylvania Academy of Fine Arts. When Muybridge's pictures of movement had first appeared in late 1878, Eakins immediately wrote to Muybridge congratulating him and showing him how the pictures might be improved from the point of view of the artist. Eakins urged Muybridge to use a scale of measurement in the background of the photographs which would make it easier for an artist to copy the positions of the horse in their correct perspectival relationship.

Eakins's appreciation of Muybridge was shared by another Philadelphian, the sportsman and scientist Fairman Rogers. It was Rogers, seconded by Eakins, who persuaded the provost of the University of Pennsylvania, William Pepper, to put the grounds of the University hospital at Muybridge's disposal, and to give him money to undertake a new photographic study of locomotion. An invitation from the University was issued to Muybridge on 8 August 1883. With an initial outlay of $5,000 guaranteed by a com-

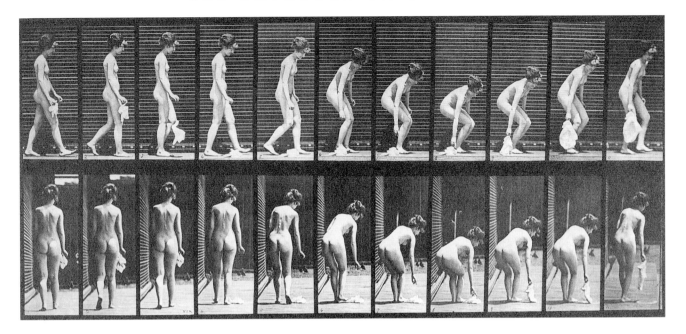

114 Eadweard Muybridge, *Dropping and lifting a handkerchief*, 1885, plate 202 from *Animal Locomotion*, 1887. Collotype. National Gallery of Canada, Ottawa, gift of Dr. Robert Crook, Ottawa, 1982.

mittee of the University, Muybridge began taking pictures at an outdoor studio that was built for him in June 1884.

The construction of Muybridge's studio—a shed whose interior was painted white or covered with a white cloth—was similar to the one he used to carry out his experiments for Stanford. Muybridge placed a bank of 24 cameras facing the shed while Eakins, who worked alongside Muybridge for most of the summer of 1884, used a "Marey wheel" camera—a single-lens camera with a single revolving slotted disc shutter that he had built in early 1883. Because he had problems with light fogging the plates, and with superimposition (the same difficulties Marey had encountered in 1882 and resolved with the artifice of the geometric man), Eakins tried a camera based on the principle of Marey's photographic gun which he used to make a series of images on a revolving octagonal plate. According to Prof. Marks, one of the authors of a book on Muybridge's work at the University, Eakins's camera was "devised from investigating the class of movement in one place, as that

of a man throwing a stone, where, in the Marey [fixed plate] camera, the images would super-impose."[24]

Like Marey, however, Eakins wanted each phase of the movement to be in a correct spatial position relative to all the others; he soon abandoned his experiments with the moving plate[25] and, by late August 1884, started making serial images on a fixed plate with an improved Marey wheel camera. Eakins's version was remarkably accurate: the exposure time was cut to one-eighth of what he had previously attained and, in the images he made, "the velocity of motion can be determined . . . with very great precision, as also the relative motions of the various members of the body" (Pl. 113).[26] That was the last summer that Eakins and Muybridge worked together. Disenchanted "with Muybridge's method and, one feels, with Muybridge himself whose showmanship was so at odds with his own public reticence",[27] Eakins left Muybridge to continue to photograph motion on his own at a studio he built behind his house. In 1886, his investigations of human locomotion complet-

171

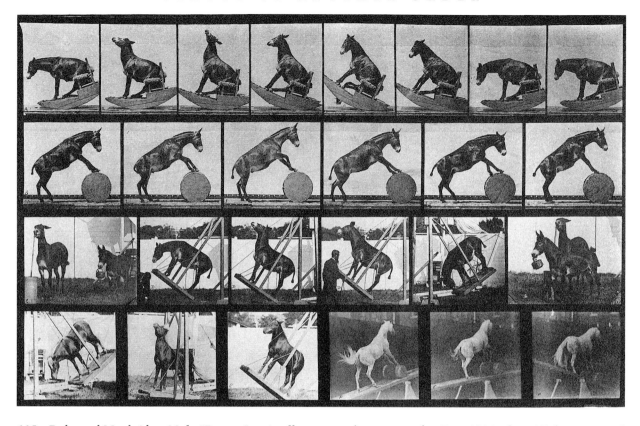

115 Eadweard Muybridge, *Mule "Denver", miscellaneous performances*, after June 1884, plate 660 from *Animal Locomotion*, 1887. Collotype. National Gallery of Canada, Ottawa, gift of Benjamin Greenberg, Ottawa, 1981.

ed, Eakins abandoned chronophotography.

Meanwhile, Muybridge spent the winter of 1884–85 in Philadelphia improving his multiple camera system. Armed with a new electro-magnetic device to operate the shutters, he began all over again the following summer. He had his subjects (the first were university athletes, and male and female models) move along a new track, in front of a roofless enclosure painted black inside and marked off in a grid with white threads. He photographed these models with up to three batteries of twelve cameras each: one parallel to the subject, and the other two at angles of 60 or 90 degrees to it (Muybridge called the pictures made with parallel series "laterals" and the others "foreshortenings"). Late in the summer he added a single camera with a row of twelve lenses (plus a 13th used for focusing), which could substitute for one of the batteries.

In August he moved his apparatus to the zoological gardens to take pictures of birds and wild animals, and in the fall he moved to the Gentleman's Driving Park in Belmont near Philadelphia where he photographed the locomotion of horses. The result of this work, eleven volumes containing a total of 781 plates assembled from 19,347 single images, was offered for publication by subscription in 1887 under the title *Animal Locomotion. An Electro-Photographic Investigation of Consecutive Phases of Animal Movements*; it is one of the most fascinating parts of the puzzle that comprises the whole history of movement photography.

From the notebooks Muybridge kept daily (now kept at George Eastman House, Rochester, New York) we know that, with six exceptions, he always made twelve lateral and 24 foreshortened views of each subject, yet only about half of

172

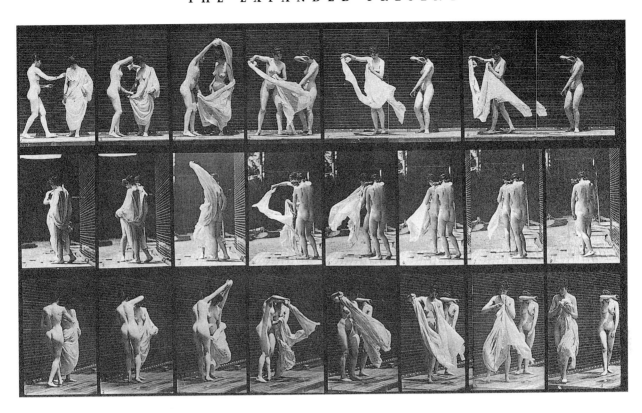

116 Eadweard Muybridge, *Woman disrobing another*, after 1885, plate 429 from *Animal Locomotion*, 1887.
Collotype. National Gallery of Canada, Ottawa, gift of Benjamin Greenberg, Ottawa, 1981.

the prints published in *Animal Locomotion* contain 36 intact images. The others are assemblages, whose sequential format dictates our perception of the relationship among the individual images that make up the finished print, even when there is no relationship (in Pl. 114, for example, we do not realize that one of the images is missing until we see that the third image at the bottom left is a reprint of the first).[28] For Muybridge, the recording of a complete movement, the capturing of all its phases, and the exact rendering of time elapsed and space traversed, were less important than a pictorially acceptable final print, even if the elements of a sequence had to come from separate picture-taking sessions. The contract between the viewer and the single photograph, which is based on the unshakeable belief that the camera cannot lie, has been extended by the viewer to include the arrangements Muybridge has made.

But despite the anonymity of the grid-like background, the seeming objectivity of the camera and authenticity of results, the unsystematic and incongruent aspects of Muybridge's photographs effectively obscure any knowledge of the underlying laws governing the mechanics of movement. In many cases the moving limbs are hidden by drapery. The very movements chosen for scrutiny—in the human realm, at least—are often unrepresentative. Are we to understand that there are constant factors that govern *Dropping and lifting a handkerchief*, or numerically expressed laws that can be derived from *Mule "Denver", miscellaneous performances* (Pls. 114, 115)? I think we have to understand these photographs not as scientific studies of locomotive mechanics but as a treasure trove of figurative imagery, a reiteration of contemporary

173

pictorial practice, and a compendium of social history and erotic fantasy. Like Marey, Muybridge used his camera to disclose those aspects of human activity that usually remained unseen—not because invisible to the naked eye, as in Marey's case, but because social conventions and morality dictated that they remain concealed except in the imaginative world of private fantasy. The gestures and postures Muybridge reveal objectify erotic impulses and extend voyeuristic curiosity in a language we now recognize to be taken from the standard pornographic vocabulary (Pl. 116).

The familiar three-dimensional construction of the setting in which the photographs were made becomes—especially in the photographs of women, where the illusion of space is always more pronounced—a schematic décor easily transformed into a bedroom, bathroom or parlour. The space stimulates more than just an interest in the rhythms of gesture and posture. Light and perceived depth, strong modelling and vigorous foreshortening call our attention to the stories being played out. Here Muybridge gives us fragments of the world, fragments that could be expanded into stories, dramas, jokes or fantasies—so that we would immediately recognize what we have never seen before. But if the explanations and representations of movements that make up *Animal Locomotion* are not scientific, they are still the most convincing *illusion* of natural movement that had hitherto been achieved. Muybridge's use of the camera emerges from and depends upon the conventional notion of photography which insists on the hegemony of the eye and its superiority over all the other senses in apprehending reality. What Muybridge produces with his camera seems real and familiar to us, to such a degree that even when he shows us phases of movement never seen before, the authority of the faith in the camera makes them undeniably acceptable. They closely adhere to what, at least since the Renaissance, we feel a picture should look like. Each frame encloses a single unit of time and space, and an illusion of three dimen-

sions has been created on a two-dimensional surface through light and dark. In portraying invisible phases of motion, Muybridge's camera has simply expanded visibility, reining the fragmentary gestures and postures of the world of motion into the traditional practice of picture-making.

In comparison, Marey's photographic analyses of movement reflect little of traditional photographic practice—he sought not to represent nature, but to discover the laws that governed it. For him the real and the visible were not at all synonymous—quite the opposite, in fact. Like all sense perception, vision was for him subject to error: rather than insisting on the camera's ability to duplicate human vision, Marey used it to create an unknown world where the observer has no part. The flat, two-dimensional calligraphy of his chronophotographs worked directly against the code of perspective built on the model of the scientific perspective of fifteenth-century Italy. There is no measured-off backdrop in the images he made to suggest space, and no clue to depth or recession can be perceived within the frame. Not only is the illusion of three-dimensional space negated, but each phase of movement is given within the same frame as all the others; the overlapping forms effectively destroy the Renaissance canon of a single frame–single time/space continuum. Marey's chronophotographs, like the data given by his graphing instruments, are ultimately contrived visualizations which have no existence apart from their realization. They challenge both the primacy of vision and its adequacy.[29] As a result, their aesthetic influence remained restricted until the explosion of abstract art in the first decades of this century, when such painters as Duchamp, Kupka and the Italian Futurists sought to abandon the replication of the visible world in order to give form to the new ideas of time and space that had been theorized by science and evidenced by photography. Then the images came to illustrate a modern experience of time and space, a thickened and simultane-

ous present, bursting with the exhilarating sensations of speed and dynamism.

THE REPRODUCTION OF MOVEMENT

In the appearance after 1895 of motion pictures on the screen for a paying public we can see the fruition of all attempts at realistic representations of movement such as Muybridge's: motion pictures were identified with life itself, and life itself in all its movement could now be mechanically replicated on the screen. Ironically, Marey's indifference to the duplication of sensory perception produced an analytic method that became the technological base of motion pictures—the technological base, in other words, of the industry devoted to duplicating the illusions of the eye and to fulfilling Muybridge's narrative fantasies.

The late 1890s saw a plethora of mechanical and optical apparatus fabricated in the attempt to resolve the technical problems of reconstituting the movements broken up by chronophotography. Marey's own cinematographic method was the result of his attempts to expand his graphic method once again. He could not synthesize his chronophotographs apart from some labour-intensive artifices such as his "synthesis in relief": an arrangement in a zoetrope of plaster birds he sculpted from his chronophotographs that allowed him to view a bird's flight from various points of view, and to reconstruct the revolution of its wings in three dimensions and in slow motion. Because his method of chronophotography functioned to capture each new location of the subject on a new location on his single plate, he could not make images of movement on the spot. Blacking out parts of the surface of the subject to eliminate them, moreover, could not be applied to all living creatures. To exceed the boundaries imposed by his black background and single camera, Marey either had to move the surface on which the images were made, or translate the images so that they were imprinted on different parts of the plate. After experimenting unsuccessfully in both these directions, he got hold of some of the newly available Eastman stripping film—paper strips about one metre long coated on one side with a sensitized gelatin emulsion—and devised a mechanism to move the film intermittently behind his camera lens. Marey's film-feeding mechanism pulled a strip of film from a roller on one side of his camera's lens, held it behind the lens long enough for an image to be made by means of a clamp mounted on a cam, and then pulled it on to a second roller on the other side of the lens. In October 1888, he presented his first results to the Académie des sciences: two bands of paper, about fifty centimetres long, one containing images of a hand opening and closing and the other of a pigeon in flight. The films were made at a speed of about 20 images per second at an exposure of $1/500$ of a second. This technique of a single camera, rotating disc shutter and the intermittent transport of film behind the camera lens marks the creation of the basic technology of the motion picture camera and projector. Returning to America in 1889 after seeing the workings of Marey's camera in Paris, Thomas Edison radically changed the direction of his experiments in motion pictures. His 1893 Kinetoscope, the first commercially successful chronophotographic synthesizer, was the result. By adding a better film-feeding mechanism to Marey's camera, the Lumière brothers were able to patent it as their Cinématographe in 1895, and to project motion pictures to paying members of the public.

Screening films for the public was not Marey's goal. Although he worked on a projector that would mechanically synthesize the results of his camera—slowing down some movements and speeding up others—he had no interest in duplicating sensory perception, no matter how entertaining the result:

Cinema produces only what the eye can see in any case. It adds nothing to the power of our sight, nor does it remove its illusions, and the real character of a scientific method is to supplant the insufficiency of our senses and correct their errors.[30]

reached the screen, provided the requisite intermittency to give the illusion of motion.

By March 1887, Anschütz had a new Schnellseher in which the diapositives were mounted on a steel disc and passed in front of the eye at 30 per second, providing sharp, lifelike and fully modelled images of a quality not to be seen in moving pictures for at least another decade. He demonstrated this Schnellseher at the Ministry of Culture in Berlin where it created a sensation, and soon news of its magic swiftly spread throughout the world. In 1888, Anschütz moved from Lissa to Berlin to market his focal-plane cameras and his photographs, and to give Schnellseher demonstrations. Then, in partnership with the electrical firm of Siemens & Halske, he attempted a wider commercial exploitation of his machine. Anschütz was a photographer, however, not a businessman; the venture soon came to grief, and in the process ruined him.

Marey's assistant Georges Demeny also saw that the instruments conceived in the scientific laboratory had an infinitely wider application than Marey had envisaged. Demeny began to work on quite a different solution to the synthesis of chronophotography when he took over a project from Marey to teach deaf children to lipread by imitating a sequence of photographed movements of the mouth. Demeny's Phonoscope, constructed in 1891, was similar to Anschütz's Schnellseher in that it contained diapositives crowning a glass disc. Demeny's intermittent, however, was a second slotted disc shutter that suppressed the light from a projecting magic lantern as one image supplanted another. The small size of these images made projection possible for only a few viewers at a time, but Demeny was not interested in projecting for large audiences; he thought that the Phonoscope would be used to make living portraits—a kind of animated family album (Pl. 118). Like Anschütz, Demeny forged a partnership with investors to market the machine for such use and, like Anschütz, he failed in the attempt, falling out with Marey along the way.

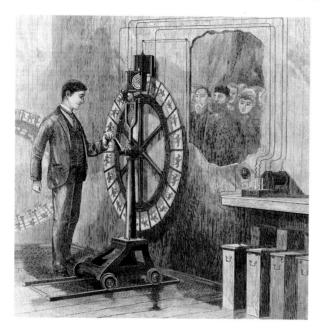

117 Ottomar Anschütz, *Electrical tachyscope*, 1899, from *Scientific American*, June 1889. Metropolitan Toronto Reference Library.

For Ottomar Anschütz, however, the projection of "living pictures" was a logical and inevitable step in his work.[31] By the autumn of 1886, he had made the first experimental model of his "Schnellseher", an apparatus which, like Muybridge's zoopraxiscope, was based on the principles of the projecting phenakistoscope (Pl. 117). But where Muybridge's zoopraxiscope had no intermittent movement, and required Muybridge to make elongated drawings from his photographs on the disc to achieve a proper representation, Anschütz's machine projected his original chronophotographs, enlarged and printed as diapositives. These—up to 24 of them—were mounted around the circumference of a wooden disc held in a freestanding wooden frame, and spun by a handle at its centre. As each image passed the eye behind a milk-glass viewing screen at the top of the wheel's frame, an electrical contact created a spark in a Geissler tube—a glass tube containing a rare gas—positioned next to the viewing screen. These repeated sparks, timed to go off just as the single image

176

Then, in an attempt to circumvent Marey's ownership of the camera he depended on to make his phonoscope images, Demeny contrived an improved film-feeding mechanism, eccentrically mounting the take-up film bobbin and later introducing the eccentric movement directly into the film path with a beater. He tried to interest the Lumière brothers in his improvements, but they were already working on their own motion-picture camera/projector. Although Demeny's beater would remain one of the principal means of producing intermittent movement in motion-picture projectors, he was unable to market the machine himself. In 1901 he ceded all the rights to Léon Gaumont and retired from the field.[32]

The advent of commercial motion pictures marked the increasing interdependence of science and industry. Instruments conceived in the laboratory for scientific purposes became appropriated by industry for commercial exploitation. As aesthetic chronophotography evolved into the dominant narrative cinema, scientific chronophotography became a specialist branch of motion-picture work which developed ever more sophisticated apparatus to analyse both slow and rapid movements. Lucien Bull, Marey's last assistant and the man who would direct his

118 Unknown, *Projecting the images on the phonoscope*, from *La Nature*, April 1892. New York Public Library.

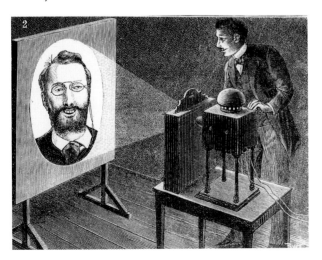

laboratory after his death, developed a high-speed film camera in 1900. By this time, Bull could get hold of an enhanced capacitor powered by an electrical circuit, and by means of a complicated timing mechanism produced by a vibrator in his circuit, he was able to furnish up to 2,000 flashes per second (Pl. 119). He dispensed altogether with the film-feeding mechanism and the camera shutter; instead, he hand-cranked the film at a uniform speed of 2–3 metres per second behind the lens, while the sparks froze movement and recorded it on the film. Cranking the film at ever faster speeds made the camera vibrate and marred the images. So Bull first diminished their size from 10 mm to 5 mm and then, in 1914, used a prism to displace optically the spark-illuminated images along the film band.

THE MOMENT DISTILLED

The coming of scientific cinema was by no means the death knell of chronophotography. It proved as useful a tool in physics as it had in physiology, as late nineteenth-century scientists took up the challenge of analysing and comprehending unseen events not in the body, but in the fluids that surround it. For just as the laws of the conservation of energy had provided a new explanatory model for the study of the animate world after the middle of the nineteenth century, they had also provided a new experimental basis for the study of electricity, magnetism, gasses, sound, light and heat in the inanimate. These invisible phenomena now had to be investigated as different manifestations of a single force or energy rather than as separate areas of physical activity, and precise instruments and apparatus had to be created to study where this energy went—how it was absorbed, resisted or dispersed. Photography was one of the most powerful of these instruments. It became particularly important in the study of air and fluid dynamics, as the interest of physicists shifted from phenomena that were invisible because of the speed with which they occurred, to the invisibility of disturbances in fluids produced by

177

governed animate and inanimate nature had prompted him in 1886 to begin to compile a sort of illustrated classical mechanics. His chrono-photographs of balls and sticks thrown or dropped in front of his camera showed that the differently shaped trajectories these projectiles made depended on the direction of the pro-pelling force and the resistance of the air. He also devised a chronophotographic method to measure the vertical acceleration of falling bod-ies, and to create geometric figures engendered by a thin cord or an arched band of bristol board as it vibrated in space around an axis. In the late 1880s he entered more deeply into the domain of physics proper in an attempt to make visible the motion of water and air. In 1900, these experiments, which stemmed initially from his studies of flight, led to his making his first wind tunnel—a box with multiple threads of smoke flowing over thin slips of mica which he intro-duced at different angles into the smoke threads. With a magnesium flash, Marey made instanta-neous images that showed the turbulent whirls and eddies as the smoke passed around his mica slips. This technique is still used today to test airfoils at low velocities.

The physicists who continued these experi-ments were interested in what happens at much higher velocities. The most important of these, German physicist and philosopher Ernst Mach (1838–1916), wanted to determine the waves made in the wake of projectiles moving faster than the speed of sound. His early experi-ments—producing shock waves by recording the displacement of soot on a glass plate by sparks—were abandoned for photography as soon as rapid dry plates came on the market. Mach knew that no plate or camera was fast enough to make an image of shock waves, but he was aware that the Schlieren ("streak") technique could be used to record their shadows. The Schlieren technique was a late 1850s invention of Bonn professor August Toepler. While working with imperfect-ly annealed glass, Toepler had discovered that uneven densities refract light waves differently in any transparent media, and he built an appa-

119 Lucien Bull, *Soap Bubble Bursting*, 1904. Gelatin silver print from a film strip. Photographic History Collection/National Museum of American History, Washington.

the speeding objects. Finally, as this study pro-ceeded into the twentieth century, photography was no longer used just to describe moving phe-nomena, but to establish their very existence for the first time.

Marey's belief in the identity of the laws that

178

ratus to take advantage of that fact. With a complicated system of lenses and diaphragms he blocked the unrefracted light rays coming through his glass so that he could observe the refracted waves. Mach was one of a number of subsequent researchers to add a camera and sensitive plate to Toepler's apparatus, setting the camera up so that the refracted waves were received on the light-sensitive plate. Then he could reflect a spark or beam of light in zig-zag fashion from a mirror, past the subject to another mirror, and then into the camera's lens. As the light passed through the air disturbed by the subject—a speeding bullet, for example—it was slightly bent, or refracted, and an image was produced on the plate both of the bullet and the surrounding air. Mach's preliminary experiments were done with his student J. Wentzel in 1884. Working with dry plates in a completely darkened room, they fired a bullet into two glass tubes setting off a spark just as the bullet passed the optical axis of the Schlieren apparatus. In this self-timing exposure, he got an image of the bullet, but not of the shock waves: his bullet did not travel faster than the speed of sound.

Because Mach theorized that the waves should exist only above the speed of sound (343 metres per second), he turned to his colleague P. Salcher to continue the experiments using the more powerful weapons at the Marine Academy in Fiume, Italy (now Rijeka, Croatia). In the summer of 1886, Salcher and his colleague S. Riegler used Mach's Schlieren technique to photograph a bullet shot from an 8-mm Gudes Infantry Rifle, travelling at 530 metres per second. They were able to capture the hyperboloid bow-wave created in the air travelling just in front of the bullet, the additional V-shaped waves proceeding from the body of the bullet and extending diagonally from its end, and a regular, pearl-like turbulence that followed in the bullet's wake. Salcher then began to experiment at the State War Ministry's Naval Section at Pola with a 9-cm artillery piece that Mach had sent from Germany. The Pola photographs showed even more detail of the waves created by the

flight of the shell, and they also showed that the greater bore of the artillery produced a different bow-wave. In the meantime, Mach had begun photographing with his son Ludwig at the Krupp artillery range in Meppen on a 4-cm rapid-firing cannon shooting a flat-headed shell at 670 metres per second. By December 1886, with the results in hand, Mach had formulated the now famous equation and the Mach numbers: the ratio of the projectile speed to the speed of sound.

Ludwig Mach continued his father's experiments until 1893, and made significant improvements to the Schlieren apparatus. He refined the control of the illuminating spark of the Leyden jar, shortened its duration by using the bullets to short-circuit the wires connected to each of the jar's terminals, and narrowed its focus. The photographs he made, clearer and sharper than anything done before with the Schlieren method, made the interplay of mechanical and thermal energies evident, and they transformed the study of ballistics. They demolished the theories that there was a vacuum formed behind the speeding bullet, and that wounds were inflicted by the air the bullet pushed in front of it. They showed clearly how sharper bullets created less drag and turbulence, and provided visual evidence for the second bang that we hear when a supersonic projectile is fired (Pl. 120).

In 1893, the English physicist Sir Charles Vernon Boys took up Mach's experiments with the Schlieren apparatus, reducing the duration of the spark to about one ten-millionth of a second to make photographs of a bullet piercing a sheet of glass. Boys dispensed with both camera and lens. He fired the bullet (at 650 metres per second) just in front of, and across, a photographic plate. The air compressed by the passage of the bullet with its different refractive index than air at normal pressure acted as a "lens" to bend the light falling on the photographic plate.

Boys had been experimenting with electric spark photography since the 1880s when he photographed falling drops of water and floating soap bubbles.[33] His technique was rather cum-

bersome, however, because he had to move the photographic plate by hand through his camera, and time its movement with the rotation of a slotted disc shutter and his electric spark. In 1894, the English scientist Arthur M. Worthington (1852–1916), professor of physics at the Royal Naval College in Devonport, took up Boys's photographic study of hydrodynamics and hydromechanics, and devised a different method of spark photography that would serve him well for more than 20 years.

Where Boys attempted to follow the different phases of a single splash, Worthington worked from the assumption that the sequence of events in any particular splash is the same as in any other splash if the conditions of its making and dropping are the same. He therefore constructed an apparatus that could forge different drops of equal size and drop them from exactly the same place on to the same surface. Then, in a dark room with a camera with an uncovered

lens and using a spark whose duration was less than three-millionths of a second—a speed prohibiting any appreciable change of form while the drop was illuminated—Worthington made a single image of each splash on a separate plate, but timed his spark to go off a fraction of a second later each time so he could track the whole evolution of the splash. The resulting pictures, he wrote, gave him the greatest pleasure in

contemplating the exquisite forms that the camera has revealed and watching the progress of a multitude of events, compressed indeed within the limits of a few hundredths of a second, but none the less orderly and inevitable and of which the sequence is in part easy to anticipate and understand while in part it taxes the highest mathematical powers to elucidate.[34]

Worthington's photographs showed the sequential instants of the jet or column of liquid rising

120 Ernst Mach, *Shock waves from bullets*, 1888. Modern gelatin silver print. Ernst-Mach-Institut, Freiburg, Germany.

121 Arthur M. Worthington, *Instantaneous Photographs of Splashes*, 1908. Gelatin silver collage. National Museum of Photography, Film and Television, Bradford.

from the surface around a drop when it hits, the shape of the crater around the jet, and the subsequent ripples and bubbles created as the two fluids interacted. The photographs in Pl. 121 are a series showing what happened when he dropped solid spheres, both rough and smooth, into liquids of different viscosities and at different velocities (Worthington recommended to his readers that "anyone who is not afraid of missing breakfast should keep a bag of marbles in his bath-room"). He captured the characteristic crown of droplets made by their entrance into the liquid, and even refined his apparatus to record the activities created below the liquid's

surface. But although he was able to follow the rapid changes of forms that took place in the bonding surface of the liquid, its stretching and compressing, and to picture its rapidly shifting evolution, he confessed that:

The interior particles of the liquid itself have remained invisible to us. But it is precisely the motion of these particles that the student of hydrodynamics desires to be able to trace. His study is so difficult that even in the apparently simple case of the gently-undulating surface of deep water, the reasoning necessary to discover the real path of any particle can at present only

181

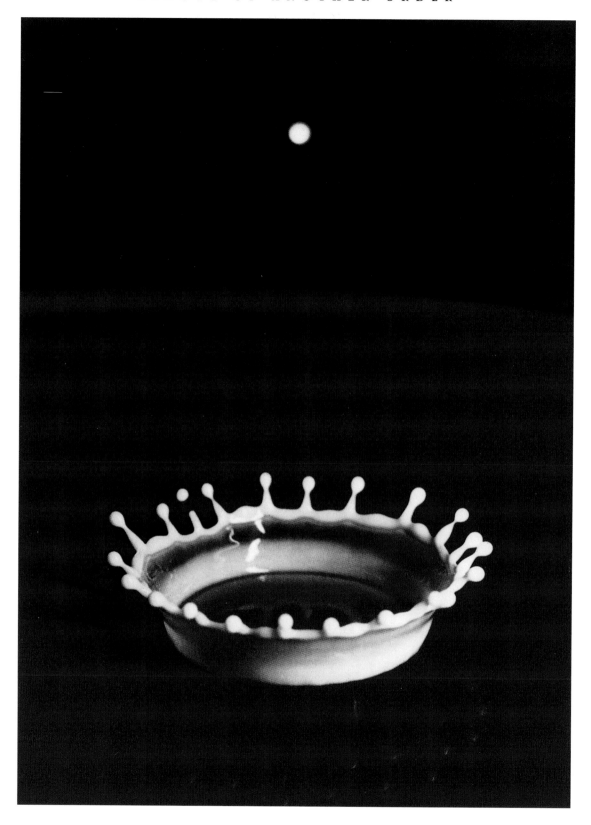

182

be followed by the highly-trained mathematician.[35]

The "real path of any particle" did not lie beyond the camera's reach for very long. The addition of the camera to the cloud chamber (by C. T. R. Wilson in 1911) and then the bubble chamber (by Donald Glaser in 1952) recorded the path of ionized particles through supersaturated vapour, and brought the most powerful detector yet to the seething universe of atomic and nuclear physics. Now the photography of movement provided its ultimate challenge to the authority of vision, producing a universe of theoretical mechanics that could be elucidated only by mathematics. In doing so, it also completed its transformation of science itself: what began as a mechanical means attesting to the pre-eminent position of the eye in the nineteenth century had, in the twentieth, served to change both the domain and general understanding of science. Beginning with Marey's chronophotography, the camera's rendering of invisible motion helped remove science from the province of amateurs, philosophers, tinkerers and seekers after knowledge and place it in the province of a few highly organized, and institutionally financed, professionals. Now clearly shut off from everyone not closely engaged in it, science was transformed from the language of the educated layman and the stuff of public knowledge to a recondite field of specialization whose theories were understood only by other theoretical physicists, and whose visible articles included images of lines, dots, curves, squiggles and smudges.

HAROLD EDGERTON

Then Harold Edgerton (1903–90), an inventor and developer of the electronic flash, made stop-action pictures that collapsed the intellectual boundary between entertainment and science, and renewed our belief in the power of photography to lend authority to vision. In 1925, while he was working as a research associate for the General Electric Company in Schenectady, New York, before taking up graduate studies in engineering at MIT, Edgerton noticed the optical effect described by Wheatstone: the bright flashes of a mercury-arc rectifier which he used to send power surges to a large electric motor made the fast-spinning parts of the turning motor look as if they were standing still. His curiosity piqued, Edgerton subsequently learnt of experiments in which flashes were produced by electrical discharges in evacuated tubes, and of the 1920 Swiss and American patents for an intermittent light source used to examine motors in motion taken out by the Peugeot Automobile Company. By 1932, back at MIT, he had produced his own sequential flash device.

Edgerton called his unit a stroboscope. It could emit 60 ten-microsecond flashes per second, a hitherto unimaginable speed. Its most innovative and critical aspect, however, was its renewability. As soon as his capacitor recharged (and it could be recharged in less than one microsecond), it could flash the tube enclosing the rare gas again. At first Edgerton used his stroboscope just to examine the turning rotor of synchronous motors; but he soon added a camera to record the frozen actions the flashing light made visible. He started with a motion-picture camera—dispensing, as had Lucien Bull, with both the shutter and the intermittent feeding mechanism. Synchronized with the camera so that with each flash a frame of film was exposed, the flashing light decomposed the phases of movement of one of his motors into 3,000 images per second, one third faster than Bull had been able to produce with his open spark, and fast enough that when the film was projected at normal speed the swift turning of the motor could be studied in slow motion.

Now an assistant professor at MIT, Edgerton looked to the commercial possibilities of his

122 Harold Edgerton, *Milk drop coronet*, 1957. Dye transfer print. National Gallery of Canada, Ottawa.

stroboscope and formed a partnership with two of his graduate students for its manufacture and sale. He filed for his first patent in 1933 with the agreement of MIT, which benefited from the patent profits to add staff and equipment to the electrical engineering department. For the rest of his life, Edgerton served as a liaison between MIT and industry, bringing in contracts for strobe research and photography, and developing partnerships with corporate sponsors such as Kodak which funded further research and helped him promote his work.

By 1934, Edgerton had turned exclusively to photography. In the process he redid the chronophotographic experiments of Marey, the Schlieren experiments of Mach, and the hydrodynamic experiments of Worthington (Pls. 122, 123). It was all quite easily accomplished. In personality Edgerton was much like Marey, a man to whom he paid homage throughout his career. He was a talented *bricoleur* who, with his strobe and from 1937 his single-burst gas-discharge tube, photographed everything from flying bullets to drops of liquid, the flight of insects and birds, the flow of air through fans and propellers, instants of sports actions and the cracking of materials during impact.[36] These images were brought to a larger public after a meeting with Westinghouse engineer and photographer Gjon Mili in 1937. As Edgerton and his MIT partners refined their experimental electronic flash systems, Mili informed them how the systems performed and gave them technical information from other photographers using them. This was the beginning of Mili's career as a professional photographer specializing in stop-action shots that he took on assignment for *LIFE* magazine. Through Mili, and through his own promotion-al efforts—his 1939 book *Flash* and his popular film *Quicker 'n a Wink*—Edgerton's photographs were seen by millions of people who, even if they knew nothing of particle hydrodynamics, could smile with recognition at a picture of the coronet made by a drop of milk. Throughout the 1940s Edgerton's pictures were bought and exhibited by museums, disseminated as postcards and published in *LIFE* and *National Geographic*. In 1949, he received an award from the National Press Photographers Association "for the cumulative results of his work which have brought better pictures as well as hitherto impossible pictures into public print."[37]

The hitherto impossible was now within the purview of everyone, thanks to the popularity of Edgerton's photographs. His pictures aroused a sense of wonderment that had very little to do with their validity as scientific data. With their sharp detail and simple formal compositions, often in brilliant colour, Edgerton's photographs easily appealed to eyes that were by now conditioned by the aesthetics of straight photography—an unmediated representation of the material. The wry humour apparent behind images of bullets exploding bananas, or piercing light bulbs or apples (the latter entitled "How to Make Applesauce at MIT"), adds to this appeal, as does the fact that so many of the events pictured are from the everyday world of the commonplace. As pictured by Edgerton's camera, these invisible events are uncannily familiar. The photographs reconfirm our belief in the camera's power to picture reality as something we can see. They persudae us once more to accept the belief that the ultimate arbiter of reality is, finally, what can be pictured by a camera.

123 Harold Edgerton, *Bullet through candle flame*, 1973. Dye coupler print. National Gallery of Canada, Ottawa.

7

Capturing Light: Photographing the Universe

ANN THOMAS

Almost all our knowledge of the cosmos is carried to us by the light
that fills space and shines from planets and galaxies. To engage that flow,
humanity draws on each aspect of light—the visceral response to the beauty
of the night sky, the deep-rooted need to find patterns among its stars, the
technology of telescope and detector that gathers distant light, the physical
understanding that relates light to internal processes of suns and black holes,
to cosmic birth and death.[1] *Sidney Perkowitz, 1996*

THE EVENING SKY as we observe it is an ever-changing pattern of light and dark as our satellite the moon, the stars, the planets, and the nebulae and galaxies make their appearances when they are well positioned in relation to the orbit and rotation of our planet, the earth. Earthbound, we experience the heavens in much the same way as we do a sequence of pictures, each image slightly changed as a result of the earth's rotation. With the exception of comets, we do not experience motion in the sky as continuous but rather as segments of changed relationships. How well we can visually navigate with the naked eye around the heavens and locate our planet within this vastness depends on how much we know about the structure of the universe. But even with the most up-to-date knowledge, we do not know enough to formulate a complete picture of the cosmos. Our distant

ancestors created constellations in the sky making a portrait gallery of hunters, warriors, deities and animals in order to establish a relationship with an uncharted space. Changes in the patterns of the appearances of celestial bodies were understood in familiar terms of causality—early Inuit observers interpreted the obscuring of the moon by the earth during a lunar eclipse as the moon's disappearance into the sky: "In the old days," said an elder, "it was thought that it entered into the sky as if in a hole."[2]

Today, many aspects of the cosmos are observed through the medium of different kinds of radiation which we cannot see because they are not limited to the visible spectrum. New cosmic structures have been identified and velocities and temperatures determined and yet, in spite of our greater knowledge and deeper understanding, the sky in its visible and invisible elements continues to exercise a profound

influence upon the human imagination, as it did with Walt Whitman's student of astronomy, in his poem *When I heard the learn'd astronomer*. Having all the "proofs, the figures . . . ranged in columns" before him and knowing how to add, divide and measure the charts and diagrams, he turns to the observation of the night sky:

How soon unaccountable I became tired and sick,
Till rising and gliding out I wander'd off by myself,
In the mystical moist night-air, and from time
 to time,
Look'd up in perfect silence at the stars.

Capturing the mystery of looking into the night sky and exciting our sense of wonder, photographs of galaxies, nebulae, comets and star-filled skies nevertheless present a curious contradiction. They reduce the immensity of the universe to the familiar scale of photographic paper and television screens, and yet the vast expanses of both space and time which these images represent—amounting in certain instances to billions of light years—lie completely outside our everyday experience of viewing the world around us.

Astronomical photographs describe macrocosms beyond human scale, much like the images in the "discovery photographs" of atomic particles describe microcosms, in which the central subjects inscribe themselves as blotches, streaks or abrasions (see Chapter 4). Celestial light reaches us from a multitude of sources, such as distant galaxies, dying stars, forming stars, nearby stars, planets and passing comets in a variety of intensities and forms: modulated, twinkling, glowing, pulsating. All of this occurs against a black background, without perspectival reference points or any markers of scale.

Often it is through events of dramatic change—such as eclipses of the sun and the moon and the appearance of comets—that our attention is drawn back to contemplation of the skies and our place within the solar system. The experience of having our source of light and

energy temporarily eclipsed is a dramatic event, not without a touch of menace, just as the arrival of a comet was frequently anticipated with foreboding. The obscuring of the sun by the passage of the moon across its face—a solar eclipse—provoked a great deal of excitement amongst scientists and photographers of the nineteenth century, and with good reason. It was not only for their dramatic visual effects of changing light upon the landscape, or for the beauty of the two discs in the sky, one overshadowing the other, that these events were recorded, but rather for their rarity, particularly when the eclipse was total and offered the possibility of recording phenomena visible only while it was happening. Total eclipses, while exerting photojournalistic appeal, more importantly provided photographers and astronomers with an ideal opportunity to observe the chromosphere and the corona of the sun unimpeded by the glare of the intensely bright photosphere, as well as the stages of the eclipse.[3] Even nineteenth-century sceptics who doubted the scientific usefulness of photographs taken of the moon believed that photography could play an important role in recording astronomical changes; for them, an eclipse provided just such an opportunity.

OPTICAL ILLUSIONS AND REAL
PHENOMENA: RECORDING ECLIPSES
Television, film and photography have introduced to the popular imagination astronomical events and space missions, from eclipses to humans landing on the moon; they have given us a certain familiarity with the appearance of these phenomena and events in the solar system. Prior to these technologies, the experience of such events was typically seen through direct observation, either with the naked eye or through a telescope. With the introduction of photography, an imaging process came into place that could record these observations in a permanent form in such detail that the facts could be separated from fiction. As well as accurately recording the features of celestial bodies,

a mechanical imaging process like photography was seen as a means whereby the vagaries of human enthusiasm could be countered. Eclipses, some of which lasted several hours, aroused the emotions to such a degree that Rudolph Radau, a writer on astronomy and photography in the latter part of the nineteenth century, considered scientific objectivity to be impossible to achieve on these occasions.

Because the intense light coming from the centre of the sun is temporarily shielded during an eclipse, the outermost layer of the sun's surface—the chromosphere and its features, the corona and prominences (luminous clouds of gas appearing in the corona)—can be observed and recorded at their most pronounced. Photographs of the event can then be studied, and the spread of the corona, the shape and scale of prominences and the instants of contact that mark the beginning and end of totality can be determined. Such photographs, to prove useful for the advancement of scientific information, would have to provide a broad overall sequence of the event and detailed views of the entire contour of the disc, its form and the position of the protuberances. From the extant daguerreotypes and paper prints of the 1850s through to the 1870s, there is no evidence that these conditions were met with any kind of systematic plan or consistency. In order to be guaranteed certain and repeatable results, there was still much to be learned of a technical nature, from both the scientific and photographic points of view.

Something of the "trial and error" environment of this period of intense experimentation and invention in photographic processes was reflected in the photographing of the eclipse of 8 July 1842. The first known daguerreotype is reported to have been "exposed just before and after totality" (evidently it was a multiple-image plate), revealing a "thin crescent Sun, well defined". G. A. Majocchi of Milan was the author of this plate. He also equipped himself with sensitized papers and apparently succeeded in obtaining images on them as well, but unfortunately all that remains to us today are accounts of the event by contemporary sources.[4]

In addition to a solar eclipse, for which the totality was visible in Europe, the year 1851 was important for photography and astronomy for other reasons. There was the announcement by Frederick Scott Archer (1813–57) of his collodion on glass process, which provided a much more light-sensitive photographic medium than the daguerreotype; and the Great International Exhibition was held in London in the summer, where a prize-winning daguerreotype of the moon by John Adams Whipple (1822–91) and George Phillips Bond (1825–65) was exhibited to much acclaim.

On 6 May of that year, Sir John Frederick William Herschel (1792–1871) envisaged with the eclipse the coming together of two of his great interests, photography and astronomy. "I long to see some of your products," he wrote to Talbot, "for the Solar Eclipse such a process will be invaluable."[5] Prior to the event, a committee of the British Association for the Advancement of Science, including Herschel along with George Biddell Airy (1801–92), Astronomer Royal in England, and Wilhelm Struve (1819–1905), published recommendations to astronomers for photographing the eclipse, advising them to synchronize their telescope with its phases and to be aware that at different stages of the eclipse, papers and daguerreotype plates of varying sensitivity should be used in order to capture the best possible image.[6]

With the support of the scientific community, eager photographers, many of whom were also astronomers and therefore conversant with current issues, set out to record the eclipses in 1851, 1854 and 1858. Few photographs from the 1851 eclipse appear to be extant, but activities were recorded. Collaborations between photographers and astronomers occurred, such as that of daguerreotypists E. Vaillat and Thompson with the astronomer Ignazio Porro (1801–75).[7] At Königsberg, Berkowski was reputed to have obtained a successful daguerreotype showing both corona and prominences.[8] Hermann Krone (1827–1916) in Leipzig, Bayer in Warsaw, Fr.

124 William Langenheim and Frederick Langenheim, *Eclipse*, 26 May 1854. Four ⅙-plate and three ¹⁄₁₆-plate daguerreotypes. Gilman Paper Collection, New York.

Angelo Secchi (1818–78) in Rome and Baron Gros in Paris were also active, using, like Majocchi in 1842, both daguerreotype plates and silver chloride paper.[9] In general, images of sunspots were captured and the varying luminosities of the inner and limbic (outer edges) parts of the solar disc were confirmed through these images.[10]

William Langenheim (1807–74) and his brother Frederick (1809–79) managed to capture a sequence of seven views of the eclipse on 26 May 1854 which was mostly visible in the United States. Composed of four ⅙-plate and three ¹⁄₁₆-plate daguerreotypes, the principles governing their arrangement could be described as more artistic than scientific (Pl. 124). Taken in Philadelphia, a part of America where the weather lent itself most favourably to the recording of this event, the images are reasonably clear and the corona is visible in two of the seven images which depict the eclipse close to totality.

Some of the photographs documenting the expeditions organized to observe the eclipse of 18 July 1860 suggest that it was a festive occasion as well as one with a serious scientific agenda (Pl. 125). Armed with telescopes, lenses, metal and glass plates and, presumably, sheets of sensitized paper, many observers went to Spain, on an expedition reported in the photo-

125 George Downes, *Eclipse Expedition to Spain (Warren De la Rue at Telescope)*, c. 1860. Albumen paper print from wet collodion plate. Jane and Michael Wilson Collection.

graphic press to have been a success. Warren De la Rue (1815–89) was stationed at Rivabellosa, where he made 31 prints of the sun. His photographs, along with those taken by Secchi who was also in Spain, raised the issue of the origins of solar prominences which, like "Baily's beads" (a string of small beads of light and shadow visible just before totality, created by sunlight filtering through the irregular silhouette of the moon's mountains), had been categorized as optical illusions. The photographic evidence, however, confirmed them as real phenomena

arising from the sun.[11] Comments made by De la Rue before he left for Spain, however, indicate that improved photographic views of phenomena like prominences had been obtained by the end of the 1850s. Examining on this occasion Berkowski's daguerreotype from 1851, he was impressed by it as a pioneering effort but was struck by the "very indifferent definition of the protruberances".[12]

Light from the sun was regularly recorded by photospectroscopy by the late 1860s, giving indications of the sun's chemical components. The

190

solar eclipse of 18 August 1868, with totality visible in India, provided an excellent opportunity for making the first systematic spectrographic records of an eclipse.[13]

Over the next two decades, as photospectroscopy became better established, it became evident that it was not necessary to wait for an eclipse in order to record details of the chromosphere,[14] and by the first decades of the twentieth century new theories were in place to be tested under eclipse conditions. The eclipse of 29 May 1919 was seen as an opportunity to observe and record the effects of the gravitation field of the sun on the deflection of starlight. Two British teams, from the Royal Observatory at Greenwich and the University of Cambridge, stationed themselves respectively in Sobral, Brazil and the island of Principe in the Gulf of Guinea, from where they recorded the sun and the effect of its gravitational field on the bending of light from distant stars. Photographs made at totality allowed the stellar field around the sun to be recorded and subsequently measured. The plates taken at Sobral (Pl. 126), where the weather conditions proved more favourable, provided visual evidence of Einstein's thesis expounded in his 1915 theory of general relativity, that the gravitational fields of celestial bodies, such as the sun, deflected light and produced the effect of curved space.[15]

TRANSIT OF VENUS: "A GREAT SCIENTIFIC TOURNAMENT"

The passage of the planet Venus across the face of the sun on 8 December 1874 was an eclipse of a different kind. Exciting great curiosity because of its rarity,[16] this occasion served both as a dramatic reminder of the presence of our neighbouring planets and as an opportunity for the scientific community to gather valuable data—in this instance, the determination of the parallax of the sun, a precise calculation of the distance between it and the earth. The idea of using the transit to obtain more precise measurements originated with Halley in the seventeenth century.[17] The parallax measurements were made by simultaneously photographing the entire progress of the disc of Venus from its first contact with the inner limb of the sun to its passage across the disc and its exit at the outer limb. This was done from distant locations around the globe, thus measuring the differences in the apparent position of Venus over the sun's disc on pictures taken at the same moment.

The occasion, described as a "great scientific tournament", saw international teams of scien-

126 C. R. Davidson and A. C. D. Crommelin, *Eclipse, Sobral Brazil, 29 May 1919*. Gelatin silver print. Royal Greenwich Observatory, Cambridge.

tists, photographers and technicians located strategically around the world in order to capture images, report details, and calculate distances of Venus relative to the sun. In spite of the availability since 1873 of an improved version by Richard L. Maddox (1816–1902) of the gelatin dry plate process,[18] the daguerreotype experienced a major revival during this event. It was the process selected for the French photographic expeditionary teams headed by Armand Hippolyte Louis Fizeau (1819–96), who reasoned that for an operation to obtain critical measurements it would alleviate any shrinkage problems that were an imagined risk of the collodion wet plate process.[19] On a practical level, the use of

191

daguerreotypes also circumvented the risk of breakage of negatives during transportation. Ten kilograms of silver went into the making of 2,000 daguerreotype plates for the five French teams.

The spirit of international rivalry, and camaraderie, was strong. The French National Assembly committed 425,000 francs in support of several expeditions, which were equipped with photographic telescopes to make a large number of records. Ten German teams, meanwhile, were equipped with heliometers (refractor telescopes with lenses that split the image diametrically, allowing for small angular measurements) and were distributed across several continents. In England, eight photographic telescopes, three of which were destined for Russia, were constructed according to De la Rue's design for the photoheliograph at Kew, a model telescope for recording images of the sun.

The enthusiastic commitment of the French government to the transit of Venus expeditions was not without political controversy. Urbain Jean Joseph Le Verrier (1811–77), former Director of the Paris Observatory, publicly criticized such foreign expeditions as an enormous sacrifice of resources which could be better managed from local sites.[20] His belief that they would prove unsuccesful caused him to be seen as a pessimist by many astronomers from other countries, who were unanimously in favour of such expeditions.[21] With respect to the statistical goal, however, his grim prediction came uncomfortably close to the truth. The final yield of daguerreotype images for the French expeditions was 800, all of which were immediately given for measurement to Fizeau; in England, Airy was responsible for compiling the measurements required to determine finally the solar parallax. The failure of the seventeenth-century transit expeditions was doomed to repeat itself. In spite of the introduction of new technology, not only did the various international teams all over the globe come up with divergent numbers, but even within individual teams the mean internal errors were at a high level.

127 Pierre-César Jules Janssen, *Transit of Venus*, 1874. Daguerreotype, full plate. Société française de photographie, Paris.

The visual highlight of the expedition was produced by astronomer Pierre-César Jules Janssen (1824–1907), the man famous for pronouncing the photographic plate to be the "retina" of the scientist. Prominent among the photographer–scientists on the expedition, his revolver camera was a pioneering instrument devised to record instantaneously the sequences of this important astronomical event. The *revolver photographique* was a gun equipped with a lens in the gun barrel, two slotted-disk shutters (one fixed and one rotating) and a circular daguerreotype plate. A turning mechanism ensured the rotation of the circular sensitized plate so that 48 points of its circumference were exposed to light through the openings of the shutters; one image in a sequence of 48 was

produced on the plate approximately every 70 seconds.[22]

A superb full-plate daguerreotype (Pl. 127), housed in the collection of the Société française de photographie, Paris, is Janssen's finest extant daguerreotype of the transit of Venus. It can be interpreted as follows:

> The finlike shape in the image is a portion of the disc of the sun, and the small dark circle is Venus as it makes contact with one of the limbs of the solar disc and begins its transit. The oval cutout and the notch in the inner edge of the daguerreotype plate were there to attach the plate to the mechanism that advanced it past the lens of the telescope.[23]

COMETS: "GLORIOUS SUBJECT FOR PHOTOGRAPHY"

The irregularity with which comets make their appearance, as well as their dramatic luminosity, made them a special event for photography. Of interest was the fact that they often change rapidly in appearance as they approach the sun, a phenomenon that could not be sequentially recorded in photography until the 1880s.[24] The first photographs of these transient bodies of ice and gas coming from the far reaches of the solar system were attempted with the arrival of the comet Donati in 1858: Usherwood (active 1850s) and De la Rue are known to have attempted to record its presence. In spite of Usherwood's seven-second exposure with a portrait lens of short focal length—which was reported to have been successful, leaving him with an image of the tail—this "glorious subject for photography" proved very elusive for mid-nineteenth-century photographers. The luminosity of comets was too weak to ensure consistent successes, particularly with the processes then available. The efforts of Warren De la Rue, a London bookbinder and paper manufacturer who had been inspired by the 1851 daguerreotype of the moon by Whipple and Bond, yielded nothing at all. He tried again to capture the image of a comet in 1861, using both his telescope and portrait cam-

era and an exposure of 15 minutes, but failed to obtain even the slightest impression. He wrote:

> Some curiosity naturally exists as to the possibility of applying photography to the depiction of those wonderful bodies . . . It would be valuable to have photographic records of them, especially of their nucleus and coma, which undergo changes from day to day, and hence such a means for recording their changes as photography offers would be the best beyond comparison, if the light of the comet were sufficiently intense to imprint itself.[25]

By the turn of the century, however, Edward E. Barnard (1857–1923) and others were making

128 Edward E. Barnard, *Tail of Comet*, 1911, from *A Photographic Atlas of Selected Regions of the Milky Way*, 1913. Gelatin silver print. University of California/Lick Observatory, Santa Cruz.

such successful photographs of comets that it was concluded that they revealed more of the delicate details of the tail structure than could be observed by the eye (Pl. 128). It was remarked in 1911 that "in several pictures the tails have an appearance of violent shattering, and if successive pictures can be taken at such times we may learn something of the nature of such disturbances."[26] In contrast to the recording of eclipses and comets, the picturing of the sun, moon and stars was routine and relatively predictable, exploring in each case different scientific issues and photographic problems.

THE SUN, THE MOON AND THE STARS:
PORTRAIT SITTINGS

With its blinding light, our star the sun reveals little of its surface detail to us, unlike the moon with its gentle, reflected luminosity. A self-luminous ball of swirling hot gases, the sun presents to us the face of a flat disc which we gaze upon at our peril. Portraying this fiery face could be literally playing with fire: Warren De la Rue reported in the early 1860s that the heat of the sun at the focal plane of his photoheliograph was so intense that it set his apparatus alight.[27] Its fierceness abates as it rises and sets, presenting such spectacular and colourful displays that "sunrise" and "sunset" have become visual clichés of the picturesque in twentieth-century art. Without a workable colour photographic process in the nineteenth century, however, renderings of these spectacles had to be confined to paint and brush. Photographic representations of the sun, like those of the moon, were closely linked in the nineteenth century to scientific, rather than artistic, interests.

Knowledge about the physical properties of both sun and moon was limited. As prominent an astronomer as François Arago (1786–1853) believed that it was possible that the sun could be inhabited by beings "organised in a manner analogous to those which people our globe".[28] It was speculated that the spots that appear over the surface of the sun might be mountain peaks or dark patches of habitable land. The dark patches on the moon were thought to have been lakes; as late as 1894, wealthy New Englander Percival Lowell, a principal proponent of the belief that certain features of Mars constituted a sophisticated system of canals, founded an observatory at Flagstaff, Arizona especially to study the planet and its inhabitants.[29]

Our simplified representations of the sun, moon, stars and comets, prior to the introduction of photography and persisting until now, reflect our awe of and lack of intimacy with these subjects. Our motif for the sun is a simple disc ringed symmetrically with geometrized points that symbolize its protruberances. The moon appears in various crude simplifications of its "face" as it appears in its monthly orbit: an anthropomorphic profile representing the crescent moon, and a jovial frontal face representing the full moon. Stars are outlined as precise, six-pointed triangular configurations, bestowing a symmetry and clarity to the luminous mass which shimmers and twinkles elusively before our gaze.

In contrast to the early drawings of the moon by Galileo (Pl. 129), Copernicus and others, which tend to be more diagrammatic and schematic, photographic representations of celestial bodies and the general skyscape of the cosmos made during the period 1839–90 held all the promise of being able to reduce the unfamiliarity and distance of these celestial objects while making the details of their shapes and surfaces better known and simultaneously giving us an intimate, close-up portrait of each heavenly body. François Arago entertained great hopes that Daguerre's process would revolutionize current knowledge of the universe. He eloquently expressed his vision of how this new art form might serve astronomy on 19 August 1839, when he addressed the members of the Académie des sciences on Daguerre's discovery of the first workable photographic process. He announced that since Daguerre's process rendered these thin metal sheets "more sensitive to light than any other [process] we have used until now" it was to be hoped that photograph-

129 Galileo Galilei, *Six Phases of the Moon*, 1609–10. Pen and brown ink and brown wash. Biblioteca Nazionale Centrale, Florence.

ic maps could be made of the moon. Arago envisaged that photography could in this way accomplish in a matter of minutes "one of the most lengthy, detailed and delicate tasks of astronomy".[30]

Johann Heinrich Mädler (1794–1874), creator with Berlin banker Wilhelm Beer (1797–1850) of an important hand-drawn lunar map published in 1836, contended that the excitement over photography was exaggerated and similar to the fuss made by Descartes and his contemporaries after the discovery of the telescope. Convinced that an observer with talent and good eyesight could surpass a photographer's rendering and that the stars could as easily be studied with a

large telescope as from a photographic plate, Mädler was not willing to recognize the progress and potential of the medium in the recording of astronomical bodies and regions. In his view, photography had delivered nothing new. Since his topographic map of the moon had taken him seven years to draw, he now faced, with considerable bitterness, the introduction of the upstart medium of photography which was being claimed as doing better "in seven seconds". Not only was photography being promoted as doing the same thing as those "poor scientists who had spent their lives observing, measuring and drawing", he noted, but as doing it effortlessly, quicker and better. "Thirty years have passed since Daguerre's discovery and where have these ambitions and hopes been realized?"[31]

To a degree, Mädler was right. Technical problems of plate and emulsion sensitivity and efficiency of operation would continue to plague photographers until the advent of the dry gelatin plate in the early 1870s. Four years after Mädler's pronouncement, Hervé Faye (1814–1902) answered this question in a presentation to the Académie des sciences in 1872 of several impressive albumen silver prints of the moon by Lewis Morris Rutherfurd (1816–92) (Pl. 130). He alluded to the delicate subject of hand-drawn maps of the moon *versus* photographic renditions and countered Mädler's views, saying that Rutherfurd's photographs showed the numerous slight mounds on the surface of the moon with a precision that "no topographic map would know how to produce".[32]

Although the difficulties posed by photographing the moon, the sun, the stars, the planets, nebulae, comets and galaxies differed according to the specific subject, they shared the basic insurmountably difficult conditions of distance, lighting and motion. The subjects of astronomy were recalcitrant, and in no manner similar to those for which the camera was most often used. All of the objects lay at immense distances from the earth. In addition, with the exception of the sun, their light was weak and required extremely long exposures, sometimes

130 Lewis Rutherfurd, *Moon*, 1865. Albumen silver print. Stephen White, Los Angeles.

raphers' technical ingenuity to the limit for the first three decades of the medium's existence.

THE FACE OF THE MOON: "LEAVES HER PORTRAIT IN DAGUERRE'S MYSTERIOUS SUBSTANCE"

The moon, with its intriguing Swiss cheese craters, was the first celestial body on which astronomers and photographers focused their lenses; Daguerre is believed to have made the first photographic images of the moon, along with a daguerreotype of the solar spectrum. Undertaken at the urging of Arago prior to the announcement of Daguerre's process to the Academie, as "proof that scientific work could be conducted using this process", the present wherabouts of the image is unknown.[34] Arago's optimism about the application of photography to astronomy was, in all likelihood, based on his understanding of the potential of the medium, rather than the reality of any one example he had seen—the daguerreotype of the moon he had instructed Daguerre to make was, from all reports, "faint and lacking in detail".[35] German earth scientist Alexander von Humboldt (1769–1859) saw it just as he was preparing to leave Paris for Berlin on 3 January 1839. Bidding farewell to Arago, who was ill in bed, he saw the imperfect picture which had been delivered by Daguerre himself. In spite of criticizing its lack of clarity, Humboldt was nevertheless impressed: "Even the face of the Moon", he wrote to a friend on 7 February, "leaves her portrait in Daguerre's mysterious substance".[36]

Right from Daguerre's first attempt it became evident, however, that the motion of the moon presented a serious problem. The only solutions were either to guide the telescope by hand or to install a driving mechanism that could be synchronized with the satellite's movement. Early American daguerreotypes of the moon count among some of the most successful. Samuel D. Humphrey (active 1840s–50s) of Candaigua, New York, produced a multiple exposure of the path of the full moon, 1 September 1849. Humboldt's analogy with portraiture was apt, since

hours, to record their image upon the photographic plates of the mid nineteenth century. Unlike buildings or human portrait subjects which could be illuminated either by the sun or by artificial lighting, the objects in the night sky were themselves luminous. The fundamental desire was to bring these distant bodies closer so that they could be examined in detail, and since there was no question at that time of bringing the camera any closer to the subject, the only available means by which a distant object could be magnified was through the use of longer focal-length lenses. The combined conditions of weak luminosity and movement[33] that these objects presented would challenge the photog-

Humphrey's approach to capturing the moon on a daguerreotype plate followed the technical procedures of photographic portraits: "we prepared two plates as nearly alike as possible, and in the same manner as for taking a portrait," he noted.[37] His efforts solicited an enthusiastic response from Jared Sparks, President of Harvard, recipient of one of the daguerreotypes, who speculated that:

the art may at some future day be carried to such a degree of perfection, as to bring out the face of the Moon sufficiently large for a map. This would be a most desirable attainment; since a map of the Moon's surface can now be made only by the detached images presented to

the eye through a telescope, and then transcribed by hand.[38]

Humphrey's effort, however, bears no comparison with the lunar daguerreotypes made by Whipple and Bond early in 1851 at the Harvard Observatory (Pl. 131). One of these, exhibited at the Great International Exhibition of the same year, became a celebrated object, shown as a superior specimen of its kind at meetings of the Royal Astronomical Society and the Académie des sciences, where it was praised for "representing full incidents and details of the face of the moon, as it appears when seen by a powerful telescope". Members of the Académie des sciences were astounded to see how superior it was to former exhibits, which were "mere whitish dots about the size of a pin head, not marking in the least the well known rough and mountainous surface of that satellite." It was seen as a positive sign for the imminent production of the celestial map.[39] The success of these daguerreotypes might well have rested on the adjustment made by Whipple and Bond to the Great Equatorial telescope at Harvard. The blue-sensitive character of the daguerreotype process required that the plate be positioned at the spot in the light path where the blue light came into focus. By changing the telescope's focus from the "visual" to the "photogenic", a great improvement was made in the resolution of the image, producing a picture that was "a better representation of the Lunar surface than any engraving of it".[40]

131 Whipple and Bond, *Moon*, c. 1851. Daguerreotype. Harvard College Observatory, Cambridge.

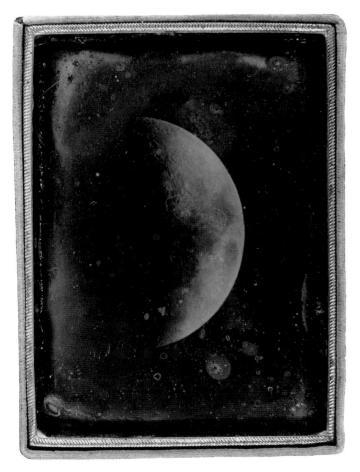

THE SUN'S IMAGE: "MOST BEAUTIFUL; ITS ROUND DISK FLOATING MAJESTICALLY IN THE AIR"

The sun was the only star whose surface could be examined, and such an undertaking was considered important for the greater understanding it would provide not only of its composition but of the constitution of other stars. This simple and apparently flat object exerted its own fascination, however. One unidentified astronomical photographer, disillusioned with the results

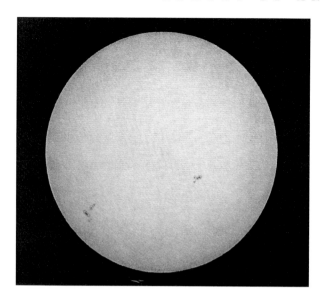

132 Foucault and Fizeau, *Photograph of the Sun, 1/60th of a second, taken on 2 April 1845 at 9:45 am,* from François Arago, *Astronomie populaire,* 1858. Photogravure made after a daguerreotype. University of Minnesota Library.

of lunar photography, proclaimed in 1857 that the sun was the best subject for photography. He counselled the use of the daguerreotype for scientific purposes and suggested that, for popular purposes, "a collodion negative of the disc, eight inches in diameter, would yield very useful and instructive prints."[41]

François Arago, ever anxious to draw photography into the service of science, encouraged Hippolyte Fizeau and Léon Foucault to photograph sunspots on a daguerreotype in 1845. The exposure they made on 2 April took a mere 1/60 second. In the lithograph from the daguerreotype, reproduced in Arago's *Astronomie populaire,* two sunspot groups appear as flecks across the lower half of the disc which possesses, in spite of its reduced size, a monumental presence (Pl. 132).[42] It recalls John Whipple's response to seeing the sun's image on the ground glass when he was photographing it during the 1851 eclipse. "The Sun's image . . . was most beautiful; its round disk floating majestically in the air . . . as he holds his onward course."[43]

The photographic capture of the sun's image, in contrast to that of the moon, required only a very brief exposure time, and also did not present the same problem of orbital motion. The corona, sunspots and solar prominences were the features that photographers attempted to record on their plates. Sunspots are regions of unusually high magnetic field that occur in the photosphere. They are cooler than surrounding regions, making them look darker, and appear and disappear in a complex cycle on the sun's disc. Significant for photographers and scientists alike was their periodic appearance. First observed by astronomers centuries earlier, they were subject to wild speculations identifying them as planets inside the orbit of Mercury, mountain tops and visible patches of habitable surface.[44] The study of sunspot activity was considered an important part of astronomical research in the nineteenth century, not only for what it might reveal of sunspots but also for what could be deduced from these observations about the nature of our sun and other stars. The systematic observation and recording of the spots began in 1826 when Heinrich Schwabe (1789–1875) began a daily sunspot count. By the early 1840s it had been established that there was a pattern to their appearance and distribution: over an eleven-year period the number of spots waxed and waned regularly.

This period of intense interest in photographing sunspots coincided with research being undertaken on the geometry of the sun and its rotation. While it was suspected that the sun revolved upon its axis, just how it did so was not known until British astronomer Richard Christopher Carrington (1826–75) carried out systematic research on sunspot activity between 1853 and 1861. From records of his daily observations he concluded that the sun did not revolve as a solid body, but that some regions appeared to move faster than others.

Carrington's research excited prominent astronomers in Europe to call for photography to assist in compiling accurate records. Just as Hervé Faye had suggested in 1849 that the sun

be recorded photographically at noon for reasons of determining solar parallax, Sir John Herschel, in 1855, repeated his 1847 call for photographers to make daily records of the sun's appearance, "especially with a view to a register of the variation of the spots". Herschel distinguished between occasional recording of their forms and the systematic record of their appearances over time, advising that while both would be useful they would require different equipment. The photographs of the forms and changes of the sunspots would function more like portraits, giving scientists the opportunity to explore in as much detail as could be provided the features and differences of individual sunspots and sunspot groups. The daily records of the sun, on the other hand, could be more schematic and generalized.[45] This was duly reported in the photographic journals with the expressed hope that more might thereby be learned of the nature of the sun.[46]

From 1858 to 1872, Warren De la Rue made daily records of sunspot activity. In 1855, commissioned by the Royal Society, he had designed and constructed a photoheliograph for the observatory at Kew. It was a 50-inch focal length telescope with a 3½-inch diameter refractor, equipped with a specially designed spring-slide shutter mounted on the plateholder with which it was possible to get "nearly instantaneous" exposures. Benjamin Loewy worked with him at Kew during the period 1862 to 1872 when they made 2,778 photographs.[47] In his Bakerian lecture to the Royal Society in 1862, De la Rue described photographs which, for their purely theatrical qualities, would have rivalled the most dramatic art photographs of the time: "I succeeded in procuring photographs of the Sun's surface, on a scale of 3 feet for the Sun's diameter. These colossal photographs were obtained by enlarging the focal image by means of a secondary magnifier . . ."[48] In addition to making photographs with strong visual impact, De la Rue was contributing to knowledge about the sun, just as he and other photographers had revealed the features of the moon's surface. Fail-

ing eyesight forced him to retire from astronomical photography in the early 1870s.[49]

"WILLOW LEAVES IN AN OCEAN OF FIRE"
After photographically recording and examining sunspots and faculae,[50] astronomers turned their attention in the 1870s to picturing other details of the photosphere, such as "granulation", the cell-like patterns which were poetically described as "grains of rice" or "willow leaves in an ocean of fire".[51] From 1874 Jules Janssen, Director of the Meudon Observatory in Paris, attempted to record this phenomenon, which was missing from most small-format photographs (Pl. 133). "Solar images require highly refined photographic techniques because the

133 Jules Janssen, *Study of the Solar Surface*, 1 April 1894, Plate VI of *Annales de l'Observatoire d'astronomie Physique de Paris*, 1896. Woodburytype. National Gallery of Canada, Ottawa.

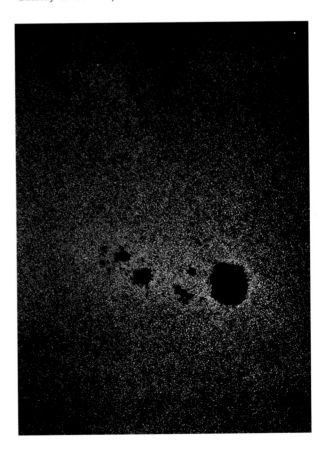

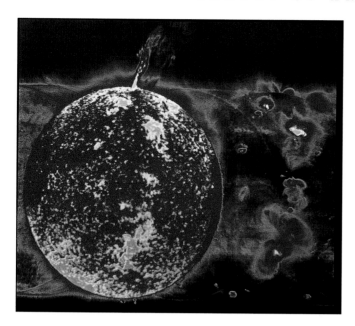

134 NASA, *Sun, ultraviolet, 28–31 nm*, c. 1990. Skylab extreme ultraviolet spectroheliograph. NASA.

THE MOON: "MOTIONLESS ON
THE COLLODION FILM AS . . .
A TERRESTRIAL OBJECT"

For all its limitations, the daguerreotype remained the favoured process throughout the 1840s and into the early 1850s for photographs of the sun, the moon, the stars and the planets.[55] The problems photographers were experiencing with both daguerreotypy and the wet collodion plate process were manifold. Daguerreotypes required long exposures because of their limited light sensitivity, and they could not be easily and effectively reproduced. The collodion wet plate process considerably extended the capabilities of scientific photography, but was difficult to use because the time required to photograph celestial bodies was often longer than the working time of the plate, before the alcohol/ether solvent mixture evaporated from the collodion film. The length of time over which an exposure could be made with collodion was limited to minutes, with five minutes being the longest exposure possible. Ingenious but impractical methods were tested to overcome this difficulty, such as pouring water over the plate while it was in the telescope or lining the camera with a wet cloth.[56]

The ambivalence of photographers in the face of these technical dilemmas is typified by the photographic work of Fr. Angelo Secchi, Director of the Observatory of the Collegio Romano. A regular contributor to discussions on astronomical photography in the 1850s, he made a daguerreotype of the 1851 total eclipse of the moon. Five years later, he used the wet collodion plate for a portrait of the moon and found that, in spite of having to synchronize the moon's motion with the telescope by hand and make a long exposure, he was able to obtain a "very tolerable photograph of the crater of Copernicus".[57] But even though it supplied new information and was considered a "tolerable photograph" by some, Secchi was not satisfied with the delivery of detail. He found the texture of the fibres in the photographic paper distracting, and considered that it suppressed details

slightest fault will be mercilessly evident; they must have a very uniform and well finished emulsion layer," he advised; if these conditions were satisfied, it was possible that within a short time the constitution of the sun would cease to be a mystery.[52] Janssen had been systematically recording with very short exposures both general images of the sun and detailed views of the surface showing the granulation, "like a rigorously focused portrait", but in 1881 there was still a perceived need for more detailed views.[53] Janssen published an atlas of his photographs of the sun, dating from 1876 to 1903.[54] A hundred years later, the constitution of the sun is better known through spectrographic recordings and its surface features have been described by way of X-ray and ultraviolet recording. An ultraviolet recording made from the Skylab with the extreme ultraviolet heliograph shows the features of the chromosphere not only in the detail that was hoped for but also with stunning graphic strength (Pl. 134).

that could not be improved even under magnification. Secchi was not alone in this opinion; others expressed the hope that he would return to the daguerreotype. "In the present state of photography", one critic wrote, "the *only* suitable process for scientific experiments of this kind is the Daguerreotype, and photographers are much to blame who lead men of science astray by misrepresentations of the capabilities of other processes. Had a direct positive been taken on a Daguerreotype plate, the image would certainly have borne a considerable amount of magnification."[58]

Astronomical photography started later in Great Britain than in the United States, France or Germany, one influencing factor being the patent restrictions placed upon the daguerreotype there. The daguerreotypes of the moon by Whipple and Bond, which had inspired Warren De la Rue,[59] also inspired the American Lewis Rutherfurd, who became a major figure in nineteenth-century astronomical photography. The Liverpool Photographic Society's *Proceedings* noted a marked interest in lunar photography in "different parts of the kingdom", beginning in 1854.

But not all photographers were impressed by Whipple's and Bond's daguerreotypes. William Crookes (1832–1919), a great advocate of the collodion wet plate process, dismissed the "pictures taken in America" as possessing no value as moon maps, "the sides being reversed in copying from the daguerreotype plates upon which they were originally taken", a curious remark since the daguerreotype reversed its subject anyway. However, he was rather pleased with the results of his own efforts in 1855, using the "noble instrument", the equatorial telescope at the Liverpool Observatory where he worked in below freezing temperatures with the wet plate process. He described his photograph as depicting the moon "motionless on the collodion film as it could have been were it a terrestrial object",[60] a description that could apply equally to another of his lunar portraits, an albumen silver print from 1858 (Pl. 135).

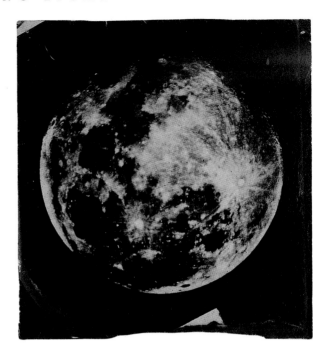

135 William Crookes, *Moon*, 1858. Albumen silver print. Stephen White, Los Angeles.

De la Rue undertook to photograph the moon as Whipple and Bond had done, but using the collodion wet plate process. In late 1852 he began to make photographs with a refractor telescope that he constructed at his home in Canonbury, London. Even at this early stage, his lunar photographs were considered fairly successful; they were selected for exhibition at the Royal Astronomical Society in 1853.[61] Like Secchi and others, his solution to the problem of motion was to guide the telescope by hand with the assistance of his colleague Mr. Thornthwaite, to synchronize it with the path of the moon. This proved to be cumbersome, and not long after he decided to abandon this work until he had a telescope with an automated guiding mechanism.[62] By 1857 he had built a motion-coordinated telescope in the village of Cranford, and was sufficiently confident of the results to send examples of his photographs to Henry Fox Talbot. Talbot replied in October 1857, thanking him for the "beautiful photographs of the moon", but not-

ing that they had not yet been perfected and suggesting that they be looked upon as the "precursor of still more important results."[63]

This comment reflects the lack of consensus at the end of the 1850s on the effectiveness of photography in recording the moon's surface; the scientific usefulness of such photographs was a contentious issue in the 1850s and 1860s. Sophisticated lunar observers found that some of the questions about what was illusory and what was real regarding the moon were clearly beyond the capabilities of photography to answer. Was the apparent increased luminosity of the moon at its centre real or not? How did the distribution of light and shade on its surface vary in intensity, and what did this indicate? How did the composition of its volcanic rock compare to that of earth? Disappointed viewers of lunar photographs were prone to dismiss them as "pretty pictures".[64] Others were persuaded that there was much to be gained from examining them, even if there were limitations as to what they could deliver. In order to compensate for lack of detailed evidence, enlargements of the images were projected to make existing details clearer and available for scrutiny.

While the limitations of photographs of celestial bodies were readily acknowledged at a gathering of the Photographic Society of Liverpool in 1854, the members remained convinced that they provided more information than drawings. The presentation of photographs showing the phases of the moon by the early English pioneer in lunar photography, Prof. J. Phillips (active 1850s), and by Hartnup and others, "excited great admiration" and was very dramatic: "thrown upon a disc about twenty feet in diameter, as large as the room would allow". Participants observed that the light cast over the surface of the moon, illuminated "mountainous projections" and demarcated craters. Created on the light-sensitive pellicle was an image "which no map of the moon, after years of cost and labour, has even yet produced so clearly." A large part of the evening's discussion consisted of debating how the "real" lunar features could

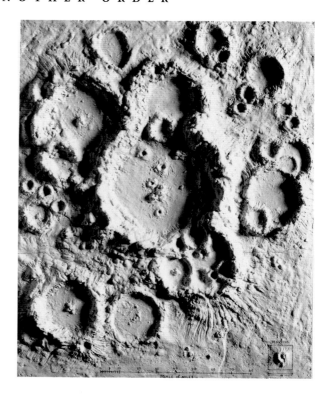

136 James Nasmyth, *Plaster of Paris model of the moon*, c. 1860, Museum of Science, London.

be distinguished from the illusory, and also how to isolate flaws that arose from the photographic process from minute lunar features.[65] Interested parties had the opportunity to examine features in greater detail; speculations were advanced on the sizes of volcanoes like Tycho, projected on this occasion to ten inches in diameter.[66]

The problem of regulating the telescope to harmonize with the motion of the moon, along with the still limited light sensitivity of the collodion wet plate process, meant that the promise of obtaining a precise and clear image of the moon was not fulfilled. Lord Rosse, in a comment to the Astronomer Royal in 1854, complained that although a "very pretty picture of the moon can be obtained", there was no known photographic process "sufficiently sensitive to give details in the least degree approaching the way in which they are brought out to the eye."[67] Other critics expressed great doubts about the

"*scientific* value of any photographs that are likely to be taken of the moon", and proposed that photography's real contribution to astronomy lay not in its delivery of detail but in its capability to record rapid change.

In the same year that his moon photographs were projected at the Liverpool Photographic Society, Prof. J. Phillips, a member of the British Association for the Advancement of Science, presented to a sub-committee charged with investigating "by accurate telescopic observations, the physical aspect of the moon", a paper entitled "Notes on the mountain Gassendi and further trials of photography of the moon". The title of his paper notwithstanding, Phillips illustrated his observations with "a very beautiful drawing of the Moon's surface by Mr. Nas-

myth", indicating that at this stage the artist maintained a certain authority over the photographer in the recording of precise detail.[68]

The problem of the vast and intangible nature of the objects of astronomical research and photography was approached in a novel way by Scottish engineer James Nasmyth (1808–90) and James Carpenter (active 1860s–70s), astronomer at the Royal Observatory in Greenwich, who chronicled their thoughts and efforts in the fascinating 1874 publication, *The Moon, Considered as a Planet, a World, and a Satellite.* Including wood engravings, lithographs, photogravures and woodburytypes, the book was based on the authors' observations and visual documentation of the moon through drawings, astro-photographs and photographs of plaster

137 James Nasmyth and James Carpenter, *Hand and Apple*, from *The Moon, Considered as a Planet, a World, and a Satellite*, 1874. Woodburytype. National Gallery of Canada, Ottawa.

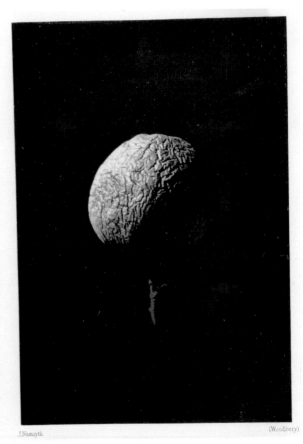

138 James Nasmyth and James Carpenter, *Moon. Crater of Vesuvius*, 1864, from *The Moon, Considered as a Planet, a World, and a Satellite*, 1874. Woodburytype. National Gallery of Canada, Ottawa.

models. Their declared wish was to "educate the eye", not only to see and understand the general form of the moon but also to undertake minute examination of "its marvellous details under every variety of phase in the hope of understanding its true nature as well as the causes which had produced them." By making plaster of Paris models (Pl. 136) of the moon's surface from Nasmyth's drawings, which were stunning examples of careful observation and eye-to-hand training, they removed the greatest obstacles that their lunar subject presented: remoteness and motion. The static models, painstakingly

created to replicate all aspects of the moon's surface, were then photographed under controlled conditions of illumination to replicate the effects of light and shadow cast upon the moon as observed through the telescope. In addition to including a woodburytype print of "an actual photograph" by Warren De la Rue and Joseph Beck, Nasmyth and Carpenter made some visual propositions about surface formations analogous to those of the moon, such as the wrinkled surface of a human hand (Pl. 137). Simulations of live volcanoes assisted the viewer in visualizing the surface of the moon as a geologically active

place (Pl. 138). These models and the attempted simulations, simplistic as they may appear to us now, followed sound scientific principles of producing laboratory models which could be observed under controlled conditions.[69]

Apart from the work done by Bertsch, the French had done comparatively little astronomical photography using salted paper processes when the selection of Rutherfurd's beautiful views of the moon's phases were presented by Hervé Faye to the Académie des sciences in late 1872. The members then learned that after two decades of trial and error progress was being made, and astronomical photography was becoming established as a workable scientific tool as well as an aesthetically satisfying accomplishment. As well as being admired for their aesthetic qualities, Faye remarked that the Rutherfurd photographs should be recognized for their contribution to lunar geology. In addition to general curiosity about what the linear patterns and patches of light and dark on the moon's surface represented, astronomers of the period also wanted to know whether its geology resembled that of the earth, and whether, in the words of Élie de Beaumont, "geological life still exists in the interior of the moon", including past and present volcanic activity, and what measurements could be recorded from the images.[70] Lewis Rutherfurd's lunar photographs came closer to the "still more important results" that Talbot had in mind when he wrote to De la Rue in 1857. Clear in detail and appearing to represent a motionless subject, the aesthetic qualities of these images—with their gestural impressions left by the application of collodion, their dark chocolate colour and intense luminous highlights—recall the haunting beauty of a Julia Margaret Cameron portrait.

But the scientific and aesthetic *tour de force* of lunar photography was the translation by Pierre Puiseux (1855–1928) and Charles Le Morvan (1865–1933) of a number of photographic negatives of the moon into enormous, crisply detailed and visually stunning photogravures (Pl. 139). Le Morvan published a reduced version of

their *Atlas photographique de la Lune 1896–1910* in 1914.[71] Systematically captured and ordered, it remained one of the most important reference documents for the geography of the moon for many decades, and continues to be a valuable source for studying the libration of the moon.[72]

THE MOON AND THE SUN IN STEREO: "SOLID BODIES NOT FLAT PICTURES"

Observing the heavens through his telescope in the mid 1850s, Warren De la Rue (like Nasmyth) witnessed the need to achieve in his photographs the same volumetric sense of form and space. In his words, he wished to picture the celestial bodies as "solid bodies" rather than as "flat pictures". He also believed that in this way more precise information could be acquired

139 Pierre Puiseux and Charles Le Morvan, *Wollaston—Golfe de la Rosée—Anaximandre, 16h 9m. Paris 1904*, Plate LXX from *Atlas Photographique de la lune 1896–1910*. Photogravure. Thomas Fisher Rare Book Room, University of Toronto.

140 Warren De la Rue, *The Moon*, c. 1858. Albumen silver stereogram. National Museum of Film, Photography and Television, Bradford.

about the surface structures of the moon, the sun and the planets.[73] While astronomical subject matter lends itself most appropriately to the stereographic process on the conceptual level, it presented technical challenges.

De la Rue began to make stereographs of the moon in an effort to realize a three-dimensional representation by the mid to late 1850s (Pl. 140).[74] Stereoscopy gave the effect of solid objects existing in space. Two images of the same subject, composed side by side but taken from slightly different viewpoints, when viewed through a stereoscopic viewer merged into one image to give the illusion of spatial depth.[75] Although they came in the wake of the introduction of popular stereoscopic photography, De la Rue's stereographs were not comparable with images taken with stereo cameras of three-dimensional subjects with backgrounds—the distance of the moon was too great to meet the requirement of capturing two slightly different viewpoints. In order to achieve a stereoscopic

effect, therefore, he used the telescope to make two exposures on the same night but separated by an interval of hours. He exhibited these stereographs of the moon at the Royal Astronomical Society in 1858. Stereographs of the sun soon followed. Wanting to show prominences and sunspots upon the disc of the sun, he photographed its surface 26 minutes apart:

Two pictures of the same sun-spot, taken at intervals sufficiently great to admit of the sun's rotation causing the necessary angular shift of its position, evidently possess the stereoscopic relation I have ascertained in this way that the faculae occupy the highest position of the sun's photosphere, the spots appearing like holes in the penumbrae, which appeared lower than the brighter regions surrounding them; in one case parts of the faculae were discovered to be sailing over a spot, apparently at some considerable height above it.[76]

206

PHOTOGRAPHING THE PLANETS:
"BAGGING JUPITER AND SATURN"

With some success in photographing the moon, attempts at recording the planets were quick to follow. Not surprisingly Jupiter, the giant and powerfully luminous planet of the solar system, was one of the first to be captured on a daguerreotype plate. The Harvard Observatory diary entry for 22 March 1851 chronicles Whipple's and Bond's efforts to photograph two of its bands with an exposure time almost the same as that required for photographing the moon.[77] Six years later, when Bond re-photographed Jupiter, he made several observations, including the apparent greater luminosity of the planet in the photograph than through the telescope. By March 1856 De la Rue had photographed Mars. Two years later it was reported that he was "not content with making game of the moon, he has bagged Jupiter, Saturn, and the double star Alpha geminorum as well."[78] Early in October 1857, Whipple and James Wallace Black (1825–96) had obtained their first photographs of Saturn and the Pleiades.[79]

In 1862, President Lee in making the presentation address at the Royal Astronomical Society expressed the expectation that De la Rue would also succeed in procuring stereoscopic pictures of the planets: "The different planes of Saturn's rings will also come into relief, the belts of Jupiter may be manifested as portions of his dark body, and ere long the mountains and elevated continents of Mars will rise up into solidity before our delighted gaze."[80] On this occasion De la Rue received the Society's gold medal for his achievements in astrophotography, especially stereography.[81]

By the 1880s and 1890s a flurry of interest in Mars—as a planet possibly inhabited with a civilization comparable to that of earth—led to increased observation of its surface. New observatories sprang up at Juvisy in France, at Flagstaff in the United States and at Teramo in Italy. Although some of the linear surface markings had been recorded in photographs in the 1890s, the detail was not clear, and it took some 75 years before the idea of advanced life on Mars was completely dispelled. With new processes and films sensitized to limited sections of the spectrum, clearer images could be obtained. In 1924 W. H. Wright and Robert J. Trumpler photographed the surface of Mars with the 36-inch telescope at the Lick Observatory, California, using plates sensitized for limited ranges of colour: the images on the infra-red and red-sensitive plates clearly showed the surface topography.[82] Several unmanned reconnaisance missions in the mid to late 1960s and early 1970s produced photographic imagery that finally shattered the theory that Mars was inhabited or habitable, and Viking Lander 2's 1978 photographs of its surface terrain revealed a barren planet strewn with volcanic rocks, as uninviting as the moon (Pl. 141).

The surfaces of Venus (Pl. 142) and Pluto (Pl. 143) have more recently been described in photographs through new techniques in astronomical observation and recording—respectively, through radar in 1990 and ultraviolet recording in 1994.[83] The colour information of the 1990 Venus radar images were matched with photographs taken from an earlier Soviet craft which landed on Venus.[84]

141 NASA, *Viking Lander 2 Mars. Soil sampler in operation*, 1978. Dye coupler print. NASA.

142 David P. Anderson, *Venus Radar 12.6 cm, Magellan Synthetic Aperture Radar*, c. 1990. Computer-generated image. SMU/NASA/ Science Photo Library.

THE MILKY WAY GALAXY:
COUNTLESS NUMBERS OF FAINT STARS

Our sun and solar system lie on the outskirts of the Milky Way, about two-thirds of the distance from its centre. As its name suggests, the Milky Way appears as a luminous band, whose light comes from a vast number of distant and faint stars. The luminosity of the stars and gaseous nebulae that lie within our galaxy is rendered all the more striking because of the blanket of darkness that surrounds them. Our galaxy has a spiral form similar to others in the universe, such as Andromeda and the Large Magellanic Cloud, and it lies within the so-called "Local Group" cluster of galaxies.

As a subject for photography, the Milky Way provided a challenge for photographers: its boundaries are imprecise and its stars and neb-

208

ulae sufficiently distant from earth that exposure times ran into hours for the fainter bodies. It is also a subject of extreme contrasts: billions of brilliant dots of light and hazy glowing gas clouds, surrounded by darkness and objects veiled from view by clouds of gas and celestial debris. While methods that can compensate for these conditions now exist, photographers in the nineteenth century had to live with the difficulties and make the best of the limitations of their materials.

A visual portrait of the Milky Way, capturing its scope and providing recognition of its character, was nevertheless slowly constructed by photographs made from the 1880s through to the 1920s. In major observatories all over the world, images of galaxies and nebulae were being captured in unprecedented detail. "After about three hours exposure," wrote an observer, "there appeared on the plates the bright cloud forms of the Milky Way in great intensity and with a wealth of detail that never could have been detected by the eye, no matter with what optical aid."[85] Amongst the astronomers whose photographs would add to this composite portrait of the Milky Way at the turn of the century were Henry Chamberlain Russell (1836–1907) in Sydney, Maximilian Franz Joseph Cornelius Wolf (1863–1932) in Heidelberg, and Edward

144 Edward Emerson Barnard, *Region of the North American Nebula*, Plate 46 from *A Photographic Atlas of Selected Regions of the Milky Way*, 1927. Gelatin silver print. Canadian Institute for Scientific and Technical Information, Ottawa.

Emerson Barnard at Lick and Yerkes. As the broad sweep and the details of the Milky Way became better understood, theories about its structure could be postulated in terms of how much it resembled or differed in its features from other galaxies, and in its relationship to the larger context of the known universe.

By 1924 Edwin Powell Hubble (1889–1953) had taken "scores of photographs of M33 and its neighbor M31" (Andromeda) and had determined that our galaxy was just one of many.[86] Throughout the 1930s and 1940s, assisted by the photographer Milton Humason (1891–1972), he continued to gather images of far-flung galaxies from the vast, uncharted spaces of the universe. By this time, photographs had become an indispensable tool of astronomy. Glass plates—the first direct images, which naturally enjoyed a higher authority than the prints derived from them—were measured, classified, carefully archived and keenly compared and studied for

143 Alan Stern (Southwest Research Institute) and Marc Buie (Lowell Observatory), NASA and ESA, *The Surface of Pluto*, 7 March 1996. Gelatin silver print. Space Telescope Science Institute.

evidence of varying luminosities, for precise locations and to ascertain the presence or disappearance of celestial bodies. Photographic prints of nebulae, stars and comets were appreciated for their dramatic beauty, borne out by the choice in some publications of photogravure and platinum as the printing media for the fuller expression of the drama and subtlety of the luminosity of the night sky.[87]

Edward Emerson Barnard appreciated the importance of making prints that were precise and handsome. The last years of his life as an astronomer and a photographer of the skies were spent preparing his celebrated *Atlas of Selected Regions of the Milky Way* (Pl. 144). A painstaking and beautifully compiled album of 50 bound-in gelatin silver prints, it was drawn from 35,000 glass plates that he made on the Bruce telescope at Yerkes. Reluctant to use a photomechanical process—in which information might be inconsistently communicated, distorted or lost, or the image poorly reproduced—he insisted on this more labour intensive but accurate approach, inspecting each print himself. He did not live to see the final publication, which appeared in 1927, four years after his death.[88] His wide-field photographs allow for the study of patterns of star clusters, bands of light and patches of dark, and spirals of nebulae.

Observing the brilliant light and the darkness of the Milky Way from the telescopes at Lick and later at Yerkes Observatory, Illinois, Barnard chronicled the intensity of the stars and the billowing masses of light-filled gas clouds, as well as those dark areas that inspired him to describe the Milky Way in 1894 to Arthur Ranyard as "essentially a region of vacancies". He believed that "the great chasm here in the Milky Way" was a series of holes in the heavens. His colleague Ranyard saw them conversely as "dark structures, or absorbing masses in space which cut out the light from a nebulous or stellar region behind them".[89] The last part of Barnard's career at Yerkes was devoted to a visual catalogue of these dark nebulae.

145 James Edward Keeler, *The Great Nebula in Andromeda*, Plate 1 from *Publications of the Lick Observatory, vol. VIII*, Regents of the University, Sacramento, 1908. Photogravure. John Erdman and Gary Schneider, New York.

"LIGHT FROM EMBRYO SYSTEMS . . . AGES AGO"

In the twentieth century, astronomical photography has progressed to the commonplace depiction of features of the universe far beyond our galaxy. Recognizing the limitations of our concept of time in daily life is one of the most thought-provoking results of seeing photographs of distant galaxies, stars and nebulae. We look upon them with the full consciousness that the light we see depicted in them started its journey thousands of years ago, and that what is represented and visible to us now may have disappeared entirely—"lookback time", astronomers call it. In 1845 Lord Rosse's enormous 45-foot reflector telescope brought into view a number

of spiral nebulae, an event that caused much excitement in astronomical circles. One contemporary observer aptly summed up both the phenomenon itself and the recording of it:

> These nebulae exhibit the appearance of a burning catherine wheel, revolving about its axis, and throwing off from its centre bent radii of luminous matter. Dr. Whewell has offered a simple explanation of these nebulous appearances. He conceives that the luminous matter is rushing towards and not projected from a centre, and that it is moving in a resisting medium. On this hypothesis the common laws of dynamics explain the singular appearance of the spiral nebulae, and lead to the conclusion that they may be systems in the process of formation! Imagine human beings on this little planet, watching and speculating on these stupendous changes occurring in the remote regions of space, and recording them on photographic tablets by light which may have emanated from the embryo systems ages ago; so long ago possibly that we may suppose them to be at this moment in a more advanced state of development![90]

Dr. Ainslee A. Common (1841–1903) made a 30-minute exposure of the great Orion nebula on 30 January 1883, which was hailed as delineating details "the eye could not distinguish in the largest telescopes". Thus it was this photograph that demonstrated the medium's superiority to visual observations.[91] By systematically photographing a class of nebulae, it was possible to determine the extent of their concentration within the galaxy. Prof. James Keeler (1857–1900) at Lick Observatory discovered by undertaking such a project that a large number of small nebulae were spiral in form (Pl. 145). In England in the 1880s Isaac Roberts (1829–1904) also focused his lens on spiral nebulae, and revealed that the form of most of them was elliptical; he also depicted the structure of the Andromeda galaxy.

"THE BEAMING COUNTENANCE OF A BEAUTIFUL STAR"

Examining a portrait of the sun, it is staggering to think that our galaxy, the Milky Way, contains tens of billions of such individual stars—each with its own blazing radiant energy, often tens of times stronger than our sun. Within the immensity of the Milky Way, these stars are remote: their faintness and ubiquity demand a different approach to that of photographing the sun, such as greater exposure times and the "map" model rather than the "portrait".

Early attempts to photograph stars, however, favoured the isolation of a particularly brilliant star, especially those that could be separated by the naked eye from the surrounding stellar field. Vega, a double star and the brightest lying in the constellation of Lyra, was captured in just over a minute on a daguerreotype plate by George Philip Bond in 1850.[92] It was reported in the photographic press that the "beaming countenance of the beautiful star" was "quite distinct, and about the size of a pin's head."[93]

The star map was to prove the more important photographic format for recording the location of stars. The idea of compiling a photographic map has been ascribed to both De la Rue in the 1860s and later to David Gill (1843–1914), Director of the Royal Observatory of the Cape of Good Hope, who was inspired to use photography more comprehensively in astronomy after successfully recording, with a hand camera, the Great Comet of 1882.[94] Benjamin Apthorp Gould (1824–96) went to Cordoba, Argentina, in the 1870s in order to participate in a project known as the Southern Durchmusterung, an inventory of the skies of the southern hemisphere. Between 1875 and 1882, he made over 1,000 photographs of star clusters and wide double stars. He saw them as a

> photographic record [that] may be subjected to repeated measurement and kept through future comparison with the heavens after the lapse of centuries, so as to permit the detection of whatever changes of position may occur among the several stars.[95]

146 Paul and Prosper Henry, *Lyra Nebula*, c. 1885. Albumen silver print. The Metropolitan Museum of Art, New York, gift of Arnold H. Crane, by exchange and purchase. The Horace W. Goldsmith Foundation Gift, 1993.

Astrographic Congress was held in Paris on 16 April 1887, where a chart was exhibited showing 2,790 stars taken by Prosper and Paul Henry; the standards that emerged for the Carte du Ciel project were based on their techniques and equipment. Each photographic plate had an accurate grid printed on its surface under the emulsion so that measurements could be easily made from standard coordinates.[97] At each observatory 600 plates were to be exposed to cover each area of sky for the first round. Another set of plates would be used for a second coverage, and instructions regarding exposure time were also given. The plates were invaluable for tracing the histories of variable stars, the appearances of asteroids and, when compared with earlier and later records, general evidence of changes. Spectroscopic star charts provided another kind of portrait of individual stars. By using a glass prism, the light radiating from each star was registered as a spectrograph; these spectral records made it possible to locate the position and the composition of the star. The colour of stars, determined by the difference of their brightness at two different wavelengths, indicates their temperature and becomes a primary determinant of their classification.

CAPTURING LIGHT: "WRITING SPREAD FORTH IN THE COSMOS"

The application of photography to spectroscopy in the nineteenth century was a major development in astronomy. It extended the visibility of spectra beyond the "visible" band into ultraviolet and infrared, and delivered a clear and immediate visualization of the chemical composition of matter as a sequence of straight lines, eliminating any references to the particularities of individual forms. By thus registering radiation wavelengths lying outside the visible spectrum, photographs of spectra recorded in a systematic way what the human eye and hand could not.

In what was evidently a related project, Gill surveyed the southern skies in the Cape Photographic Durchmusterung from 1885 to 1890.[96] His more modest 250 plates, taken from the Cape Royal Observatory, were sent to Groningen in Holland to be measured by Prof. J. C. Kapteyn (1851–1922).

A year later, Gill suggested an international congress at which a collaborative international effort to produce a map of the entire sky could be planned. Admiral Mouchez, Director of the Paris Observatory, an admirer of the astronomical photographs of Prosper (1849–1903) and Paul Henry (1848–1905) (Pl. 146), responded positively to Gill's proposal. The International

The association of photographic chemistry with spectroscopy goes back to Thomas Johann Seebeck (1770–1831), who recorded the spec-

212

trum on paper moistened with chloride of silver in 1810; it continued with experiments with the solar spectrum by Herschel, Talbot, Biot and Arago. Herschel had been working on spectral analysis for at least twenty years when he received a daguerreotype of a solar spectrum made on 27 July 1842 by John William Draper (1811–82) (see Pl. 29).[98] What was significant about this record was that it revealed through the dark absorption lines parts of the solar spectrum invisible to the eye, notably the infrared and ultraviolet.[99]

Concurrent with the photographic recording of sunspot appearances in the 1850s and 1860s was a surge of activity in spectroscopy, leading to the spectral analysis of the sun and the brightest stars to determine their elemental composition.[100] Along with Herschel, Secchi, Gustav Kirchoff (1824–87) and Robert Bunsen (1811–99), a key figure in mid nineteenth-century spectroscopic research was Dr. William Huggins (1824–1910) who recorded stellar and nebular spectrograms from his private observatory at Tulse Hill, England.[101]

By the end of the century, Secchi had completed his classification system of the stars based on their spectral type,[102] and photographic spectrograms had been obtained for most of the planets and 50 of the brightest stars by Henry Draper working from the late 1870s up to his death in

147 David Malin, *AAT23 Edge on Spiral, NGC 253*, 1980. Dye coupler print. Anglo-Australian Observatory.

1882.[103] Huggins had obtained a spectrogram of Uranus on 18 December 1879, and described the ultraviolet spectra of white stars to the Royal Society.[104] In addition to being able to determine chemical composition from the recorded wavelengths on spectrograms, it was also understood that the temperature and velocity of a celestial body could be deduced. Following the discovery by Austrian physicist Christian Doppler (1803–53) that a moving body will produce an increase or decrease in radiation wavelength depending on whether it is moving away from or towards the observer, the displacement of the absorption and emission lines in a spectrogram were used to determine the motion of celestial bodies relative to the earth.[105] By the late 1880s, Huggins, Hermann Carl Vogel (1834–98) and Julius Scheiner (1858–1913) at Potsdam Observatory, Germany, had determined relative velocities in this way, with differing degrees of success.[106] Specially prepared plates allowed the recording of bands in the electromagnetic spectrum, extending even beyond the ultraviolet and the infrared.

The extraordinary images that emerge from what is known as the "new astronomy"—observational astronomy that detects radiation from the non-optical parts of the spectrum and electronically records images from these signals—owe their existence to the advances in spectroscopy at the beginning of the twentieth century, and to the space technology at its end. It is now possible to record the movement of celestial objects towards and away from each other. Far distant objects at the outermost known boundaries of space have been rendered visible through cosmic and radio wave emissions. Cosmic matter such as gas clouds that cannot be picked up by optical telescopes can now be imaged through the recording of gamma waves. Hot gas and magnetic fields trapped in the centre of distant galaxies can now be identified, and the problems of showing both bright and low contrast areas simultaneously overcome by colour intensity coding.

The more traditional means of recording images in visible light also plays a part in the new astronomy, with ingenious techniques developed to retrieve as much information about distant galaxies and nebulae as possible through recording the light waves—or "gathering photons"—of the visible spectrum. The moon, the sun, the stars, planets, nebulae and galaxies are still photographed along with images of white dwarfs, red dwarfs, supernovae and quasars. The distance, faintness, contrast, transparency and obscurity of these objects, along with interference from the grain of the film emulsion, continue to challenge photographers working with conventional photographic methods. David Malin, a world-renowned photographer and astronomer, has developed a repetoire of techniques, such as "unsharp masking" (Pl. 147), "amplification" and tricolour composites to capture remote and undiscovered celestial bodies. A tricolour composite image by Malin of the reflection nebulae around Rho Ophiuchi (Pl. 148), compared with James Edward Keeler's *The Great Nebula in Andromeda* (see Pl. 145) dating from the beginning of the century, reflects developments in twentieth-century technology that have led to greater detail and the ability to add colour to a distant object that appears through the telescope as a barely perceptible, colourless form.[107]

> These images are not visible in the eyepiece of the telescope. At best, even the most colourful gaseous nebulae seem to be little more than faint grey luminous smudges of light, almost indistinguishable from galaxies of stars. My role has been to give these fascinating images colour and, I hope, a greater meaning.[108]

Choices of vantage point, composition, exposure, and presentation are now determined by a

148 David Malin, *Antares and the Rho Ophiuci dark cloud*, 1979. Dye coupler print. Royal Observatory, Edinburgh/Anglo-Australian Observatory.

215

very different set of technological and scientific premises. Our perspective on the universe and our place within it has changed dramatically: we are no longer earthbound. There is, literally, more than one point of view in space from which images of the skies can be described. *Day 011, Survey B Sectors 17 and 18* (Pl. 149), a gelatin silver collage, shows the shadow of a lunar landing craft—from which the photographic recording is made—cast on the surveyed surface of the moon, represented here in sectors. Manned expeditions to the moon have made the earth itself a portrait subject (Pls. 150, 151). Specialized sky-borne laboratories orbit beyond the atmosphere of the earth, where there is no interfering atmosphere. From this vantage point in space, although the distances between observer (or observing station) and subject remain immense, myriad signals of all wavelengths of radiation can be registered and images recorded from 8–12 billion light years away from earth. This data, from the exceedingly short gamma rays to the long wavelengths of radio signals, is harvested with a speed that far exceeds that of conventional photography recording only visible and near visible light waves. These electronic images are then produced through electronic conversion into readable images by charge-coupled devices, and colour is applied to reveal wavelength, velocity, temperature, shape and intensity. Electronically generated visual data is then translated into images that become photographic, giving rise to the term "non-optical" photography.

Non-optical photography developed out of a number of needs, principally the desire to visualize what we know exists from theoretical or mathematical models but are not equipped to see—even when aided, in some cases, with high-powered optical telescopes. Writing on the new astronomy of the late twentieth century, Nigel Henbest and Michael Martin noted that:

> infrared astronomers see cool clouds of dust in space, which are invisible at other wavelengths . . . these hidden dust clouds are the spawning

149 NASA and the United States Geological Survey, *Day 011, Survey B Sectors 17 and 18*, 1967. Gelatin silver collage. Robert Shapazian, Los Angeles.

216

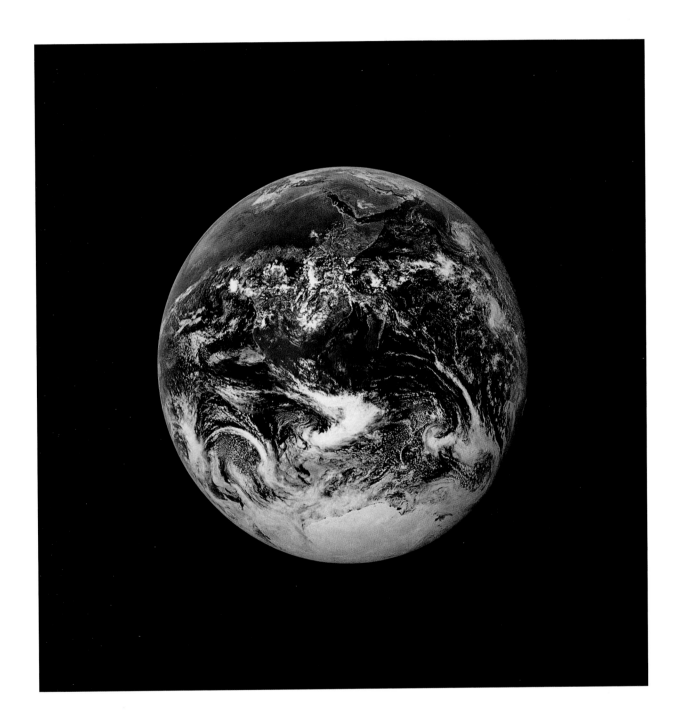

150 NASA, *Mission Apollo–Saturn 17, December 7–19, 1972*. Dye transfer print. Robert Mann Gallery, New York.

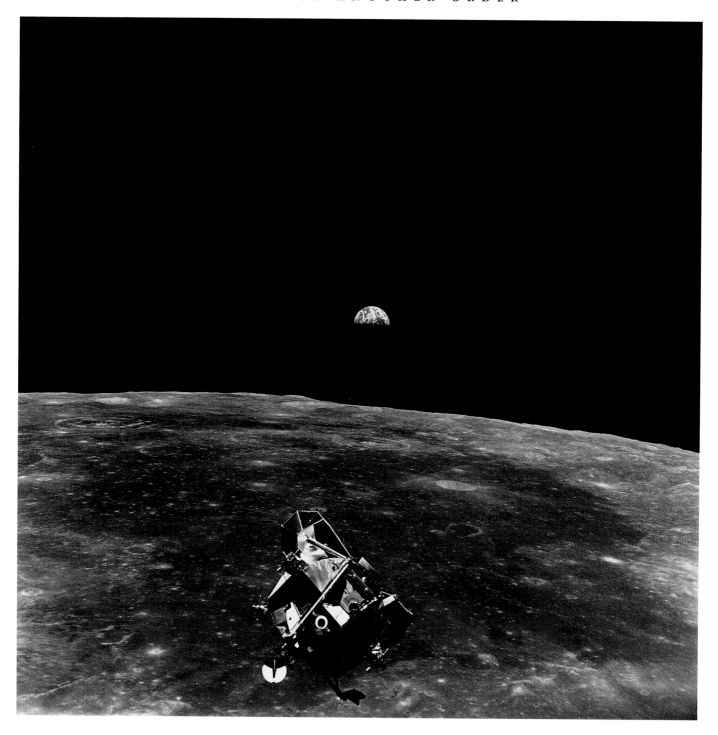

151 NASA, *Mission Apollo–Saturn 11, July 16–24, 1969 (Lunar Module Eagle returns to the Command/Service Module, Columbia, after the first lunar landing).* Dye transfer print. Robert Mann Gallery, New York.

152 Robert Williams and the Hubble Deep Field Team (STScl)/NASA, *Hubble View of Galaxies at farthest known edge of deep space beyond our Solar System,* January 1995. NASA.

grounds for new stars, and infrared astronomers are privileged to see the first signs of star birth.[109]

Our knowledge of our place in the universe has altered radically. It continues to do so with the launch of every new probe and the announcement of every new discovery emanating from images sent back to earth from our astronomical observation posts. The Hubble Space Telescope,[110] orbiting beyond earth's atmosphere in December 1995, was focused for a period of ten days[111] on a relatively small wedge of the sky believed to be empty space marking the furthermost edges of the cosmos. Instead of bringing back a blank image, it recorded a crude, shining mosaic of "faint blue galaxies" numbering approximately 1,500 (Pl. 152). These galaxies are estimated to exist 3–8 billion light years distant from our planet; in other words, in "lookback time", the earth would have been in its infancy when they existed in their depicted abundance.[112]

Astronomical photographs revolutionize our thinking about some of the most basic aspects of photography: distance, faintness, motion, staging and exposure time. They refresh our initial captivation with a medium that enabled us to picture fragments of everyday reality and that now permits us to do the same in remote and intangible corners of the universe. Beautiful and loaded with information, they also introduce us to the ambiguities and wonders of inscribing vast regions of space and periods of time on to small pieces of paper.

NOTES

CHAPTER 1
PHOTOGRAPHY'S ILLUSTRATIVE ANCESTORS
MIMI CAZORT

1 Claus Nissen, *Die naturwissenschaftliche Illustration: ein geschichtlicher Überblick*, Bad Münster am Stein 1950.

2 Devon Leigh Hodges, *Renaissance Fictions of Anatomy*, Amherst 1985, p. 3.

3 K. D. Keele and C. Pedretti 1977, in *Leonardo da Vinci: Anatomical Drawings from the Royal Collection*, catalogue of the Royal Academy of Arts, London 1977, p. 121. Leonardo's failure to have his drawings of mechanics, hydraulics, human anatomy and meteorological occurrences circulated in printed form relegated his scientific discoveries to the fate of medieval illustrated manuscripts: useful only to the few who had access to the originals. However, the fact that his drawings were prized and jealously guarded by his heirs, ultimately finding their ways into public collections, attests to the dawning recognition of the importance of visual records for scientific documentation.

4 H. F. Brown, *The Venetian Printing Press*, London 1891; Elizabeth Armstrong, *Robert Estienne, Royal Printer*, Cambridge 1954; Peter Bieterholz, "Basel and France in the Sixteenth Century: The Basel Humanists and Printers in their Contexts with Francophone Culture", *Travaux d'humanisme et Renaissance*, CXII, Geneva 1971.

5 The British universities, established at the same period, were also concerned with science. The Royal Faculty of Physicians and Surgeons at the University of Glasgow, for instance, was established in 1599. The centres in Britain were, however, less involved in the publication of illustrated texts. John Banister's *The History of Man, sucked from the sappe of the most approved Anatomie*, London 1517 was unillustrated, although a later illuminated manuscript pictures Dr. Banister dissecting (see ms. 364, Hunterian, Glasgow University). The intricate relationship between the guilds and the universities remains to be explored.

6 Conrad Gessner, *Historiae animalium, Liber iv*, Frankfurt 1612; Guillaume Rondelet, *Libri de piscibus marinis in quibus verae piscium effigies expressae sunt*, Leiden 1554.

7 A. Hyatt Mayor, *Prints and People*, New York 1971, nos. 5–10.

8 Francesco Colonna, *Hypnerotomachia polifili*, Venice 1499; Albrecht Dürer, *The Fall of Man*, Nuremberg 1504.

9 A notable exception is Gaspare Aselli's *De Lactibus sive Lacteis venis*, Milan 1627. These remarkable images show the intestines of a dog. A rare series of proof prints and preparatory drawings exist in the Philadelphia College of Physicians.

10 L. Ledoux-Lebard, "La gravure en couleurs dans l'illustration des ouvrages médicaux depuis les origines jusqu'à 1800", *Bulletin de la Société française d'histoire de la médecine*, 1911, pp. 218–25; 1912, pp. 171–93. See also ictor Carlson and John Ittman, *Regency to Empire: French Printmaking 1715–1814*, exhibition catalogue, Minneapolis 1984; and Florian Rodari et al., *Anatomie de la couleur: L'Invention de l'estampe en couleurs*, exhibition catalogue, Paris 1996.

11 Otto Brunfels, *Herbarum vivae Eicones*, Johann Schott, Strasbourg 1530 (86 woodcuts by Hans Weiditz); Leonhardt Fuchs, *Historia stirpium*, Basel 1542 (185 woodcuts); Marcello Malpighi, *Opera omnia, tomis duobus conprenhensa*, London 1683–87. See Claus Nissen, *Die botanische Buchillustration. Ihre Geschichte und Bibliographie*, vol. I *Geschichte*; vol. II *Bibliog*, Stuttgart 1951; Lobera de Avila, *Vanquita de nobles cavalleros*, ed. H. Steiner, Augsburg 1530 (illustrated with woodcut by Hans Burgkmair of standing man showing the location of plague sites); Laurentius Rusius, *Hippiatria sive marescalia*, C. Wechelum, Basel 1532, for remarkable horse woodcut illustrations; Conrad Gessner, *Historia animalium*, Laurentius, Frankfurt 1617, 5 vols.; Marcello Malpighi, *Opera medica et anatomica varia*, Venice 1743 (with Suor Isabella's frontispiece with leopards); Andreas Vesalius, *Humani corporis fabrica*, Basel 1543; Julius Casserius, *De vocis auditusque . . .*, Ferrara 1600; Pierre Belon, *L'Histoire de la nature des oyseaux, avec leurs descriptions, et naïfs portraicts retirez du natural*, Paris 1555, pp. 40–41 for comparison between bird and human skeletons. Berengario da Carpi, *Carpi commentaria cum amplissimis additionibus super anatomia Mundini*, Bologna 1521.

12 "A similitudine testiculorum bulbi omnes Venerem stimulant", Giovanni Battista della Porta, *Phytognomonica . . . in quibus nova, facillamaque affertur methodus, qua plantarum, animalium, mettaloru . . .*, Naples 1588, II, p. 142.

13 The word porpoise is derived from *porcus piscis*, "hog fish", a fact that evidently puzzled the illustrator.

14 T. H. Clarke, *The Rhinoceros from Dürer to Stubbs 1515–1799*, Philip Wilson, London 1986

15 Guillaume Rondelet, op. cit., pp. 128–29. The creature and its accompanying text were copied in Conrad Gessner, op. cit., "De Aquatibus", p. 439.

16 Rondelet, op. cit.; Gessner, op. cit., p. 102. Gessner justifies his marine monsters by classical references to equally improbable creatures ("*Quis enim no. admiretur, quod als antiquis . . . Tritonibus, Serenibus, Nereidibus, Naiadibus ac plurisque aliis marinis monstris scriptum est?*", p. 441).

17 Giovanni Battista della Porta, *De Humana Physiognomia*

..., Naples 1602 (illustrated with engravings, printed with the text). The most influential publication for artists was Charles Le Brun's *Conférence . . . sur l'expression générale et particulière*, Edition Picart, Paris, 1678. See Charles Bell, *Essays on the Anatomy of Expression*, London 1806 (illustrated with lithographs); also Jean Pierre de Crousaz, *Traité du beau, ou l'on montre en quoi consiste ce que l'on nomme ainsi, par les examples tirez de la plupart des arts et des sciences*, Amsterdam 1715; Alexander Cozens, *Principles of Beauty Relative to the Human Head*, James Dixwell, London 1778. Leonardo had also been concerned with the potential of anatomical understanding to further the depiction of expression; see L. H. Heydenreich, *Leonardo da Vinci*, Basel 1954, 2 vols., I, p. 30.

18 The illustration of scientific instruments and devices has its own history. Early surgical instruments are seen in the "*Tabula decem*", or ten plates of head dissections in Walter Hermann Ryff, *Des aller fürtrefflischsten, höchsten und adelischsten geschöpffs aller Creaturen . . .*, Baltasar Beck, Strasburg 1541, and in Andreas Vesalius, *De humani corporis fabrica*, Basel 1543. Apparatus for preparing chemical compounds illustrated texts by alchemists, such as Leonhart Thurneisser's *Das ist confermatio concertationis, oder ein Bestettigung*, Berlin 1576, p. 105v, which has a moveable diagram of a working furnace-distillery.

19 Cazort et al., *The Ingenious Machine of Nature: Four Centuries of Art and Anatomy*, Ottawa 1996, pp. 179, 186. The earliest representation of the use of a microscope in anatomical dissection may be Romeyn de Hoogh's frontispiece to the 1674 Amsterdam edition of William Harvey's *De Generatione Animalium*, which shows two female anatomists, one dissecting a dog (or a pig) with the help of a hand-held microscope. Gian Lorenzo Bernini based his sculptural details of a bee (symbol of the Barberini family) on a model drawn under magnification; see *Opera scelte di Marcello Malpighi*, ed. Luigi Belloni, Turin 1967, p. 39.

20 Cazort et al., op.cit., p. 192, fig. 67.

21 The representation of the world of nature was "intimamente unito ad un esigenza conoscitiva e una prassi collezionistica tipica della cultura della 'Wunderkammer'"; see Fausta F. Guelfi, "Otto Marseus van Schrieck a Firenze", in "Contribuito alla storia dei rapporti fra scienza e arte figurativa nel seicento toscano", *Antichità viva*, XVI, 1977, no. 2, pp. 15–26; no. 4, pp. 13–21, p. 13.

22 See the catalogues for the exhibitions *Firenze e la Toscana dei Medici nell' Europa del Cinquecento*, Florence 1980. Pride of ownership also served as a powerful stimulus and funding source for scientific illustration, such as in Tobias Aldino's superbly illustrated book on the plants in Cardinal Farnese's private garden in Rome, the *Exactissima descriptio rariarum quarandam plantarum que continentur Roma in Horto Farnesiano Tobia Aldino cesanate auctore Cardinale Odoardo Farnese medico chimico et eiusdem horti praefecto*, Jacobo Mascardo, Rome 1625.

23 The ethnological material in the National Institution for the Promotion of Science, incorporated into the Smithsonian Institution, Washington, D.C., in 1857, was known as "National Cabinet of Curiosities"; see Douglas Cole, *Captured Heritage: The Scramble for Northwest Coast Artifacts*, Vancouver 1995, pp. 8, 10.

24 The Italian term *grotteschi* originated with the discovery in the sixteenth century of such Roman ruins as the Domus Aurea of the Emperor Nero, which included wall decorations of combined animal and floral forms. Such hybrids were adopted by Renaissance artists as decorative elements.

25 The public appetite for freaks and images of freaks is indicated by G. van der Gucht's engraving of a "Negro Hermaphrodite", dated 20 April 1741 and inscribed: "This person, a native of Angola in Africa, was first shown in London in June, 1740 . . . neither sex but a wonderful mixture of both." See also Frederick Ruysch, *Opera omnia anatomico–medico–chirurgica*, Amsterdam 1737.

26 Ulisse Aldrovandi, *Monstrorum historia*, Nicola Tebaldini, Bologna 1642. See also Giuseppe Olmi, "Avvertimenti del Dottore Aldrovandi sopra la pitture mostrifiche et prodigioso, Osservazione della natura e raffigurazione in Ulisse Aldrovandi (1522–1605)", *Annali dell' Istituto storico italo–germanico in Trento*, III, 1977, pp. 177–80.

27 The skeletal golden eagle appears in an engraving designed by Jacopo Ligozzi for Giulio Casserio's *De vocis auditusque organis*, Ferrara 1600–01 with other specimens probably from Aldrovandi's collection; see Mimi Cazort, "On Dissected Putti and Combustible Chameleons", *Print Collectors' Newsletter*, vol. XVII, no. 6, pp. 197–201. Ligozzi worked both for the Grand Duke Francesco de' Medici and Aldrovandi, and produced for the latter "Setti volumi di disegni a colori di animali", "Dieci volumi di piante, fiori e frutti" and "Un volume miscellaneo di animali e piante", which are in the Biblioteca dell' Università di Bologna.

CHAPTER 2
INVENTION AND DISCOVERY
LARRY J. SCHAAF

1 This was Faraday's exclamation when he directed the audience to Talbot's first exhibition of photographs, at the Royal Institution on 25 January 1839. Quoted in Vernon Heath, *Recollections*, Cassell, London 1892, p. 49.

2 Letter from James D. Forbes to John Herschel, 9 March 1840, HS7: 295, Royal Society, London.

3 The story, of course, is much more complex. See, for example, Josef Maria Eder, *History of Photography*, trans. Edward Epstean, Columbia University Press, New York 1945; and Larry J. Schaaf, "The First Fifty Years of British Photography: 1794–1884", in *Technology and Art: the Birth and Early Years of Photography*, ed. Michael Pritchard, The Royal Photographic Society, Bath 1990, pp. 9–18.

4 See John H. Hammond, *The Camera Obscura, A Chronicle*, Adam Hilger, Bristol 1981.

5 H. Fox Talbot, "Brief Historical Sketch of the Invention of the Art", *The Pencil of Nature*, no. 1, Longman, Brown, Green and Longmans, London 1844.

6 See Larry J. Schaaf, *Tracings of Light: Sir John Herschel & the Camera Lucida*, The Friends of Photography, San Francisco 1989.

7 As one reviewer caustically noted, "such means are like

the railing of a road; they may keep the active traveller on the right course, but they cannot make the lame walk. Let not any one imagine that he can learn to draw, merely by purchasing a Camera Lucida; he might as soon learn music, by merely buying a fiddle," *The Athenæum*, no. 148, 28 August 1830, p. 540.

8 H. Fox Talbot, "Brief Historical Sketch . . .", op. cit.

9 Quoted from Helmut and Alison Gernsheim, *L. J. M. Daguerre*, Secker and Warburg, London 1956, p. 1.

10 Letter from Talbot to Herschel, 27 March 1833, HS17: 270, Royal Society of London.

11 A good indication of the breadth of Talbot's interests and education is given in H. J. P. Arnold's *William Henry Fox Talbot: Pioneer of Photography and Man of Science*, Hutchinson Benham, London 1977.

12 H. Fox Talbot, "Brief Historical Sketch . . .", op. cit.

13 Davy might have incorporated his friend's work into his evening lectures on the "Chemistry of the Arts", which started in 1802. He published Wedgwood's process in "An Account of a method of copying Paintings upon Glass, and of making Profiles, by the agency of Light upon Nitrate of Silver. Invented by T. Wedgwood, Esq. With Observations by H. Davy", *Journals of the Royal Institution*, vol. 1, no. 9, 22 June 1802, pp. 170–74.

14 Henry, Lord Brougham, *Lives of Philosophers of the Time of George III*, Charles Griffin, London 1866, p. 121.

15 In the Science Museum Library, London. See Arthur Gill, "James Watt and the Supposed Early Photographs", *The Photographic Journal*, vol. 105, May 1965, pp. 162–63.

16 Carlisle wrote that he: "about forty years ago, made several experiments with my lamented friend, Mr. Thomas Wedgwood [sic], to obtain and fix the shadows of objects by exposing the figures painted on glass, to fall upon a flat surface of shamoy leather wetted with nitrate of silver, and fixed in case made for a stuffed bird, we obtained a temporary image or copy of the figure, which, however, was soon obscured by the effects of light." He revealed this fresh from seeing the first photographs that Talbot exhibited to the public. "On the Production of Representations of Objects by the Action of Light", *Mechanics Magazine*, vol. 30, no. 809, 9 February 1839, p. 329.

17 "Singular Method of Copying Pictures, and Other Objects, by the Chemical Action of Light", *Ackermann's Repository*, vol. 2, no. 10, 1 October 1816, pp. 203–4. Other publications that published Wedgwood's work prior to the public announcement of photography included: *Annali di Chimica e Storia Naturale*, vol. 21, 1802, pp. 212–18; *Annals of Philosophy*, vol. 3, 1802, p. 151; *Nicholson's Journal*, vol. 3, November 1802, pp. 165–70; *Bibliothèque Britanique*, Geneva, vol. 22, January 1803, pp. 93–98; *Bulletin des Sciences par la Société Philomathique*, vol. 3, no. 69, 1803, p. 167; *Annales de Chimie*, vol. 45, 1803, p. 256; *Annalen des Physik*, vol. 13, 1803, pp. 113–19; Fredrick Accum, *A System of Theoretical and Practical Chemistry*, London 1803, vol. 1, pp. 122–24 and Philadelphia 1814, vol. 1, pp. 159–61; John Imison, *Elements of Science and Art*, London 1803, vol. 2, pp. 606–9, new edition 1822, pp. 328–29; *Journal für die Chemie, Physik, und Mineralogie*, vol. 4, 1807; Benjamin Silliman, *Epitome of Experimental Chemistry*, Boston 1810, p. 196; Hewson

Clarke and John Dougall, *The Cabinet of Arts, or General Instructor*, T. Kinnersley, London 1817, pp. 774–75; *Magazin for Naturvidenskaberne*, Christiania 1824, pp. 23–28; John Webster, *Manual of Chemistry*, 2nd edn., Boston 1828, p. 432.

18 Some of these ephemeral images remained visible nearly a century after they were made. In arguing the need for a photographic museum, Samuel Highly claimed that "many specimens very illustrative will presently be swept away as rubbish." To emphasize this, he claimed that "only last night I was looking at specimens of some of Wedgwood's experiments with chloride of silver." Highly, "Needed, A Photographic Library and Museum", *The Photographic News*, vol. 29, no. 1415, 16 October 1885, pp. 668–69.

19 This particular example, from 1839, is inscribed in ink on the verso "A. B. post [postremo? i.e., at last] July 14 cleared no. Merc." For a discussion of this experimental method, see Larry Schaaf, *Records of the Dawn of Photography: Talbot's Notebooks P & Q*, Cambridge University Press, Cambridge 1996, n. 64.

20 Only two surviving examples of this have been identified to date. See Larry Schaaf, *Sun Pictures VII; Photogenic Drawings by William Henry Fox Talbot*, Hans P. Kraus, Jr., New York 1995, pp. 12–13.

21 Constance wrote to describe a lighting effect: "the colouring reminded me a good deal of some of your shadows . . . shall you take any of your mouse traps with you into Wales? It would be charming for you to bring home some views." Letter from Constance Talbot to Henry Talbot, 7 September 1835, LA35-26, Fox Talbot Museum, Lacock. This is the only time the term appears in their correspondence, and Talbot himself never used it.

22 *Notebook M*, undated paragraph some time on or after 28 February 1835, Fox Talbot Museum, Lacock.

23 Although significant work was done on Niépce in the nineteenth and early twentieth centuries, it is only recently that this has been substantially advanced. See Paul Jay, *Niépce, Genèse d'une invention*, Société des Amis du Musée Nicéphore Niépce, Chalon-sur-Saône 1988. Some of the most interesting research, combining the scientist's understanding with the photographer's practice, has been done by Jean-Louis Marignier. A well illustrated, practical demonstration of the process is in his *Héliographies: 1989 première reconstitution du procède du Nicéphore Niépce*, Musée Nicéphore Niépce, Chalon sur Saône 1989. Some of the technical foundations of Niépce's process are further covered in his "Asphalt as the World's First Photopolymer—Revisiting the Invention of Photography", *Processes in Photoreactive Polymers*, ed. V. V. Krongauz and A. D. Reifunac, Chapman and Hall, New York 1995, pp. 3–33.

24 Surprisingly, the image he chose is a copy of a design by Daguerre, "Un Clair de Lune", an 1818 illustration of Melesville's play *Le Songe*. Labels on the back of Niépce's framed image include "Heliography—les premières résultants obtenus spontanément par l'action de la lumière par M. Niépse [sic] de Chalon sur Saone. 1827" and "from a print about 2½ feet long. F. Bauer. Kew Green." It is in the collection of the Royal Photographic Society, Bath.

25 Quoted in Victor Fouque, *The Truth Concerning the Invention of Photography. Nicéphore Niépce. His Life, Letters and Works*, trans. Edward Epstein, Tennant and Ward, New York 1935, p. 35.

26 See R. C. Smith, "Nicephore Niepce in England", *History of Photography*, vol. 7, no. 1, January 1983, pp. 43–50; and Larry J. Schaaf, "Niépce in 1827 England", *Symposium 1985: Proceedings and Papers*, European Society for the History of Photography, Bradford, April 1985, pp. 112–19.

27 Both are in the Gernsheim Collection, Harry Ransom Humanities Research Center, The University of Texas at Austin.

28 First revealed in Thomas Young's Bakerian Lecture, given on 24 November 1803, and published as "Experiments and Calculations Relative to Physical Optics", *Philosophical Transactions*, vol. 94, part 1, 1804, pp. 15–16.

29 William Hyde Wollaston, "On Certain Chemical Effects of Light", *Nicholson's Journal of Natural Philosophy, Chemistry, and the Arts*, vol. 8, August 1804, pp. 293–95.

30 After yet another postponement of the Committee of Papers meeting due on 13 December 1827, the Council resolved "that the Papers proposed, –&c to be considered by the Committee of Papers, shall be deposited in the departments of the Royal Society for inspection and perusal by the Members of Council, at least one week before the meeting of the Committee, and that notice of the Papers being so deposited shall be inserted in every Summons." *Minutes of the Council of the Royal Society*, vol. x, Royal Society of London. The "summonses" to the members were ephemera and not preserved by the Society. It is possible that copies exist in individuals' archives that might establish whether Niépce's paper received any hearing, but none has so far been traced.

31 Frederick Scheer, *Kew and its Gardens*, B. Steill, London 1840, p. 36. Herschel attended at least one of these sessions (although clearly not the one Niépce spoke at). In Herschel's *Diary*, he noted on 28 May 1825 (a Saturday): "Be at Sir E Home's to go to Kew." W0007, Harry Ransom Humanities Research Center, The University of Texas at Austin.

32 Letter from Evrard Home (Sir Evrard's son) to Robert Brown, 17 December 1840, British Museum (Natural History), London.

33 This incident, which took place around the year 1800, is recorded "from an unpublished MS in his own handwriting." A group of men including Benjamin West, the President of the Royal Academy, Mr. Banks, and Mr. Cosway, a writer on painting, "having agreed amongst themselves that the representation of the crucifixion did not appear natural, though it had been painted by the greatest artist of his age, wished to put this to a test. They, therefore, requested me to nail a subject on a cross, saying, that the tale told of Michael Angelo and others was not true of their having stabbed a man tied to a cross, and then making a drawing of the effect." At the time, a murder within a hospital left no doubt that a Mr. Legg would be found guilty and executed. Was he to become the first documented martyr to art historical studies? "A building was erected near the place of execution; a cross provided; the subject was nailed on the cross; the cross

suspended; when the body, being warm, fell into the position that a dead body must fall into, let the cause of death be what it may. When cool, a cast was made, under the direction of Mr. Banks, and when the mob had dispersed, it was removed to my theatre.... The cast is still in existence, and is preserved in the studio of Mr. Behnes." Obituary of Joseph Constantine Carpue FRS, *The Lancet*, vol. 1, 7 February 1846, pp. 166–68.

34 Talbot's published works are detailed in Mike Weaver's *Henry Fox Talbot: Selected Texts and Bibliography*, Clio Press, Oxford 1992. Talbot's family carefully preserved thousands of his photographs and numerous sets of research notes, diaries and notebooks. The bulk of the collection is split between the Fox Talbot Museum in Lacock and the National Museum of Photography, Film and Television in Bradford; significant bodies of material are in collections throughout the world. Some indication of Talbot's voluminous correspondence is given in Larry J. Schaaf, *The Correspondence of William Henry Fox Talbot: a Draft Calendar*, Glasgow University Library Studies, Glasgow 1995.

35 *New York Observer*, 20 April 1839. It subsequently emerged that Daguerre's house had not been destroyed in this fire and that concerned neighbours had removed its contents to safety. While François Arago claimed to have seen Daguerre's research notebook ten days later, it stretches belief that such a valuable historical object was never quoted from at the time. No subsequent record of anyone ever having seen it has been traced, and it seems most reasonable to question that such a formal record ever existed.

36 While we may never know how Daguerre achieved his triumph, the science underlying the daguerreotype process is now beginning to be understood. An excellent modern study is by M. Susan Barger and William B. White, *The Daguerreotype: Nineteenth-century Technology and Modern Science*, Smithsonian Institution Press, Washington 1991.

37 Helmut and Alison Gernsheim, *L. J. M. Daguerre*, op. cit., pp. 69–70.

38 The main evidence for this effort was a unique broadside in the Cromer Collection (passed on to the George Eastman House and subsequently destroyed by accident while out on loan). In it, Daguerre announced that the subscription would open on 15 January 1839 with an exhibition of 40 pictures, an exhibition that never took place. Beaumont Newhall has suggested that Arago's enthusiastic response intervened, and that the broadside was never distributed. See Newhall, "An Announcement by Daguerre", *Image*, vol. 8, no. 1, March 1959, pp. 32–36; also Newhall, *The History of Photography from 1839 to the Present*, rev. and enl. edn., The Museum of Modern Art, New York 1982, p. 18.

39 This situation is discussed at length in Robert Fox's "Scientific Enterprise and the Patronage of Research in France, 1800–70", in *The Patronage of Science in the Nineteenth Century*, ed. G. l'E. Turner, Noordhoof International Publishing, Leyden 1976, pp. 9–51.

40 Extensive references to this rivalry are given in Maurice Crosland's *The Society of Arcueil, A View of French*

Science at the Time of Napoleon 1, Harvard University Press, Cambridge, Massachusetts 1967. Crosland felt that Biot was primarily at fault, largely from his practice as a senior scientist of putting his name on other people's work. Of Biot's rival, he claimed that "Arago could never be considered in a dehumanized way as someone who produced scientific work. He had considerable personal qualities and the influence which he exerted depended as much on this as upon the quality of his scientific work. Arago made an excellent secretary by virtue of his wide grasp of science and his ability to handle men He quickly grasped the essentials of a memoir and with his powers of expression he was able to hold the attention of his colleagues and even their admiration"; pp. 462–63. Jed Z. Buchwald, while recognizing Biot's difficult temperament, still felt that his science was far superior to that of Arago; see *The Rise of the Wave Theory of Light: Optical Theory and Experiment in the Early Nineteenth Century*, The University of Chicago Press, Chicago 1989, pp. 86–88. As the infirmities of old age began to catch up with both men, their fundamental respect for each other re-emerged. Ironically for the introduction of photography, Arago and Biot patched up their difficulties in 1840, the year after Daguerre's and Talbot's announcements.

41 Letter from Margaret Herschel to Caroline Herschel, 14 December 1844; L0589, Harry Ransom Humanities Research Center, The University of Texas at Austin.

42 Roger Hahn, *Dictionary of Scientific Biography*, vol. 1, Charles Scribner's Sons, New York 1970, pp. 200–203.

43 The English editor of the *Literary Gazette*, William Jerdan, took credit (and probably rightfully so) for forcing Daguerre to acknowledge his debt to the work of one of his own countrymen, gloating about "the circumstances connected with the previous discoveries communicated to M. Daguerre, which were first stated in the *Literary Gazette*, and led to considerable controversy and no inconsiderable resentment on the part of the *Daguerrists* at the time, but were finally acknowledged, and their author made a sharer in the reward so justly and liberally assigned by the French government to M. Daguerre for his ingenious improvements, which carried the art so much nearer to perfection." These were recounted in the review of the first number of Talbot's *Pencil of Nature* in the *Literary Gazette*, no. 1432, 26 June 1844, p. 410.

44 Bayard had been working on a photographic process before 1839 and was able to show an independently invented paper negative before Talbot's working details were disclosed. Seeing the negative–positive approach as a disadvantage compared with Daguerre's, he invented a direct positive process *on paper* by early spring 1839. Arago, however, persuaded him to keep this a secret by supplying Bayard with some apparatus and encouraging him to develop it further. Daguerre's announcement then totally eclipsed Bayard's efforts. There was contact both explicit and implied between Talbot and Bayard. See Nancy Keeler, "Souvenirs of the Invention of Photography on Paper: Bayard, Talbot, and the Triumph of Negative–Positive Photography", *Photography, Discovery and Invention*, The J. Paul Getty Museum, Malibu 1990, pp. 47–62; Jean Claude Gautrand and Michel Frizot, *Hippolyte Bayard,*

Naissance de l'image photographique, Les Trois Cailloux, Paris 1986.

45 Letter from Talbot dated 30 January 1839 to the editor of the *Literary Gazette*, no. 1150, 2 February 1839, pp. 73–74.

46 Years later, Talbot remembered that "the first person who applied photography to the solar microscope was undoubtedly Mr. Wedgwood . . . but none of his delineations have been preserved, and I believe that no particulars are known. Next in order of time to Mr. Wedgwood's, came my own experiments. Having published my first photographic process in January, 1839, I immediately applied it to the solar microscope, and in the course of that year made a great many microscopic photographs, which I gave away to Sir John Herschell [sic], Sir Walter Calverley Trevelyan, and other friends. The size of these pictures was generally half that of a sheet of writing paper, or about eight inches square. The process employed was my original process, termed by me at first 'Photogenic drawing,'—for the calotype process was not yet invented. I succeeded in my attempts, chiefly in consequence of a careful arrangement of the solar microscope, by which I was enabled to obtain a very luminous image, and to maintain it steadily on the paper during five or ten minutes, the time requisite . . . the magnifying power obtained was . . . 289 in surface. The definition of the image was good. After the invention of the calotype process, it became of course a comparatively easy matter to obtain these images; and I then ceased to occupy myself with this branch of photography, in order to direct my whole attention to the improvement of the views taken with the camera." Letter from Talbot to Samuel Highley, Jnr., 10 May 1853, read at the Twentieth Ordinary Meeting of the Society of Arts, *Journal of the Society of Arts*, 13 May 1853, p. 292.

47 LA40-12, Fox Talbot Museum, Lacock. Talbot's photogenic drawings relied on ample sunlight for their exposure. Since the weather had been miserable since the first public announcement of photography, he was unable to produce any new prints in sufficient quantity to meet the demand. Talbot's half-sister, Caroline Mount Edgcumbe, was a lady-in-waiting to Queen Victoria; on several occasions, she presented Henry Talbot's works to the Royal household.

48 Quoted in translation from *Photography in Russia, 1840–1940*, ed. David Elliott, Thames and Hudson London 1992.

49 Quoted in translation from Anna Auer, "Andreas Ritter von Ettingshausen (1796–1878), *History of Photography*, vol. 17, no. 1, spring 1993, pp. 117–20.

50 *The Athenaeum*, no. 618, 26 August 1839, p. 643.

51 These were detailed in a broadside, *A Brief Description of the Photogenic Drawings Exhibited at the Meeting of the British Association, at Birmingham, in August, 1839, by H. F. Talbot, Esq.* A total of 93 images was shown in four categories, including a number of copies of botanical specimens, feathers, copies of other art forms, and 20 views made in the camera obscura.

52 While this image cannot be dated with certainty, it is typical of the work that Talbot was accomplishing by the start of 1840. The only other known surviving print of this is in one of Talbot's personal albums (now in a private collection); five out of the 24 images in this album are positively

dated, and they all fall in the range of June–December 1840.

53 For a record of these in Talbot's own hand, see the facsimiles in Larry J. Schaaf, *Records of the Dawn of Photography: Talbot's Notebooks P & Q*, Cambridge University Press, Cambridge 1996.

54 Letter from Brewster to Talbot, 16 November 1837. Brewster continued: "in placing your name at the head of this very little volume, I express very imperfectly the admiration which I feel for your scientific acquirements, and for the zeal with which you devote your fortune and talents to the noblest purposes to which they can be applied." The original letter was attached to Brewster's article, "A Treatise on the Microscope", in the 7th edition of the *Encyclopedia Britannica*. It appears that the original, owned by the historian Henry Guttman, was lost when Guttman's house was bombed during World War II. Fortunately, he had sent a typescript of the letter to Beaumont Newhall, from whose archives in the J. Paul Getty Museum this is quoted.

55 Undated letter from Constance Talbot to Lady Elisabeth Feilding, LA36-58, Fox Talbot Museum, Lacock. Although once thought to date from 1835, internal evidence confirms the dating of 1842.

56 See Graham Smith, *Disciples of Light: Photographs in the Brewster Album*, The J. Paul Getty Museum, Malibu 1990.

57 Letter from Brewster to Talbot, 13 November 1847, 1937-4963, National Museum of Photography, Film and Television, Bradford.

58 See Larry J. Schaaf, "Herschel, Talbot and Photography: Spring 1831 and Spring 1839", *History of Photography*, vol. 4, no. 3, July 1980, pp. 181–204.

59 Interestingly, even though Talbot used the term "fixer" for his process, and Herschel used "washing out" for his, modern usage has reversed the meanings of these terms.

60 The original terms hyposulphurous or sodium hyposulphite are the source of our hypo today. Once the chemical character of this compound was more firmly established later in the nineteenth century, the proper term became sodium thiosulph*ate*. In 1819, two decades before the public announcement of photography, Herschel's results were published in a series of articles in the *Edinburgh Philosophical Journal*: "On the Hyposulphurous Acid and its Compounds" (communicated 8 January 1819), vol. 1, no. 1, June 1819, pp. 8–29; "Additional Facts relative to the Hyposulphurous Acid" (communicated 15 May 1819), vol. 1, no. 2, October 1819, pp. 396–400; "Some additional facts relating to the habitudes of the Hyposulphurous Acid, and its union with Metallic Oxides" (communicated November 1819), vol. 2, no. 3, January 1820, pp. 154–56.

61 These compounds were first *identified* (but not investigated) by François Chaussier, "Sur un nouveau genre de combinaison du soufre avec les alkalis", *Bulletin des Sciences par la Société Philomathique*, vol. 2, no. 9, 1799, pp. 70–71. In a companion article, Louis Nicolas Vauquelin contributed a "Notice sur le Sel nommé Hydro-sufure sulfuré de Soude", p. 71.

62 Herschel, "Instantaneous Photography", *The Photographic News*, vol. 4, no. 88, 11 May 1860, p. 13.

63 See Larry J. Schaaf, *Out of the Shadows*, op. cit., plate 38.

64 A useful and enlightening framework for understanding Herschel's scientific philosophy is his *Preliminary Discourse on the Study of Natural Philosophy*, Longman, Rees, Ormé, Brown and Green, London 1830.

65 Diary entry for 10 March 1835, WO018, Harry Ransom Humanities Research Center, The University of Texas at Austin. Figure 3 has a pencil notation on the back: "from a specimen grown by Baron von Ludwig. April 1835." It is possible that this is the March drawing, finished in April by Margaret.

66 These include his "Note on the Art of Photography, or the application of the Chemical Rays of Light to the purposes of Pictorial Representation", *Proceedings of the Royal Society*, vol. 4, no. 37, 1839, pp. 131–33. The full text of his previously unpublished manuscript is reproduced in Larry J. Schaaf, "Sir John Herschel's 1839 Royal Society Paper on Photography", *History of Photography*, vol. 3, no. 1, January 1979, pp. 47–60. Herschel's most detailed articles on photography are "On the Chemical Action of the Rays of the Solar Spectrum on Preparations of Silver and other Substances, both metallic and non-metallic, and on some Photographic Processes", *Philosophical Transactions*, vol. 130, part 1, 1840, pp. 1–59, and "On the Action of the Rays of the Solar Spectrum on Vegetable Colours, and on some new Photographic Processes", *Philosophical Transactions*, vol. 132, part 1, 1842, pp. 181–214.

67 Letter from Herschel to Talbot, 24 March 1843, 1937-4923, National Museum of Photography, Film and Television, Bradford.

68 On receiving these, Talbot wrote to Herschel on 29 March 1843, "many thanks for the specimens, some of which I have retained as desired, but should be glad to have a memorandum of their nature; these are No. 844 black, & 780 blue; both negative," HS17:315, Archives of the Royal Society. Herschel replied that "No. 780 *negative blue* is done by washing paper with a mixed solution of equal parts Ferro-tartrate of Ammonia (or Ferro-citrate) and Ferro sesquicyanate of Potash (the *Red* Ferrocyanate)," 1937-4924, National Museum of Photography, Film and Television, Bradford.

69 Herschel's postscript was dated 29 August 1842 and was added to his "On the Action of the Rays of the Solar Spectrum on Vegetable Colours, and on some new Photographic Processes", *Philosophical Transactions*, vol. 132, 1842, pp. 181–214.

70 Letter from Herschel to his wife, 10 August 1841, L0539, Harry Ransom Humanities Research Center, The University of Texas at Austin.

71 John F. W. Herschel, "On the Action of the Rays of the Solar Spectrum on the Daguerreotype Plate", *Philosophical Magazine*, ser. 3, vol. 22, no. 143, February 1843, pp. 120–132. Herschel added a note about the work of Edmund Becquerel (1820–91): "since this was written, M. Becquerel's interesting paper on the Spectrum, read to the French Academy, June 13, 1842, has come into my hands."

72 Hunt's early work is usefully summarized in James Yingpeh Tong, *Facsimile Edition of Robert Hunt's A Popular Treatise on the Art of Photography*, Ohio University Press, Athens, Ohio 1973. See also Helmut Gernsheim, "Robert Hunt FRS, 1807–1887", in *One Hundred Years of Photographic History: Essays in honor of Beaumont Newhall*,

ed. Van Deren Coke, University of New Mexico Press, Albuquerque 1975, pp. 62–64.

73 Robert Hunt, *Researches on Light, in Its Chemical Relations, Embracing a Consideration of All the Photographic Processes*, 2nd edn., Longman, Brown, Green and Longmans, London 1854, pp. 175–76. The chromatype, rarely encountered, was a simple and elegant process. One started with plain writing paper and coated it with copper sulphate. Once dry, it was washed over with a solution of potassium dichromate of potash and dried again. When first exposed to the light, a dull brown negative started forming, but continued exposure led to a yellow positive on a white ground. With either exposure (the extended exposure produced superior final images), a positive image was brought out by flooding it with a solution of silver nitrate. Washing in pure water then converted the image to a red tone, and made it permanent. If any salts were present in the water, the image was weakened a bit and became lilac in tone.

74 Robert Hunt, "On Chromatype, a new Photographic Process", *Report of the British Association for the Advancement of Science*, 1843, pp. 34–35.

75 Letter from George Butler to Henry Talbot, 25 March 1841, LA41-22, Fox Talbot Museum, Lacock.

76 Charles Piazzi Smyth, "On the Form of Plants in Teneriffe [sic]", read before the Royal Scottish Society for the Arts, 30 December 1857. This paper was abstracted in the *Proceedings of the Royal Scottish Society for the Arts*, vol. 5, 1858, p. 59. The full manuscript is preserved in the National Library of Scotland, no. 3868. Quoted in Larry J. Schaaf, "Piazzi Smyth at Teneriffe: Photography and the Disciples of Constable and Harding", *History of Photography*, vol. 5, no. 1, January 1981, pp. 27–50.

77 Nissan N. Perez, *Focus East: Early Photography in the Near East (1839–1885)*, Harry N. Abrams, Inc., New York 1988, pp. 168–69. See also Compte de Simony's *Une curieuse figure d'artiste: Girault de Prangey, 1804–1892*, J. Belvet, Dijon 1937.

78 "En général, on se montre peu disposé à admettre que le même instrument servira jamais à faire des portraits [one is little disposed to admit that the same instrument will ever be able to make portraits]", François Arago, "Le Daguerréotype", *Compte Rendu*, vol. 9, no. 8, 19 August 1839, p. 266.

79 This has been the subject of several studies, all of which reveal many fascinating details, but none of which satisfactorily explain why the process caught on so well in the new world. See Beaumont Newhall, *The Daguerreotype in America*, revised edition (New York: New York Graphic Society, 1968); Richard Rudisill, *Mirror Image, The Influence of the Daguerreotype on American Society* (Albuquerque: University of New Mexico Press, 1971); *America and the Daguerreotype*, edited by John Wood (Iowa City: University of Iowa Press, 1991).

80 The President was Antoine Etienne Reynaud Augustin Serres. For more on Thiésson and his context, see Janet E. Buerger, *French Daguerreotypes*, The University of Chicago Press, Chicago 1989, p. 91. Thiésson took a daguerreotype portrait of Daguerre in 1844 which is now in the Musée Carnavalet; it forms the frontispiece to the

Gernsheims' *L. J. M. Daguerre*, op. cit.

81 Ibbetson continued, however, that "on showing the book, however, to M. Arago, at Paris, at the commencement of the year 1840, he informed me that Mr. Fox Talbot had worked on the same subject, and had patented a process. This stopped my proceedings." Letter from L. L. Boscawen Ibbetson, *Journal of the Society of Arts*, vol. 1, 31 December 1852, p. 69.

82 "Our Weekly Gossip", *The Athenæum*, no. 1586, 20 March 1858, p. 372.

83 Letter from James D. Forbes to John Herschel, 17 August 1840, HS7:296, The Royal Society, London.

84 Ibbetson worked quickly. Buckland marvelled that "from a beautiful fossil starfish I sent by one day's mail to Captain Ibbetson, in London, I received by the next mail, a parcel of most exact impressions, taken from a photographic drawing, transferred to stone, by the process above mentioned." Buckland's Anniversary Address, "Photography", *The Annals and Magazine of Natural History*, vol. 9, no. 58, June 1842, p. 355.

85 Two examples were presented: "the same process was followed in the case of the next illustration, but the original impression was obtained by means of the *hydro-oxygen light* instead of that of the sun. The object represented is the transverse section of a *madrepore* (a species of coral), magnified twelve and a half times." Book review, "Electrotype and Daguerreotype", *The Westminster Review*, vol. 34, no. 2, September 1840, pp. 434–60.

86 "Our Weekly Gossip", *The Athenæum*, no. 669, 22 August 1840, p. 663.

87 Letter from Talbot to Herschel, 21 March 1839, HS17:289, Royal Society, London.

88 Letter from Talbot to Hooker, 27 February 1833, Royal Botanic Gardens, Kew.

89 Letter from Talbot to Hooker, 26 March 1839, Royal Botanic Gardens, Kew.

90 See Larry J. Schaaf, *Sun Gardens: Victorian Photograms by Anna Atkins*, Aperture, New York 1986.

91 Letter from Anna Atkins to Sophia Bliss, 8 October 1843, Tel Aviv Museum of Art.

92 Letter from Children to Talbot, 14 September 1841, LA41-57, Fox Talbot Museum, Lacock.

93 John George Children, "Lamarck's Genera of Shells", *The Quarterly Journal of Science, Literature, and the Arts*, vol. 16, 1823. The 256 original drawings that Atkins produced were purchased in 1973 by the Zoological Department of the British Museum (Natural History).

94 Letter from Children to Hooker, 3 October 1835, Royal Botanic Gardens, Kew.

95 For a good analysis of the factors that promoted women's entry into this field, see D. E. Allen, "The Women Members of the Botanical Society of London, 1836–1856", *The British Journal for the History of Science*, vol. 13, no. 45, 1980, pp. 240–54.

96 *Annals of Natural History*, vol. 4, no. 23, November 1839, p. 212.

97 A. A. [Anna Atkins], *British Algae: Cyanotype Impressions*, 3 volumes, privately published, Halstead Place, Sevenoaks 1843–53.

98 One friend was the Sussex botanist, Anne Dixon. See Larry

J. Schaaf, *Sun Gardens*, op. cit., pp. 35–36. See also John L. Wilson, "The Cyanotype", in *Technology and Art: the Birth and Early Years of Photography*, ed. Michael Pritchard, The Royal Photographic Society, Bath 1990, pp. 19–26.

99 Letter, Hooker to Talbot, 21 June 1839. Royal Botanic Gardens, Kew. The photogenic drawing of the plant Talbot sent must have been very similar to the one illustrated in Schaaf, *Out of the Shadows*, fig. 36.

100 Robert Hunt, *The Poetry of Science, or Studies of the Physical Phenomena of Nature*, Reeve, Benham and Reeve, London 1848, p. xxiii.

CHAPTER 3
THE SIGNATURE OF LIGHT
JOHN P. MCELHONE

There are a number of studies of the role of science and scientists in the pre-history and history of photography. Listed here are those which have guided my understanding of the subject and on which I have depended in preparing this essay. Josef Maria Eder, *Geschichte der Photographie*, 4th edn., 1932, trans. Edward Epstean as *History of Photography*; Columbia University Press, New York 1945, and republished Dover, New York 1978, is a fundamental document in the history of photographic technology. Reese Valmer Jenkins, "Some Interrelations of Science, Technology, and the Photographic Industry in the Nineteenth Century", doctoral dissertation, The University of Wisconsin, 1966, is particularly helpful. Several of the essays in the conference proceedings published as *Pioneers of Photography: Their Achievements in Science and Technology*, ed. Eugene Ostroff, SPSE—The Society for Imaging Science and Technology, Springfield, Virginia 1987, are very relevant. Janet E. Buerger, *French Daguerreotypes*, The University of Chicago Press, Chicago 1989, contains a short chapter (chap. 6, pp. 82–92) that gives a very comprehensive picture of the involvement of French scientists with daguerreotypy. Larry J. Schaaf's studies on the invention of photography in Britain are consistently thoughtful, scholarly and entertaining; note particularly "The First Fifty Years of British Photography: 1794–1844", *Technology and Art: the Birth and Early Years of Photography*, ed. Michael Pritchard, The Royal Photographic Society, Bath 1990, pp. 9–18; and the richly documented *Out of the Shadows: Herschel, Talbot, & the Invention of Photography*, Yale University Press, New Haven 1992.

1 Newton's views actually incorporated both conceptions of light, since he accepted the presence of the ether and conceived that the light particles had alternating cycles, or "fits of easy transmission and fits of easy reflection". This alternating, or periodic, behaviour allowed him to explain "Newton's rings", the concentric coloured rings in the film of air between a lens and a flat sheet of glass.

2 Eder, op. cit., pp. 60–83.

3 M. Hellot, "Sur une nouvelle encre sympatique", *Histoire de l'Académie royale des sciences, avec les mémoires de mathématique & de physique*, 1737, pp. 104–105.

4 Eder, op. cit., pp. 86–88.

5 Jenkins, op. cit., p. 8, notes two works: Guyot, *Nouvelles récréations*, 1769–70; and William Hooper, *Rational Recreations*, 1774.

6 Eder, op. cit., pp. 96–99; and T. H. James, "Why Photography Wasn't Invented Earlier", *Pioneers of Photography*, op. cit., p. 12.

7 John Dalton, *New System of Chemical Philosophy*, London 1808 and 1810.

8 James, *Pioneers of Photography*, op. cit., p. 12.

9 Satish C. Kapoor, "Louis Berthollet", *Dictionary of Scientific Biography*, ed. Charles Coulston Gillispie, Charles Scribner's Sons, New York 1970, pp. 73–82.

10 Eder, op. cit., pp. 116–18; and Schaaf, *Out of the Shadows*, op. cit., pp. 23–25

11 Eder, op. cit., pp. 102–107.

12 [Thomas] Seebeck, "Über die Einwirkung farbiger Beleuchtung auf ein Gemisch von gasförmiger oxydirter Salzsäure und Wasserstoffgas", *Journal für Chemie und Physik*, vol. 2, 1811, pp. 263–64; also quoted in Eder, op. cit., p. 154.

13 Eder, op. cit., p.157.

14 Eder, op. cit., p. 169.

15 Mme. Somerville, "Expériences sur la transmission des rayons chimiques du spectre solaire à travers différents milieux", *Comptes rendus hebdomadaires des séances de l'Académie des sciences*, vol. 3, 1836, pp. 473–76.

16 J. F. W. Herschel, "On the Hyposulphurous Acid and its Compounds", *Edinburgh Philosophical Journal*, vol. 1, no.1, 1819, pp. 8–29; this information was also made available in William T. Brande's popular textbook, *A Manual of Chemistry*, London 1819.

17 "The Discovery of X-Rays", *The Faber Book of Science*, ed. John Carey, Faber and Faber, Boston 1995, pp. 181–87.

18 Alfred Romer, "Henri Becquerel", *Dictionary of Scientific Biography*, op. cit., vol. 1, pp. 558–61; and Henri Becquerel, "No Sun in Paris", *The Faber Book of Science*, op. cit., pp. 188–90.

19 Mungo Ponton, *Edinburgh New Philosophical Journal*, vol. 27, no. 53, 1839, pp. 169–71.

20 John Herschel, "On the Action of the Rays of the Solar Spectrum on Vegetable Colours, and on some new Photographic Processes", *Philosophical Transactions of the Royal Society*, part 1, 1842, p. 191.

21 The information in this section comes largely from T. H. James, "The Search to Understand Latent Image Formation", *Pioneers of Photography*, op. cit., pp. 47–71.

22 A "reducing agent", by donating its electrons, causes other compounds reacting with it to change their state of electrical charge. In the case of silver halide, the silver ion carrying a single positive charge is "reduced" to the metallic state of silver, with a net zero charge.

23 Edgar W. Morse, "Thomas Young", *Dictionary of Scientific Biography*, op. cit., vol. 14, p. 564.

24 Thomas Young, "The Bakerian Lecture. On the Theory of Light and Colours", read 12 November 1801, published in *Philosophical Transactions of the Royal Society*, vol. 92, part 1, 1802, pp. 20–21.

25 In current terminology we refer to red, green and blue as the *additive* primaries, and to the *complementary* colours cyan, magenta and yellow as the *subtractive* secondaries.

26 J. Clerk Maxwell, "On the Theory of Three Primary

Colours", *British Journal of Photography*, vol. 8, no. 147, 1861, pp. 270–71; [Thomas Sutton], *Photographic Notes*, 15 June 1891, pp. 169–70.

27 Interestingly, Maxwell's demonstration should not have worked at all, given the fact that collodion emulsions were only sensitive to blue and ultra-violet light. A possible explanation is suggested in Ralph M. Evans, "Maxwell's Color Photograph", *Scientific American*, vol. 205, no. 5, 1961, pp. 118–28.

28 The 1869 publications of both du Hauron and Cros are reprinted in *Two Pioneers of Color Photography: Cros and Du Hauron*, ed. Robert Sobieszek, Arno Press, New York 1979.

29 Various mechanical means of overcoming this "colour blindness" in the photographic process were used prior to the discovery of optical sensitization. Opaque and translucent paints, crayons and pencils were applied directly on to negatives to modify faulty or missing tones; specially prepared "cloud" negatives were printed in combination with landscape negatives; coloured filters could be used to help "pre-visualize" and choose subjects that would result in the best possible contrasts; make-up was used on portrait subjects to shift the colour of their skin to one that would be reproduced "naturally" on the photographic negative.

30 Eder, op. cit., pp. 458–60; James, "Latent Image Formation", *Pioneers of Photography*, op. cit., p. 63.

31 There are two substantial technical histories of three-colour photography: E. J. Wall, *The History of Three-Color Photography*, 1925, repr. The Focal Press, London 1970; and Joseph S. Friedman, *History of Color Photography*, The American Photographic Publishing Co., Boston 1944. Two illustrated histories of the subject are Brian Coe, *Colour Photography: The First Hundred Years, 1840–1940*, Ash and Grant, London 1978; and *Color as Form: A History of Color Photography*, exhibition catalogue, International Museum of Photography at George Eastman House, Rochester 1982.

32 Thomas Young, "The Bakerian Lecture. Experiments and Calculations relative to physical Optics", read 24 November 1803, published in *Philosophical Transactions of the Royal Society*, vol. 94, part 1, 1804, pp. 1–16.

33 The intricate history of scientific debate on the nature of light in this period is given by Jed Z. Buchwald, *The Rise of the Wave Theory of Light: Optical Theory and Experiment in the Early Nineteenth Century*, The University of Chicago Press, Chicago 1989.

34 "Max von Laue", *Nobel Prize Winners*, ed. Tyler Wasson, The W. H. Wilson Co., New York 1987, pp. 599–601.

35 Lawrence Bragg, D. C. Phillips and H. Lipson, *The Development of X-ray Analysis*, Bell and Sons, London 1975, p. 13.

36 Thomas Bolas, "Historical Development of Heliochromy . . .", *A Handbook of Photography in Colours*, Marion and Co., London 1900, pp. 5–6.

37 Edmond Becquerel, "De l'image photographique colorée du spectre solaire", *Annales de chimie et de physique*, 3ème série, 22, Paris 1848, pp. 451–59; also "De l'image photochromatique du spectre solaire", in ibid., 25, 1849, pp. 447–74; "Nouvelles recherches sur les impressions colorées . . .", in ibid., l42, 1854, pp. 81–106.

38 Levi Hill, *A Treatise on Heliochromy*, Robinson and Caswell, New York 1856; and Joseph Bourdeau, "Color Daguerreotypes: Hillotypes Recreated", *Pioneers of Photography*, op. cit., pp. 189–99.

39 Wilhelm Zenker, *Lehrbuch der Photochromie (Photographie der Natürlichen Farben)*, 1st edn. 1868; repr. Friedrich Vieweg und Sohn, Braunschweig 1900, pp. 116–29. Lord Rayleigh made the same suggestion independently; see "On the Maintenance of Vibrations by Forces of Double Frequency, and on the Propagation of Waves through a Medium endowed with a Periodic Structure", *The London, Edinburgh, and Dublin Philosophical Magazine and Journal of Science*, 5th series, vol. 24, no. 147, 1887, p. 158.

40 Otto Wiener, "Stehende Lichtwellen und die Schwingungsrichtung polarisirten Lichtes [Standing light waves and oscillating polarized light]", *Annalen der Physik und Chemie*, 3rd series, vol. 40, no. 6, Leipzig 1889, pp. 203–43 and one plate.

41 G. Lippmann, "La photographie des couleurs", *Comptes rendus hebdomadaires des séances de l'Académie des sciences*, vol. 112, 1891, pp. 274–75; also published in *Bulletin de la societé française de la photographie*, 2ème série, vol. 7, 1891, pp. 74–75. For comprehensive explanations of Lippmann's interference photography and its scientific context, see P. Connes, "Silver Salts and Standing Waves: The History of Interference Colour Photography", *Journal of Optics*, vol. 18, no. 4, Paris 1987, pp. 147–66; and M. Susan Barger and William B. White, The Daguerreotype: Nineteenth-Century Technology and Modern Science, Smithsonian Institution Press, Washington 1991, pp. 99–106.

42 Interference photography proved adaptable to many photographic materials: Lippmann demonstrated successful results with albumen, collodion and gelatin binders containing silver chloride, silver bromide, silver iodide or potassium dichromate as the light-sensitive component.

43 This phase inversion at a reflecting surface was predicted by Fresnel's experiments with polarized light, and implied by Maxwell's equations.

44 Jean-Marc Fournier and Paul L. Burnett, "Color Rendition and Archival Properties of Lippmann Photographs", *Journal of Imaging Science and Technology*, vol. 38, no. 6, 1994, p. 508.

45 Gabriel Lippmann, in an 1897 speech to the Royal Photographic Society, cited in Thomas Bolas, op. cit., p. 51.

46 G. Lippmann, "Sur la théorie de la photographie des couleurs simples et composées par la méthode interférentielle", *Comptes rendus hebdomadaires des séances de l'Académie des sciences*, vol. 118, 1894, pp. 92–102; also published in *Journal de physique théorique et appliquée*, 3ème série, vol. 3, 1894, pp. 97–107.

47 For instance, see the lead editorial comment in the *British Journal of Photography*, vol. 38, no. 1607, 20 February 1891.

48 There has been a recent flourish of interest in Lippmann interference colour photography among physicists. No fewer than eight articles published in professional journals since 1984 are listed in Hans I. Bjelkhagen, Tung H. Jeong

and Dalibor Vukičevič, "Color Reflection Holograms Recorded in a Panchromatic Ultrahigh-Resolution Single-Layer Silver Halide Emulsion", *Journal of Imaging Science and Technology*, vol. 40, no. 2, 1996, p. 145.

49 Connes, op cit, p. 162.

50 Yu. N. Denysiuk, *Fundamentals of Holography*, trans. A. Chubarov, Mir Publishers, Moscow 1984.

51 Bjelkhagen et al., op. cit., p. 139.

CHAPTER 4
THE SEARCH FOR PATTERN
ANN THOMAS

1 As quoted in James Borcoman, *Charles Nègre 1820–1880*, The National Gallery of Canada, Ottawa 1976, p. 15.

2 "On the Application of Photography to the Continuous Self-Registration of Magnetic and Meteorological Phenomena, as Practised at the Royal Observatory at Greenwich", *The British Journal of Photography*, vol. 12, no. 267, 16 June 1865, p. 316.

3 "Séance du lundi 14 mars 1853: correspondance", *Comptes rendus hebdomadaires des séances de l'Académie des sciences, 1853*, 1er semestre, tome XXXVI, no. 11, p. 500.

4 "Séance du lundi 25 avril 1853: correspondance", *Comptes rendus . . .*, 1er semestre, tome XXXVI, no. 17, p. 740.

5 "Séance du lundi 6 juin 1853: mémoires et communications: Zoologie. Rapport sur un ouvrage inédit, intitulé: *Photographie zoologique*; par MM. Rousseau et Dévéria [sic]", *Comptes rendus . . .*, 1er semestre, tome XXXVI, no. 23, pp. 991–94.

6 "Application of Photography to Zoological Studies", *Humphrey's Journal devoted to the Daguerreian and Photogenic Arts, also embracing the Sciences, Arts and Literature*, vol. 5, no. 22, 1 March 1854, pp. 350–51.

7 "Règistre des procès verbaux. Séances de l'assemblée des professeurs administrateurs du Muséum d'histoire naturelle", vol. 50, séance du 4 octobre 1853, p. 259.

8 Valerie Lloyd, *Roger Fenton: Photographer of the 1850s*, South Bank Board and Yale University Press, London 1988, p. 10.

9 The *Minutes of the St. Andrews Literary and Philosophical Society 1838–1861* for 4 March 1839 record that "The secretary at the request of Sir David [Brewster], . . . exhibited some specimens of drawings executed by Mr. Fox Talbot by the Photogenic paper by the solar rays".

10 Lionel S. Beale, *How to Work with the Microscope*, Harrison, London 1865, 3rd edn., p. vi.

11 Ann Shelby Blum, *Picturing Nature: American Nineteenth-Century Zoological Illustration*, Princeton University Press, Princeton 1993, p. 287.

12 "Photography Applied to Natural Sciences", *The Liverpool Photographic Journal*, vol. 2, no. 22, 13 October 1855, p. 122. In 1856 Richard Owen was made first superintendent of the Natural History Department of the British Museum, and was later promoted to Director when the collections were moved to South Kensington.

13 Blum, op. cit., p. 268.

14 Augustus A. Gould, Introduction to James Deane, MD, *Ichnographs from the Sandstone of Connecticut River*, Little Brown and Company, Boston 1861, p. 4. The publication involved the contributions of Dr. Henry I. Bowditch, Thomas T. Bouvé, Prof. Hitchcock and Roswell Field.

15 Michèle and Michel Auer, *Encyclopédie internationale de photographes de 1839 à nos jours [Photographers' Encyclopaedia International, 1839 to the present]*, Editions Camera Obscura, Geneva 1985.

16 *Notice sur les systèmes de montagnes, 1852*, referred to in René Taton, *Science in the Nineteenth Century*, Basic Books, New York 1965, p. 335.

17 "Séance du lundi 30 avril 1860: correspondance. Orographie. Note sur l'application de la photographie à la géographie physique et à la géologie; par M. A. Civiale", *Comptes rendus . . .*, 1er semestre, tome L, no. 18, p. 827.

18 A. Civiale, *Les Alpes, au point de vue de la géographie physique et de la géologie; voyages photographiques dans le Dauphiné, la Savoie, le Nord de l'Italie, la Suisse et le Tyrol . . .*, J. Rothschild, Paris 1882, p. 49.

19 David G. Smith, ed., *The Cambridge Encyclopaedia of Earth Sciences*, Prentice Hall Canada, Scarborough, Ontario and Cambridge University Press, Cambridge 1981, pp. 21–22.

20 Charles Piazzi Smyth, "Cloud-forms that have been to the Glory of God their Creator, and the wonderment of learned men. As now begun to be recorded by Instant Photographs, taken at Clova, Ripon, in 1892, 93 and 94", vol. 1, p. 10, Royal Society, London.

21 Larry Schaaf, "Charles Piazzi Smyth, Photography, and the Disciples of Constable and Harding", paper presented to Scottish Contributions to Photography, an international symposium at the Glasgow School of Art, 5 March 1983, published in *Photographic Collector*, vol. 4, no. 3, winter 1983, p. 315.

22 As early as 1855 an attempt was made by a Mr. Pouillet to measure the height of clouds by photography. The system he proposed required two cameras and two operators stationed at a distance of approximately ¾ mile apart (adjusted according to the estimated height of the cloud) and an observer in the middle. The observer would choose the appropriate cloud, and signal his decision to the operators who would trigger their shutters. The height of the cloud would later be calculated from the photographs, marked from their negatives with central points, and according to the operators' positions relative to one another and the focal length of the lenses. See *Liverpool Photographic Journal*, vol. 2, no. 19, 14 July 1855, p. 84.

23 He had two cameras, separated by distances ranging from 5 inches to 5 feet, with drop shutters that were triggered simultaneously.

24 See note 20.

25 Piazzi Smyth's trip to Egypt in 1864 to re-measure the Great Pyramid of Gizeh was inspired by John Taylor's ascribing of religious significance to its dimensions. This mystical interest did not receive the approbation of the scientific community.

26 H. A. Brück and M. T. Brück, *The Peripatetic Astronomer: The Life of Charles Piazzi Smyth*, Adam Hilger, Bristol and Philadelphia 1988, p. 187.

27 "Clouds that have been at Clova, Ripon . . .", vol. 1, p. 15, Royal Society, London.

28 H. A. Brück and M. T. Brück, ibid., p. 253.

29 René Taton, *Science in the Nineteenth Century*, Basic Books, New York 1965, p. 375.

30 Larry J. Schaaf, *Sun Gardens*, op. cit., p. 8. "In the introduction to her 1843 book *British Algae: Cyanotype Impressions*, Atkins explained that 'the difficulty of making accurate drawings of objects as minute as many of the Algæ and Confervæ, has induced me to avail myself of Sir John Herschel's beautiful process of Cyanotype, to obtain impressions of the plants themselves, which I have much pleasure in offering to my botanical friends.'"

31 *Leaf prints: or Glimpses at Photography*, Benerman & Wilson, Philadelphia 1868. Also Francesco Panizzi-Savio, *Flora fotografata delle piante più pregevoli e peregrine di Sanremo e sue adiacenze*, Fotografie de Pietro Guidi, San Remo, 1870–77, ?153 photos; S. C. [Sydeny Courtfield], *Ferns of the British Isles Described and Photographed*, John van Voorst, London 1877.

32 The publisher Edward Newman of London proposed to publish a volume of life-size photographs of British ferns by Mrs Glaisher, *British ferns photographed from nature*, but abandoned the project after only a handful had been prepared. They were to be salt prints; a portfolio of 12 folio photographs, with a printed prospectus, is preserved in the Linnaean Society of London. Information from Gavin Bridson, note to the author, 1 January 1995.

33 Courtfield, ibid.

34 In relation to photograms of this period and their value to the study of botany, Bridson is of the view that Bauer's *Delineations...*, in which he represents the *Erica* species, established a standard that could not be surpassed by photography. Gavin Bridson, note to the author, 1 January 1995.

35 *Magicians of Light: Photographs from the Collection of the National Gallery of Canada*, National Gallery of Canada, Ottawa 1993, p. 100. This publication refers to the subject as a breadfruit, but it has subsequently been indentified as a durian.

36 Larry Schaaf, "Charles Piazzi Smyth, Photography, and the Disciples of Constable & Harding", paper presented to *Scottish Contributions to Photography*, an international symposium at the Glasgow School of Art, 5 March 1983, published in *Photographic Collector*, vol. 4, no. 3, Winter 1983, p. 320.

37 An account of Charles Piazzi Smyth's lecture, "On some of the leading plants of the lowest zone in Teneriffe", delivered to the Botanical Society of Edinburgh, appeared in *Transactions of the Botanical Society of Ediburgh*, vol. v, 1858, p. 191.

38 Hermann Schoepf, "Gestaltete Mikrofotografie", p. 214.

39 Larry J. Schaaf, *Out of the Shadows: Herschel, Talbot, & the Invention of Photography*, Yale University Press, New Haven and London 1992, p. 45.

40 Larry J. Schaaf, *Records of the Dawn of Photography: Talbot's Notebooks P & Q*, Cambridge University Press/National Museum of Photography, Film and Television, Cambridge and New York 1996, p. 145. Note 118: "On September 1839, Talbot wrote to Herschel 'I believe you have not seen any of my photographic attempts with the Solar Microscope. I therefore enclose 4 specimens of magnified lace. I have great hopes of this branch of the Art proving very useful, as, for instance in copying the forms of minute crystallization which are so complicated as almost to defy the pencil . . . I expect to be able to compete with M. Daguerre in drawing with the Solar Microscope, when a few obvious improvements have been adopted. By the way did he show you anything remarkable *of this kind*?"

41 Dr. Wolfgang Baier, *Quellendarstellungen zur Geschichte der Fotografie*, VEB Fotokinoverlag, Leipzig 1966, p. 389.

42 Dr. L. Otto and Dr. H. Martin, *150 Jahre Mikrophotographie*, Höhere Graphische Bundes-Lehr-und Versuchsanstalt, Vienna 1989, p. 12. On 7 February 1839 Metternich wrote to his Ambassador in Paris, Anton Count Apponyi, asking about Daguerre's discovery, requesting examples of the "dessins gravées par la lumière", and for his name to be put on the subscription list for details of the process. He went on to say (p. 14) that he understood that these would in any event soon be made public and that when this happened he would like examples plus the materials for him to make his own.

43 Ibid., p. 16.

44 Ibid., p. 18. This daguerreotype has been dated 4 March 1840 but, according to Otto and Martin, Prof. Josef Berres showed it to his colleagues on 25 February 1840.

45 "La notion principale, essentielle des corps organisés, réside précisément dans leur organisation. Que nous importe, par exemple, de savoir que le fluide séminale contient plus ou moins d'albumine . . .", A. L. Donné, *Cours de microscopie complémentaire des études médicales. Anatomie microscopique et physiologie des fluides de l'économie*, J. B. Baillière, Paris 1844, p. 20.

46 Ibid., pp. 36–3

47 Count Lorenzo Montemerli, *Biographie du Docteur Gruby offerte par les membres de la Compagnie humanitaire italienne à ses amis*, Charles de Mourgues frères, Paris 1874, pp. 8–9.

48 Dr. Maddox in England, whose work was considered by some to be vastly superior to many practitioners, but who was forced to give up after an unsuccessful scheme to market his photomicrographs and because of failing eyesight; Auguste Adolphe Bertsch (died 1871) in France, who gained a reputation not only for the high quality of his photomicrographs but also for his technical improvements and who went missing in 1871 during an uprising in the communes; Albert Moitessier (1833–89), author of a number of books on photomicrography who produced photomicrographs of exemplary exactitude, as did A. L. Donnadieu (before 1840–after 1907), professor of zoology at the Faculty of Science, University of Lyon; and C. Hoole, the photographer who assisted metallurgist and geologist H. C. Sorby (1833–89) in making photomicrographs that showed for the first time the microstructure of artificial steel, which were presented to the British Association of the Advancement of Science in 1864. See Cyril Stanley Smith, *From Art to Science: Seventy-Two Objects Illustrating the Nature of Discovery*, MIT Press, Cambridge, Massachussetts and London 1980, p. 112.

49 Copies of Dean's Medulla Oblongata appear with the dates 1863, 1864 and 1865, but nothing later.

50 "The American Photographical Society", *The American Journal of Photography*, vol. 6, no. 23, 1 June 1864, pp. 541–42. It is possible that the publication referred to here was the earlier portfolio version of photolithographs. A portfolio of the albumen silver prints was also produced during the period 1863–65.

51 *Soundings from the Atlantic*, Ticknor and Fields, Boston 1864, pp. 272–73.

52 Dr. Jules Luys, *Iconographie Photographique des Centres Nerveux*, J. B. Baillière, Paris 1873.

53 The application of new staining techniques to cell specimens by Camillo Golgi (1844–1926) at Pavia and Santiago Ramon y Cajal (1852–1934) in 1889, involving silver nitrate and gold chloride rather than organic dyes, rendered internal structures of cells and particularly nerve endings visible and therefore easier to record photographically. Also, the refinement of the microtome in the latter part of the nineteenth century, permitting ever finer slices of samples to be cut, had the consequent effect of making photomicrography an increasingly important and influential tool.

54 Christiane Hemmerich, "Die Biolgische Kunsttheorie im Werk von Ernst Haeckel", in *Karl Blossfeldt*, Schirmer Mosel, Munich n.d., unpaginated. Mention is made here that Moritz Meurer, teacher of Blossfeldt, instructed his students in the Natural Philosophy of Ernst Haeckel.

55 Cooke showed a similar preoccupation with the fundamental geometry underlying natural and built form in his books *The Spiral in Art and Nature* (1903) and *The Curves of Life* (1914). In the latter, he used a photograph by Frederick Evans, *Lincoln Cathedral: Stairs in the S. W. Turret*, to illustrate the form of the spiral staircase. For fuller discussion, see Anne Hammond, "The Soul of Architecture", in *Frederick H. Evans: Selected Texts and Bibliography*, vol. 1, World Photographers Reference Series, G. K. Hall, Boston 1992, p. 4.

56 D'Arcy Thompson, *On Growth and Form*, Cambridge University Press, Cambridge, vol. 1; 2nd edn. repr. 1963, pp. 389–90.

57 A. M. Worthington, *A Study of Splashes*, Longmans, Green and Co., London 1908, p. 38; Thompson, op. cit., p. 67, cites various papers in the *Proceedings of the Royal Society* from 1876 to 1882.

58 Commenting that the subject of snow crystals lies outside the scope of his book, Thompson goes on to discuss with great eloquence the importance of their study. "Crystals", he writes, "have much to teach us about the variety, the beauty and the very nature of form. To begin with the snow crystal is a regular hexagonal plate or thin prism; that is to say, it shows hexagonal faces above and below, with edges set at co-equal angles of 120°. Ringing her changes on this fundamental form, Nature superadds to the primary hexagon endless combinations of similar plates or prisms, all with identical angles but varying lengths of side; and she repeats, with an exquisite symmetry, about all three axes of the hexagon, whatsoever she may have done for the adornment and elaboration of one . . .", pp. 153–54. In *A Search for Structure: Selected Essays on Science, Art, and History*, MIT, Cambridge, Massachussets 1981, Cyril Stanley Smith notes that "although the snowflake appears commonly enough on today's Christmas cards, its decorative qualities do not seem to appear in art until after its depiction in scientific works," pp. 228–30.

59 For example, Plate XLIV, "Various forms of snow crystals drawn by Mr. Glaisher in the winter of 1855", *Microscopical Journal*, vol. 3, p. 179, reproduced in Beale, op. cit., p. 143.

60 Around 1600, Dominic Cassini made drawings of magnified snow crystals, and the co-inventor of the microscope, Robert Hooke (1635–1703), made a series of drawings while studying freshly fallen snowflakes and ice patterns; see D'Arcy Thompson, op. cit., p. 153.

61 Douglas Prior, *W. A. Bentley*, no. 10 in *The History of Photography Series*, Arizona State University, May 1984, p. [3].

62 Prior, ibid. Bentley seems to have travelled only in the north-east of the United States and to Canada, giving lectures. In 1925 he spent the winter outside Montreal, lectured at McGill and continued his collection of snowflakes. He concluded at the end of this trip, however, that the quality of storms and snowflakes was not as good as in his home town in Vermont.

63 William J. Humphreys was the chief physicist at the U.S. weather bureau. Prof. George Perkins taught geology at the University of Vermont, where he and Bentley met in early 1897. They collaborated on an article, "A Study of Snow Crystals", published in May 1898 in *Appleton's Popular Scientific*. Bentley also published articles in *The Christian Herald*, *Popular Mechanics*, *National Geographic*, the *New York Times Magazine*, *Harper's Magazine* and every month for ten months in the *Monthly Weather Review*. See Prior, ibid.

64 Eugene Kinkead and Roman Vishniac, *Roman Vishniac*, Grossman Publishers, New York 1974, p. 31.

65 Ibid., p. 27.

66 C. J. Burnett, "On the Application of Photography to Botanical and Other Book Illustration", *The Liverpool and Manchester Photographic Journal*, vol. 2, no. 18, 15 September 1858, p. 227.

67 Carl Struwe (born 1898) and August Kreyenkamp were other artist–photographers who worked with photomicroscopy.

68 Roger Brielle, "Laure Albin Guillot ou la Science Féerique", *Art et Décoration: Revue Mensuelle d'Art Moderne*, tome LX, July–December 1931, Éditions Albert Lévy, Librairie Centrale des Beaux-Arts, Paris p. 165.

69 See note 38.

70 Franz Roh, "Der Wert der Photographie", *Mittelungsblatt der Pfälzischen Landesgewerbeanstalt*, 1, February 1930, trans. as "The Value of Photography" in *Photography in the Modern Era: European Documents and Critical Writings, 1913–1940*, ed. Christopher Phillips, The Metropolitan Museum of Art, Aperture, New York 1989, p. 161.

71 Wolfgang Born, "Photographische Weltanschauung", *Photographische Rundschau*, Halle 1929, pp. 141–42, trans. in *Photography in the Modern Era*, op. cit., pp. 156–57.

72 László Moholy-Nagy, *Malerei, Fotografie, Film*, Bauhausbucher, vol. 8, 1925, trans. as *Painting, Photography, Film*, MIT, Cambridge, Massachusetts 1969, p. 29.

73 Albert Renger-Patzsch, "Ziele", *Das Deutsche Lichtbild*,

1927, p. xviii, trans. as "Aims" in *Photography in the Modern Era*, op. cit., p. 105.

74 Hugo Sieker, "Absolute Realistik. Zu Photographien von Albert Renger-Patzsch", *Der Kreis*, 1928, trans. as "Absolute Realism: on the Photographs of Albert Renger-Patzsch" in *Photography in the Modern Era*, op. cit., p. 112.

75 Berenice Abbott is better known for her portraits and photographs of New York architecture of the 1930s.

76 I. Bernard Cohen, "Some Recollections of Berenice Abbott", an enlarged version of a talk given at the Berenice Abbott memorial, New York Public Library, 8 February 1992, unpublished ms., p. 11.

77 Francis Lee Friedman, *Introduction to Physics* and *Physics: Laboratory Guide*, both 2nd edns, D. C. Heath and Co., Lexington, Massachusetts 1965.

78 Cohen, op. cit., p. 14.

79 In addition to visualizing important principles in the physical sciences, Abbott's photographs from this period were acknowledged for their formal beauty by American historian of photography Beaumont Newhall, who noted that "all the drama, beauty and arresting suspense of the physical laws and the natural phenomena are excitingly presented", Hank O'Neal, *Berenice Abbott: American Photographer*, McGraw-Hill, New York 1982, p. 27.

80 Ibid., p. 48.

81 Graham Farmelo, "The Discovery of Xrays", *Scientific American*, vol. 73, no. 5, November 1995, pp. 87-88.

82 Because of the equipment and elements involved in producing X-ray images, radiography, unlike photomicroscopy, was never adopted as a technique by the German avant garde or any other group of artists. Nevertheless, it exerted great appeal; Moholy-Nagy reproduced several in *Malerei, Fotografie, Film* of 1925, op. cit. In 1931 Dr. Karl Döhmann demonstrated his aesthetic interest in X-rays by experimenting with a reversal process that allowed a "positive" X-ray image to be made from a "negative" one.

83 Henri Becquerel, *Sur une propriété nouvelle de la matière, la radio-activité*, Imprimerie Royal P. A. Norstedt et fils, Stockholm 1905, p. 1

84 A. L. Donné, *Cours de microscopie complémentaire des études médicales. Anatomie microscopique et physiologie des fluides de l'économie*, J. B. Baillière, Paris 1844, p. 6.

85 W. H. Fox Talbot, *The Pencil of Nature*, Longman, Brown, Green and Longmans, London 1844-46.

86 Curator of Astronomy at the Science Museum, London, from 1980 to 1991, John Darius was a pioneer in the history of the photography of science. In large part this project was inspired by his work, and I am indebted to his contribution.

87 Sir David Brewster, *A Treatise on the Microscope, forming the article under that head in the seventh edition of the Encyclopaedia Britannica*, Adam and Charles Black, Edinburgh 1837, p. 2.

88 François Arago, *Rapport fait à l'Académie des sciences de Paris le 19 août 1839*, L'Échoppe, Paris n.d., facsimile of the report that appeared in *La France littéraire*, vol. 35, 1839, p. 21.

89 Berenice Abbott, *New Guide to Better Photography*, rev. edn, Crown Publishers, Inc., New York 1953, p. 1 (1st edn 1941).

CHAPTER 5
"A PERFECT AND FAITHFUL RECORD"
MARTIN KEMP

1 Hugh Welch Diamond, "Photography Applied to the Phenomena of Insanity", report of an address to the Royal Society, *Journal of the Photographic Society*, 3-4, 1856-58, pp. 88-89; full address published by Sander Gilman, *The Face of Madness, Hugh W. Diamond and the Origins of Psychiatric Photography*, Brunner/Mazel, New York 1976, pp. 17-24.

2 Bernhard Siegfried Albinus, *Tabulae sceleti et musculorum corporis humani*, Verbeek, Leiden 1747. See Martin Kemp, "'The Mark of Truth': Looking and Learning in Some Anatomical Illustrations from the Renaissance and the Eighteenth Century", *Medicine and the Five Senses*, ed. W. Bynum and R. Porter, Cambridge University Press, Cambridge 1993, pp. 85-122.

3 William Hunter, *Anatomia uteri humani gravidi [Anatomy of the Human Gravid Uterus]*, Baskerveille, Birmingham 1774; see Kemp, "The Mark of Truth", op. cit., pp. 113-19.

4 Examples are Vesalius, *De humani corporis fabrica*, Oporinus, Basle 1543 (for tools); Govard Bidloo, *Anatomia humani corporis*, Sommern, Dyke and Boom, Leiden 1685 (for fly); and Hunter, *Anatomia uteri humani*, op. cit. (for reflected window).

5 Henry Gray, *Anatomy Descriptive and Surgical*, Parker, London, 1858; see Martin Kemp, "Style and Non-Style in Anatomical Illustration", *Constructing and Deconsructing the Body: Art and Anatomy xvth-xxth Century*, Centre des Pensières, Annecy, 8-11 May 1997.

6 For a review of the issues, see Martin Kemp, "Showing it for Real", *Materia Medica*, ed. K. Arnold, exhibition catalogue, Wellcome Institute, London 1995, pp. 9-23, and "Medicine in View: Art and Visual Representation", *The Oxford Illllustrated History of Western Medicine*, ed. I. Loudon, Oxford University Press, Oxford, 1997, pp. 1-22.

7 Vesalius, *Fabrica*; see Martin Kemp, "Temples of the Body and Temples of the Cosmos: Vision and Visualization in the Vesalian and Copernican Revolutions", *Picturing Knowledge. Historical and Philosophical Problems Concerning the Use of Art in Science*, ed. B. Baigrie, Toronto University Press, Toronto 1996, pp. 40-85. For earlier anatomical illustration more generally, see Mimi Cazort, Monique Kornell and K. B. Roberts, *Ingenious Machine of Nature. Four Centuries of Art and Anatomy*, exhibition catalogue, National Gallery of Canada, Ottawa 1996.

8 "The Craze for Photography in Medical Illustration", editorial, *New York Medical Journal*, LIX, 1894, pp. 721-22; and William Keiller, "The Craze for Photography in Medical Illustration", letter on pp. 788-89.

9 *British Medical Journal*, I, 1886, p. 163.

10 Medicus, "Indecency in Photography", letter to *The New York Medical Journal*, LIX, 1894, pp. 724-25. See Andreas-Holger Maehle, "The Search for Objective Communication", *Non-Verbal Communication in Science Prior to 1900*, ed. R. Mazzolini, Olschki, Florence 1993, pp. 573-76.

11 "A Remarkabe Case of Double Monstrosity in an Adult",

232

The Lancet, II, 1865, p. 185; response in *The British Medical Journal*, II, p. 165.

12 Willam Cheselden, *Osteographia, or the Anatomy of the Bones*, London 1733.

13 For chronophotography, see Marta Braun, *Picturing Times. The Work of Etienne-Jules Marey (1830–1904)*, Chicago University Press, Chicago and London, 1992, and Chapter 6 of the present volume.

14 H. Baraduc, *L'âme humaine, ses mouvements, ses lumières et l'iconographie de l'invisible fluidique*, Carré, Paris 1896.

15 An anthology of medical photographs is provided by Joel-Peter Witkin, *Masterpieces of Medical Photography: Selections from the Burns Archive*, Twelvetrees, Pasadena 1987. For a range of approaches to the issues, see Alison Gernsheim, "Medical Photography in the Nineteenth Century", *Medical and Biological Illustration*, XI, 1961, pp. 85–92 and 147–56; Robert Ollerenshaw, "Medical Illustration: the Impact of Photography on its History", *Journal of the Biological Photographic Association*, XXXVI, 1968, pp. 3–13; Daniel Fox and James Terry, "Photography and the Self-Image of American Physicians", *Bulletin of the History of Medicine*, LII, 1978, pp. 435–57; Sander Gilman, *Seeing the Insane*, John Wiley, New York 1982; S. Burns, *Medical Photography in America*, The Burns Archive, New York 1983; David Green, "Veins of Resembance", *Oxford Art Journal*, VII, 1985, pp. 3–16: Daniel Fox and Christopher Lawrence, *Photographing Medicine. Images and Power in Britain and America since 1840*, Greenwood Press, New York and London 1988; Ludmilla Jordanova, "Medicine and Visual Culture", *Social History of Medicine*, III, 1990, pp. 89–99; Jacques Gasser, with Stanley Burns, *Photographie et Médecine*, Institut Universitaire d'Histoire de la Médecine et de la Santé Publique, Lausanne 1991; Andreas-Holger Maehle, "The Search for Objective Communication", op. cit.; Chris Amirault, "Posing the Subject of Early Medical Photography", *Discourse*, XVI, 1993–94, pp. 51–76.

16 Johann Caspar Lavater, *Physiognomische Fragmente*, 4 vols., Weidmanns Erben and Reich, Leipzig and Winterthur, 1775–78. For other editions, translations, abridgements etc., see Gavin Bridson and James White, *Plant, Animal and Anatomical Illustration in Art and Science*, St. Paul's Bibliographies, Winchester, 1990, no. E 690 ff.

17 Franz Gall and Johann Spurzheim, *Anatomie et physiologie du système nerveux en général et sur celui du cerveau en particulier*, 4 vols., F. Schoell, Paris 1809; and Spurzheim, *Observations sur la phraenologie*, Treuttel and Würtz, Paris 1818.

18 See Steven Jay Gould, *The Mismeasure of Man*, Norton, New York 1981; Elizabeth Edwards, "'Photographic Types': The Pursuit of Method", *Visual Anthropology*, III, 1990, pp. 235–58; Elizabeth Edwards, "Ordering Others: Photography, Anthropologies and Taxonomies", *Invisible Light: Photography, Classification in Art, Science and Everyday*, ed. R. Roberts, exhibition catalogue, Museum of Modern Art, Oxford, forthcoming 1997; Elizabeth Edwards, "Beyond the Boundary: A Consideration of the Expressive in Photography and Anthropology", *Rethinking Visual Anthropology*, ed. M. Banks and H. Morphy, Yale University Press, London and New Haven

1997, pp. 53–80; *Misura d'uomo*, ed. G. Barsanti, S. Gori-Savellini, P. Guarnieri and C. Pogliano, exhibition catalogue, Museo di Storia della Scienza, Florence 1986.

19 Carl Dammann, *Anthropologisch-ethnographisches Album in Photographien*, Wiegart, Hempel and Parey, Berlin 1873–76; trans. as *Ethnological Gallery of the Various Races of Man*, Trubner, London 1875. See also E. B. Taylor, "Dammann's Race-Photographs", *Nature*, XIII, 1876, p. 184.

20 Paul Broca, "Sur le volume et la forme du cerveau suivant les individus et suivant les races", *Bulletin de la Société d'Anthropologie*, II, 1861, pp. 139–207, 301–21, 441–6, and *Mémoires d'anthropologie*, Reinwald, Paris 1871; see Gould, *The Mismeasure of Man*, op. cit., pp. 82–112.

21 William Marshall, *A Phrenologist amongst the Todas, or the Study of a Primitive Tribe in South India. History, Character, Customs, Religion, Infanticide, Polyandry, Language*, Longman, Green, London 1873.

22 Ibid., p. viii.

23 Ibid., p. vi.

24 Ibid., p. 15.

25 Ibid., p. 32.

26 Ibid., p. 35.

27 Jaynie Anderson, "Giovanni Morelli et sa définition de la 'scienza dell' arte'", *Revue de l'art*, LXXV, 1987, pp. 49–55.

28 John Down, "Observations on the Classification of Idiots", London Hospital Reports, 1866, pp. 259–62; see Gould, *The Mismeasure of Man*, op. cit., p. 134.

29 John Lamprey, "On a Method of Measuring Human Form for Students of Ethnology", *Journal of the Ethnological Society*, I, 1869, pp. 84–85. See Frank Spencer, "Some Notes on the Attempt to Apply Photography to Anthropometry during the Second Half of the Nineteenth Century", *Anthropology and Photography, 1875–1920*, ed. E. Edwards, Yale University Press, London and New Haven 1992, pp. 99–107; and E. Edwards, "Photographic Types", op. cit.

30 Frank Spencer, "Some Notes . . .", op. cit., p. 99, quoting from the Huxley manuscripts in the Imperial College of Science and Technology, London.

31 Francis Galton, *Inquiries into the Human Faculty*, Macmillan, London 1883. See David Green, "Veins of Resemblance . . .", op. cit. For Galton more generally, see Karl Pearson, *The Life, Letters and Labours of Francis Galton*, 4 vols., Cambridge University Press, Cambridge 1914–30; D. W. Forrest, *Francis Galton. The Life and Work of a Victorian Genius*, Elek, London 1974.

32 Francis Galton, "Eugenics: its Definition, Scope and Aims", *Sociological Papers*, I, 1905, p. 50.

33 Galton, *Inquiries . . .*, op. cit., Introduction.

34 Ibid., p. 5.

35 Francis Galton, "Composite Portraits", *Journal of the Anthropological Institute*, VIII, 1878, pp. 132–48, reprinted in *Nature*, XVIII, 1878, pp. 97–100.

36 Francis Galton, "Address to the Department of Anthropology, Section H", *British Association Report*, 1877, pp. 94–100, reprinted in *Nature*, XVI, 1877, pp. 344–47.

37 Francis Galton, "Photographic Chronicles from Childhood to Age", *Fortnightly Review*, CLXXXI, 1882, pp. 26–31.

38 Galton, *Inquiries . . .*, op. cit., p. 7.

39 Arthur Batut, *La photographie appliqué à la production du type d'une famille, d'une tribu ou d'une race*, Gauthier-Villars, Paris 1887.

40 Bénédicte Auguste Morel, *Traité des dégénérescences physiques, intellectuelles, et morales de l'espèce humaine et des causes qui produisent ces variétés maladives*, Baillière, Paris 1857; Lieut.-Col. Douglas, "The Degenerates and the Modes of their Elimination", *Physician and Surgeon*, I, 1900, pp. 48–89.

41 Francis Galton, "Hereditary Improvement", *Frazers Magazine*, VII, 1873, pp. 116–30.

42 Charles Le Brun's 1667 lecture to the Académie Royale in Paris was published posthumously for the first time as *Sentiments de plus habiles peintres sur la pratique de la peinture et sculpture, mise en table de precepts*, H. Testelin, Paris 1680, 1696; repr. Geneva 1972. The most widely diffused edition was published as *Conférence de M. le Brun . . . Sur l'expression générale et particulière*, De Lorme-Picart, Amsterdam and Paris, 1698; this was used for translation into Italian as *Le figure delle passioni. Conferenze sull' espressione e la fisionomia*, ed. M. Giuffreddi, Rafaello Cortiva, Milan 1992.

43 James Parsons, "Human Physiognomy Explained", *Supplement to the Philosophical Transactions*, 1747; Charles Bell, *Essays on the Anatomy of the Expression in Painting*, Longman, Hurst, Ress and Orme, London 1806.

44 Guillame-Benjamin Duchenne de Boulogne, *Mécanisme de la physionomie humaine ou analyse electro-physilogique de l'expression des passions*, 2 vols., Ballière, Paris 1876; trans. R. Andrew Cuthbertson, *The Mechanism of Human Facial Expression*, Cambridge University Press, Cambridge 1990. See also Hugh Marles, "Duchenne de Boulogne", *History of Photography*, XVI, 1992, pp. 395–96.

45 Duchenne, *Mécanisme*, op. cit., p. xii.

46 Ibid., p. 15.

47 Ibid., pp. 42–43, 49.

48 Ibid., pp. ix, 55–56, 132.

49 Ibid., plate no. 77.

50 Charles Darwin, *The Expression of the Emotions in Man and Animals*, Murray, London 1872.

51 Ibid., p. 5

52 Ibid., p. 155

53 Ibid., pp. 12–13.

54 Ibid., p. 376

55 Ibid., pp. 29–30.

56 Ibid., p. 17.

57 Joseph T. Burke and Colin Cambell, *Hogarth: The Complete Engravings*, Alpine Fine Arts Collection, London n.d., pls. 162, 163.

58 Germain Bazin, *Théodore Géricault. Études critiques, documents et catalogue raisonné*, 6 vols., La Bibliothèque des Arts, Paris 1987–94, vol. 6, cat. nos. 2101–5, pp. 69–76.

59 Gilman, *The Face of Madness . . .*, op. cit.

60 Diamond, "On the Application of Photography . . .", in Gilman, op. cit., pp. 19–20.

61 For Charcot as a cultural figure, see Deborah Silverman, *Art Nouveau in Fin-de-Siècle France. Politics, Psychology and Style*, University of California Press, Berkeley, Los Angeles and London, 1989, esp. pp. 91–106; for Charcot and photography, see Georges Didier Huber-man, *Invention de l'hystère. Charcot et l'iconographie Photographique de la Salpêtrière*, Macula, Paris 1982; Douglas Fogle, "Die Passionen des Körpers. Fotografie und männliche Hysterie", *Fotogeschichte: Beitrage zur Geschichte und Asthetik der Fotografie*, vol. 13, no. 49, 1993, pp. 67–78; Daphne de Marneffe, "Looking and Listening. The Construction of Clinical Knowledge in Charcot and Freud", *Signs*, XVII, 1991, pp. 71–111.

62 Jean Martin Charcot, *Nouvelle iconographie de la Salpêtrière*, Lecrosnier and Babé, Paris 1888, vol. I, p. ii.

63 Jean-Martin Charcot and Paul Richer, *Les démoniaques dans l'art*, Delahaye and Lecrosnier, Paris 1887; and *Les difformes et les malades dans l'art*, Delahaye and Lecrosnier, Paris 1889 (both reprinted by Israël, Amsterdam 1972).

64 Désiré-Magloire Bourneville and Paul Regnard, *Iconographie photographique de la Salpêtrière*, 3 vols., Delahaye, Paris 1876–80.

65 Henri Dagonet, *Nouveau traité élémentaire et pratique des maladies mentales*, Ballière, Paris 1876, p. iv.

66 For his pathological anatomy, see Paul Blocq and Albert Londe, *Anatomie pathologique de la moelle épinière*, Masson, Paris c. 1891, preface by J. M. Charcot, illustrated with 48 photomicrographs reproduced in photogravure by Lumière and Sons of Lyon.

67 Albert Londe, "La Photographie en médicine", *La Nature*, 1883, pp. 215–18.

68 Albert Londe, *La photographie médicale. Application aux sciences médicales et physiologiques*, Gautier-Villars, Paris 1893. See also the review by Ludwig Jankau, *Die Photographie in der praktischen Medezin*, Seitz and Schauer, Munich 1894.

69 Cesare Lombroso, *L'uomo deliquente in rapporto all' antropologia, alla giurisprudenza ed alle discipline carcerarie*, Bocca, Turin 1876. Translations include *L'Homme criminel*, Félix Alcan, Paris 1887 and *Criminal Man*, Putnam, London and New York 1911.

70 Ibid., pp. xiv–xv.

71 Alphone Bertillon, *La photographique judicaire*, Villars, Paris 1890, and *Identification anthropomètrique. Instructions signalétiques*, Imprimière administrative, Melun 1890–93.

72 Enrico Morselli and Sante de Sanctis, *Biografia di un bandito*, Treves, Milan 1903; Mariano Patrizzi, *La fisiologia d'un bandito*, Bocca, Turin 1904.

73 Havelock Ellis, *The Criminal*, Scott, London 1980.

74 Arthur Conan Doyle, "A Scandal in Bohemia", *The Adventures of Sherlock Holmes*, George Newnes, London, 1892, pp. 7–8. See, more generally, Carlo Ginsberg, "Morelli, Freud and Sherlock Holmes: Clues and the Scientific Method", *History Workshop*, IX, 1980, pp. 5–36.

75 John Cleland and John Yule Mackay, *Human Anatomy*, J. Maclehose and Sons, Glasgow 1896, preface.

76 Nicolaus Rüdinger, *Atlas des peripherischen Nervensystems des menschlichen Körpers*, Cotta'schen, Munich 1861. For photography and medicine, see Gernsheim 1961; Burns, op. cit., 1983; Fox and Lawrence, op. cit., 1988; and Maehle 1993.

77 Nicolaus Rüdinger, *Die Anatomie der Menschlichen Gehirn-Nerven*, Cotta'schen, Munich 1868, and *Die*

Anatomie der menschlichen Rückenmarks-Nerven, Cotta'schen, Stuttgart 1870.

78 Nicolaus Rüdinger, *Topographisch-chirurgische Anatomie des Menschen*, 4 vols., Cotta'schen, Stuttgart 1873–79.

79 For the invention and development of the collotype, see Joseph Maria Eder, *History of Photography*, trans. E. Epstean, Columbia University Press, New York 1972, pp. 553–54, 617–20, 647.

80 Thomas Billroth, *Stereoskopische Photographien chirurgischer Kranken*, Erlangen, Enke 1867.

81 Albert Ludwig S. Neisser, *Stereoskopischer Atlas. Sammlung photographischer Bilder aus dem Gesammtgebiet der klinischen Medizin, der Anatomie und der pathologischen Anatomie etc.*, Fischer, Barth, Kassel and Leipzig 1894–1900.

82 David Waterston, *The Edinburgh Stereoscopic Atlas of Anatomy*, T. C. and E. C. Jack, Edinburgh 1905.

83 For Brewster and the stereoscope, see Martin Kemp, "'Philosophy in Sport' and the 'Sacred Precincts': Sir David Brewster on the Kaleidoscope and the Stereoscope", *Muse and Reason. The Relation of Arts and Sciences 1650–1850*, ed. B. Castel, J. Leith and A. Riley, Queens Quarterly, Kingston, Canada 1994, pp. 203–32.

84 The example in the Wellcome Institute, London, is inscribed: "TC & EC JACK EDINBURGH. PROV.Y. PROTECTED".

85 Alfred Donné and Léon Foucault, *Cours de microscopie complémentaire des études médicales*, with an *Atlas exécuté d'après nature au microscop-daguerréotype*, Ballière, Paris 1845.

86 For Mandl, see *Zeitschrift der Gesellschaft der Aerzte zu Wien*, 1860; Johann Nepomuk Czermak, *On the Laryngoscope and its Employment in Physiology and Medicine*, trans. from the French by G. D. Gibb, The New Sydenham Society, London 1861.

87 Lennox Browne and Emil Behnke, *Voice, Song and Speech*, Low, Marston, Searle and Rivington, London 1883.

88 For Rosebrugh, Jackman and Webster, see Gernsheim, op. cit., 1961.

89 Walter Woodbury, *Encyclopaedia of Photography*, Iliffe, London 1890, pp. 509–10; Max Nitze, *Kystophotographischer Atlas*, Bergman, Wiesbaden 1894.

90 Gernsheim, "Medical Photography . . .", op. cit., pp. 148–49.

91 Henry C. Wright, "Photography and the Healing Art", letter to the *Journal of Photography*, v, 1863, pp. 347–48. See also his "On the Medical Uses of Photography", *The Photographic Journal*, IX, 1867, p. 204.

92 A. de Montméja and J. Regnade, *La revue photographique des Hôpitaux de Paris*, Paris 1869.

93 It was published by Lippincott in Philadelphia between 1870 and 1872.

94 Johannes Wildberger, *Zehn photographische Abbildungen zum Nachweis der günsten Heilresultate . . .*, Hirschfeld, Leipzig 1863; Adolf Lorenz, *Pathologie und Therapie der seitlichen Rückgrat-Verkr'ümmungen (Scoliosis)*, Hölder, Vienna 1886.

95 Lewis Sayre, *Spinal Disease and Spinal Curvature*, Smith, Elder, London 1877.

96 Jonathan Pereira, *The Elements of Materia Medica*, 1st edn., 2 vols., Longam, Orme, Brown, Green and Longman, London 1839–40.

97 Eadweard Muybridge, *Animal Locomotion. An Electro-Photographic Investigation of Consecutive Phases of Animal Movements*, University of Pennsylvania, Philadelphia 1897.

98 Alexander John Balmanno Squire, *Photographs Coloured from Life of the Diseases of the Skin*, John Churchill and Sons, London 1865; M. A. Hardy and A. de Montméja, *Clinique photographique de l'Hôpital Saint-Louis*, Chamerot and Lauwereyns, Paris 1868; George Fox, *Photographic Illustrations of Skin Diseases*, Treat, New York 1886.

99 Squire, op. cit., preface.

100 Maehle, op. cit., pp. 578–81.

CHAPTER 6
THE EXPANDED PRESENT
MARTA BRAUN

This chapter owes much to the contributions of Deac Rossell, who generously shared with me his vast knowledge of Anschütz, Kohlrausch, Mach and the intricacies of technology; Joyce Bedi, who understands Edgerton and his work better than anybody; Joel Snyder, whose thinking on Marey is a constant stimulus, and Sydney Leach who, as always, has cheerfully answered more questions than I should ever have asked. It owes no less to the help of Gérard Jeanblanc, André Gunthert, Michel Poivert, Catherine Mathon, Mary-jo Stevenson, Ida Levi Leach and Eric Wright. I am grateful to them.

1 Charles Wheatstone, "An Account of Some Experiments to Measure the Velocity of Electricity and the Duration of Electric Light", *Philosophical Transactions of the Royal Society of London*, part II, 1834, p. 591.

2 William Henry Fox Talbot, "Note on Instantaneous Photographic Images", *Abstracts of the Papers Communicated to the Royal Society of London*, no. 6, 19 June 1851, p. 82.

3 William Henry Fox Talbot, "On the Production of Instantaneous Photographic Images", *Philosophical Magazine*, 4th series, vol. 3, no. 15, January 1852, p. 73.

4 For a description of Feddersen's and Ducretet's experiments, see Sigmund Theodor Stein, *Das Lichte im dienste Wissenschaftliche Forschung*, Wilhelm Knapp, Halle a. S. 1888, vol. II, pp. 148–50.

5 It is interesting to note that Janssen deliberately chose the daguerreotype, outdated by the 1870s, because it was considered to be the medium that would provide the greatest uniformity and stability for the recording of fine detail that was necessary to obtain measurable data.

6 Jules Janssen, "Présentation du Revolver Photographique et épreuves obtenues avec cet instrument", *Bulletin de la Société Française de Photographie*, XXII, Paris 1876, pp. 100–108.

7 *Bulletin de la Société Française de Photographie*, 2 July 1869, pp. 172–77. Two of the ten photographs Ozanam published from his study are marked with the blind stamp of Edouard Baldus, the famous landscape and architectural

photographer and his neighbour on the rue d'Assas. The extent of Baldus's (or his studio's) contribution, however, is not known.

8 Sigmund Theodor Stein, op. cit., Wilhelm Knapp, Halle a. S. 1885, vol. I, p. 341.

9 Etienne-Jules Marey, *Movement*, trans. Eric Pritchard, Appleton, New York 1895; repr. Arno Press, New York 1972, p. 33.

10 Marey, *La Chronophotographie, Conférence du Conservatoire National des Arts et Métiers*, Gauthier-Villars, Paris 1899, p. 8. For similar views see Louis Gastine, *La Chronophotographie, sur plaque fixe et sur pellicule mobile*, Masson and Gauthier-Villars, Paris 1897, pp. 13ff; Joseph Eder, *La photographie instantanée*, Paris 1888, chap. XXI.

11 Wilbur Wright, "Some Aeronautical Experiments", lecture to the Western Society of Engineers, 18 September 1901, in *The Papers of Wilbur and Orville Wright*, ed. Marvin W. McFarland, McGraw Hill, New York 1953, I, p. 99. The Wrights were also instructed by Marey's later photographic descriptions of flight, and see Wilbur and Orville Wright, "Experiments and Observations in Soaring Flight", *Journal of the Western Society of Engineers*, December 1903, in ibid., I, p. 333.

12 "Chronophotographic series taken up until this point— Muybridge with dark images against a bright background, and Marey with bright images against a dark background— had achieved more of an outline than a precise dimension representation; it was reserved to a German photographer, Anschütz in Lissa, to reach the highest level in this area, as well as in his individual high-speed photographs." F. A. Schmidt, "Die Augenblicksphotographie und ihre Bedeutung für die Bewegungslehre", *Deutsche Turn-Zeitung*, Leipzig, 51, 22 December 1887, p. 763, trans. Annette Schroeder.

13 Deac Rossell, *Ottamar Anschütz and his Electrical Wonder*, the Projection Box, London, 1966, p. 9.

14 When the shutter wire was broken, it released a spring which closed the electrical circuit for its camera. The circuit activated an electromagnet that pulled a restraining bar away from a very tightly wound spring attached to the piston of an airtight plunger. The plunger then rapidly moved forward to send a surge of compressed air through a tube that moved the focal-plane shutter across the plate of the camera; see Deac Rossell, "Lebende Bilder: Die Chronophotographen Ottomar Anschütz und Ernst Kohlrausch", in *Wir Wunderkinder: 100 Jahres Filmproduktion in Niedersachsen*, ed. Pamela Müller and Susanne Höbermann, Gesellschaft für Filmstudien e. V., Hanover 1995, pp. 13–34.

15 The best study of Londe is Denis Bernard and André Gunthert, *L'Instant rêvé Albert Londe*, Jacqueline Chambon-Trois, Paris 1993. It contains a full bibliography of Londe's publications.

16 Londe had produced this variable speed circular disk shutter in 1881, in collaboration with the watchmaker Charles Dessoudeix; it was the basis of all his successive cameras. See Denis Bernard and André Gunthert, "Albert Londe: l'image multiple", *La recherche photographique*, 4, May 1988, p. 11.

17 Marey and Georges Demeny, *Etudes de physiologie artistique faites au moyen de la chronophotographie*, première série, vol. I: *Du Mouvement de l'homme*, Berthaud, Paris 1893.

18 Marey, *Movement*, op. cit., p. 183.

19 Paul Richer, *Physiologie Artistique de l'Homme en Mouvement*, Octave Doin, Paris 1895, p. 22.

20 Marey, *Movement*, op. cit., p. 139.

21 The information on Kohlrausch is taken from Deac Rossell's "Lebende Bilder . . .", op. cit., pp. 24–30.

22 F. A. Schmidt, "Die Augenblicksphotographie . . .", op. cit., pp. 760, 764.

23 Muybridge's case was based on the fact that *The Horse in Motion* contained photographs which had been copyrighted by him. In May 1881 Stanford had paid Muybridge $2,000 for his work, and had sold him for a nominal $1 all rights to "any and all photographic apparatus, consisting of cameras, lenses, electric shutters, negatives, positives and photographs, magic lanterns, zoopraxiscopes; and patents and copyrights that have been employed in, and about the representation of animals in motion upon my premises at Palo Alto"; Bill of Sale and Assignment, Leland Stanford to E. J. Muybridge, 30 May 1881, Bancroft Library, University of California, Berkeley. In 1885, however, Muybridge finally lost the case, on the grounds that regular payments from Stanford effectively made him an employee. Depositions from the suit can be found in the C. P. Huntington Collection, George Arents Research Library, Syracuse University.

24 William Marks, "The Mechanism of Instantaneous Photography", in *Animal Locomotion: The Muybridge Work at the University of Pennsylvania*, ed. W. D. Marks, H. Allen and F. X. Dercum, Lippincott, Philadelphia 1888; repr. Arno Press, New York 1973, p. 12.

25 Only two images, now in the collection of the Franklin Institute, Philadelphia, remain from these experiments.

26 Marks, op. cit., p. 15.

27 Anita Mozley, introduction to *Muybridge's Complete Human and Animal Locomotion*, Dover, New York 1989, p. xxix.

28 For a list of the plates in *Animal Locomotion* which show inconsistencies, and the methods Muybridge used to hide the missing negatives, see Marta Braun, "Muybridge's Scientific Fictions", *Studies in Visual Communication*, vol. 10, no. 3, 1984, p. 20 n.10.

29 Joel Snyder, "Visualization and Visibility", in *Picturing Science, Producing Art*, ed. Caroline A. Jones and Peter Galison, Routledge, London forthcoming.

30 Etienne-Jules Marey, preface to Charles-Louis Eugène Trutat, *La photographie animée*, Gauthier-Villars, Paris 1899, p. ix.

31 The history of Anschütz's Schnellseher is taken from Rossell, *Ottomar Anschütz . . .*, op. cit.

32 Georges Demeny, *Pionnier du cinéma*, Pagine, Douai 1997.

33 Sir Charles Vernon Boys, "Notes on photographs of rapidly moved objects, and on the oscillating electric spark", *The Philosophical Magazine and Journal of Science*, 5th series, vol. 30, September 1890, p. 248; *Soap-bubbles and the forces which mould them. Being a course of three lectures delivered at the London Institution in December 1889,*

and January 1890 before a juvenile audience, Society for Promoting Christian Knowledge, London 1890.

34 A. M. Worthington, *A Study of Splashes*, Longmans, Green and Co., London 1908, pp. 1–2.

35 Ibid., p. 118.

36 Joyce Bedi, "Faster than a Speeding Bullet!", unpublished paper given to the Society for the History of Technology, Lowell, Massachusetts 1994.

37 Douglas Collins, "Biographical Essay", in *Seeing the Unseen: Dr. Harold E. Edgerton and the Wonders of Strobe Alley*, ed. Roger R. Bruce, Trust of George Eastman House, Rochester, New York 1994, p. 56.

CHAPTER 7
CAPTURING LIGHT
ANN THOMAS

1 Sidney Perkowitz, *Empire of Light: A History of Discovery in Science and Art*, Henry Holt, New York 1996, p. 14.

2 Mitiarjuk Nappaaluk, "Mitiarjuk's Inuit Encyclopaedia", *Tumivut*, Winter, 1993, p. 18.

3 The corona is the irregularly shaped outermost layer of the sun's atmosphere; it becomes visible during a total solar eclipse as a white halo.

4 Dorrit Hoffleit, *Some Firsts in Astronomical Photography*, Harvard College Observatory, Cambridge 1950, p. 17.

5 Larry J. Schaaf, ed., *Selected Correspondence of William Henry Fox Talbot*, Science Museum and National Museum of Photography, Film & Television, London 1994, p. 59.

6 Daniel Norman, "The Development of Astronomical Photography", *Osiris*, 5, Harvard College Observatory, Cambridge 1938, p. 564.

7 Janet E. Buerger, *French Daguerreotypes*, The University of Chicago Press, Chicago 1989, p. 90.

8 Hoffleit, ibid., p. 37: "In his 1862 Bakerian Lecture De la Rue states that the Koenigsberg photograph had been taken by Dr. A. L. Busch".

9 Buerger, op. cit., p. 90.

10 Norman, op. cit., p. 565.

11 Rudolpho Radau, *La photographie et ses applications scientifiques*, Gauthier-Villars, Paris 1878, p. 23.

12 Hoffleit, op. cit., p. 21.

13 A. Pannekoek, *A History of Astronomy*, Dover Publications, New York 1961, p. 409, repr. from the Dutch 1st edn. 1951.

14 Pierre Jules C. Janssen and Joseph Norman Lockyer (1836–1920) arrived independently at the conclusion that the emission lines of the solar prominences can be observed without the disc-darkening of an eclipse. See Pannekoek, op. cit., pp. 409–10.

15 G. M. Harvey, "Gravitational Deflection of Light: a Reexamination of the Observations of the Solar Eclipse of 1919", *The Observatory*, vol. 99, December 1979, pp. 195–98.

16 There have been only five transits of Venus since 1639 when the phenomenon was first observed by Jeremiah Horrocks (1618–41); the next is predicted for 7 June 2004.

17 Under Edmund Halley (1656–1742), the transits of 6 June 1761 and 3 June 1769 were measured but only at the points of ingress and egress. The results were disappointing and considered to be too divergent to be useful.

18 Josef Maria Eder, *History of Photography*, Dover Publications, New York 1978, pp. 422–24, repr. of 1st edn., Columbia University Press, New York 1945.

19 M. Susan Barger, *The Daguerreotype: Nineteenth-Century Technology and Modern Science*, Smithsonian Institution Press, Washington and London 1991, p. 90.

20 Le Verrier became Director of the Paris Observatory in 1854 on the death of François Dominique Arago, and held the position until 1870 when he was dismissed. The untimely death of his successor brought him back for a short period in the early 1870s.

21 Radau, op. cit., p. 28.

22 Although the *revolver photographique* might have been capable of producing an image every 1 or 1½ seconds (Braun, op. cit., p. 54), Joseph Maria Eder (op. cit., p. 506) claims that the interval between exposures for the transit of Venus was approximately 70 seconds.

23 Barger, op. cit., p. 93.

24 "Astro-Photography", *Photographic Notes. Journal of the Photographic Society of Scotland and of the Manchester Photographic Society*, vol. 2, no. 39, 15 November 1857, p. 417.

25 Warren De la Rue, "The Progress of Celestial Photography", *Photographic Notes*, vol. 6, no. 132, 1 October 1861, p. 282. The coma is the spherical cloud of gas and dust that surrounds the nucleus of the comet, which is in turn made up of ice embedded with rock and dust particles.

26 "Photography, Celestial", *Encyclopaedia Britannica*, Cambridge University Press, Cambridge 1910, 11th edn., vol. 21, p. 523.

27 Warren De la Rue, "Report on the Progress of Celestial Photography since the Meeting at Aberdeen", *The British Journal of Photography*, vol. 8, no. 150, 16 September 1861, pp. 323–24.

28 François Arago, *Astronomie populaire*, Gide, Paris, and T. O. Weigel, Leipzig 1858, vol. 2, p. 181.

29 Pannekoek, op. cit., p. 379.

30 *Rapport fait à l'Académie des sciences de Paris le 19 août 1839*, L'Échoppe, Paris n.d., facsimile of report in *La France littéraire*, vol. 35, 1839, p. 18.

31 Radau, op. cit., p. 13.

32 Ibid., pp. 11–12.

33 Sidereal motion, the movement of planets or their satellites in relation to stars, made photography particularly difficult when the emulsions were less sensitive and any movement within the exposure period registered on the plate. In time telescopes were equipped with clock drive mechanisms to permit the synchronization of the instrument with sidereal movement.

34 Barger, op. cit., p. 55.

35 Norman, op. cit., p. 560.

36 Wolfgang Baier, *Quellendarstellungen zur Geschichte der Fotografie*, VEB Fotokinoverlag, Leipzig 1966, p. 396.

37 "Lunar Daguerreotypes", *The Daguerrian Journal*, vol. 1, no. 1, 1 November 1850, p. 14.

38 Ibid.

39 "Lunar Daguerreotypes," ibid., vol. 2, no. 6, 1 August 1852, p. 179.

40 Hoffleit, op. cit., p. 24.

41 "Photographic Notes", *Journal of the Photographic Society of Scotland and of the Manchester Photographic Society*, vol. 2, no. 39, 15 November 1857, p. 416.

42 François Arago, *Astronomie populaire*, op. cit., vol. 1, fig. 163.

43 "Important Experiment. Daguerreotype of the Sun", *The Daguerrian Journal*, vol. 2, no. 7, 15 August 1851, p. 210.

44 Simon Mitton, ed., *The Cambridge Encyclopaedia of Astronomy*, Prentice-Hall of Canada, Scarborough 1977, p. 140.

45 "Photographs of the Sun", *The Liverpool Photographic Journal*, vol. 1, no. 17, 12 May 1855, p. 58.

46 Rev. W. J. Read, "On the Applications of Photography", *Photographic Notes. Journal of the Photographic Society of Scotland and of the Manchester Photographic Society*, vol. 1, no. 12, 1 October 1856, p. 185.

47 Radau, op. cit., p. 16.

48 Hoffleit, op. cit., p. 23.

49 Radau, op. cit., p. 8.

50 Bright spots whose appearance heralds the emergence of sunspots.

51 Radau, op. cit., p. 17.

52 Ibid., p. 19.

53 A. Davanne, *La photographie appliquée aux sciences. Conférence faite à la Sorbonne le 26 février, 1881*, Gauthiers-Villars, Paris 1881, p. 26.

54 Jules Janssen, *Atlas de photographies solaires*. Observatoire d'Astronomie Physique, Sis à Meudon, Paris 1903.

55 Barger, op. cit., pp. 84–85: "In addition, inherent limitations in the daguerreotype process further restricted what could be daguerreotyped. The primary blue sensitivity of the daguerreotype presented two distinct limitations. First, it limited the selection of stellar objects that could be considered for daguerreotyping. Red stars, for instance, were beyond the reach of the daguerreian system. Second, when daguerreotypes were made using a refractor telescope or one in which light is focused by being passed through glass lenses, the plate had to be placed at the point along the telescope barrel where blue light comes to a focus. This point was called the chemical focus and is not the same as the visual focus. Because of prismatic effects, due to refraction of the light by the lenses, radiation of different colours comes to a focus at different points along the telescope barrel. The difference between chemical and visual focus was a problem for every application of the daguerreotype process where light passed through a lens before exposure; moreover, the increased focal length of a telescope magnified the problem so that it could not be ignored."

56 Norman, op. cit., p. 580.

57 "Photographic Notes", *Photographic Notes. Journal of the Photographic Society of Scotland and of the Manchester Photographic Society*, vol. 1, no. 14, 1 November 1856, p. 215.

58 Ibid.

59 Norman, op. cit, p. 566.

60 William Crookes, "On the Photography of the Moon", *The Daguerrian Journal*, vol. 9, no. 5, 1 July 1857, p. 73.

61 Norman, op. cit, p. 566.

62 "Meetings of Societies. South London Photographic Society", *The British Journal of Photography*, vol. 8, no. 134, 15 January 1861, pp. 51–53.

63 Schaaf, op. cit., p. 69.

64 Fr. Secchi, "Lunar Photography", *The Daguerrian Journal*, vol. 8, no. 23, 1 April 1857, p. 354.

65 "The Liverpool Photographic Society", *The Liverpool Photographic Journal*, vol. 1, no. 10, 14 October 1854, p. 127.

66 Ibid., vol. 1, no. 6, 10 June 1854, p. 71.

67 Ibid., vol. 1, no. 10, 14 October 1854, p. 127.

68 Ibid., p. 137.

69 Much closer to our time, experiments on Jupiter's atmosphere have been undertaken since 1995 by Peter Olson and Jean Baptiste Manneville. In attempting to find out how Jupiter's ten to twelve bands are formed, the researchers have built, in addition to numerical models, a copper sphere 25 cm wide that nests inside a 30-cm Plexiglass sphere filled with liquids. See Jeff Kanipe, "Planet in a Bottle", *New Scientist*, vol. 153, no. 263, 4 January 1997, p. 29.

70 Radau, op. cit., p. 12.

71 The *Atlas Photographique* . . . was initially the work of Puiseux and Maurice Loewy (1833–1907), but upon Loewy's death Le Morvan assisted Puiseux in the completion of the twelfth fascicule. It was published in 1910 by the Observatoire de Paris.

72 Libration refers to the slight oscillation of a celestial body about its mean position; in the case of the moon, it means that 59 per cent of its face can be seen rather than 50 per cent.

73 Thomas Sutton, editor of *Photographic Notes*, took issue with the regard in which De la Rue's celestial photographs were held, in particular the stereographs, in "On Some of the Uses and Abuses of Photography", *Photographic Notes*, vol. 8, no. 163, 15 January 1863, p. 18: "Take for instance his stereo slides of the moon; these merely illustrate the fact of the rotundity of the visible part of the moon, which was known before, and they do *not* prove that the mountains stand out in actual relief, as some people suppose they do."

74 Warren De la Rue, "Lunar Stereographs", letter to the Editor, *The Photographic Journal*, vol. 6, no. 97, 1 July 1859, p. 468.

75 Applying principles of stereoscopic or binocular vision that go back to Euclid, Sir Charles Wheatstone made the first stereoscope in 1838 for use with hand-drawn designs. Wheatstone experimented with the application of photography to stereoscopy by using Talbot's photographs in 1839, and by 1849 Sir David Brewster had developed the methods for making and viewing photographic stereoscopic views. Views made in this way and looked at through a stereoscopic viewer were enormously popular from about 1854.

76 Hoffleit, op. cit., p. 23.

77 Ibid., p. 37.

78 *The Liverpool and Manchester Photographic Journal*, vol. 2, no. 13, 1 July 1858, p. 162.

79 Norman, op. cit., p. 577.

80 Hoffleit, op. cit., p. 24.

81 Ibid., p. 24.

82 Pannekoek, op. cit., p. 380.

83 The discovery of Pluto in 1930 was made through the examination of photographic plates.

84 Nigel Henbest and Michael Martin, *The New Astronomy*, 2nd edn., Cambridge University Press, Cambridge 1996, p. 26.

85 Pannekoek, op. cit., p. 475.

86 The prefix M is used to designate objects catalogued by Charles Joseph Messier (1730–1817). Messier numbered over 100 nebulae, star clusters and galaxies and published them in 1774, with supplements appearing in 1780 and 1781.

87 One example is *Publications of the Lick Observatory*, vol. VIII, Regents of the University, Sacramento 1908.

88 William Sheehan, *The Immortal Fire Within: The Life and Work of Edward Emerson Barnard*, Cambridge University Press, Cambridge, 1995, p. 355.

89 Ibid.

90 "Astro-Photography", *Photographic Notes. Journal of the Photographic Society of Scotland and of the Manchester Photographic Society*, vol. 2, no. 39, 15 November 1857, p. 417.

91 Norman, op. cit., p. 587.

92 Hoffleit, op. cit., p. 37.

93 "Stellar Daguerreotype", *The Daguerrian Journal*, vol. 1, no. 1, 1 November 1850, p. 13.

94 Hoffleit, op. cit., p. 37.

95 Ibid., p. 34.

96 Ibid., p. 38.

97 Norman, op. cit., pp. 588–89.

98 In 1823, John Herschel suggested that Frauenhofer lines indicate the presence of metals in the sun. In 1836, he started practical photometry in astronomy at the Cape of Good Hope, when he compared the brightness of observed stars to the brightness of an image of the moon formed by a small lens; see Pannekoek, op. cit., p. 385. In mid 1839, "Herschel presents to the Royal Society the results of his own and other investigators' spectrum studies using various light-sensitive materials, including photographic materials," Barger, op. cit., pp. 58, 63.

99 Jon Darius, *Beyond Vision*, Oxford University Press, New York 1984, p. 20.

100 One of the issues under debate was whether the sun's interior was solid, liquid or gaseous. Because the spectrograms of the 1850s were continuous, Gustav Kirchhoff (1824–87) proposed that it was liquid, a position countered by John Herschel and Fr. Angelo Secchi who thought it was gaseous and that the continuous spectrum was caused by humidity in the atmosphere. See Pannekoek, op. cit., pp. 406–8.

101 Pannekoek, op. cit., p. 450. Huggins states that, on the basis of stellar spectra, the same elements are present in the stars as in the sun and on earth.

102 Ibid., pp. 450–51.

103 Ibid., p. 452.

104 Hoffleit, op. cit., p. 37.

105 If an object is moving towards earth its light registers bands in the shorter wavelength, towards the violet. If it is moving away from earth, the displacement lines occur towards the red end of the spectrum. The latter phenomenon, known as the redshift, has been important to the twentieth-century debate about the creation of the universe and the theory that it is expanding. The "Doppler effect" is responsible for the change in the pitch of the sound of, say, a train whistle when it is approaching and receding.

106 Pannekoek, op. cit., p. 451.

107 The long exposures required for such distant subjects cannot be recorded directly on to colour film. In order to obtain a colour image, specialized black-and-white fine-grain films for astronomical photography are used together with colour separation film.

108 David Malin, *A View of the Universe*, Sky Publishing and Cambridge University Press, Cambridge, Massachusetts and Cambridge, England 1993, p. 21.

109 Nigel Henbest and Michael Martin, op. cit., p. 9.

110 The Hubble Space Telescope was launched in April 1990 but suffered from poor grinding of its main mirror and had to be repaired in 1993. After a successful repair mission, it has a resolution power 30 times greater than any ground telescope, and is able to register signals from a very wide spectral range.

111 Sharon Begley, "A Heavenly Host", *Newsweek*, 29 January 1996, p. 52.

112 *Sky News: the Canadian Magazine of Astronomy and Stargazing*, vol. 1, no. 4, November/December 1995, p. 8.

BIBLIOGRAPHIES

CHAPTER 1
PHOTOGRAPHY'S ILLUSTRATIVE ANCESTORS
MIMI CAZORT

Albinus, Bernhard Siegfried. *Tabulae sceleti et musculorum corporis humani*, Johann and Hermann Verbeek, Leiden 1747

Aldino, Tobias. *Exactissima descriptio rariorum quarandam plantarum que continentur Roma in Horto Farnesiano Tobia Aldino cesanate auctore Cardinale Odoardo Farnese medico chimico et eiusdem horti praefecto*, Jacobo Mascardo, Rome 1625

Aldrovandi, Ulisse. *Monstrorum historia*, Nicola Tebaldini, Bologna 1642

Armstrong, Elizabeth. *Robert Estienne: Royal Printer*, Cambridge 1954

Bell, Charles. *Essays on the Anatomy of Expression*, London 1806.

Belon, Pierre. *L'Histoire de la nature des oyseaux, avec leurs descriptions, et naifs portraits retirez du natural*, Paris 1555

Bieterholz, Peter. "Basel and France in the Sixteenth Century: The Basel Humanists and Printers in their Contexts with Francophone Culture", *Travaux d'humanisme et Renaissance*, CXII, Geneva 1971

Brown, H. F. *The Venetian Printing Press*, London 1891

Brunfels, Otto. *Herbarum vivae Eicones*, Johann Schott, Strasbourg 1530

Carlson, Victor and John Ittman. *Regency to Empire: French Printmaking 1715–1814*, Minneapolis 1984

Casserio, Giulio. *De vocis auditusque organis historia anatomica*, Baldino, Ferrara 1600–01

Cazort, Mimi, Kenneth B. Roberts and Monique Kornell, *The Ingenious Machine of Nature: Four Centuries of Art and Anatomy*, Ottawa 1996

Cazort, Mimi. "On Dissected Putti and Combustible Chameleons", *Print Collectors' Newsletter*, vol. XVII, no. 6

Cheselden, William. *Osteografia, or the Anatomy of the Bones*, London 1733

Clarke, T. J. *The Rhinoceros from Dürer to Stubbs 1515–1799*, Philip Wilson, London 1986

Cole, Douglas. *Captured Heritage: The Scramble for Northwest Coast Artifacts*, Vancouver 1995

Colonna, Francesco. *Hypnerotomachia polifili*, Venice 1499

Cozens, Alexander. *Principles of Beauty Relative to the Human Head*, James Dixwell, London 1778

Crousaz, Jean Pierre de. *Traité du beau, ou l'on montre en quoi consiste ce que l'on nomme ainsi, par les examples tirez [sic] de la plupart des arts et des sciences*, Amsterdam 1715

De Avilla, Lobera. *Vanquita de nobles cavalleros*, Augsburg 1530

Florence, Biblioteca Medicea Laurenziana. "La rinascita della scienza", *Firenze e la Toscana dei Medici nell' Europa del Cinquecento*, ed. Paolo Galuzzi, Florence 1980

Fuchs, Leonhard. *Historia stirpium/Historia plantarum*, Basel 1542

Gesner, Conrad. *Historia animalium*, 5 vols. , Laurentius, Frankfurt 1617

Guelfi, Fausta F. "Otto Marseus van Schrieck a Firenze", in "Contribuito alla storia dei rapporti fra scienza e arte figurativa nel seicento toscano", *Antichità viva*, XVI, no. 2 , 1977

Harvey, William. *De Generatione Animalium*, ed. Amsterdam 1674

Heydenreich, L. H. . *Leonardo da Vinci*, 2 vols., Basel 1954

Hodges, Devon Leigh. *Renaissance Fictions of Anatomy*, Amherst 1985

Keele, Kenneth D. and Carlo Pedretti. *Leonardo da Vinci: Anatomical drawings from the Royal collection*, Royal Academy of Arts, London 1977

Le Brun, Charles. *Conférence de M. Le Brun sur l'expression générale et particulière*, Edition Picart, Paris, 1678

Ledoux-Lebard, L. "La gravure en couleurs dans l'illustration des ouvrages médicaux depuis les origines jusqu'à 1800", *Bulletin de la societé française d'histoire de la médicine*, 1911 and 1912

Malpighi, Marcello. *Opera omnia, tomis duobus conprehensa*, London, 1683–87

Malpighi, Marcello. *Opera medica et anatomica varia*, Venice 1743

Malpighi, Marcello. *Opera scelte di Marcello Malpighi*, ed. Luigi Belloni, Turin 1967

Mayor, A. Hyatt. *Prints and People*, The Metropolitan Museum, New York 1971

Nissen, Claus. *Die botanische Buchillustration. Ihre Geschichte und Bibliographie*, 2 vols., Stuttgart 1951

Nissen, Claus. "Le figurazione scientifiche", *Encyclopedia universale dell' arte*, vol. XII, Venice and Rome 1972

Olmi, Giuseppe. "Avvertimenti del Dottore Aldrovandi sopra la pitture mostrifiche et prodigioso, Osservazione della natura e raffigurazione in Ulisse Aldrovandi (1522–1605)", *Annali dell' Istituto storico italo–germanico in Trento*, III, 1977

Porta, Giovanni Battista della. *Phytognomonica . . . in quibus nova, facillamaque affertur methodus, qua plantarum, animalium, mettaloru. . .*, Naples 1588

Porta, Giovanni Battista della. *De Humana Physiognomia. . .*, Naples 1602

Rodari, Florian, et al. *Anatomie de la couleur: L'invention de l'estampe en couleurs*, Paris 1996

Rondelet, Guillaume. *Libri de piscibus marinis in quibus verae piscium effigies expressae sunt*, Leiden 1554

Rusius, Laurentius. *Hippiatria sive marescalia*, C. Wechelum, Basel 1532

Ruysch, Frederick. *Opera omnia anatomico–medico–chirurgica*, Amsterdam 1737

Ryff, Walter Hermann. *Des aller furtrefflischsten, hochsten und adelischsten geschopffs aller Creaturen. . .*, Baltasar Beck, Strasburg 1541

Thurneisser, Leonhart. *Das ist confermatio concertationis, oder ein Besteitigung*, Berlin 1576

Vesalius, Andreas. *De humani corporis fabrica*, Johannes Oporinus, Basel 1543

CHAPTER TWO
INVENTION AND DISCOVERY
LARRY J. SCHAAF

Accum, Fredrick. *A System of Theoretical and Practical Chemistry*, London 1803 and Philadelphia 1814; *Annalen des Physik*, vol. 13, 1803

Allen, D. E. "The Women Members of the Botanical Society of London, 1836–56", *The British Journal for the History of Science*, vol. 13, n. 45, 1980

Annales de Chimie, vol. 45, 1803

Annali di Chimica e Storia Naturale, vol. 21, 1802

Annals of Natural History, vol. 4, no. 23, November 1839

Annals of Philosophy, vol. 3, 1802

Arago, François. "Le Daguerréotype", *Compte rendu*, vol. 9, no. 8, 19 August 1839

Arnold, H. J. P. *William Henry Fox Talbot: Pioneer of Photography and Man of Science*, Hutchinson Benham, London 1977

Athenæum, nos. 148, 28 August 1830; 618, 26 August 1839; 669, 22 August 1840; 1586, 20 March 1858

Atkins, Anna. *British Algae, Cyanotype Impressions*, 3 volumes, privately published, Halstead Place, Sevenoaks 1843–53

Auer, Anna. "Andreas Ritter von Ettingshausen (1796–1878)", *History of Photography*, vol. 17, no. 1, Spring 1993

Barger, M. Susan and William B. White. *The Daguerreotype:*

Nineteenth-century Technology and Modern Science, Smithsonian Institution Press, Washington 1991

Bibliothèque Britannique, vol. 22 Geneva January 1803

Brougham, Lord Henry. *Lives of Philosophers of the Time of George III*, Charles Griffin and Company, London 1866

Buchwald, Jed Z. *The Rise of the Wave Theory of Light: Optical Theory and Experiment in the Early Nineteenth Century*, The University of Chicago Press, Chicago 1989

Buerger, Janet E. *French Daguerreotypes*, The University of Chicago Press, Chicago 1989

Bulletin des Sciences par la Société Philomathique, vol. 3, no. 69, 1803

Carlisle, Anthony. "On the Production of Representations of Objects by the Action of Light", *Mechanics Magazine*, vol. 30, no. 809, 9 February 1839

Chaussier, François. "Sur un nouveau genre de combinaison du soufre avec les alkalis", *Bulletin des Sciences par la Société Philomathique*, vol. 2, no. 9, 1799

Children, John George. "Lamarck's Genera of Shells", *The Quarterly Journal of Science, Literature, and the Arts*, vol. 16, 1823

Clarke, Hewson and John Dougall. *The Cabinet of Arts, or General Instructor*, T. Kinnersley, London 1817

Crosland, Maurice. *The Society of Arcueil, A View of French Science at the Time of Napoleon I*, Harvard University Press, Cambridge 1967

Davy, Humphry. "An Account of a Method of Copying Paintings upon Glass, and of Making Profiles, by the Agency of Light upon Nitrate of Silver. Invented by T. Wedgwood, Esq. With Observations by H. Davy", *Journals of the Royal Institution*, vol. 1, no. 9, 22 June 1802

Eder, Josef Maria. *History of Photography*, trans. Edward Epstean, Columbia University Press, New York 1945

"Electrotype and Daguerreotype", *The Westminster Review*, vol. 34, no. 2, September 1840

Elliott, David, ed. *Photography in Russia 1840–1940*, Thames and Hudson, London 1992

Fouque, Victor. *The Truth Concerning the Invention of Photography. Nicéphore Niépce. His Life, Letters and Works*, trans. Edward Epstein, Tennant and Ward, New York 1935

Fox, Robert. "Scientific Enterprise and the Patronage of Research in France, 1800–70", *The Patronage of Science in the Nineteenth Century*, ed. G. L'E. Turner, Noordhoof International Publishing, Leyden 1976

Gautrand, Jean Claude and Michel Frizot. *Hippolyte Bayard, Naissance de l'image photographique*, Les Trois Cailloux, Paris 1986

Gernsheim, Helmut. "Robert Hunt FRS, 1807–1887", *One Hundred Years of Photographic History; Essays in Honor of Beaumont Newhall*, ed. Van Deren Coke, University of New Mexico Press, Albuquerque 1975

Gernsheim, Helmut and Alison. *L. J. M. Daguerre*, Secker & Warburg, London 1956

Gill, Arthur. "James Watt and the Supposed Early Photographs", *The Photographic Journal*, vol. 105, May 1965

Hahn, Roger. *Dictionary of Scientific Biography*, vol. 1, Charles Scribner's Sons, New York 1970

Hammond, John H. *The Camera Obscura, A Chronicle*, Adam Hilger, Bristol 1981

Heath, Vernon. *Recollections*, Cassell, London 1892

Herschel, John F. W. "On the Hyposulphurous Acid and its Compounds", *Edinburgh Philosophical Journal*, vol. 1, no. 1, June 1819 (communicated 8 January 1819)

Herschel, John F. W. "Additional Facts relative to the Hyposulphurous Acid", *Edinburgh Philosophical Journal*, vol. 1, no. 2, October 1819 (communicated 15 May 1819)

Herschel, John F. W. "Some additional facts relating to the habitudes of the Hyposulphurous Acid, and its union with Metallic Oxides", *Edinburgh Philosophical Journal*, vol. 2, no. 3, January 1820 (communicated November 1819)

Herschel, John F. W. *Preliminary Discourse on the Study of Natural Philosophy*, Longman, Rees, Ormé, Brown, & Green, London 1830

Herschel, John F. W. "Note on the Art of Photography, or the application of the Chemical Rays of Light to the purposes of Pictorial Representation", *Proceedings of the Royal Society*, vol. 4, no. 37, 1839

Herschel, John F. W. "On the Chemical Action of the Rays of the Solar Spectrum on Preparations of Silver and Other Substances, both Metallic and Non-Metallic, and on Some Photographic Processes", *Philosophical Transactions*, vol. 130, part 1, 1840

Herschel, John F. W. "On the Action of the Rays of the Solar Spectrum on Vegetable Colours, and on Some New Photographic Processes", *Philosophical Transactions*, vol. 132, part 1, 1842

Herschel, John F. W. "On the Action of the Rays of the Solar Spectrum on the Daguerreotype Plate", *Philosophical Magazine*, vol. 22, no. 143, February 1843

Herschel, John F. W. "Instantaneous Photography", *The Photographic News*, vol. 4, no. 88, 11 May 1860

Highley, Samuel. "Needed, A Photographic Library and Museum", *The Photographic News*, vol. 29, no. 1415, 16 October 1885

Hunt, Robert. "On Chromatype, a New Photographic Process", *Report of the British Association for the Advancement of Science*, London 1843

Hunt, Robert. *The Poetry of Science, or Studies of the Physical Phenomena of Nature*, Reeve, Benham, & Reeve, London 1848

Hunt, Robert. *Researches on Light, in Its Chemical Relations, Embracing a Consideration of All the Photographic Process-es*, 2nd edn., Longman, Brown, Green, and Longman's, London 1854

Ibbetson, L. L. Boscawen, *Journal of the Society of Arts*, vol. 1, 31 December 1852

Imison, John. *Elements of Science and Art*, London, 1803; new edn., 1822

Jay, Paul. *Niépce, Genèse d'une Invention*, Société des Amis du Musée Nicéphore Niépce, Chalon sur Saône 1988

"Joseph Constantine Carpue, FRS", Obituary, *The Lancet*, vol. 1, 7 February 1846

Journal für die Chemie, Physik, und Mineralogie, vol. 4, 1807

Keeler, Nancy. "Souvenirs of the Invention of Photography on Paper: Bayard, Talbot, and the Triumph of Negative–Positive Photography", *Photography, Discovery and Invention*, The J. Paul Getty Museum, Malibu 1990

Literary Gazette, no. 1432, 26 June 1844

Magazin for Naturvidenskaberne, Christiania, Norway 1824

Marignier, Jean-Louis. *Héliographies; 1989 première reconstitution du procédé du Nicéphore Niépce*, Musée Nicéphore Niépce, Chalon sur Saône 1989

Marignier, Jean-Louis. "Asphalt as the World's First Photopolymer—Revisiting the Invention of Photography", *Processes in Photoreactive Polymers*, ed. Krongauz and A. D. Reifunac, Chapman & Hall, New York 1995

New York Observer, 20 April 1839

Newhall, Beaumont. "An Announcement by Daguerre", *Image*, vol. 8, no. 1, March 1959

Newhall, Beaumont. *The Daguerreotype in America*, revised edn., New York Graphic Society, New York 1968

Newhall, Beaumont. *The History of Photography From 1839 to the Present*, rev. and enl. edn., The Museum of Modern Art, New York 1982

Nicholson's Journal, vol. 3, November 1802

Perez, Nissan N. *Focus East; Early Photography in the Near East 1839–1885*, Harry N. Abrams, Inc. , New York 1988

"Photography", *The Annals and Magazine of Natural History*, vol. 9, no. 58, June 1842

Rudisill, Richard. *Mirror Image, The Influence of the Daguerreotype on American Society*, University of New Mexico Press, Albuquerque 1971

Schaaf, Larry J. "Sir John Herschel's 1839 Royal Society Paper on Photography", *History of Photography*, vol. 3, no. 1, January 1979

Schaaf, Larry J. "Herschel, Talbot and Photography; Spring 1831 & Spring 1839", *History of Photography*, vol. 4, no. 3, July 1980

Schaaf, Larry J. "Piazzi Smyth at Teneriffe: Photography and the Disciples of Constable and Harding", *History of Photography*, vol. 5, no. 1, January 1981

Schaaf, Larry J. "Niépce in 1827 England," *Symposium 1985: Proceedings & Papers*, European Society for the History of Photography, Bradford, April 1985

Schaaf, Larry J. *Sun Gardens: Victorian Photograms by Anna Atkins*, Aperture, New York 1986

Schaaf, Larry J. *Tracings of Light: Sir John Herschel & the Camera Lucida*, The Friends of Photography, San Francisco 1989

Schaaf, Larry J. "The First Fifty Years of British Photography: 1794–1884", *Technology and Art: the Birth and Early Years of Photography*, ed. Michael Pritchard, The Royal Photographic Society, Bath 1990

Schaaf, Larry J. *Out of the Shadows: Herschel, Talbot & the Invention of Photography*, Yale University Press, London and New Haven 1992

Schaaf, Larry J. *Sun Pictures VII: Photogenic Drawings by William Henry Fox Talbot*, Hans P. Kraus, Jr., Inc., New York 1995

Schaaf, Larry J. *The Correspondence of William Henry Fox Talbot: a Draft Calendar*, Glasgow University Library Studies, Glasgow 1995

Schaaf, Larry J. *Records of the Dawn of Photography; Talbot's Notebooks P & Q*, Cambridge University Press, Cambridge 1996

Scheer, Frederick. *Kew and Its Gardens*, B. Steill, London 1840

Silliman, Benjamin. *Epitome of Experimental Chemistry*, Boston 1810

Simony, Compte de. *Une curieuse figure d'artiste: Girault de Prangey, 1804–1892*, J. Belvet, Dijon 1937

"Singular Method of Copying Pictures, and Other Objects, by the Chemical Action of Light", *Ackermann's Repository*, vol. 2, no. 10, 1 October 1816

Smith, Graham. *Disciples of Light: Photographs in the Brewster Album*, The J. Paul Getty Museum, Malibu 1990

Smith, R. C. "Nicéphore Niépce in England, *History of Photography*, vol. 7, no. 1, January 1983

Smyth, Charles Piazzi. "On the Form of Plants in Teneriffe", read before the Royal Scottish Society for the Arts, 30 December 1857, abstracted in *Proceedings of the Royal Scottish Society for the Arts*, vol. 5, 1858

Talbot, William Henry Fox. Letter to the Editor, dated 30 January 1839, *Literary Gazette*, no. 1150, 2 February 1839

Talbot, William Henry Fox. *A Brief Description of the Photogenic Drawings Exhibited at the Meeting of the British Association, at Birmingham, in August, 1839, by H. F. Talbot, Esq.*

Talbot, William Henry Fox. *The Pencil of Nature*, Longman, Brown, Green, & Longman's, London 1844–46

Talbot, William Henry Fox. "Letter to Samuel Highley, junior, 10 May 1853, read at the Twentieth Ordinary Meeting of the Society of Arts", *Journal of the Society of Arts*, 13 May 1853

Tong, James Yingpeh. *Facsimile Edition of Robert Hunt's A Popular Treatise on the Art of Photography*, Ohio University Press, Athens 1973

Vauquelin, Louis Nicolas. "Notice sur le Sel nommé Hydrosufure sulfuré de Soude", *Bulletin des Sciences par la Société Philomathique*, vol. 2, no. 9, 1799

Weaver, Mike. *Henry Fox Talbot: Selected Texts and Bibliography*, Clio Press Ltd., Oxford 1992

Webster, John. *Manual of Chemistry*, 2nd edn., Boston 1828

Wilson, John L. "The Cyanotype", *Technology and Art: the Birth and Early Years of Photography*, ed. Michael Pritchard, The Royal Photographic Society, Bath 1990

Wollaston, William Hyde. "On Certain Chemical Effects of Light", *Nicholson's Journal of Natural Philosophy, Chemistry, and the Arts*, vol. 8, August 1804

Wood, John, ed. *America and the Daguerreotype*, University of Iowa Press, Iowa City 1991

Young, Thomas. "Experiments and Calculations Relative to Physical Optics", *Philosophical Transactions*, vol. 94, part 1, 1804

CHAPTER THREE
THE SIGNATURE OF LIGHT
JOHN McELHONE

Barger, M. Susan, and William B. White. *The Daguerreotype: Nineteenth-Century Technology and Modern Science*, Smithsonian Institution Press, Washington 1991

Bellone, Roger, and Luc Fellot. *Histoire mondiale de la photographie en couleurs*, Hachette Réalités, Paris 1981

Buchwald, Jed Z. *The Rise of the Wave Theory of Light: Optical Theory and Experiment in the Early Nineteenth Century*, University of Chicago Press, Chicago 1989

Buerger, Janet E. *French Daguerreotypes*, University of Chicago Press, Chicago 1989

Coe, Brian. *Colour Photography: The First Hundred Years 1840–1940*, Ash & Grant, London 1978

Connes, P. "Silver Salts and Standing Waves: The History of Interference Colour Photography", *Journal of Optics*, vol. 18, no. 4, Paris 1987

Ducos du Hauron, Alcide. *La triplice photographique des couleurs et l'imprimerie*. Gauthier-Villars, Paris 1897

Dumoulin, Eugène. *Les couleurs reproduites en photographie: Histoire, théorie et pratique*. Gauthier-Villars, Paris 1876

Eder, Joseph Maria. *History of Photography*, 4th German edn. trans. Edward Epstean, Dover Publications, New York 1978

Evans, Ralph M. "Maxwell's Color Photograph", *Scientific American*, vol. 205, no. 5, 1961

Fournier, Jean-Marc. "La photographie en couleur de type Lippmann: Cent ans de technique et de technologie", *Journal of Optics*, vol. 22, no. 6, Paris 1991

Fournier, Jean-Marc, and Paul L. Burnett. "Color Rendition and Archival Properties of Lippmann Photographs", *Journal of Imaging Science and Technology*, vol. 38, no. 6, 1994

Fournier, Jean-Marc. "An Investigation On Lippmann Photographs: Materials, Processes and Color Rendition", *Proceedings of SPIE (Practical Holography VIII)*, no. 2176, 1994

Friedman, Joseph S. *History of Color Photography*, American Photographic Publishing Company, Boston 1944

Höfel, Klaus, et al. *Farbe im Photo: Die Geschichte der Farbphotographie von 1861 bis 1981*, Josef-Haubrich-Kunsthalle, Cologne 1981

Ives, Frederic E. *A New Principle in Heliochromy*, printed by the author, Philadelphia 1889

Jenkins, Reese Valmer. "Some Interrelations of Science, Technology, and the Photographic Industry in the Nineteenth Century", Ph. D. dissertation, University of Wisconsin 1966

König, E. *Natural-Color Photography*, trans. E. J. Wall, Iliffe & Sons Ltd, London 1906

Nareid, Helge. "A Review of the Lippmann Colour Process", *Journal of Photographic Science*, no. 36, 1988

Neuhauss, R. *Die Farbenphotographie nach Lippmann's Verfahren*, Wilhelm Knapp, Halle 1898

Ostroff, Eugene, ed. *Pioneers of Photography: Their Achievements in Science and Technology*, SPSE—The Society for Imaging Science and Technology, Springfield 1987

Phillips, N. J., H. Heyworth, and T. Hare. "On Lippmann's Photography", *Journal of Photographic Science*, no. 32, 1984

Phillips, Nicholas J. "Links Between Photography and Holography: The Legacy of Gabriel Lippmann", *Proceedings of SPIE (Applications of Holography)*, no. 523, 1985

Pritchard, Michael, ed. *Technology and Art: The Birth and Early Years of Photography*, Royal Photographic Society Historical Group, Bath 1990

Schaaf, Larry J. *Out of the Shadows: Herschel, Talbot, & the Invention of Photography*, Yale University Press, New Haven and London 1992

Sobieszek, Robert, ed. *Early Experiments with Direct Color Photography: Three Texts*, Arno Press, New York 1979

Sobieszek, Robert, ed. *Two Pioneers of Color Photography: Cros & Du Hauron*, Arno Press, New York 1979

Valenta, Eduard. *Die Photographie in natürlichen Farben . . .*, Wilhelm Knapp, Halle 1894

Von Hübl, Arthur Freiherrn. *Three-Colour Photography, Three-Colour Printing and the Production of Photographic Pigment Pictures in Natural Colours*, trans. Henry Oscar Klein, A. W. Penrose & Co., London 1904

Wall, E. J. *The History of Three-Color Photography*, Focal Press, London 1970

Werge, John. *The Evolution of Photography*, reprint of the 1890 edn., Arno Press, New York 1973

CHAPTER FOUR
THE SEARCH FOR PATTERN
ANN THOMAS

Abbott, Berenice. *New Guide to Better Photography*, Crown Publishers, Inc., New York 1953

"American Photographical Society, The", *The American Journal of Photography*, vol. 6, no. 23, 1 June 1864

"Application of Photography to Zoological Studies", *Humphrey's Journal Devoted to the Daguerreian and Photogenic Arts, also Embracing the Sciences, Arts and Literature*, vol. 5, no. 22, 1 March 1954

Auer, Michèle and Michel. *Encyclopédie Internationale de Photographes de 1839 à nos jours/Photographers Encyclopaedia International, 1839 to the present*. Éditions Camera Obscura, Geneva 1985

Baier, Dr. Wolfgang. *Quellendarstellungen zur Geschichte der Fotografie*, VEB Fotokinoverlag, Leipzig 1966

Beale, Lionel S. *How to Work with The Microscope*, 3rd edn., Harrison, London 1865

Blum, Ann Shelby. *Picturing Nature: American Nineteenth-Century Zoological Illustration*, Princeton University Press, Princeton 1993

Borcoman, James. *Charles Nègre 1820–1880*, The National Gallery of Canada, Ottawa 1976

Brewster, Sir David. *A Treatise on the Microscope, Forming the Article under that Head in the Seventh Edition of the Encyclopaedia Britannica*, Adam and Charles Black, North Bridge, Edinburgh 1837

Brielle, Roger. "Laure Albin Guillot ou la Science Féerique", *Art et décoration: Revue mensuelle d'art moderne*, vol. LX, Éditions Albert Lévy, Librairie Centrale des Beaux-Arts, Paris July–December 1931

Brück, H. A. and M. T. *The Peripatetic Astronomer: The Life of Charles Piazzi Smyth*, Adam Hilger, Bristol and Philadelphia 1988

Burnett, C. J. "On the Application of Photography to Botanical and Other Book Illustration", *The Liverpool and Manchester Photographic Journal*, vol. 2, no. 18, 15 September 1858

Cohen, I. Bernard. "Some Recollections of Berenice Abbott", an enlarged version of a talk given by the author at the Berenice Abbott memorial at The New York Public Library, unpublished MS, 8 February 1992

C[ourtfield], Sy[dney]. *Ferns of the British Isles Described and Photographed*, John van Voorst, London 1877

Deane, James, MD. *Ichnographs from the Sandstone of Connecticut River*, Little Brown and Company, Boston 1861

Donné, A. L. *Cours de Microscopie complémentaire des études médicales. Anatomie, microscopie et physiologie des fluides de l'économie*, J. B. Baillière, Paris 1844

Donné, Alfred and Léon Foucault. *Cours de Microscopie complémentaire des études médicales: Atlas exécuté d'après*

nature au microscop–daguerréotype, J. B. Baillière, Paris 1845

Farmelo, Graham. "The Discovery of X-rays", *Scientific American*, vol. 273, no. 5, November 1995

Hammond, Anne. "The Soul of Architecture in Frederick H. Evans: Selected Texts and Bibliography", *World Photographers Reference Series*, vol. 1, G. K. Hall & Co, Boston 1992

Hemmerich, Christiane. "Die Biolgische Kunsttheorie im Werk von Ernst Haeckel", *Karl Blossfeldt*, Schirmer Mosel, Munich n. d.

Kanipe, Jeff. "Planet in a Bottle", *New Scientist*, vol. 153, no. 263, 4 January 1997

Kinkead, Eugene and Roman Vishniac. *Roman Vishniac*, Grossman Publishers, New York 1974

La mésure du ciel: de la plaque photographique aux techniques spatiales, Observatoire de Paris, Paris 1987

Liverpool Photographic Journal, vol. 2, no. 19, 14 July 1855

Lloyd, Valerie. *Roger Fenton: Photographer of the 1850s*, South Bank Board and Yale University Press, London 1988

Luys, Dr. Jules. *Iconographie photographique des centres nerveux. Atlas de soixante-dix photographies avec soixante-cinq chémas [sic] lithographiées*. J. B. Baillière, Paris 1873

Moholy-Nagy, Laszlo. *Painting, Photography, Film*, MIT Press, Cambridge 1969

O'Neal, Hank. *Berenice Abbott: American Photographer*, McGraw-Hill Book Company, New York 1982

"On Some of the Leading Plants of the Lowest Zone in Teneriffe", delivered to the Botanical Society of Edinburgh, in *Transactions of the Botanical Society of Ediburgh*, vol. v, 1858

"On the Application of Photography to the Continuous Self-Registration of Magnetic and Meteorological Phenomena, as Practised at the Royal Observatory at Greenwich", *The British Journal of Photography*, vol. 12, no. 267, 16 June 1865

Otto, Dr. L. and Dr. H. Martin. *150 Jahre Mikrophotographie*, Höhere Graphische Bundes-Lehr-und Versuchsanstalt, Vienna 1989

Phillips, Christopher, ed. *Photography in the Modern Era: European Documents and Critical Writings, 1913–1940*, The Metropolitan Museum of Art, Aperture, New York 1989

"Photography Applied to Natural Sciences", *The Liverpool Photographic Journal*, vol. 2, no. 22, 13 October 1855

Prior, Douglas. "W. A. Bentley", *The History of Photography Series*, no. 10, Arizona State University, Phoenix May 1984

"Régistre des procés verbaux. Séances de l'assemblée des professeurs administrateurs du Muséum d'histoire naturelle", vol. 50, séance du 4 octobre 1853

Schaaf, Larry J. "Charles Piazzi Smyth, Photography, and the Disciples of Constable & Harding", paper presented to Scottish Contributions to Photography, an international symposium at the Glasgow School of Art, 5 March 1983, *Photo-*

graphic Collector, vol. 4, no. 3, Winter 1983

Schaaf, Larry J. *Sun Gardens: Victorian Photograms by Anna Atkins*, Aperture, organized by Hans P. Kraus, Jr., New York 1985

Schaaf, Larry J. *Out of the Shadows: Herschel, Talbot & the Invention of Photography*, Yale University Press, New Haven and London 1992

Schaaf, Larry J. *Records of the Dawn of Photography: Talbot's Notebooks P & Q*, Cambridge University Press in cooperation with the National Museum of Photography, Film & Television, Cambridge and New York 1996

"Séance du lundi 14 mars 1853: correspondance", "Séance du lundi 25 avril 1853: correspondance", *Comptes rendus hebdomadaires des séances de l'Académie des sciences*, 1ᵉʳ semestre, tome XXXVI, no. 11, 1853

"Séance du lundi 6 juin 1853: mémoires et communications: Zoologie: Rapport sur un ouvrage inédit, intitulé: *Photographie zoologique*; par MM. Rousseau et Dévéria [sic]". *Comptes rendus hebdomadaires des séances de l'Académie des sciences*, 1ᵉʳ semestre, tome XXXVI, no. 23, 1853

"Séance du lundi 30 avril 1860: correspondance: Orographie: Note sur l'application de la photographie à la géographie physique et à la géologie, par M. A. Civiale", *Comptes rendus hebdomaires des séances de l'Académie des sciences*, 1ᵉʳ semestre, tome L, no. 18, 1860

Smith, David G., ed. *The Cambridge Encyclopaedia of Earth Sciences*, Prentice Hall Canada Inc. and Cambridge University Press, Scarborough 1981

Smyth, Charles Piazzi. *Cloud-forms that have been to the Glory of God their Creator, and the wonderment of learned men. As now begun to be recorded by Instant Photographs, taken at Clova, Ripon, in 1892, 93 and 94*, vol. 1, collection of the Royal Society, London

St. Andrews Literary and Philosophical Society, minutes for 4 March 1839, *Minutes of the St. Andrews Literary and Philosophical Society 1838–1861*, Saint Andrews

Stanley Smith, Cyril. *A Search for Structure: Selected Essays on Science, Art, and History*, MIT Press, Cambridge 1981

Sutton, Thomas. "On Some of the Uses and Abuses of Photography", *Photographic Notes*, vol. 8, no. 163, 15 January 1863

Taton, René. *Science in the Nineteenth Century*, Basic Books, New York 1965

Thompson, D'Arcy. *On Growth and Form*, 1st abridged edn., Cambridge University Press, Cambridge 1961

"Various Forms of Snow Crystals Drawn by Mr. Glaisher in the Winter of 1855", *Microscopical Journal*, vol. 3, 1855

Worthington, A. M. *A Study of Splashes*, Longman's, Green and Co., London 1908

CHAPTER FIVE
"A PERFECT AND FAITHFUL RECORD"
MARTIN KEMP

"A Remarkabe Case of Double Monstrosity in an Adult", *The Lancet*, no. 2, 1865

Albinus, Bernhard Siegfried. *Tabulae sceleti et musculorum corporis humani*, Verbeek, Leiden 1747

Amirault, Chris. "Posing the Subject of Early Medical Photography", *Discourse*, no. 16, 1993–94

Anderson, Jaynie. "Giovanni Morelli et sa définition de la 'scienza dell' arte", *Revue de l'art*, no. 75, 1987

Baraduc, H. *L'âme humaine, ses mouvements, ses lumières et l'iconographie de l'invisible fluidique*, Carré, Paris 1896.

Batut, Arthur. *La Photographie appliqué a la production du type, d'une famille, d'une tribu ou d'une race*, Gauthier-Villars, Paris 1887

Bazin, Germain. *Théodore Géricault. Études critiques, documents et catalogue raisonné*, 6 vols. La Bibliothèque des Arts, Paris 1987–94

Bell, Charles. *Essays on the Anatomy of the Expression in Painting*, Longman, Hurst, Ress and Orme, London 1806

Bertillon, Alphonse. *La photographique judicaire*, Villars, Paris 1890

Bertillon, Alphonse. *Instructions signalétiques*, Imprimière administrative, Melun 1890–93

Bidloo, Govard. *Anatomia humani corporis*, Sommern, Dyke and Boom, Leiden 1685

Billroth, Thomas. *Stereoskopishe Photographien chirurgischer Kranken*, Enke, Erlangen 1867

Blocq, Paul and Albert Londe. *Anatomie pathologique de la moelle épinière*, with preface by Jean Martin Charcot, illustrated with 48 microphotographs reproduced in photogravure by Lumière and Sons of Lyon, Masson, Paris c. 1891

Bourneville, Désiré-Magloire and Paul Regnard. *Iconographie photographique de la Salpêtrière*, 3 vols., Delahaye, Paris 1876–80

Braun, Marta. *Picturing Time: The Work of Etienne-Jules Marey (1830–1904)*, Chicago University Press, Chicago and London 1992

Bridson, Gavin and James White. *Plant, Animal and Anatomical Illustration in Art and Science*, St. Paul's Bibliographies, Winchester 1990

Broca, Paul. *Mémoires d'anthropologie*, Reinwald, Paris 1871

Broca, Paul. "Sur le volume et la forme du cerveau suivant les individus et suivant les races", *Bulletin de la Société d'Anthropologie de Bruxelles*, II, 1861

Browne, Lennox and Emil Behnke. *Voice, Song and Speech*, Low, Marston, Searle and Rivington, London 1883

Burke, T. Joseph and Colin Cambell. *Hogarth: The Complete Engravings*, Alpine Fine Arts Collection, London n. d.

Burns, S. *Medical Photography in America*, The Burns Archive, New York 1983

Cazort, Mimi with Monique Kornell and B. Kenneth Roberts. *The Ingenious Machine of Nature: Four Centuries of Art and Anatomy*, National Gallery of Canada, Ottawa 1996

Charcot, Jean Martin and Richer, Paul. *Les démoniaques dans l'art*, Delahaye and Lecrosnier, Paris 1887; repr. Israël, Amsterdam 1972

Charcot, Jean Martin. *Nouvelle iconographie de la Salpêtrière*, vol. I, Lecrosnier and Babé, Paris 1888

Charcot, Jean Martin. *Les difformes et les malades dans l'art*, Delahaye and Lecrosnier, Paris 1889; repr. Israël, Amsterdam 1972

Cheselden, William. *Osteographia, or the Anatomy of the Bones*, London 1733

"Craze for Photography in Medical Illustration, The", Editorial, *New York Medical Journal*, LIX, 1894

Czermak, Johann Nepomuk. *On the Laryngoscope and its Employment in Physiology and Medicine*, trans. G. D. Gibb, The New Sydenham Society, London 1861

Dagonet, Henri. *Nouveau traité élémentaire et pratique des maladies mentales*, Ballière, Paris 1876

Dammann, Carl. *Anthropologish–Ethnologisches Album in Photographien*, Wiegart, Hempel and Parey, Berlin 1873–74

Dammann, Carl. *Ethnological Gallery of the Various Races of Man*, Trubner, London 1875

Darwin, Charles. *The Expression of the Emotions in Man and Animals*. Murray, London 1872

De Marneffe, Daphne. "Looking and Listening. The Construction of Clinical Knowledge in Charcot and Freud", *Signs* 17, 1991

De Montméja A. and J. Regnade. *La revue photographique des hôpitaux de Paris*, Paris 1869

Diamond, Hugh Welch. "On the Application of Photography to the Physiognomic and Mental Phenomena of Insanity. Report of an Address to the Royal Society", *Journal of the Photographic Society*, no. 3-4, 1856–58

Didi-Huberman, Georges. *Invention de l'hystérie: Charcot et l'iconographie photographique de la Salpêtrière*, Macula, Paris 1982

Donné, Alfred and Léon Foucault. *Cours de microscopie complémentaire des études médicales. Atlas exécuté d'après nature au microscop-daguerréotype*. Baillière, Paris 1845

Douglas, Lieut.-Col. "The Degenerates and the Modes of their Elimination", *Physician and Surgeon*, no. 1, 1900

Down, John. *Observations on the Classification of Idiots*, Hospital Reports, London 1866

Duchenne de Boulogne, Guillame-Benjamin. *Mécanisme de la physionomie humaine ou analyse electro- physiologique de l'expression des passions*, 2 vols., trans. R. Andrew Cuthbertson, Cambridge University Press, Cambridge 1990

BIBLIOGRAPHY TO CHAPTER 5

Eder, Joseph Maria. *History of Photography*, trans. E. Epstean, Columbia University Press, New York 1972

Edwards, Elizabeth. "'Photographic Types': The Pursuit of Method", *Visual Anthropology*, no. 3, 1990

Edwards, Elizabeth. "Beyond the Boundary: Ethnography and Photographic Expression", *Rethinking Visual Anthropology*, ed. M. Banks and H. Morphy, Yale University Press, London and New Haven 1997

Edwards, Elizabeth. "Ordering Others: Photography, Anthropologies and Taxonomies", *Invisible Light: Photography, Classification in Art, Science and Everyday*, ed. R. Roberts, Museum of Modern Art, Oxford 1997, forthcoming

Ellis, Havelock. *The Criminal*, Scott, London 1980

Fogle, Douglas. "Die Passionen des Körpers: Fotografie und männliche Hysterie", *Fotogeschichte: Beitrage zur Geschichte Asthetik der Fotografie*, vol. 13, no. 49, 1993

Forrest, Derek William. *Francis Galton: The Life and Work of a Victorian Genius*, Elek, London 1974

Fox, Daniel and James Terry. "Photography and the Self-Image of American Physicians", *Bulletin of the History of Medicine*, no. 52, 1978

Fox, Daniel and Christopher Lawrence. *Photographing Medicine: Images and Power in Britain and America since 1840*, Greenwood Press, New York and London 1988

Fox, George. *Photographic Illustrations of Skin Diseases*, Treat, New York 1886

Gall, Franz and Johann Spurzheim. *Anatomie et physiologie du système nerveux en général et sur celui du cerveau en particulier*, 4 vols., F. Schoell, Paris 1809

Galton, Francis. "Hereditary Improvement", *Frazers Magazine*, no. 7, 1873

Galton, Francis. "Address to the Department of Anthropology, Section H", *British Association Report*, 1877; repr. *Nature*, no. 16, 1877

Galton, Francis. "Composite Portraits", *Journal of the Anthropological Institute*, no. 8, 1878; repr. *Nature*, no. 18, 1878

Galton, Francis. "Photographic Chronicles from Childhood to Age", *Fortnightly Review*, no. 181, 1882

Galton, Francis. *Inquiries into the Human Faculty*. Macmillan, London 1883

Galton, Francis. "Eugenics: its Definition, Scope and Aims", *Sociological Papers*, no. 1, 1905

Gasser, Jacques, with Stanley Burns. *Photographie et Médicine*, Institut Universitaire d'Histoire de la Médicine et de la Santé Publique, Lausanne 1991

Gernsheim, Alison. "Medical Photography in the Nineteenth Century", *Medical and Biological Illustration*. no. 11

Gilman, L. Sander. *The Face of Madness: Hugh W. Diamond and the Origins of Psychiatric Photography*, Brunner/Mazel, New York 1976

Gilman, L. Sander. *Seeing the Insane*, John Wiley, New York 1982

Ginsberg, Carlo. "Morelli, Freud and Sherlock Holmes: Clues and the Scientific Method", *History Workshop*. no. 9, 1980

Gould, Steven Jay. *The Mismeasure of Man*, Norton, New York 1981

Gray, Henry. *Anatomy Descriptive and Surgical*, Parker, London 1858

Green, David. "Veins of Resemblance", *Oxford Art Journal*, no. 7, 1985

Hardy, M. A. and de A. Montméja. *Clinique photographique de l'Hôpital Saint-Louis*, Chamerot and Lauwereyns, Paris 1868

Hunter, William. *Anatomia uteri humani gravidi [Anatomy of the Human Gravid Uterus]*, Baskerville, Birmingham 1774

Jankau, Ludwig. *Die Photographie in der praktischen Medezin*, Seitz and Schauer, Munich 1894

Jordanova, Ludmilla. "Medicine and Visual Culture", *Social History of Medicine*, no. 3, 1990

Keiller, William. "The Craze for Photography in Medical Illustration", letter, *New York Medical Journal*, LIX, 1894

Kemp, Martin. ""The Mark of Truth": Looking and Learning in Some Anatomical Illustrations from the Renaissance and the Eighteenth Century", *Medicine and the Five Senses*, ed. W. F. Bynum and R. Porter. Cambridge University Press, Cambridge 1993

Kemp, Martin. "'Philosophy in Sport' and the 'Sacred Precincts': Sir David Brewster on the Kaleidoscope and the Stereoscope", *Muse and Reason: The Relation of Arts and Sciences 1650–1850*, ed. B. Castel, J. Leith and A. Riley, *Queens Quarterly*, Kingston 1994

Kemp, Martin. "Showing it for Real", *Materia Medica*, ed. K. Arnold, Wellcome Institute, London 1995

Kemp, Martin. "Temples of the Body and Temples of the Cosmos: Vision and Visualization in the Vesalian and Copernican Revolutions", *Picturing Knowledge: Historical and Philosophical Problems Concerning the Use of Art in Science*, ed. B. S. Baigrie, Toronto University Press, Toronto 1996

Kemp, Martin. "Medicine in View: Art and Visual Representation", *The Oxford Illlustrated History of Western Medicine*, ed. I. Loudon, Oxford University Press, Oxford 1997

Kemp, Martin. "Style and Non-Style in Anatomical Illustration", *Constructing and Deconstructing the Body: Art and Anatomy XVth–XXth Century*, Centre des Pensières. Annecy, 8–11 May 1997

Lamprey, John. "On a Method of Measuring Human Form for Students of Ethnology", *Journal of the Ethnological Society*, no. 1, 1869

Lavater, Johann Caspar. *Physiognomische Fragmente*, 4 vols., Weidmanns Erben and Reich, Leipzig and Winterthur, 1775–78

Le Brun, Charles. *Méthode pour apprehender à dessiner les*

passions . . . Conférences sur l'expression des passions, Paris 1667

Lombroso, Cesare. *L'uomo deliquente in rapporto all' antropologia, alla giurisprudenza ed alle discipline carcerarie*, Bocca, Turin 1876

Londe, Albert. "La Photographie en médicine", *La Nature*, 1883

Londe, Albert. *La Photographie médicale: Application aux sciences médicales et physiologiques*, Gautier-Villars, Paris 1893

Lorenz, Adolf. *Pathologie und Therapie der seitlichen Rückgrat-Verkrümmungen (Scoliosis)*, Hölder, Vienna 1886

Maehle, Andreas-Holger. "The Search for Objective Communication", *Non-Verbal Communication in Science Prior to 1900*, ed. Renato Giuseppe Mazzolini, Olschki, Florence 1993

Marles, Hugh. "Duchenne de Boulogne", *History of Photography*, no. 16, 1992

Marshall, William. *A Phrenologist Amongst the Todas, or the Study of a Primitive Tribe in South India: History, Character, Customs, Religion, Infanticide, Polyandry, Language*, Longman, Green, London 1873

Medicus, "Indecency in Photography", letter to *The New York Medical Journal*, LIX, 1894

Misura d'uomo. ed. G. Barsanti, S. Gori-Savellini, P. Guarnieri and C. Pogliano, Museo di Storia della Scienza, Florence 1986.

Morel, Bénédicte Auguste. *Traité des dégénérescences physiques, intellectuelles, et morales de l'espèce humaine et des causes qui produisent ces variétés maladives*, Baillière, Paris 1857

Morselli, Enrico and Sante de Sanctis. *Biografia di un bandito*, Treves, Milan 1903

Muybridge, Eadweard. *Animal Locomotion: An Electro-Photographic Investigation of Consecutive Phases of Animal Movements*, University of Pennsylvania, Philadelphia 1897

Neisser, S. Albert Ludwig. *Stereoskopischer Atlas: Sammlung photographischer Bilder aus dem Gesammtgebiet der klinischen Medizin, der Anatomie und der pathologischen Anantomie etc.*, Fischer Barth, Kassel and Leipzig 1894–1900

Nitze, Max. *Kystophotographischer Atlas*, Bergman, Wiesbaden 1894

Ollerenshaw, Robert. "Medical Illustration: the Impact of Photography on its History", *Journal of the Biological Photographic Association*, no. 36, 1968

Parsons, James. "Human Physiognomy Explained", *Supplement to the Philosophical Transactions*, 1747

Patrizzi, Mariano. *La fisiologia d'un bandito*, Bocca, Turin 1904

Pearson, Karl. *The Life, Letters and Labours of Francis Galton*, 4 vols., London 1914–30

Pereira, Jonathan. *The Elements of Materia Medica*, 2 vols.,

Longam, Orme, Brown, Green and Longman's, London 1839–40

Rüdinger, Nicolaus. *Atlas des peripherischen Nervensysytems des menschlichen Körpers*, Cotta'schen, Munich 1861

Rüdinger, Nicolaus. *Die Anatomie der menschlichen Gehirn-Nerven für Studirende und Aertze*, Literarisch-Artistische Anstalt, Munich 1868

Rüdinger, Nicolaus. *Die Anatomie der menschlichen Rüden-marks-Nerven*, Cotta'schen, Stuttgart 1870

Rüdinger, Nicolaus. *Topographisch-chirugische Anatomie des Menschen*, 4 vols., Cotta'schen, Stuttgart 1873–79

Sayre, Lewis. *Spinal Disease and Spinal Curvature*, Smith, Elder, London 1877

Silverman, Deborah. *Art Nouveau in Fin-de-Siècle France: Politics, Psychology and Style*, University of California Press, Berkeley, Los Angeles and London 1989

Spencer, Frank. "Some Notes on the Attempt to Apply Photography to Anthropometry during the Second Half of the Nineteenth Century", *Anthropology and Photography, 1875–1920*. ed. E. Edwards, Yale University Press, London and New Haven 1992

Spurzheim, Johann. *Observations sur la phraenologie*. Treuttel and Würtz, Paris 1818

Squire, Alexander John Balmanno. *Photographs Coloured from Life of the Diseases of the Skin*, John Churchill and Sons, London 1865

Tylor, B. Edward. "Dammann's Race-Photographs", *Nature*, no. 13, 1876

Vesalius, Andreas. *De humani corporis fabrica*, Oporinus, Basel 1543

Waterston, David. *The Edinburgh Stereoscopic Atlas of Anatomy*, Jack, Edinburgh 1905

Wildberger, Johannes. *Zehn Photographische Abbildungen zum Nachweis der günsten Heilresultate. . . .*, Hirschfeld, Leipzig 1863

Witkin, Joel-Peter. *Masterpieces of Medical Photography: Selections from the Burns Archive*, Twelvetrees, Passadena 1987

Woodbury, Walter. *Encyclopaedia of Photography*, Iliffe, London 1890

Wright, C. Henry. "Photography and the Healing Art", letter to *The Journal of Photography*, no. 5, 1863

Wright, C. Henry. "On the Medical Uses of Photography", *The Photographic Journal*, no. 9, 1867

CHAPTER SIX
THE PHOTOGRAPHY OF MOVEMENT
MARTA BRAUN

Bedi, Joyce. "Faster than a Speeding Bullet!", unpublished paper given to the Society for the History of Technology, Lowell, Massachusetts 1994

Bernard, Denis and André Gunthert. "Albert Londe: l'image multiple", *La recherche photographique*, 34, May 1988

Bernard, Denis and André Gunthert. *L'Instant rêvé Albert Londe*, Jacqueline Chambon-Trois, Paris 1993

Boys, Sir Charles Vernon. "Notes on Photographs of Rapidly Moved Objects, and on the Oscillating Electric Spark", *The Philosophical Magazine and Journal of Science*, 5th series, vol. 30, September 1890

Boys, Sir Charles Vernon. *Soap-bubbles and the Forces which Mould Them, Being a Course of Three Lectures Delivered at the London Institution in December 1889, and January 1890 before a Juvenile Audience*, Society for Promoting Christian Knowledge, London 1890

Braun, Marta. "Muybridge's Scientific Fictions", *Studies in Visual Communication*, vol. 10, no. 3, 1984

Braun, Marta. *Picturing Time: The Work of Etienne-Jules Marey (1830–1904)*, University of Chicago Press, Chicago 1992

Collins, Douglas. "Biographical Essay", *Seeing the Unseen: Dr. Harold E. Edgerton and the Wonders of Strobe Alley*, ed. Roger R. Bruce, Trust of George Eastman House, Rochester 1994

Darius, Jon. *Beyond Vision*, Oxford University Press, New York and Oxford 1984

Daston, Lorraine and Peter Galison. "The Image of Objectivity", *Representations*, 40, Fall 1992

Demeny, Georges. *L'Education physique en Suède*. Editions Scientifiques, Paris 1892

Demeny, Georges. *Les bases scientifiques de l'éducation physique*. Alcan, Paris 1893

Eder, Joseph. *La photographie instantanée*, Paris 1888

Edgerton, Harold E. "Strobe Photography: A Brief History", *Optical Engineering*, 23 July/August 1984

Galloway, John. "Seeing the Invisible: Photography in Science", *Impact of Science on Society*, no. 168, 1992

Gastine, Louis. *La Chronophotographie, sur plaque fixe et sur pellicule mobile*, Masson and Gauthier- Villars, Paris 1897

Hendricks, Gordon. *The Photographs of Thomas Eakins*, Grossman, New York 1972

Janssen, Jules. "Présentation du Revolver Photographique et épreuves obtenues avec cet instrument", *Bulletin de la Société française de photographie*, XXII, Paris 1876

Johns, Elizabeth. *Thomas Eakins: the Heroism of Modern Life*, Princeton University Press, Princeton 1983

Marey, Etienne-Jules and Georges Demeny. *Études de physiologie artistique faites au moyen de la chronophotographie*, 1er série, vol. I: *Du Mouvement de l'homme*, Berthaud, Paris 1893

Marey, Etienne-Jules. *Movement*, Appleton, New York 1895; repr. Arno Press, New York 1972

Marey, Etienne-Jules. *La Chronophotographie, Conférence du Conservatoire National des Arts et Métiers*, Gauthier-Villars, Paris 1899

Marey, Etienne-Jules. preface to Charles-Louis Eugène Trutat, *La photographie animée*, Gauthier-Villars, Paris 1899

Marks, William, "The Mechanism of Instantaneous Photography", *Animal Locomotion: The Muybridge Work at the University of Pennsylvania*, ed. W. D. Marks, H. Allen, and F. X. Dercum, Lippincott, Philadelphia 1888; repr. Arno Press, New York 1973

Mathon, Catherine and Anne-Marie Garcia. *Les chefs-d'oeuvre de la photographie dans les collections de l'École des Beaux-Arts*, École nationale supérieure des Beaux-Arts, Paris 1991

McFarland, Marvin W., ed. *Wilbur Wright and Orville Wright: The Papers of Wilbur and Orville Wright*, McGraw Hill, New York 1953

Mozley, Anita. *Introduction to Muybridge's Complete Human and Animal Locomotion*, Dover, New York 1989

Ozanam, Docteur Charles. *Les Battements du coeur et du pouls reproduits par la photographie*, S. Ragon, Paris 1868

Ozanam, Docteur Charles. "Procès verbal", *Bulletin de la Société française de photographie*, 2 July 1869

Richer, Paul. *Physiologie artistique de l'homme en mouvement*, Octave Doin, Paris 1895

Rossell Deac. "Lebende Bilder: Die Chronophotographen Ottomar Anschütz und Ernst Kohlrausch", *Wir Wunderkinder: 100 Jahre Filmproduktion in Niedersachsen*, ed. Pamela Müller and Susanne Höbermann, Gesellschaft für Filmstudien, Hanover 1995

Rossell, Deac. *Ottomar Anschütz and His Electrical Wonder*, The Projection Box, London 1997

Schmidt, F. A. "Die Augenblicksphotographie und ihre Bedeutung für die Bewegungslehre", *Deutsche Turn-Zeitung*, Leipzig, 51, 22 December 1887

Snyder, Joel. "Visualization and Visibility", *Picturing Science, Producing Art*, ed. Caroline A. Jones and Peter Galison, Routledge, London forthcoming

Stein, Sigmund Theodor. *Das Lichte im dienste Wissenschaflicher Forschung*, 2nd edn., Wilhelm Knapp, Halle a. S., vol. I 1885; vol. II 1888

Talbot, William Henry Fox. "Note on Instantaneous Photographic Images", *Abstracts of the Papers Communicated to the Royal Society of London*, no. 6, 19 June 1851

Talbot, William Henry Fox. "On the Production of Instantaneous Photographic Images", *Philosophical Magazine*, 4th series, vol. 3, no. 15, January 1852

Volkmer, Ottomar. *Die photographische Aufnahme von Unsichtbaren*, Verlag von Wilhelm Knapp, Halle a. S. 1894

Wheatstone, Charles. "An Account of Some Experiments to Measure the Velocity of Electricity and the Duration of Electric Light", *Philosophical Transactions of the Royal Society of London*, part II, 1834

Whitesides, George M. "Truth and Beauty in Scientific Photography", *Technology Review*, 99, May/June 1996

Worthington, A. M. *A Study of Splashes*, Longmans, Green and Co., London 1908

Wright, Wilbur. "Some Aeronautical Experiments", lecture to the Western Society of Engineers, 18 September 1901; repr. in *The Papers of Wilbur and Orville Wright*, ed. Marvin W. McFarland, McGraw Hill, New York 1953

Wright, Wilbur. "Experiments and Observations in Soaring Flight", *Journal of the Western Society of Engineers*, December 1903; repr. in *The Papers of Wilbur and Orville Wright*, ed. Marvin W. McFarland, McGraw Hill, New York 1953

CHAPTER SEVEN
CAPTURING LIGHT
ANN THOMAS

Arago, François. *Rapport fait à l'Académie des sciences de Paris le 19 août 1839*, L'Échoppe, Paris n. d.

Arago, François. *Astronomie populaire*, Gide, Paris and T. O. Weigel, Leipzig 1858

"Astro-Photography", *Photographic Notes: Journal of the Photographic Society of Scotland and of the Manchester Photographic Society*, vol. 2, no. 39, 15 November 1857

Barger, M. Susan, and William B. White. *The Daguerreotype: Nineteenth-Century Technology and Modern Science*, Smithsonian Institution Press, Washington 1991

Begley, Sharon. "A Heavenly Host", *Newsweek*, 29 January 1996

Buerger, Janet E. *French Daguerreotypes*, University of Chicago Press, Chicago 1989

Crookes, William. "On the Photography of the Moon" *The Daguerrian Journal*, vol. 9, no. 5, 1 July 1857

Darius, Jon. *Beyond Vision*, Oxford University Press, Oxford and New York 1984

Davanne, A. *La photographie appliquée aux sciences. Conférence faite à la Sorbonne le 26 février, 1881* Gauthiers-Villars, Paris 1881

De la Rue, Warren. "Lunar Stereographs", letter to the Editor, *The Photographic Journal*, vol. 6, no. 97, 1 July 1859

De la Rue, Warren. "Report on the Progress of Celestial Photography since the Meeting at Aberdeen", *The British Journal of Photography*, vol. 8, no. 150, 16 September 1861

De la Rue, Warren. "The Progress of Celestial Photography" *Photographic Notes*, vol. 6, no. 132, 1 October 1861

Eder, Josef Maria. *History of Photography*, Dover Publications, New York 1978

Harvey, G. M. "Gravitational Deflection of Light: a Reexamination of the Observations of the Solar Eclipse of 1919", *The Observatory*, 99, December 1979

Henbest, Nigel and Michael Martin. *The New Astronomy: Second Edition*, Cambridge University Press, Cambridge 1996

Hoffleit, Dorrit. *Some Firsts in Astronomical Photography*, Harvard College Observatory, Cambridge 1950

"Important Experiment: Daguerreotype of the Sun", *The Daguerrian Journal*, vol. 2, no. 7 15 August 1851

"Liverpool Photographic Society, The", *The Liverpool Photographic Journal*, vol. 1, no. 6, 10 June 1854 and no. 10, 14 October 1854

"Lunar daguerreotypes", *The Daguerrian Journal*, vol. 1, no. 1, 1 November 1850 and vol. 2, no. 6, 1 August 1852

Malin, David. *A View of the Universe*, Sky Publishing Corporation and Cambridge University Press, Cambridge, Massachusetts and Cambridge, England 1993

"Meetings of Societies: South London Photographic Society", *The British Journal of Photography*, vol. 8, no. 134, 15 January 1861

Mitton, Simon, ed. *The Cambridge Encyclopaedia of Astronomy*, Prentice-Hall of Canada, Scarborough 1977

Nappaaluk, Mitiarjuk. "Mitiarjuk's Inuit Encyclopaedia", *Tumivut*, Winter 1993

Norman, Daniel. "The Development of Astronomical Photography" *Osiris*, 5, Harvard College Observatory, Cambridge 1938

Pannekoek, A. *A History of Astronomy*, Dover Publications, New York 1961

Perkowitz, Sidney. *Empire of Light: A History of Discovery in Science and Art*, Henry Holt and Company, New York 1996

"Photographic Notes", *Journal of the Photographic Society of Scotland and of the Manchester Photographic Society*, vol. 1, no. 14, 1 November 1856 and vol. 2, no. 39, 15 November 1857

"Photographs of the Sun", *The Liverpool Photographic Journal*, vol. 1, no. 17, 12 May 1855

Radau, Rudolpho. *La photographie et ses applications scientifiques*, Gauthier-Villars, Paris 1878

Read, Rev. W. J. "On the Applications of Photography", *Photographic Notes: Journal of the Photographic Society of Scotland and of the Manchester Photographic Society*, vol. 1, no. 12, 1 October 1856

Schaaf, Larry J., ed., *Selected correspondence of William Henry Fox Talbot*, Science Museum and National Museum of Photography, Film & Television, London 1996

Secchi, Fr. Angelo. "Lunar Photography", *The Daguerrian Journal*, vol. 8, no. 23, 1 April 1857

Sheehan, William. "Edward Barnard's Magnificent Milky Way", *Astronomy*, vol. 24, no. 6, June 1996

Sky News: the Canadian Magazine of Astronomy & Stargazing, vol. 1, no. 4, November–December 1995

"Stellar Daguerreotype", *The Daguerrian Journal*, vol. 1, no. 1, 1 November 1850

INDEX

Numbers in *italic* are numbers of plates.